HUMAN
PLANET

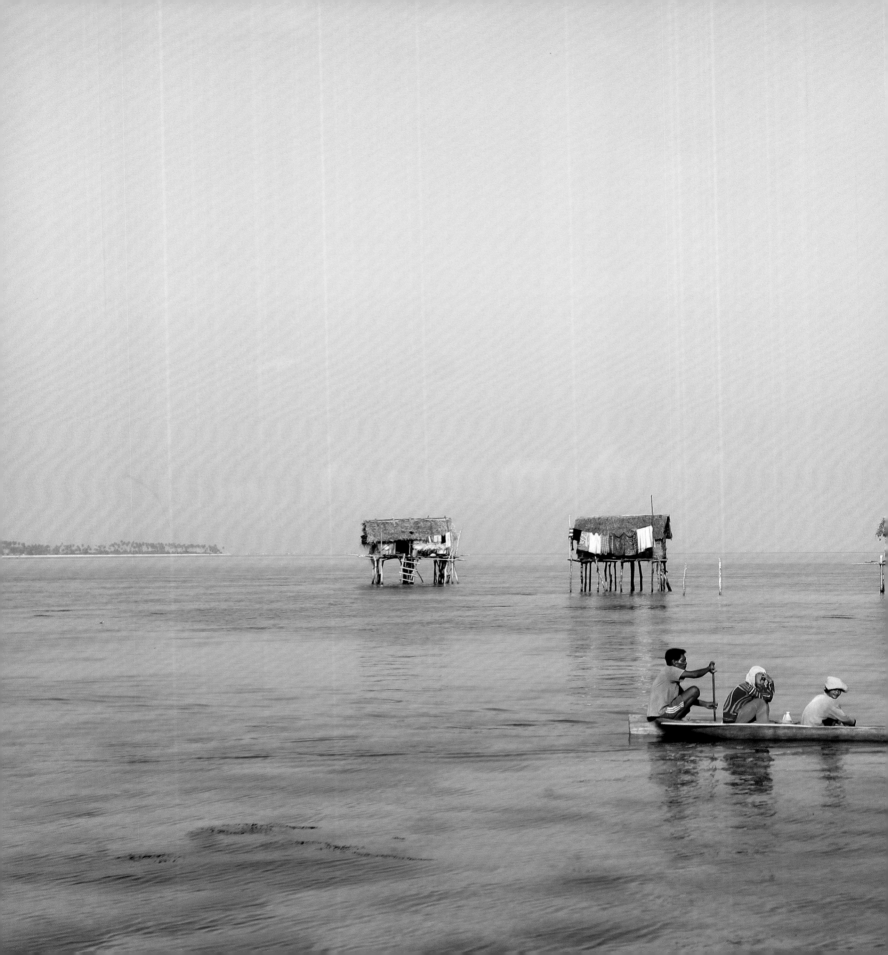

HUMAN
PLANET

NATURE'S GREATEST HUMAN STORIES

DALE TEMPLAR AND **BRIAN LEITH**

**NICOLAS BROWN, CIARAN FLANNERY,
TOM HUGH-JONES** AND **TUPPENCE STONE**

PHOTOGRAPHY BY
TIMOTHY ALLEN

BOOKS

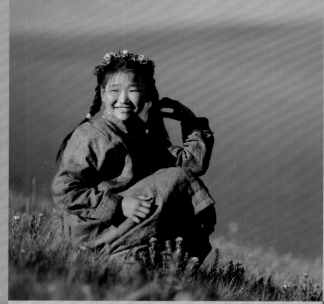

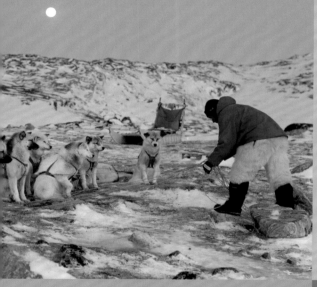

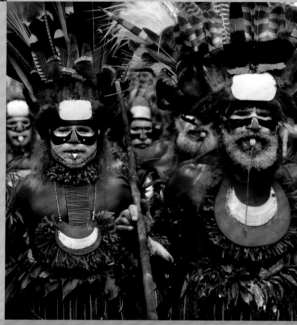

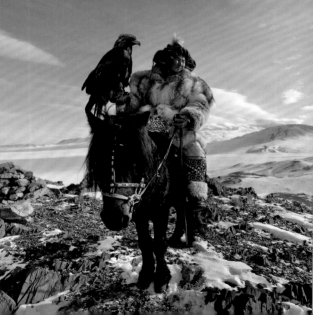

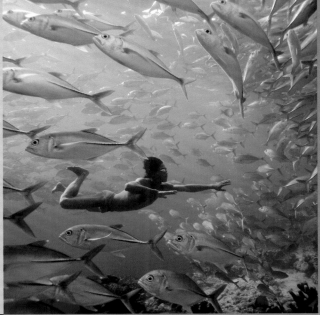
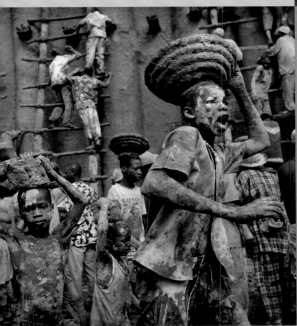
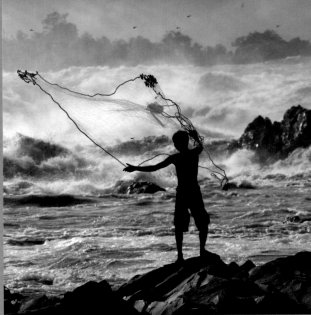
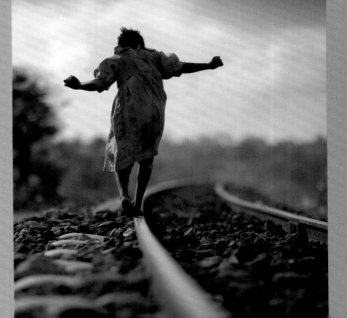

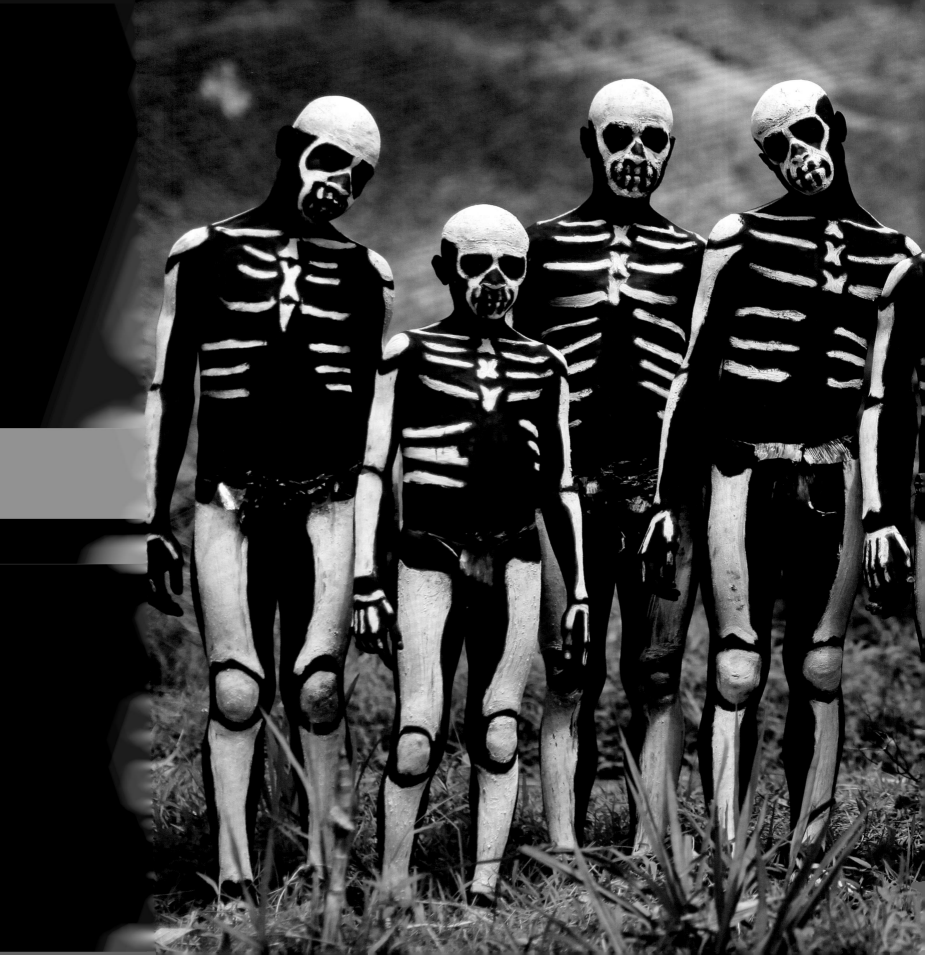

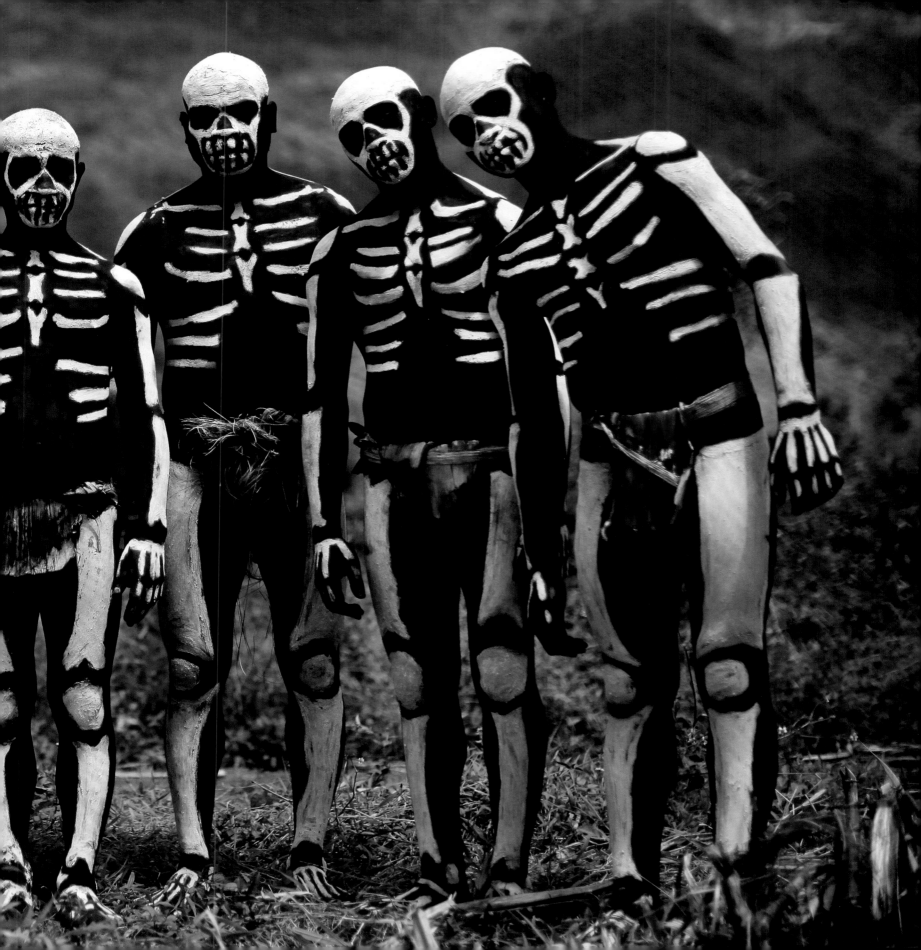

FOREWORD

We humans are remarkable. By any objective biological measure, we are probably the most remarkable species of all. What other creature communicates so extensively, creates such vast communities to live in, carves the planet's landscapes to such an extent? What other species has come to dominate the planet – and managed to master survival in virtually every habitat? From searing deserts to frozen poles and steamy jungles, we have made a life for ourselves in every corner of the world.

Our current age could be called the age of explosive human expansion, which in turn is spawning environmental and ecological problems – from habitat loss to the extinction of species – not to mention climate change. But if we regard our species as just a plague upon the planet – a species running amok – we're in danger of overlooking a biological truth: we humans have impressive skills and abilities. Indeed, we are without doubt the most adaptable and most powerful species that evolution has ever created.

WHY HAVE WE DONE IT? *HOW* HAVE WE DONE IT?

The question of *why* we have spread so successfully and so rapidly around the world is probably unanswerable. What drives the bee to seek pollen with such relentless energy, the spider to build a web with such determination, the swallow to fly so unwaveringly towards its summer home? These are the deepest questions of biology – caught somewhere between selfish genes and arm-waving philosophy. The meaning of life always seems to be something like 'go forth and multiply', and this inner drive seems to run through the core of all living things. In that sense we are, like all living things, unremarkable – simply fulfilling our deepest genetic imperatives like any other creature.

The question of *how* we've done it – and how we still do it – is much more interesting and thought-provoking. What are the key human attributes that have enabled us to become so successful? Is it our prodigious intelligence? Our compulsive urge to communicate? Our intimate sociability? The answer seems to be yes, yes and yes. And each story we tell in the series, each sequence we have filmed, is an insight into how we have exploited some aspect of our human uniqueness – our acute senses and intuitions, our sociability and collaborativeness, our ingenuity and innovation, sometimes even our sheer brute strength – to overcome all obstacles in our way and adapt to life in the most arduous and brutal places imaginable.

Think for a moment about the nature of those obstacles, the difficulties we've had to overcome to survive and thrive in the most demanding parts of our world.

Take deserts. Like all living things, humans are about 70 per cent water. How on Earth have we managed to survive in the one place where water is virtually absent? Presumably we were driven to these desperate places by wars or famines, or drastic changes in our home environment … But how did we manage to carve a life there? How did we find water in the desert, let alone all the precious resources, such as food and shelter, that we need?

Rainforests may appear to be biologically rich – full of plants and animals to sustain us, as well as constant warmth and generous rainfall. Surely life here must be easy? But in fact the opposite is true. Life in the jungle is tough – and to prosper requires great skill and knowledge.

How on Earth can you make a living in the Arctic, where all water is locked away as ice, where you can't grow any plants, where prey animals are almost impossible to track down and where temperatures plummet to a life-destroying deep freeze?

STORIES OF OUR SPECIES

Human Planet is a series of stories about how humans struggle to make a living in virtually every habitat to be found in the world – some of them extremely brutal. How do we find food on a desolate mountaintop? How do we create shelter and clothing in

OPPOSITE *A Bajau free-diver. Most of his community's food comes from the sea, and Bajauns touch land only for fresh water and wood and to trade seafood.* PREVIOUS PAGE *Papuan festival participants, representing spirits of the forest.*

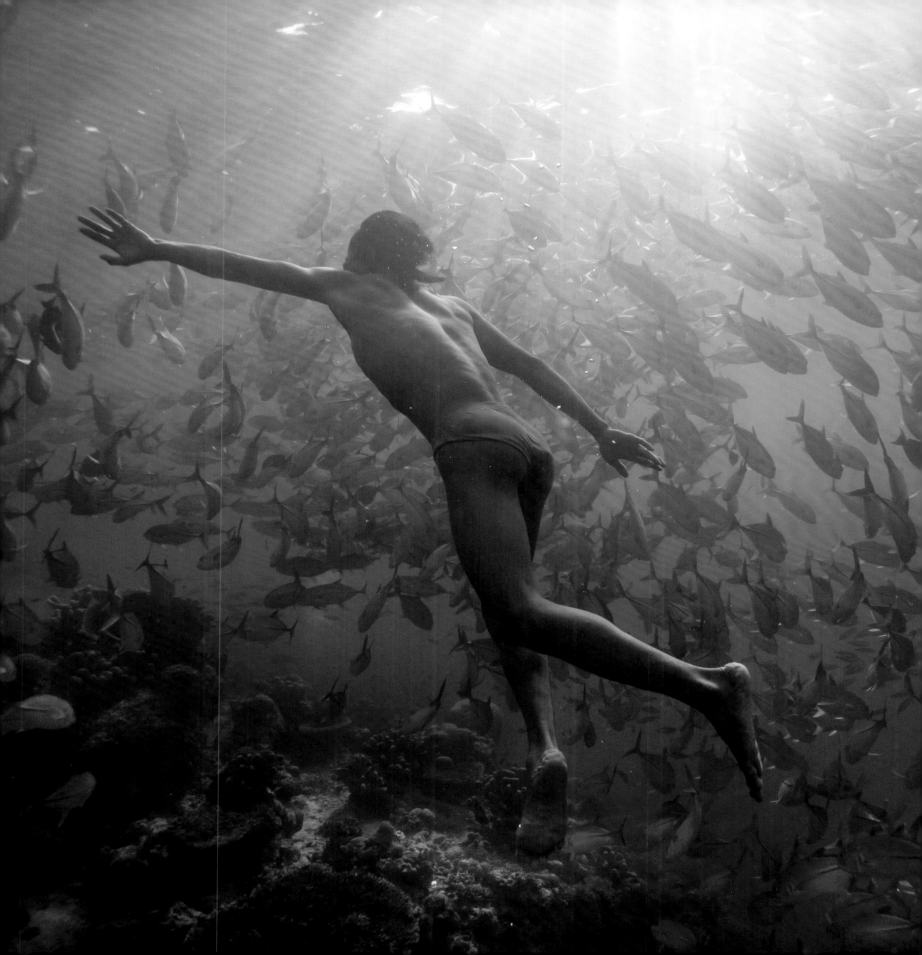

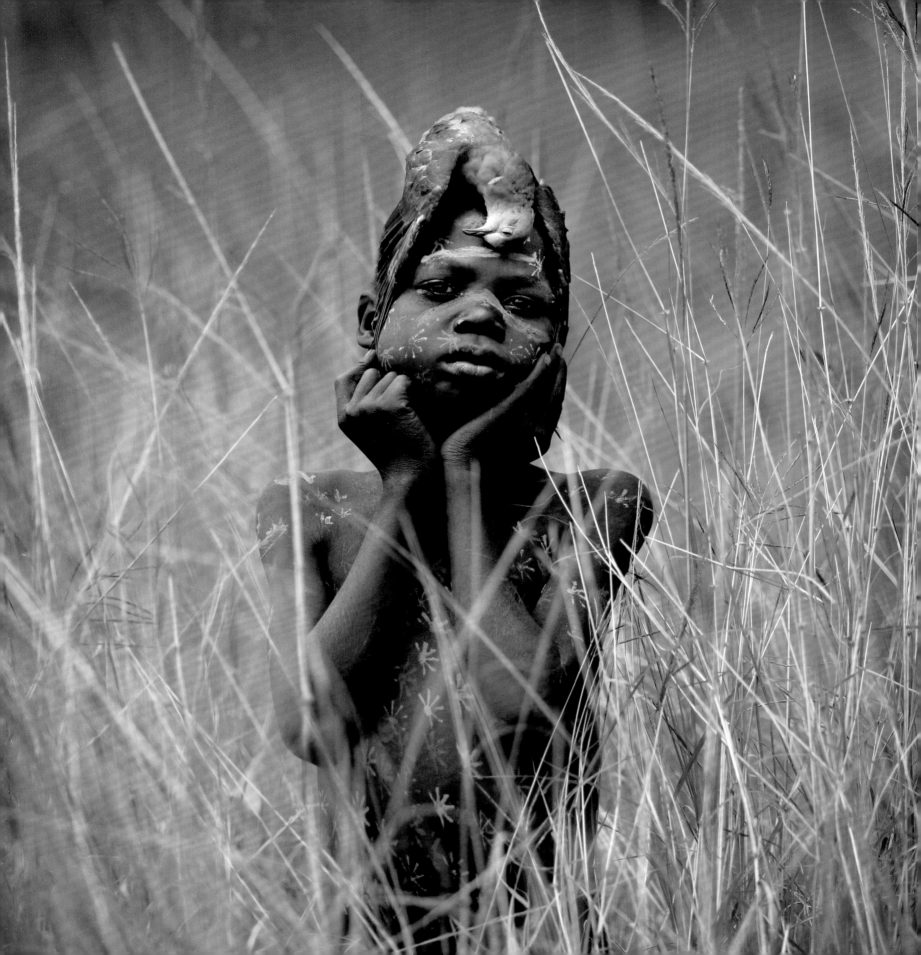

the freezing Arctic? Where can we find refuge from storms, fires and floods? These are not just stories about the rites and rituals of human cultures – that would be the domain of anthropology. Nor are they stories about the plants and animals that humans associate with – that's the domain of natural history. No, these are stories about surprising connections, remarkable interactions and fascinating relationships between our own species and all other aspects of nature in its widest sense.

I should explain that 'nature' in this book doesn't just mean plants and animals – though many of our most fascinating stories are about remarkable connections between ourselves and other living creatures. Nature for us also means landscapes and climate, earthquakes and oceans – in other words, the natural forces beyond our control. Like all other animals and despite our ingenuity and creativity, we are still exposed to a world where we must find food, water and shelter and must constantly side-step disaster.

How should we tell this story of our place in nature? In the end and after much debate, the production team decided to tell it through our lives in seven major habitats of the world – grasslands, oceans, rivers, mountains, deserts, jungles and the Arctic – reflecting our journey over many thousands of years as we have overcome obstacles and mastered difficulties in our ever-widening expansion.

HOLDING NATURE AT BAY

But if, in a sense, this is the story of how we have made a living in virtually every corner of our planet, then in which habitat do the majority of us live today? What is the relevance of *our* connection to nature as we sit in our living rooms watching televisions in Britain, Brazil or Bulgaria? In the end, we decided that the final programme in the series, the final chapter in this book, should be the story of the habitat we have created for ourselves and built all over the world – the urban habitat.

When creating our specially designed habitat – towns and cities – we have, of course, attempted to hold at bay all the nasty bits of nature – storms and droughts, cold and rain, predators and famine, bugs and beasts. And at the same time we've tried to ease the flow of food and fresh water *into* and the flow of effluent and waste *out of* our new homes. We've tried to invite nature in on *our* terms: neat and orderly, clipped and domesticated. We have attempted to create a world around us where we bring in the helpful bits we do want and leave out the unruly bits we don't. A fine intention. Except, of course, it hasn't quite worked out that way.

The first thing we've found is that, no matter how hard we try to hold wild, unruly nature at bay, we can't. We've also found that getting the acceptable bits of nature – food, water, energy – *into* our cities is a lot easier than getting the waste products *out*. Just look at the images of some third-world rubbish dumps, the polluted rivers that flow out of some conurbations and the choking, yellow smogs that float over even modern city centres.

Yet another discovery has been that nature keeps trying to hold *us* at bay and exploit us as a habitat. Witness our ongoing battle to hold human parasites and 'predators' in check? And this battle is, of course, exacerbated by our habit of aggregating our numbers in densely packed urban centres, where the spread of infection is so much easier and faster.

One thing's for sure about the urban habitat: if we get it wrong *here*, we stand to lose big time. It's in our greatest aggregations that we face the worst possible outcomes, whether it's from earthquake, flood, disease or famine.

THE FUTURE OF THE HUMAN PLANET

Given the speed and efficiency with which we've spread our wings and colonized the planet, it's understandable that we're an arrogant species – constantly nudging ourselves forward, sweeping competitors aside, assuming we're the boss. We still exude an air of control and hubris – we have mastered nature. The world is our oyster.

Or is it? Have we reached a crossroads on this apparent path towards human domination of the planet? I suspect we have.

BRIAN LEITH

OPPOSITE *Child of the grasslands. His people are the Suri herders of southern Ethiopia, who rely on their cattle for almost all their needs.*
OVERLEAF *A Mongolian Kazakh with his trained golden eagle.*

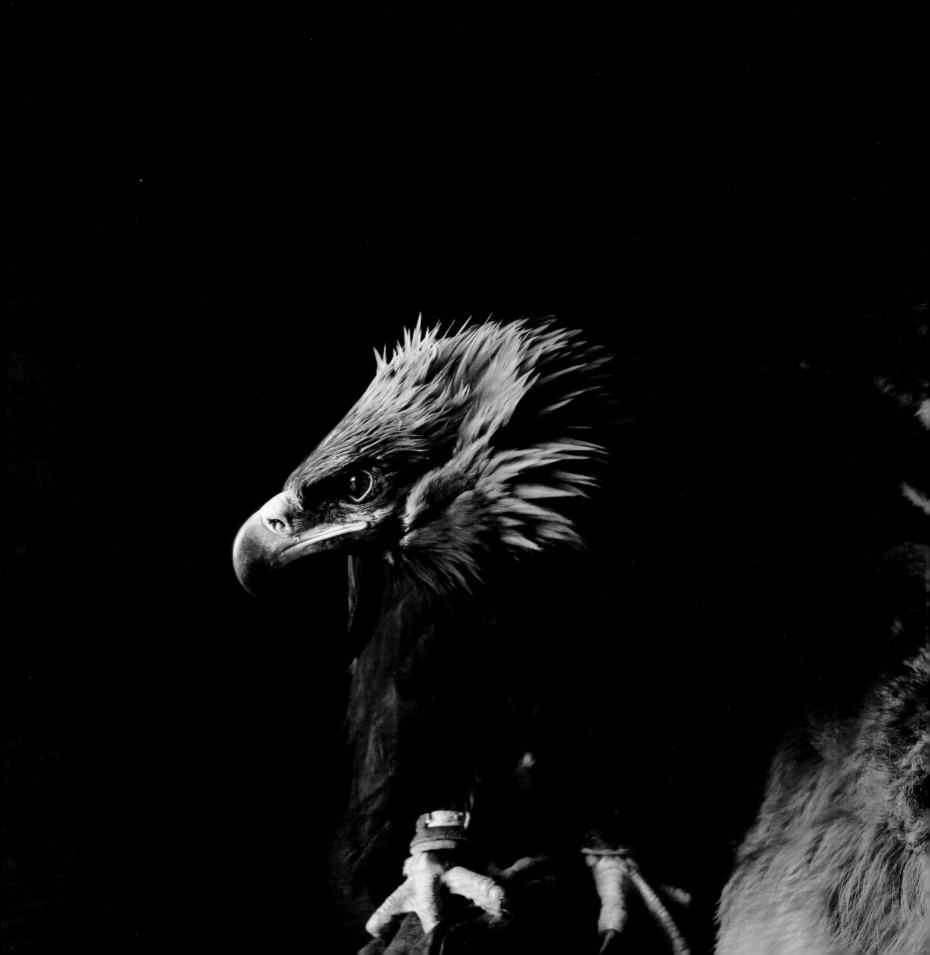

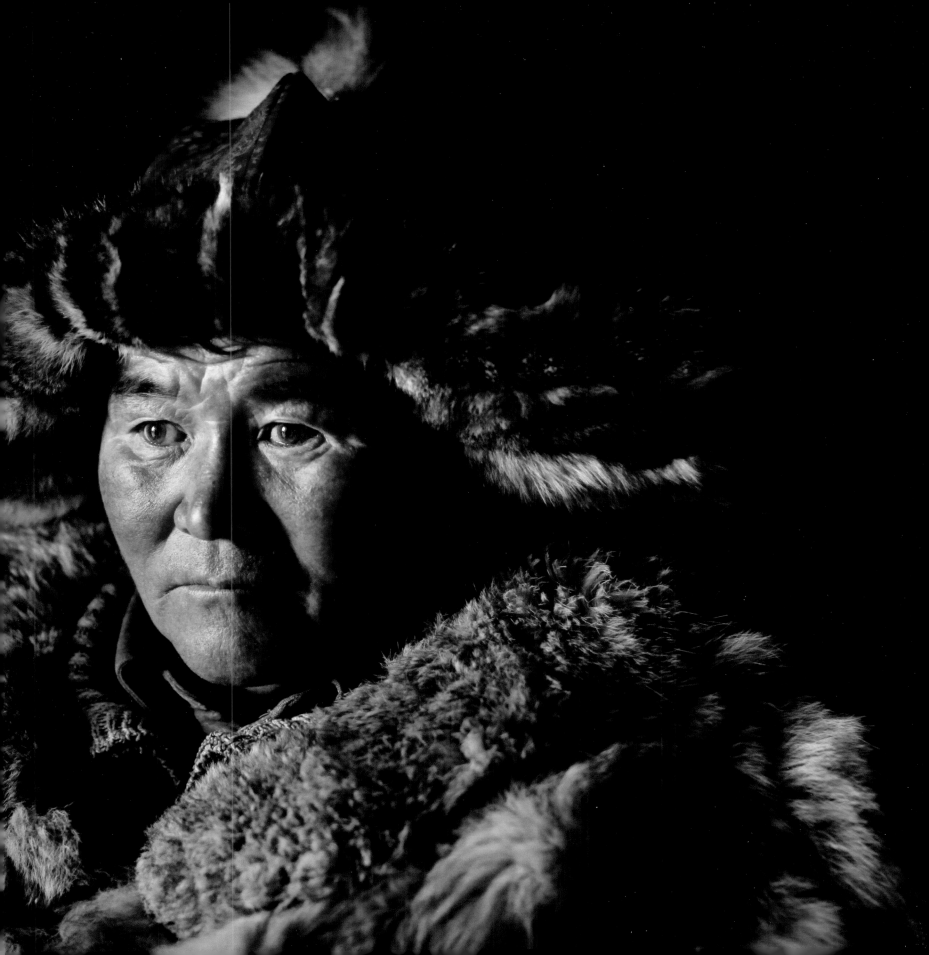

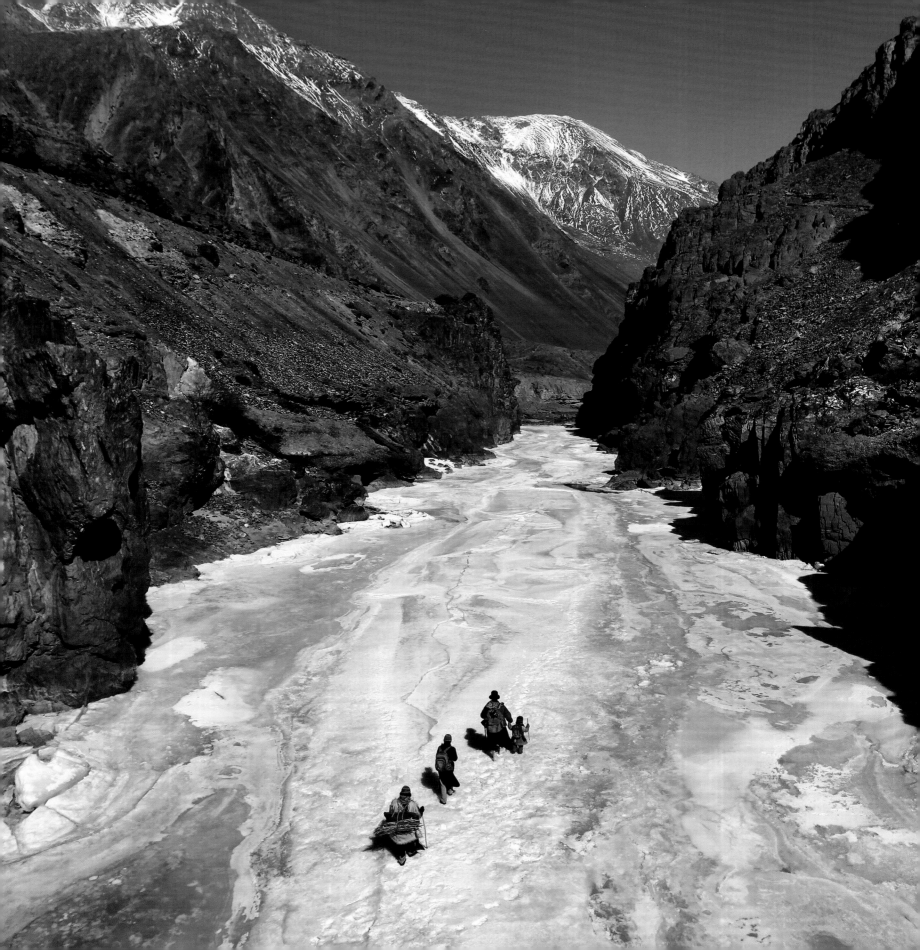

INTRODUCTION

THE MARCH
OF HUMANITY

In evolutionary terms, our species is an upstart, but in just a few hundred thousand years, humans have spread across the face of the planet. We have found a way to live in almost every possible environment without being forced to make any major physical adaptations. To live in the cold, we haven't grown thick coats; to survive by the sea, we haven't developed webbed feet. We've used our enormous brains to adapt, and by doing so, the Earth today is indeed the 'human planet'.

We call ourselves *Homo sapiens* – wise man – and it's easy to understand why we feel superior. We are curious, social, communicative and extremely intelligent, to a degree unrivalled by any other species. But in evolutionary terms, we are just the ape that got lucky.

The African fossil record of bipedal apes goes back 6 million years, and there is endless scientific debate about the number of hominid species that evolved and died out and exactly when modern humans first emerged. One of the most popular theories dates our evolution to about 200,000 years ago. What seems pretty certain is that, by 30,000 years ago, only two major species of hominids were left – *Homo sapiens* and *Homo neanderthalensis*. Critically, though, modern humans had the competitive edge over the other hominids. When Neanderthals died out some 24,000 years ago, *Homo sapiens* was left to take over the world.

Today, Antarctica is the only continent where humans still have no settled, long-term populations. Our total number is heading towards 7 billion, and we have created urban habitats all over the world, where more than half of humans now live. Yet essentially we are a grassland species. So why and how did we end up living in almost every habitat in the world? Oceans are great places to find fish, but what drove us to sail to remote islands surrounded by salt water? Without fresh water, humans die in a few days – so why inhabit a desert? How did humans come to live high up on mountains, where the air is short of oxygen? And why on Earth did a naked ape ever head towards the North Pole?

In a short introduction, it's impossible to do justice to the story of global human colonization. So what follows is a scene-setter – a taster for the remarkable stories of the few people who, in the twenty-first century, still live in close contact with nature.

BORN IN THE GRASS

At some point, somewhere in Africa, at least 200,000 years ago, *Homo sapiens* had moved onto the grasslands. This may have been accelerated about 190,000 years ago by the ice ages. Tropical forests had continued to retreat as grasslands expanded. Perhaps there was increased competition within the shrinking forests that forced earlier hominids to emerge into woodland and then grassland, but whatever the reason, hominids began to walk on two legs.

The grasslands were indeed our Garden of Eden. Here early humans had everything they needed: water, fruits and roots and, most important, herds of large animals to hunt. They never needed to develop the speed, acceleration or tools – the claws and jaws – of the big carnivores. Some were scavengers, waiting for lions, cheetahs, dogs or hyenas to do the tiring work of hunting. But others used their intelligence to produce hunting tools. It wasn't necessary to kill an animal outright. Once wounded, the hunters would simply pursue it, running long distances over many hours, made possible by their bipedal posture and developed leg muscles. The hunt would end when the animal collapsed exhausted.

It was some time before the two biggest human revolutions occurred in the grasslands. The first was the domestication of grass itself about 11,000 years ago in Mesopotamia – the 'fertile crescent' that lies today in Turkey, Syria and Iraq. Humans observed that the cross-breeding of certain wild grasses produced strains with fuller heads of seed. Agriculture had been born.

The second huge leap for humankind came at much the same time. Across the Sahara and around the fertile crescent, different groups of people started domesticating grazing animals. At the end of the last ice age, temperatures increased and the grasslands started to dry up. It's thought that, in Africa, this

OPPOSITE *Farming domesticated grasses in Ethiopia. Discovering how to do this was a major human breakthrough.* PREVIOUS PAGE *Using the frozen-river highway out of the Himalayan Zanskar Valley, where lives are ruled by the seasons.*

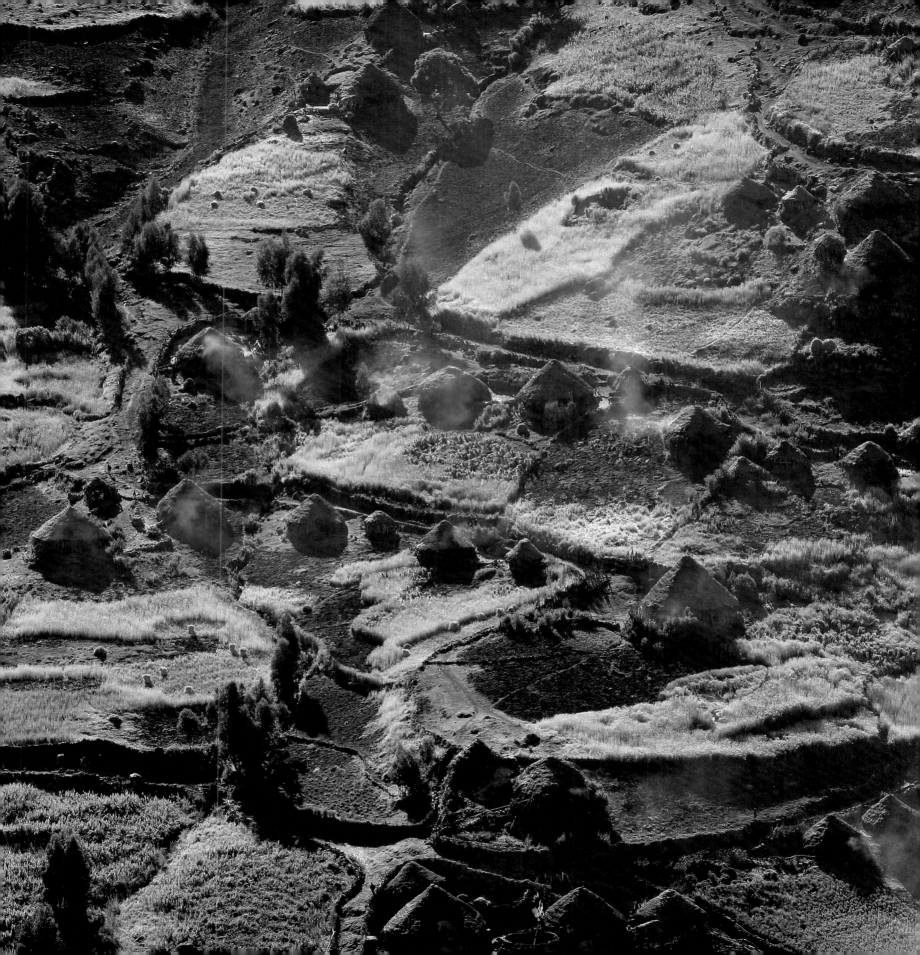

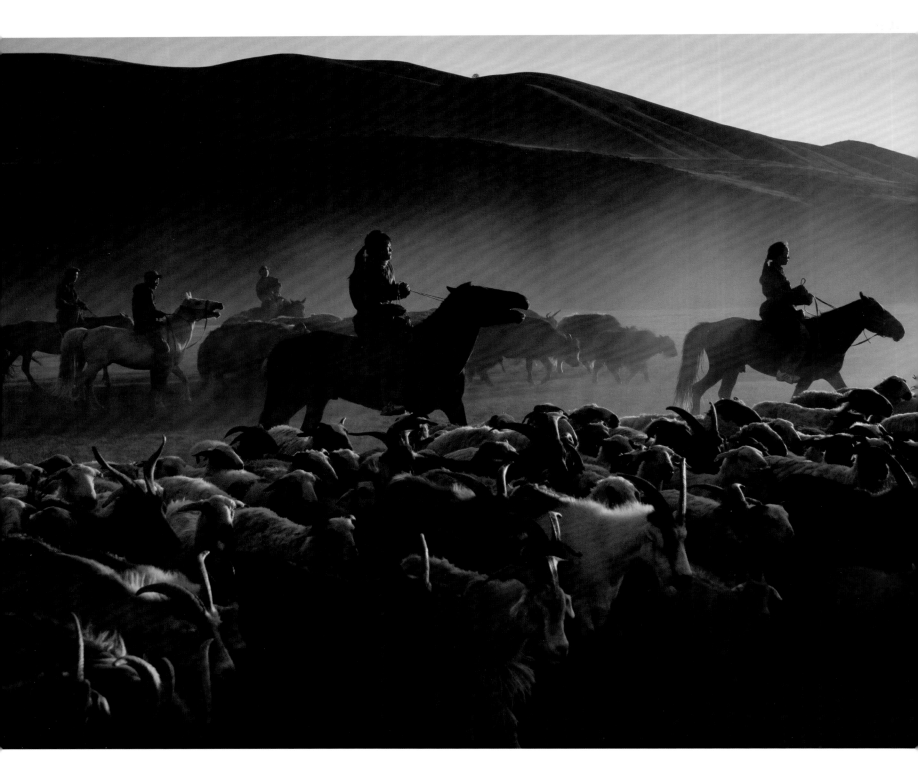

ABOVE *Nomadic pastoralists driving their herds of goats, yak-oxen hybrids and horses to new pastures on the Mongolian plains – a land without fences. They carry their homes with them as they follow the grazing, probably in much the same way as people have done for thousands of years.*

threw groups of people and wild cattle closer together, allowing us to manipulate the movement of the herds.

Once we had domesticated both grass and wild animals, we could produce more food than we needed as individuals. A surplus allowed trade to begin, and with this, the next big step in our journey – the development of complex societies.

THE RIVER CONNECTION

It's not surprising that so many successful societies grew up beside rivers. Rivers have everything we need – fresh drinking water for us and our livestock, irrigation water for our crops and an additional source of nutrition, fish. Rivers are also natural highways, allowing the development of trade between different river communities, and out to sea and beyond. Even today, our greatest cities still sit beside great rivers.

The first complex, politically centralized civilizations began to form 5000–4500 years ago. The Nile, the longest river in the world, became the axis of two remarkable civilizations: the Egyptians in the north and the Nubians in the south – providing water and rich silt deposits for farming and linking them to sub-Saharan Africa and the Mediterranean.

Like the Nile, the Tigris-Euphrates river system in the Middle East ran through an area of otherwise inhospitable desert. But following the development of agriculture and then irrigation, the first cities were built beside the rivers and their tributaries. The land between – Mesopotamia – went on to become the birthplace of some of the greatest empires of the ancient world, including Babylonia and Assyria.

The same pattern can be seen in China. About 9000 years ago, the early dynasties of China were built around the agricultural communities that first appeared along the Yellow and Yangtze rivers. In northern India, the Harappan civilization, populated by the Dravidian people, started to develop along the Indus River some 5000 years ago. It was these early great river-valley civilizations that paved the way for our modern urban life.

DESERTS, OASES AND CAMELS

It is unlikely that early humans would have chosen to live in a desert. But regions that today are hot, dry and inhospitable would, in prehistory, have been very different. About 170,000–130,000 years ago, researchers believe that parts of the Sahara were lush grasslands filled with game and watered by channels that flowed intermittently from present-day Libya and Chad to the Mediterranean Sea. Some of these rivers were up to 5km (3.1 miles) wide and may have provided a route from our birthplace in East Africa to the Middle East.

When the last ice age ended, and after an initial wet period caused by the melting of the ice caps, the heart of the Sahara started to dry up. Over several thousand years, the water channels sank under ground and the huge herds of game moved away, as did most humans. Those hardy people who stayed – in what is, today, the largest hot desert in the world – settled around oases. Some started the risky business of trading across the desert. That they were able to do this was because of a superbly desert-adapted animal, the dromedary camel, which was probably domesticated in the Sahara about 5000–4500 years ago (as was the Bactrian camel in the Gobi Desert of China and Mongolia).

At the time camels were being domesticated, Fazzan in the heart of Libya was becoming an oasis surrounded by sand dunes. The people who stayed there became desert specialists, growing specialized crops. By 2000 or so years ago, the Garamantian society of farmers and merchants had been established, with a sophisticated irrigation system, channelling water up from subterranean aquifers. It took 500 years before the Garamantians finally lost their battle with desertification. But their legacy remains – the tunnel systems they developed are still in use.

Today the Earth is continuing to warm, and so the deserts are still expanding. We must continue to use our ingenuity and technological know-how to find ways to counter the impact of global warming. As grasslands crumble into deserts, the global challenge of how to feed a burgeoning population intensifies.

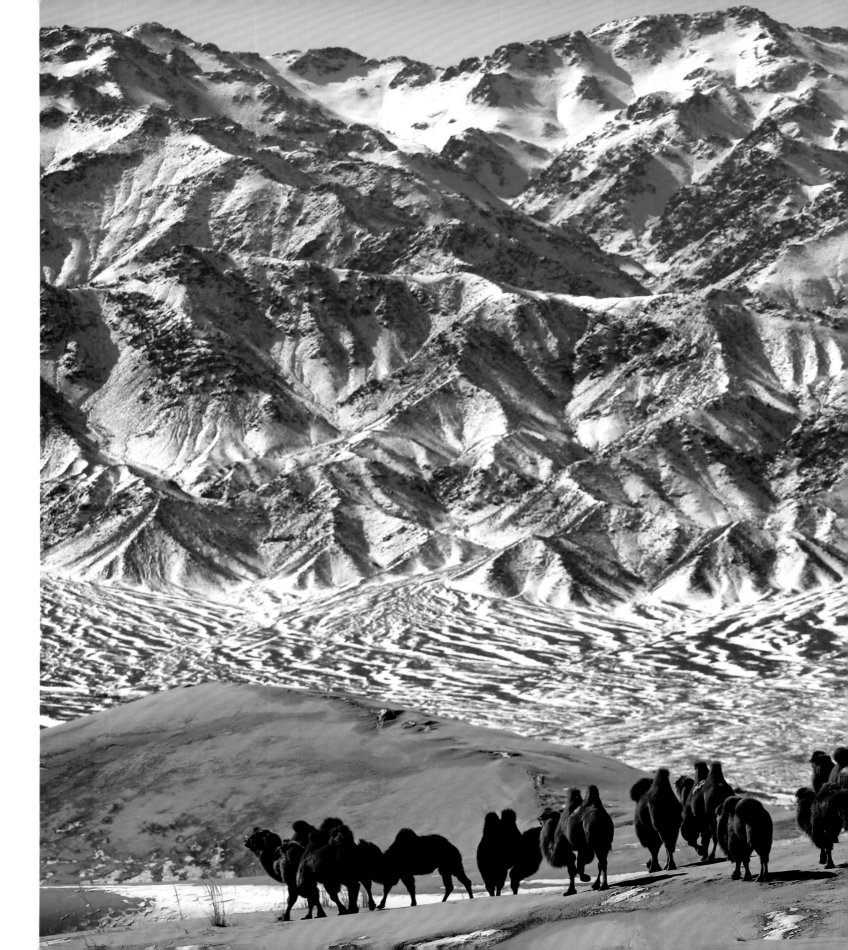

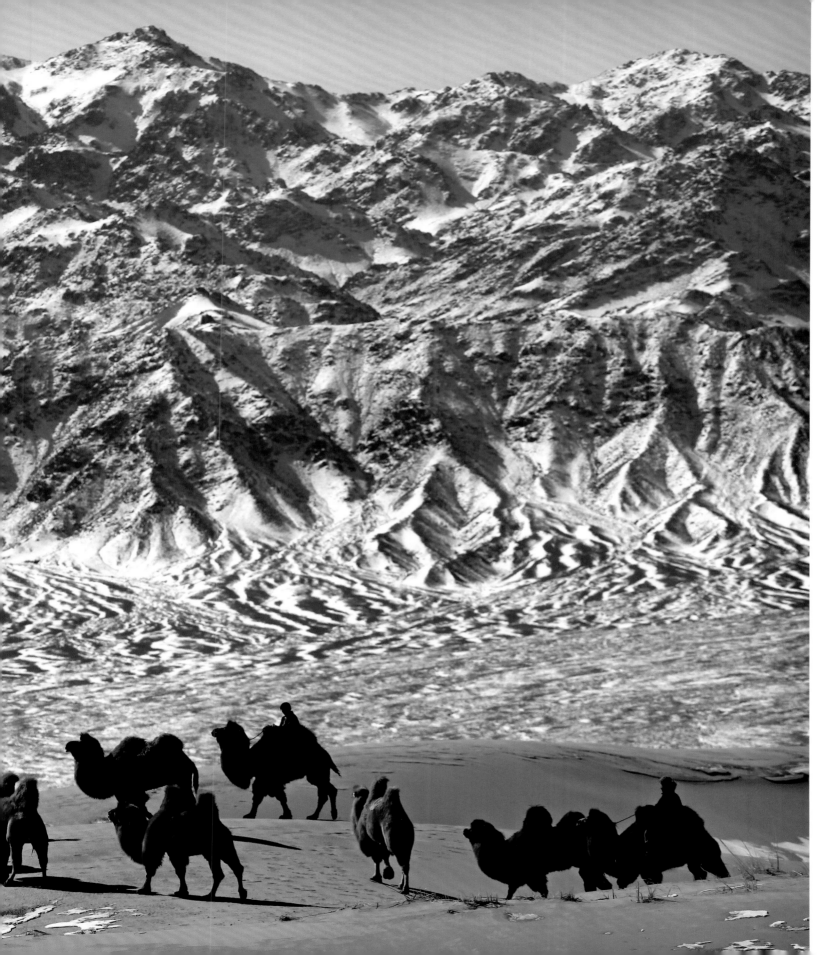

MOUNTAINS – REACHING FOR THE STARS

Very few people live at high altitudes, and for a good reason. The higher you go, the lower the atmospheric pressure and the less air there is to breathe. Our bodies are adapted to life near sea level, where our blood receives the right amount of oxygen for constant refreshment. As soon as we start to climb higher than about 2500 metres (8200 feet), we are in a place that a lowland ape isn't designed to be.

Hand in hand with the oxygen-thin air comes the cold and the poor-quality soil. This limits both the crops that can be grown and the number of meat-providing animals to just a few mountain-adapted ones – not ideal at altitude, when the body actually needs more fuel to keep going. Yet humans by nature have always reached for the stars, whether they've been pushed there by conflict or simply because they want to be closer to the heavens. Against all the odds, specialized groups of people have lived at high altitude since prehistoric times, adapting physically to the extremes. Mountain-adapted men and woman have larger lung capacities and more efficient circulatory systems than the rest of us. They also tend to be short and stocky with barrel chests – all adaptations to the high life.

The Earth's highest landmass is the Himalayas – the 'land of snow'. For the first hunter-gatherers moving east from Africa and across India, it was a natural barrier to migration. Archaeological evidence suggests that the first actual Himalayan settlements were on the vast Tibetan plateau to the north, some 25,000–20,000 years ago.

It seems to have taken much longer for humans to populate the highest heartland of the mountains. Nepal sits at the top of the world, with eight of the ten highest mountains within its borders. The earliest evidence of a Nepalese population dates to about 9000 years ago.

Perched higher still, to the east of Nepal, is Bhutan. Humans appear to have arrived here only some 4000 years ago. Bhutan's isolation has meant that it has remained practically free from the global influences of the modern world – until television finally arrived in 1999.

THE ANDEAN ALTIPLANO

There are many theories about the populating of the Americas, but it is probable that humans first moved from Central America into South America at least 15,000 years ago, reaching the low mountains of Monte Verde in Chile around 14,000 years ago. Stretching down the west coast of the continent is the Andes. As temperatures increased and the ice melted about 13,000 years ago, people were able to cross the central Argentine Andes, and there is evidence of early habitation at 3000 metres (9850 feet). Archaeological evidence suggests people settled in the mountains much later, in a region called the Altiplano. This landlocked trough of high plains, 800km (500 miles) long and just 300km (186 miles) wide, sits between two mountain ranges and stretches north-south across southern Peru, Bolivia and northern Chile and Argentina.

About 3500 years ago, warmer, wetter weather allowed the development of agriculture on this high plateau. With their mountain-adapted domesticated animals and crops, the Andeans learned to use altitude to their best advantage. Lower down, they grew a range of crops that included coca, plantains and citrus fruits. Higher up, they grew maize, and higher again, potatoes and other tubers. Above 4000 metres (12,000 feet), where arable agriculture wasn't viable, they grazed their animals.

Andean people were pastoralists long before they began growing crops. Camelids such as vicuñas and guanacos evolved in the Andes and thrive on the low-quality grass and in the oxygen-poor air, as do domesticated alpacas and llamas, which provide clothing, protein, transport and even fuel in the form of dung. The Altiplano can be freezing, and at these high altitudes, there are no trees to provide firewood. Today the Andean people still burn dung to keep warm and cook food. As farming evolved, dung was also used as fertilizer. Agriculture transformed the

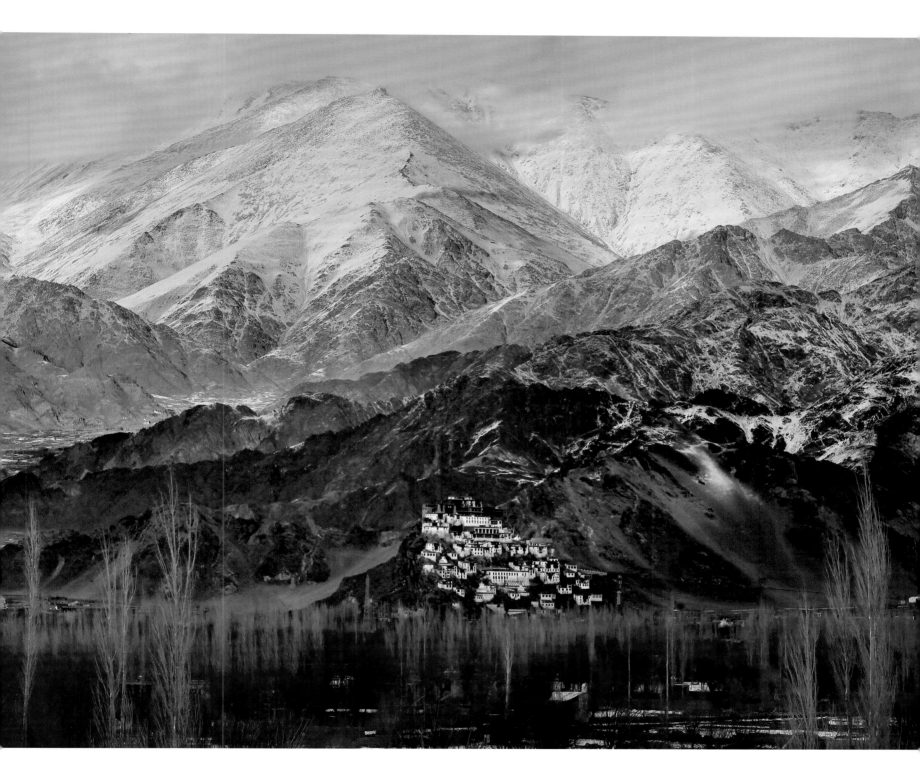

ABOVE *The Ladakh mountain range, a high-altitude region of extreme climate and sparse vegetation.*
People survive here through traditional knowledge of the environment and a respect for life.
PREVIOUS PAGE *Camel herding in the snow-covered Gobi Desert. Bactrian camels are key to survival here.*

23

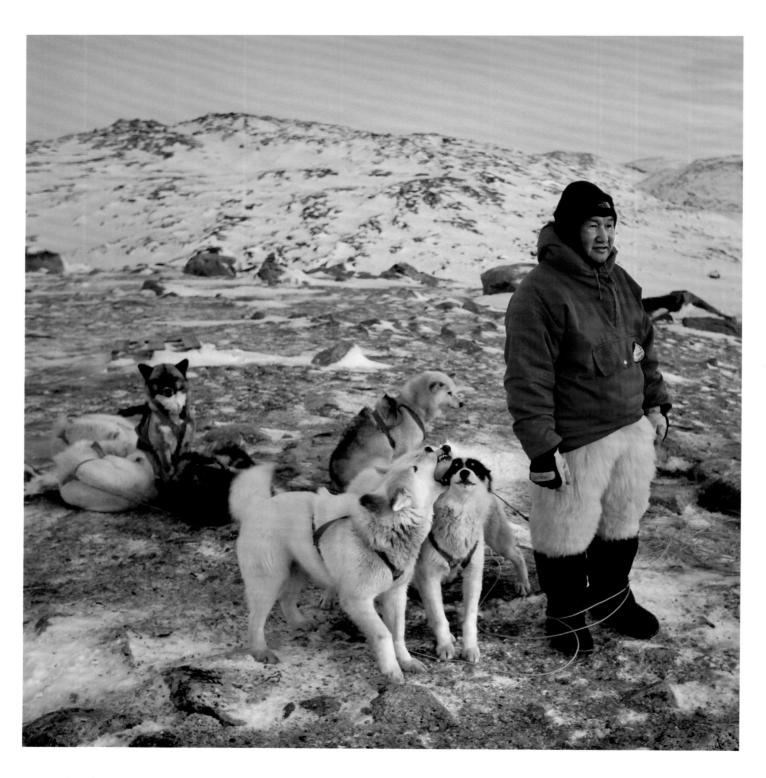

ABOVE *A Greenlander and his domesticated canids. Dogs and sleds have been used here almost certainly since the first Inuits arrived in Greenland around 1250 AD. Today, as in the past, these high-Arctic people live clustered close to the shore, giving access to sea mammals, other food sources and the frozen-ice highway.*

potential for human life, with communities living at the different altitudes developing a mutually cooperative existence and an exchange of goods. As a result, the Altiplano became the most populated region of the Andes. All this changed in the sixteenth century, when the Spanish invaded Peru. Many of the mountain people were wiped out by diseases they had no immunity to. The Spanish also introduced wheat and barley – low-elevation crops – and larger communities developed down at sea level.

LIFE IN THE FREEZER

Some populations of humans started to head north as soon as they left Africa. The move to the temperate climates made sense, but why did they keep going? Why would the naked ape opt for a life in the frozen north?

The information we currently have doesn't provide a consistent story, but there are some common themes. It is believed that the first humans who headed for the far north spread into Siberia somewhere between 50,000 and 30,000 years ago. Siberia is so vast that it's easy to understand why human settlement appears to have been a complex and lengthy process, with migrations possibly originating from eastern Europe, southern Russian, central Asia and Mongolia.

One of the best-known archaeological sites is Mal'ta in southern Siberia. Though not technically Arctic in geographic terms, it reveals that people were living an Arctic-style existence some 22,000 years ago. This settlement included semi-underground winter houses constructed with large animal bones and reindeer antlers, and it seems that the men travelled considerable distances to hunt reindeer and even woolly mammoths.

Evidence for the first truly Arctic peoples is inconclusive, but artefacts from 30,000 years ago have been found in the Yana River valley in Siberia, 500km (310 miles) north of the Arctic Circle. At this time, the climate was in the process of cooling, turning open meadows into icy tundra. These early people must have hunted big game, but it's not known whether they lived here year-round or if they were hunters from slightly warmer climates farther south.

THE FIRST AMERICAN

Many believe that the first people to arrive in North America crossed from Siberia. What is today the Bering Strait separating Alaska and Russia was, between 25,000 and 14,000 years ago, above sea level and regularly ice-free. This land was called Beringia, and it is thought that several waves of Siberian people walked across the continents in search of new hunting grounds. These included the ancestors of the native peoples of North America, the Yup'ik Eskimos. Today, there are Yup'ik Eskimos still living in Siberia and Alaska.

Just as they do today, the early people of the American Arctic lived close to the sea, clustered along the migratory routes of sea mammals but regularly hunting inland for game such as caribou and mountain sheep.

Other groups gradually moved east into the northern Canada (today known as Inuits). Their 9500km (6000-mile) migration occurred in small waves. Many stayed put when they reached the rich whaling grounds of the East, such as Baffin and Somerset islands. Other tribes, possibly 4000 years ago, crossed into Greenland, moving over the ice of the narrow Thule Strait. Different groups of Inuit people came and went. Then in 1250 AD, the Thule people arrived in Greenland and stayed.

In 985, Norse hunters led by the infamous Viking leader Erik the Red landed on Greenland and set up colonies in the far south of the island. But by the mid-1400s, these colonies had disappeared. A possible reason may have been the deteriorating climate – 1300 was the beginning of the Little Ice Age, which lasted for more than 500 years, and by comparison with the Inuit Thule, the Norse people may not have been so well adapted to Arctic life. By the sixteenth century, when more European explorers arrived, the Inuit were in sole possession of the entire North American Arctic.

RETURN TO THE RAINFOREST

It takes the special mix of consistent heat and moisture found at the equator to create tropical rainforests – the most ecologically diverse habitats on the planet. All of our closest ape relatives still inhabit such forests, yet few humans thrive in them. Once the first hominids had adapted to a grassland existence and become bipedal, they lost the ability to live a largely arboreal existence. By comparison, the bonobo – our closest relative – can walk on two legs if it needs to but has muscular forelimbs perfectly adapted to life in the trees.

The earliest evidence of modern humans living around tropical rainforests comes from Sarawak on the island of Borneo and dates back to the middle of a warm period some 45,000 years ago. These people lived in caves close to the sea. They fished, but their tools suggest they also hunted and foraged in the forest, feeding on the vast range of animals and edible plants such as yams, taro and sago that many rainforest people still eat today.

The hot, wet period that developed at the end of the last ice age some 13,000–12,000 years ago was ideal for the spread of rainforests, and there is evidence of rainforest hunter-gatherers in South America about that time. Then, some 3500 years ago, a sophisticated rainforest-based civilization began to flourish in Central America. Rainforests have surprisingly poor soil for agriculture. What enabled people to populate the Amazon was the creation of a sustainably fertile soil called terra preta, made with charcoal. Terra preta enabled crops to be grown and the development of large towns and a system of linked villages in the Amazon basin, long before Europeans arrived in the fifteenth and sixteenth centuries.

As happened in the Andes, when the European invaders arrived, they brought with them smallpox, mumps, measles and influenza, to which the Amazonians had little or no resistance. Within a hundred years of the Europeans settling, some estimate that the Amerindian population was reduced by up to 90 per cent. The survivors were either pushed into the forest interior or had already been isolated there. Today, the only true rainforest-dwellers are relatively small tribal groups, many of them nomadic or semi-nomadic.

OUT INTO THE BLUE

Why did a mammal that had evolved to walk on land, breathe air and drink fresh water head out into a realm designed for fish, especially considering that until relatively recently, people thought the world was flat and that the ocean led to the edge of existence?

Some populations were pushed into the sea because of economic and political pressures, but other early oceanic explorers were clearly just being human – essentially curious. Humans like challenges. We embrace the unknown, using our intelligence to overcome our physical disadvantages. Long before maps or compasses, we took to the ocean and found our way to the smallest and remotest specks of land on Earth.

The first people of the sea lived along the coasts of the major continental land masses, hunting nutritious food on the seashore. Some believe this diet may even have fuelled the growth of our enormous brains. Land-based fishermen soon discovered even richer pickings out at sea. Simple rafts turned into larger boats going greater distances away from the coast. As our sailing prowess and confidence developed, trade spread along the coastlines.

Thousands of years ago, and despite the fear of falling off the edge of the Earth, people were already heading out to sea. These early voyagers faced a hostile and unpredictable environment. Around 5000 years ago, seafaring ships were big and strong enough to survive journeys across the open ocean. Navigation skills developed using the stars, the sun and an understanding of currents, winds and tides. Increasingly these first ocean adventurers returned home safe and sound. This puts into perspective the much-heralded achievements of the Dutch, English and Spanish explorers over the past 600 years.

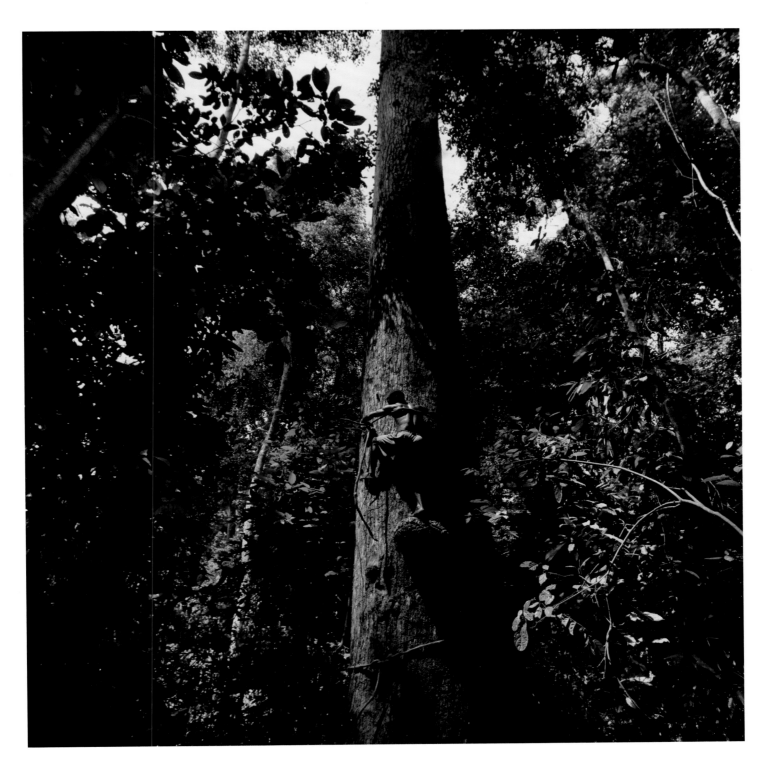

ABOVE *A* BaAka *honey-collector in the Congo, climbing with the aid of just liana (vine) ropes to reach a hive in the rainforest canopy. Modern humans may have lost the physical climbing attributes of our tropical ape-ancestors, but our ingenuity has led to other ways of extracting what we want from the rainforest.*

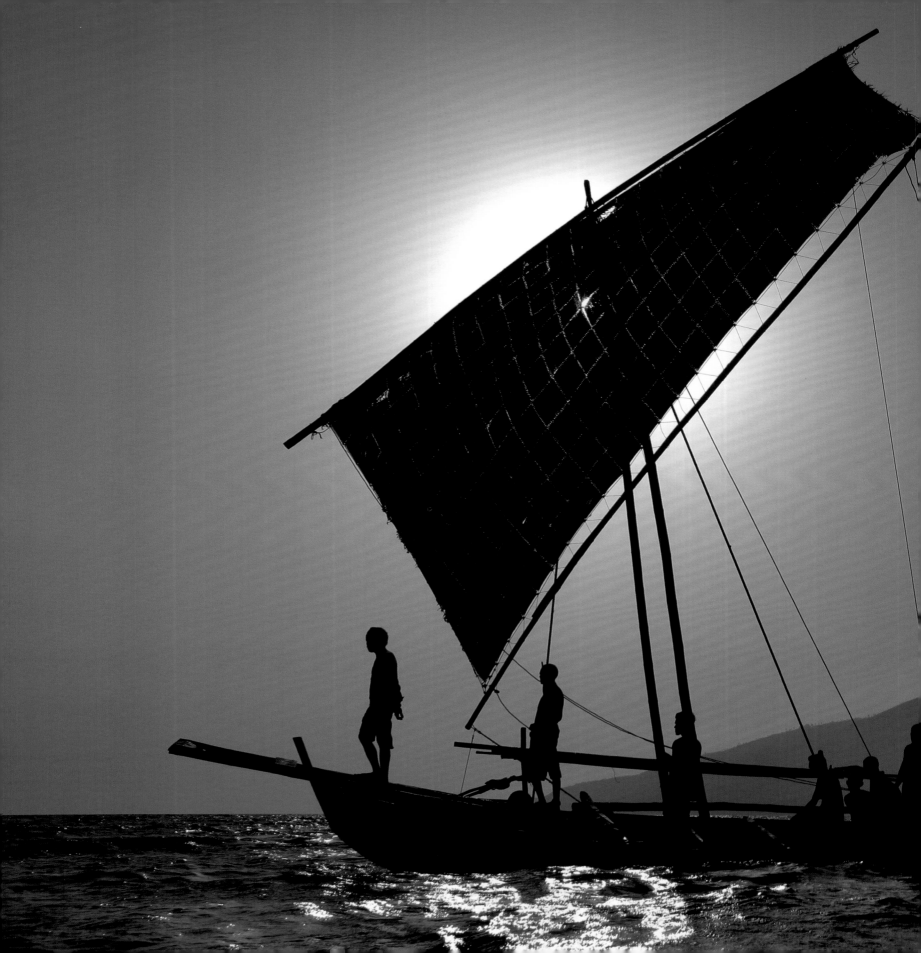

THE GREATEST SEAFARERS

Our journey into the greatest ocean of all, the Pacific, is the most astonishing. It started as an island-hopping exercise. Straddling the equator and stretching between mainland Southeast Asia and Australia roughly across 5000km (3000 miles) is a chain of 17,508 islands. The first humans arrived on them in the last ice age, when sea levels were much lower, exposing more land. Even with land bridges and shorter crossings, their journey southeast was an impressive one. It ended on the huge continent of Sahul, which gave rise to Australia and New Guinea. Sahul had abundant plant and animal life, with few predators. It's believed that, in just a few thousand years, the ancestors of today's Aborigines had populated much of the continent.

When the last ice age ended, the sea level rose, swallowing land and separating New Guinea and Australia. In Australia, many inland lakes dried up, and vast deserts formed, concentrating the population around the coast. Some people decided to head out into the unexplored Pacific, and it was they who populated many of the western islands some 5000 years ago. From here, it's thought that even more remote sea colonization began, probably with the eastward spread of people from Melanesia to Fiji and Polynesia on boats carrying plants, animals and both male and female sailors. Within 2000 years, the Marquesas Islands in far-eastern Polynesia were settled, but it wasn't until much later, 200–600 AD, that people made it north to Hawaii, one of the last places to be occupied by humans.

The early settlement the thousands of remote islands in the vast Pacific is remarkable. These first explorers had no prior knowledge of Pacific geography, no metal and no instruments for navigation. Clearly many would have perished making such epic journeys. What is even more remarkable is how people survived, even when they found land. The further you head into the Pacific, the less biodiversity there is. Marine food may be abundant on coral reefs, but on islands there is little game, limited land for agriculture and, worst of all, little fresh water.

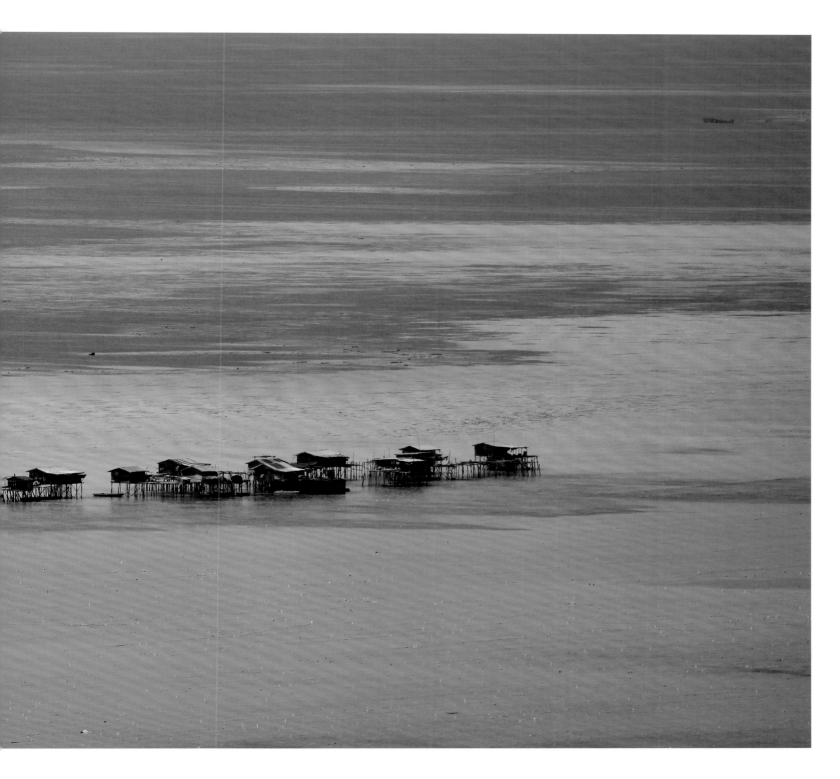

ABOVE *A stilted Bajau Laut village off Sabah, Borneo. These sea-gypsy people have no official nationality and live life almost totally on the sea, surviving on what the coral reef has to offer.*
PREVIOUS PAGE *Indonesian fishermen in a boat very similar to one their ancestors would have used.*

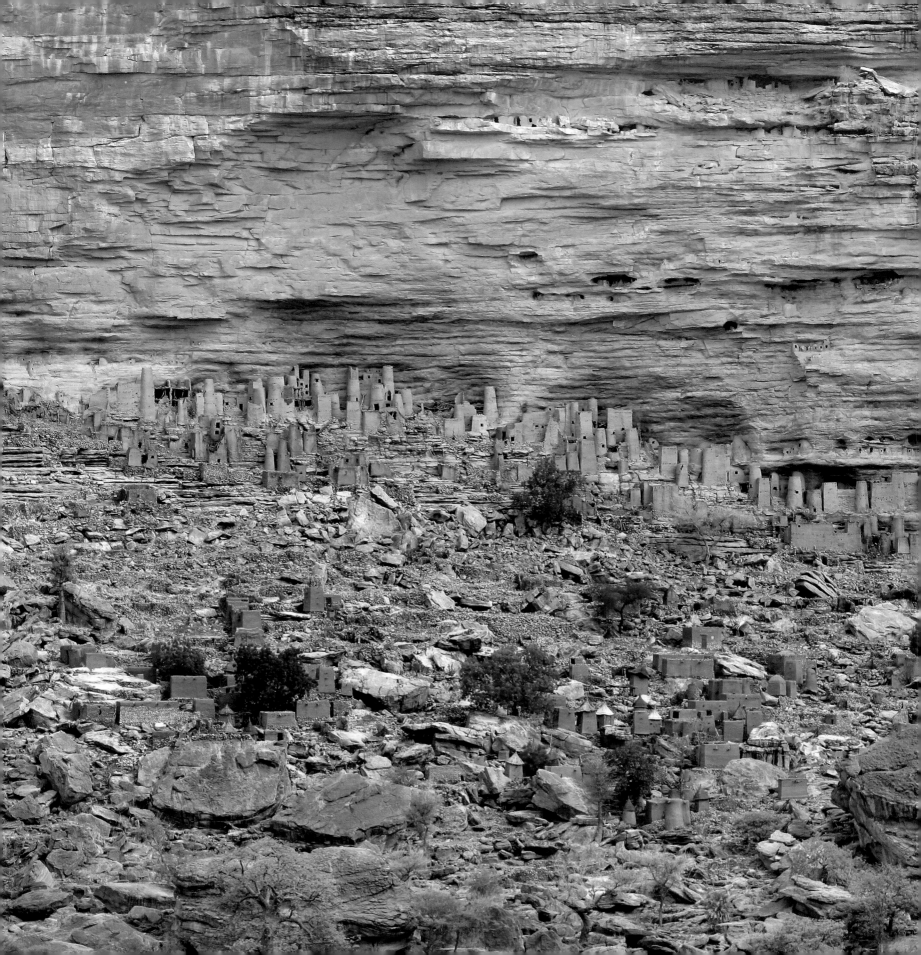

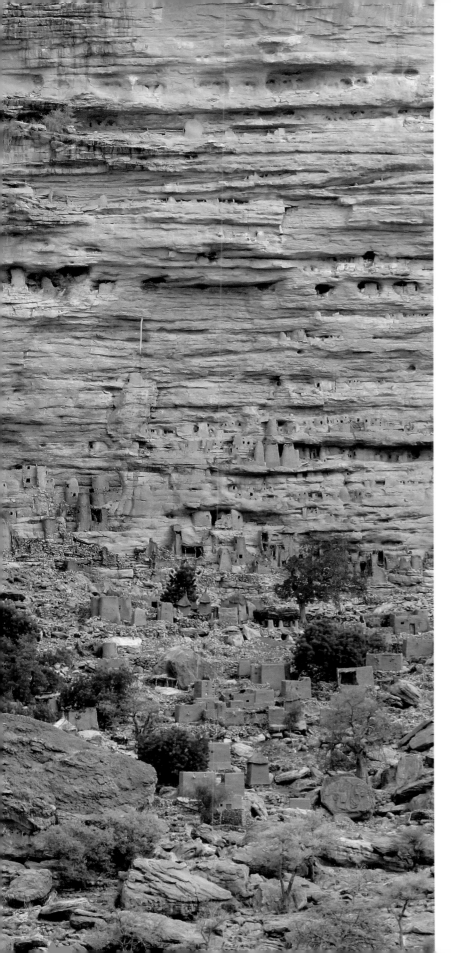

The most extreme are the atolls – reefs around lagoons, where the land is rarely more than a few metres above sea level and covered with sand rather than soil. Coconut palms with their shallow roots are, however, perfectly adapted to such conditions, and enabled the human colonizers to survive.

THE RISE OF THE CITY

The famous walls of Jericho surrounded one of the first larger human communities, dating from at least 7500 BC. Based on subsistence agriculture, Jericho was a settlement where farmers had come together for protection. However, the first real urbanized communities arose only as agriculture developed.

With the increasing production, food surpluses could support people not directly engaged in food production. These people began to play different roles in society. A market economy led to faster technological advances, the growth of manufacturing, improved transportation and advances in communication. With complex societies came state structures, with laws and political systems. Cities absorbed agricultural products from the surrounding countryside and in return provided manufactured goods and varying degrees of military protection. Nevertheless, even the greatest cities were still vulnerable to the vagaries of nature.

Ephesus, in Turkey, was one of the most important and developed cities in the Roman Empire. Its port attracted overland traders from the far east and the west. But as the port silted up, Ephesus lost its vital connection to the sea. Its decline and fall were inevitable. As Rome grew, feeding its citizens became a remarkable feat of logistics. The city was sustained by a fleet of grain ships, special silos, a new harbour and crops from as far away as Egypt. But eventually Rome outgrew even this formidable supply system and collapsed along with its empire.

Not until the start of the nineteenth century did technology allow urban metropolises to develop in virtually any environment. The growth of Tokyo and Los Angeles has been unchecked, despite their lack of adequate water supplies. Like most cities in the

LEFT *The houses and granaries of a Dogon settlement, Mali, and behind, in the cliffs of the Bandiagara escarpment, the deserted homes of the Tellem people. Dogon agriculture here uses traditional soil and water conservation techniques.*

33

twentieth century, they have ballooned in size, even if they do sit on two of the Earth's most active earthquake zones.

For city-dwellers, it's particularly easy to feel removed from the nature that so viscerally shaped our human journey. At their best, urban environments are places where, for many of us, there is always water on tap, fresh food in packs, solid houses for protection from the elements. Too hot, and we turn on the air-conditioning. Too cold, and we pump up the heat. When we get ill, we go to hospital. It doesn't even matter if we live in a waterless desert: Las Vegas was until recently one of the fastest-growing cities in the USA. It doesn't matter if we live in the tropics: Singapore was once a rainforest. In terms of distance from any mainland, Hawaii is the most remote island group on Earth. Yet downtown Honolulu is like any other McDonald's-loving town in America. It's easy to forget that every sheet of shiny steel, every piece of glass in a modern skyscraper originated from the natural world. Indeed, everything in our urban Eden comes from nature.

If we agree that modern humans have been around for 200,000 years, and we look at the duration of our journey as an hour, then it's taken less than half a second for us to urbanize the planet. Safe inside our city fortresses, we have become so successful that our population is exploding. Linked to that, though, is the effect on the rest of the planet. We are using up the Earth's resources at a rapid rate, and the by-products of our consumption are fuelling global warming. For the first time, a single species rather than a natural phenomenon is damaging the environment.

As we wake up to the realization that the overexploitation of nature may threaten our own existence, we are forced to look at the future. Technology will indeed help us create new 'green' cities, but we also need to re-examine ancient human traditions and their reservoir of knowledge. As you will discover reading this book, there are still communities living cheek-by-jowl with wild nature, just as we did when we first made our historic journey across the globe. Though these are fast disappearing, we still have a chance to glean wisdom from our truly diverse 'human planet'.

RIGHT *A rhesus macaque in the urban jungle of Jaipur. However we construct our cities and towns, we will never be able to exclude nature. Indeed, we still rely on nature to the same extent as the very first humans did.*

THE MARCH OF HUMANITY

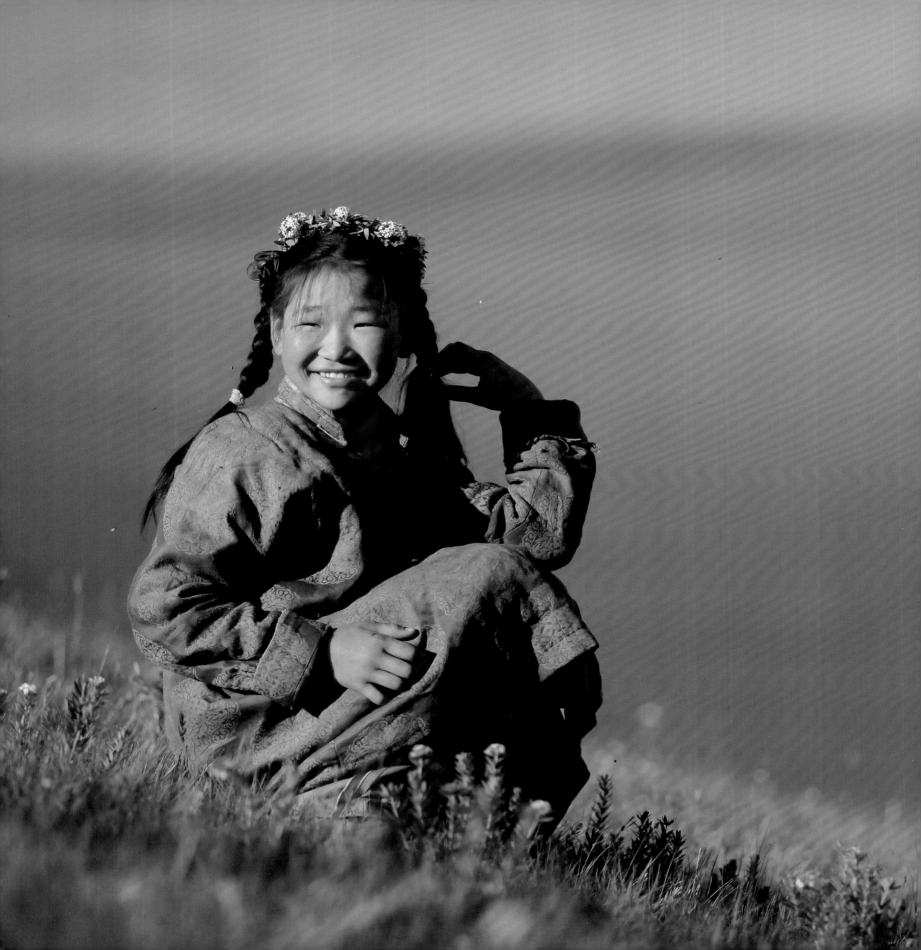

GRASSLANDS
1

GRASSLANDS ARE THE LANDSCAPES WHERE WE REFINED AND DEVELOPED WHAT IT IS TO BE HUMAN. ONCE WE DISCOVERED THE POWER OF FIRE TO SHAPE GRASSLANDS, WE BEGAN TO RECONSTRUCT THEM, SPREADING FIELDS ACROSS MOUNTAINS, FORESTS AND EVEN DESERTS. THE GRASSLAND LANDSCAPE REACHES INTO OUR SOULS, REFLECTED IN THE SUBURBAN LAWNS AND URBAN PARKS THAT WE CREATE TODAY. THE HUMAN JOURNEY IS INTERWOVEN WITH GRASS AND GRASSLAND ANIMALS.

THIS CHAPTER EXPLORES WAYS OF LIVING ON THE GRASSLANDS, FROM THE MOST ANCIENT TO THE MOST RECENT. IT'S A STORY THAT BEGINS WITH SCAVENGERS AND RESOURCEFUL HUNTER-GATHERERS AND LEADS TO THE CITY DWELLERS MOST OF US ARE TODAY, DRIVEN BY A SERIES OF INGENIOUS REVOLUTIONS IN OUR RELATIONSHIP WITH THE NATURE OF GRASSLANDS.

The upright stance of ancestral humans is thought to have developed when we came down from the trees and took to the woodland floor. When we emerged onto the grasslands at least 200,000 years ago, bipedal *Homo sapiens* could see danger coming in a landscape where there was nowhere to hide and few trees to climb. Our ancestors had no horns or canine teeth that could be used as weapons but what they did have was intelligence. And that intelligence has been the driving force for the innovation in our relationship with grasslands over the millennia. Just

as grasslands have been a key to our past, they have been the essential ingredient in our present and will provide the defining component of our future. Through fire and agriculture, we have created grasslands everywhere. Irrigation has enabled us to layer rice terraces up mountains and grow cereals in deserts. We have divided whole islands into field plots bordered by walls and created seas of wheat across the American prairies. But there are still some communities that choose to live within wild grasslands, competing with both predators and herds of herbivores.

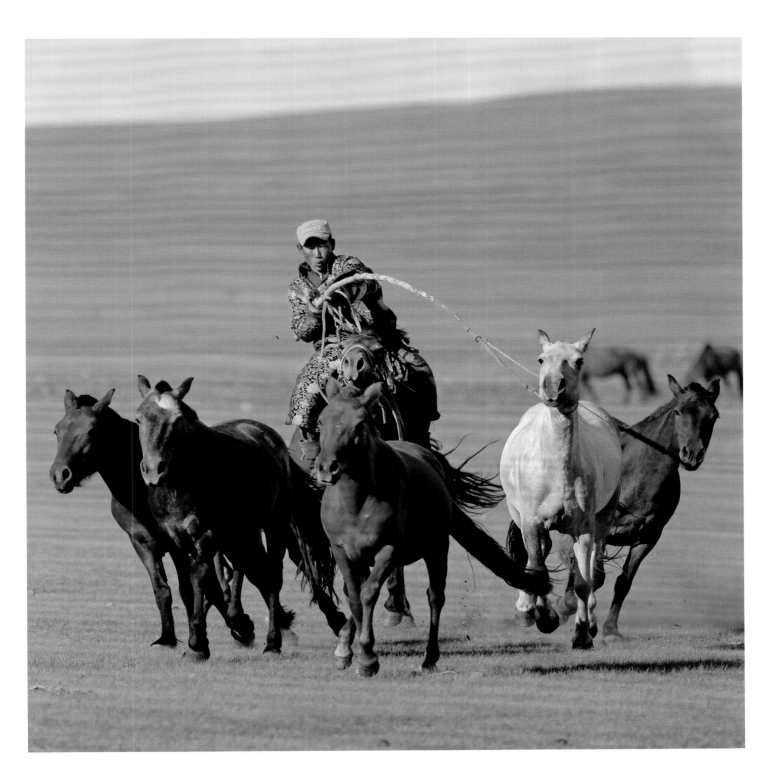

ABOVE A *nomadic Mongolian horseman lassoing a mare from his free-ranging herd. The bond between horse and plains-living human is thousands of years old – the horse providing both food and transport.*
PREVIOUS PAGE *Child of the grasslands. Family life involves following the grazing in a land without fences.*

THE TOUGH PLANTS

Much of the landscape reflects a battle between the grasses and the trees. Where there is enough water, trees, woods and forests dominate, leaving the drier lands as the grass-dominated savannahs, prairies and steppes. These rolling grass-covered landscapes provide no interruption to strong winds and no respite from intense heat or severe cold. That the grasses themselves flourish here – and can withstand being frozen, drowned, burnt, trampled or grazed – is because they grow continuously from the base, making them quick to regenerate and highly productive. They create a skin of fertility woven in roots, stems and tussocks that take advantage of every drop of rain, which is why grasses cover more of the Earth's surface and feed more animals than any other plant.

The world's great grasslands cover almost a quarter of the land surface and include the prairies of North America; the continental steppes of Eurasia, stretching from the European plain to the Iranian east; the Central Asian steppes, which stretches unbroken nearly a third of the way around the globe; the Mongolian grasslands, which give way to the Gobi Desert; the pampas of Argentina; and the African veldt. Then there are the savannahs, with a scattering of bush and sparse trees, that characterize great swathes of East Africa, the dusty fringes of the Kalahari and northern Australia. There are also grasslands that undergo massive changes with the seasons – six months dry, six months submerged by great floods. But by far the most common grasslands are the millions of hectares under cereal cultivation. Indeed, our success in taming the grasslands means that few 'wild' ones remain.

Where open prairie ends and bush savannah begins is not a boundary that has concerned humans. Similarly, the term grasslands as used in this chapter means landscapes where the major vegetation types are grasses, and where grasses provide the key to people's connection with nature.

Though we cannot digest most grasses, we can live off the animals that can digest them and have done for most of our history. Just 400 years ago, the American prairies supported a greater biomass than the intensely managed croplands of today, including 60 million buffalo, 50 million pronghorn and hordes of smaller animals. But wild grasslands are boom-and-bust landscapes forcing the herds to migrate. They dictate that people, too, must be nomads.

Whether hunters or herders, grassland people also have to live alongside predators. Pack-hunting killers such as wolves, lions or hyenas, and lone assassins such as leopards make grasslands a high-stakes landscape.

RIGHT *Moving home in search of fresh grass. On the plains of Mongolia, herders use their sheep, horses, goats and yaks to convert grass into food (milk and meat), clothing (wool and leather) and fuel (dung). Other cultures consume grasses first-hand, cooking the seeds of domesticated forms such as wheat and rice.*

GRASSLANDS

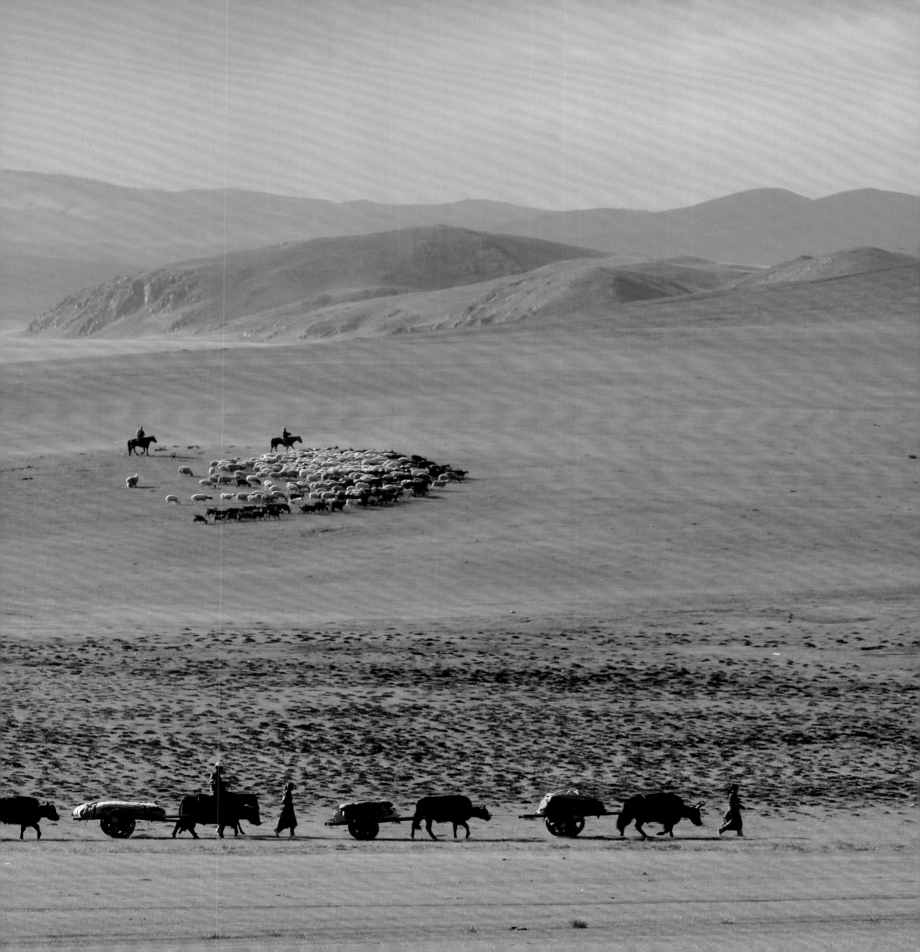

STEALING THE LION'S SHARE

The original human way of life was hunting and gathering, and it is still practised today by the Bushmen of the Kalahari in Botswana and Namibia, the Hadza of Tanzania and the Dorobo of Tanzania and Kenya. Yet it is a dying skill.

Big herds follow the new grass that springs from the burning and the rains, and when migrations of wildebeest in their thousands pass through their territory, it's a boom time for hunter-gatherers. Humans, though, aren't the only predators: lions, leopards and hyenas are both competition and potentially fatal threats.

Among the Dorobo of Kenya, the bravest hunters are the ones who take advantage of lions – letting the pride do all the legwork and then stealing the kill from under their noses. They live on the savannah of southwest Kenya and northern Tanzania, and hunting is an essential part of their culture. When a child is born, the father will mark the occasion by hunting a giraffe, using simply stealth and a bow and poisoned arrow.

Twice a year, the Dorobo witness the migration of hundreds of thousands of wildebeest, which cross between the open grasslands of the Masai Mara and the Loita plains – drawn on by new rains and the promise of fresh grass. To get there, they have to pass through the bottleneck of the Olginye valley and, most dangerously, the bushy gullies where both humans and lions lurk.

Dorobo hunters watch the wildebeest movements at dawn from rock lookouts. Sounds at night may also help them orientate their hunt the following morning. But above all, the Dorobo use the lions to assist in their search for food. They can tell just from tracks whether the lions are hunting or simply moving, how fast they are going and whether the pride includes juveniles or experienced lionesses. They might use the lions to push the wildebeest towards their own hunt or, if the tracks are fresh and show a pursuit, they might follow them in the hope of coming to a kill.

If the Dorobo hunters see a lion kill, they approach the feeding animals close enough to assess the pride and whether or not cubs are present. To walk into a pride with cubs would be suicide, not because the lions would protect the kill but because lionesses might become very aggressive if they felt their young were threatened. Once the hunters have assessed the situation, they challenge the lions. Walking shoulder to shoulder, bows drawn, they approach the feeding pride until the lions give way. Reaching the kill, they work fast, with at least one man keeping watch while the others hack off chunks of meat or scavenge what remains of the carcass. It's a courageous way of gathering food.

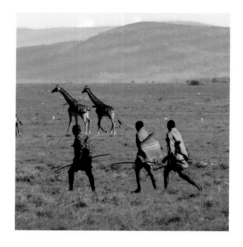

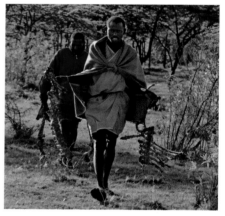

RIGHT, TOP *Dorobo hunters. On the open plain they have little chance of getting close enough to game to kill with an arrow.* RIGHT, ABOVE *A scavenging trip. Having located a lion kill, Lemono (in front) and Rikita gather the remains of the carcass. This time, though, they are too late to get the meat.*

GRASSLANDS

ABOVE *Lookout rock. From here Rikita (left) and Mpatinga can survey the savannah below. They have a better chance of ambushing a wildebeest or impala in the wooded grassland than in the open plains beyond. Having heard lions make a kill in the night, they also know that meat for scavanging might be close by.*

THE HONEY PACT

Not all relationships with other species on the savannah are competitive. In East Africa, several tribes including the Masai have learnt to communicate with small brown birds to their mutual advantage. Conversations between the honeyguides and the people lead to rewards for both – honey for the people they wouldn't otherwise find, and bee grubs for the birds from a hidden beehive they couldn't otherwise break open.

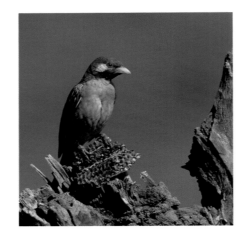

It's like a wonderful game of hide-and-seek but with a serious purpose, since honey is a rich, calorific food. The greater honeyguide is one of only two bird species proven to lead humans to honey. Masai boys learn the rules of the game in childhood, and by their teens they are accomplished honey collectors.

The boys attract a honeyguide by knocking on hollow trees and whistling. In answer, the bird gives a special 'follow me' call as it leads the way, flitting from branch to branch. It's a peculiar, chattering call and an undulating fan-tailed flight – both behaviours that honeyguides use only when communicating with humans. The boys whistle back, and the conversation between bird and human continues.

After drawing the boys to the vicinity of a wild hive, the bird changes its tune. It either flies about the tree where the hive is hidden or circles the area to let the boys know the golden treasure is near. It's then up to the boys to find the bees and check the condition of the hive. If there is honey, they will make fire by friction using firesticks that they carry in their quivers. The kindling is lit, and the fresh grass burns slowly, producing lots of smoke to subdue the bees.

Only then can the boys break open the hive and extract the honey, but always remembering to leave a reward for the honeyguide. (The story goes that, if you don't reward the honeyguide, next time it will lead you to a lion or buffalo.) It gets a nutritious meal of bee grubs and honey, together with the combs (unusually among birds, it can digest the wax). So by working together humans and birds can do what neither could do alone.

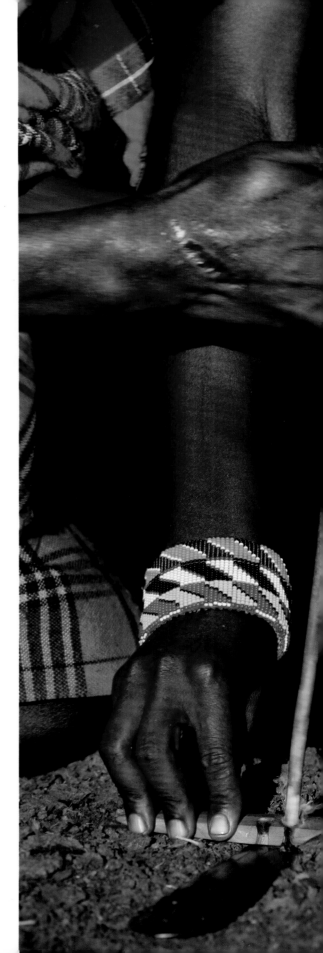

ABOVE *A greater honeyguide with the remains of a honeycomb. In return for leading the young Masai honey hunters to the hive, it gets a meal of wax comb and bee grubs. The greater honeyguide is one of only two bird species known to work with humans in a partnership where each benefits from the work of the other.*

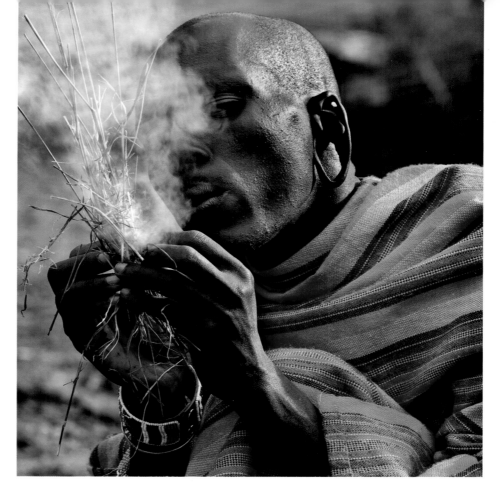

FIREPOWER

The most powerful tool used by grassland people is fire. Bush fires are part of the seasonal ecology of grasslands – the natural disaster borne of aridity and strong winds, to which many of the plants are adapted. Evidence suggests our ancestor, *Homo erectus*, may have used fire as much as 400,000 years ago to manipulate the landscape and get access to new food sources. Small burns staggered in time and space create a mosaic of different habitats, some newly burnt with a fresh flush of grass, some more mature with fruit and seeds. Such a mixture attracts more game, which in turn makes hunting easier. Burning itself can also help flush out game. In Australia, the Martu women will follow the fire-line ashes, tracking goanna lizards that have gone to ground to escape the flames. Today, we despair when wild land is burnt to create pasture, but it has been our ancestors' sustained and repeated burning over millennia that has helped to create the landscapes we now consider to be natural wilderness – including the Serengeti of East Africa and the Kalahari of southern Africa.

LEFT AND ABOVE *Masai men using a fire-stick to get a fire going and then nurturing the smouldering grass. Using fire to clear vegetation has allowed humans to extend the grasslands and improve hunting. Fire also brought about cooking, which makes meat and seeds easier to digest.*

THE ARROW OF KNOWLEDGE

The Kalahari Ju/'hoansi Bushmen still burn the land to improve their hunting. The hunters' skills come from an intimate knowledge of the environment that few other societies have retained, though modern desires and shifting ambition mean that such knowledge is dying out. One of few remaining hunters is /Kun N≠amce. He can read the signs left by every animal that lives on the Kalahari savannah – from the hyenas, lions and scorpions that could kill him to the kudus, porcupines and beetles he eats. He has both a mental map of the geography of their land and a map of the behaviour of the animals that live there – a way of seeing the world to which most of us are blind but which is vital to survival in the arid savannah.

His weapon is a simple bow and arrows. Each arrow is made out of two different grasses, one that holds the arrow tip and a broader grass for a shaft, jointed with a spindle-shaped bead of bone or wood and bound with sinew threads. This weak-point construction is an essential design feature. The metal tips are covered with poison extracted from the larvae of the *Diamphidia simplex* beetle. /Kun gets it by digging into the parched earth at the base of a particular species of myrrh tree for peanut-sized hard balls of sand encasing the beetle grubs. The mashed-up grubs create a poison so potent that he need re-anoint his arrows only once a year. Yet to use the deadly arrows effectively, he has to be close enough to get a shot.

In a rough grassy hide near a waterhole, /Kun waits. At 15 metres (50 feet) from the waterhole, there is a good chance of an accurate shot. A kudu approaches nervously. The arrow flies, and the kudu bolts. The shaft falls away, but if /Kun is in luck, the barb has struck home. He waits for an hour or so for the poison to do its work before he starts to track the victim. He and his fellow hunter N//ao N!ani have to stay close enough to find the kudu before a lion or leopard does but at a distance that doesn't make the animal run farther and extend the chase.

There is a concentration and a transformation as they move, making hand gestures in silent conversation, telling the story they see in the tracks. 'To track an animal, you must first know it, but with tracking you begin to dance, you become that animal. You must think like that animal,' says /Kun. The track tells them how strong the animal remains, how fast it is moving. When they finally run in for the kill, N//ao N!ani delivers the death blow with a spear. The hunters eat roast liver at the scene, but the meat belongs to the maker of the arrow (it might be a woman or a child), and it is carried back to share among the whole village. The feast is followed by dancing, in which /Kun shares the story of the hunt so everyone will know how that animal died.

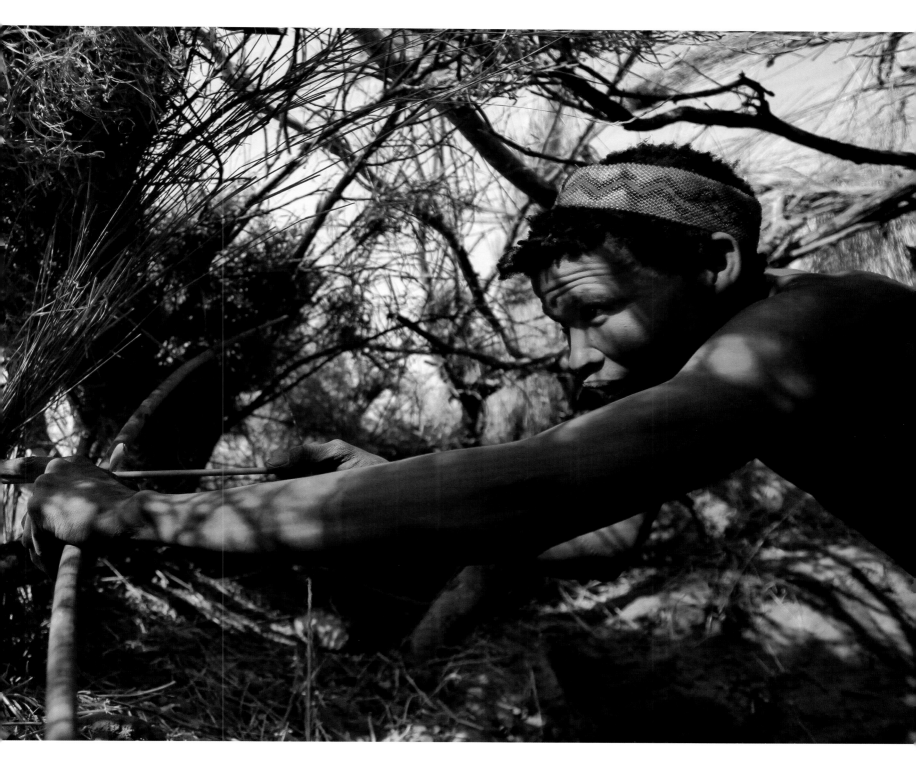

ABOVE N//ao N!ani preparing to shoot. His hide has been built beside a waterhole from sticks and grass. He is one of the few remaining Ju/'hoansi Bushmen with the skills to live totally off the land. Once his arrow has hit its quarry and the poison in its tip has started to work, N//ao N!ani will track the animal until it collapses.

TAMING GAME AND FIGHTING RIVALS

Archaeology suggests that about 11,000 years ago there was a revolution in our relationship with the animals of the grasslands that radically altered the way we lived and moulded new cultures. People began to domesticate grazing animals. From being hunters of the herds we became their protectors, and the predators who had been competition became true enemies. As herders, we embraced the concept of ownership and tied ourselves into a perpetual search for grass.

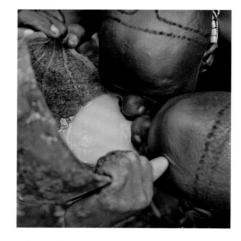

In the remote Omo Valley of southern Ethiopia live the Suri and their arch-enemies the Nyangatom. Their cultures are distinct, but both tribes are tied to their cattle and the grasslands that sustain them. Cattle bring wealth and status but also conflict and danger. To marry, a man needs to have a big-enough herd of cattle – about 40. This takes dedication and even cattle-raiding. Today, many Suri carry AK47s bartered for cattle from conflicts across the border in Sudan, but for those without guns or bullets, courage must do if they are to protect their herds.

Good grazing is in short supply, and when the Suri men go in search of the best grass, they risk encountering Nyangatom cattle-raiders as well as lions and leopards (man-eaters are common here). Either way, defending their cattle may become a fight to the death. So young Suri men must learn to master their fears and become brave, which they do through violent donga stick-fighting contests.

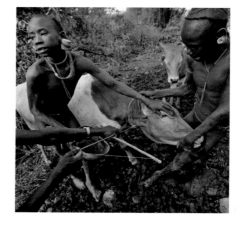

Aratula and his friends Barguru and Shahuri travel together in their search for grass for their cows. The young men may be gone from their village for weeks, during which time they depend entirely on their cows. Shelter will be a rough basher of bent branches and cowhide. At night, they herd the cattle into a thorn-fence corral. Emerging at dawn, their first job of the day will be to rekindle a fire from the grey embers, around which the cattle cluster for warmth. When Barguru milks his favourite cow, using a calabash (a gourd bottle), he shares the milk with his friends and then pours the last drops into a pit hollowed out in the dung-mire with his heel so his dog can drink it.

The boys then select a cow to bleed, to give them strength for the day ahead. While Shahuri holds the cow's head to extend its neck forward, Aratula tightens a tourniquet around its neck, and Barguru fires a small arrow into the now bulging jugular vein, producing a fountain of blood. The tourniquet is then released and the wound pressed closed. The boys drink together, crouched beside their cows, spitting out the fresh clots between their teeth.

As soon as they can lift a stick, young boys practise donga. It is a skilled martial art, with names for every thrust and parry, and it takes years to perfect. The duelling stick is

TOP TO BOTTOM *Breakfast, Suri style. The boys are taking their families' cattle to new pastures. While they are away from their village, in the valley of Omo, Ethiopia, they live on milk from their cows and a daily take of blood, obtained by using an arrow to pierce a cow's jugular vein.*

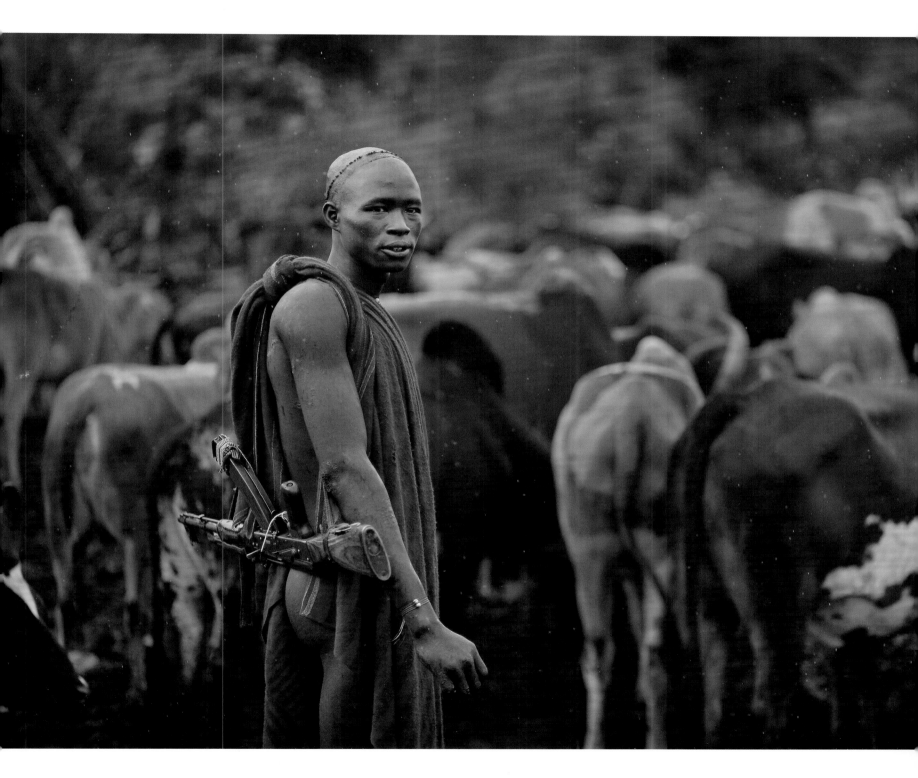

ABOVE *Aratula guarding his family's herd of cattle. His AK47 rifle is for defence, obtained from over the border in Sudan in exchange for four cows. Its main use is to warn off cattle-raiders from the Suri's arch-enemies and neighbours, the Nyangatom, but its use is limited by the availability of bullets.*

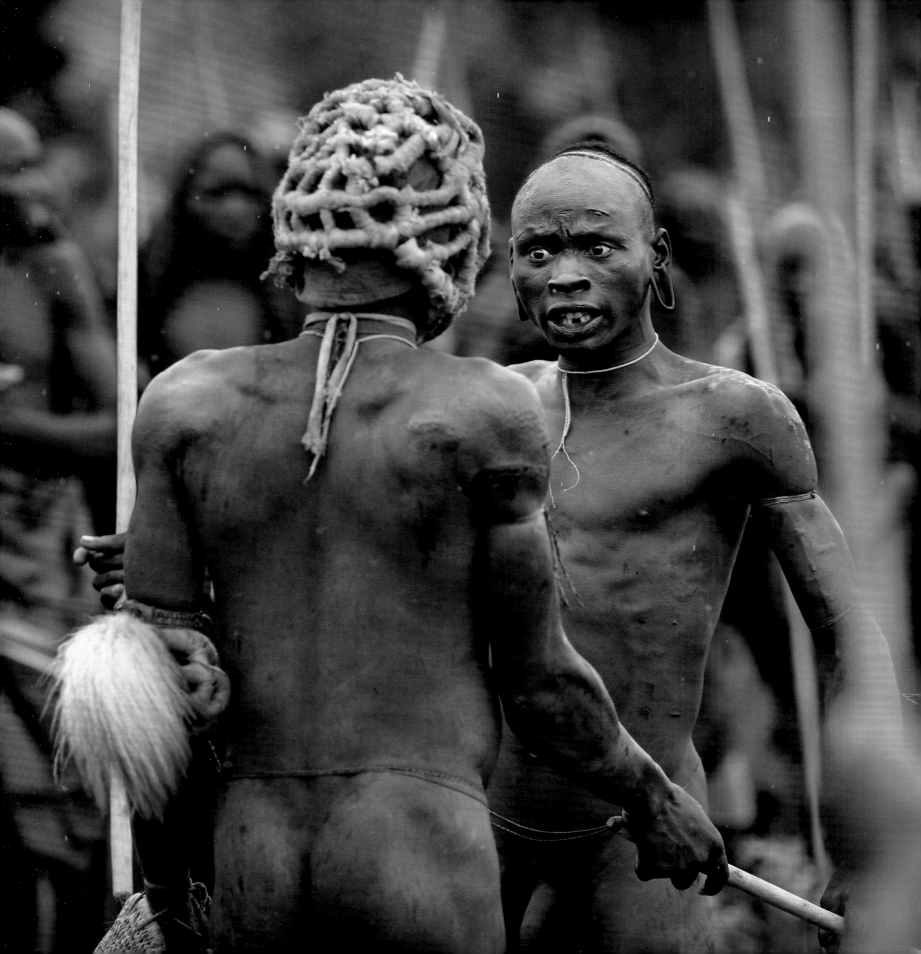

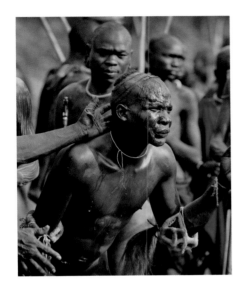

the donga – 2 metres (6.5 feet) long and carved into a phallus at its tip. The most prized dongas are made from kalochi wood, which is very strong and flexible and whips well in battle. In contests called sagine, young Suri men from neighbouring villages fight each other in the hope of becoming banzanai – brave men – able to defend their cattle to the death.

Before a fight, they drink cattle blood, wash, decorate their bodies with coloured earths and then don armour made of woven grass. The fight ring is formed by the surging crowd. Nervous novices posture and swing their dongas through the air, though without conviction. But when two fighters engage, the tension is electric. The naked duels are frantic, brutal and bloody. Skilled fighters have broken fingers, slash scars and deformed skulls. But if you can take the blows and knock down your opponent, you prove to yourself and your tribe that you have what it takes to protect your cattle. The victors are held on the shoulders of their chanting fellows as banzanai, while the bloodied losers are disgraced.

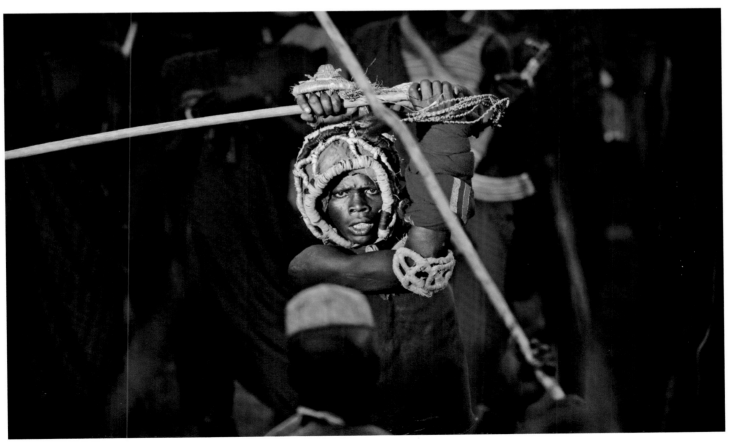

ABOVE *A fighter wearing woven-grass head and knuckle protection. Not to wear it is a sign of bravado.*
TOP *The consequences of not wearing protection.* OPPOSITE *A face-off. Having drawn blood, the lead fighter attempts to face down his opponent.* OVERLEAF *Suri clans gathered around the fighters at the donga.*

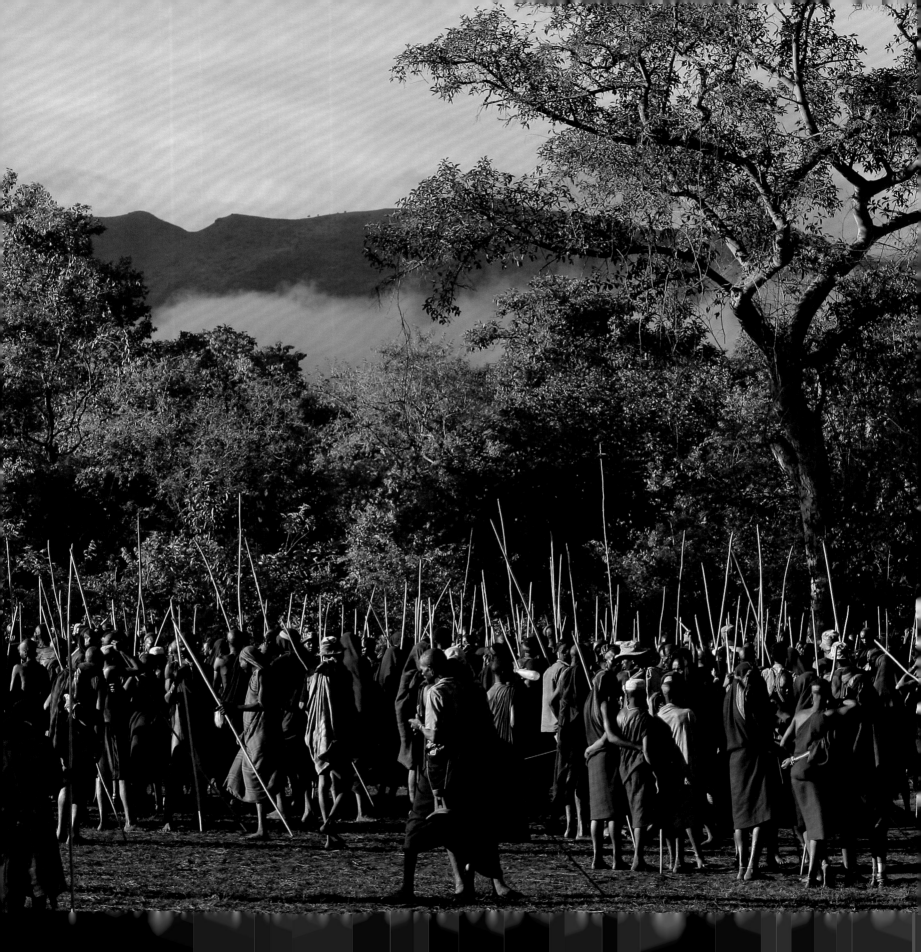

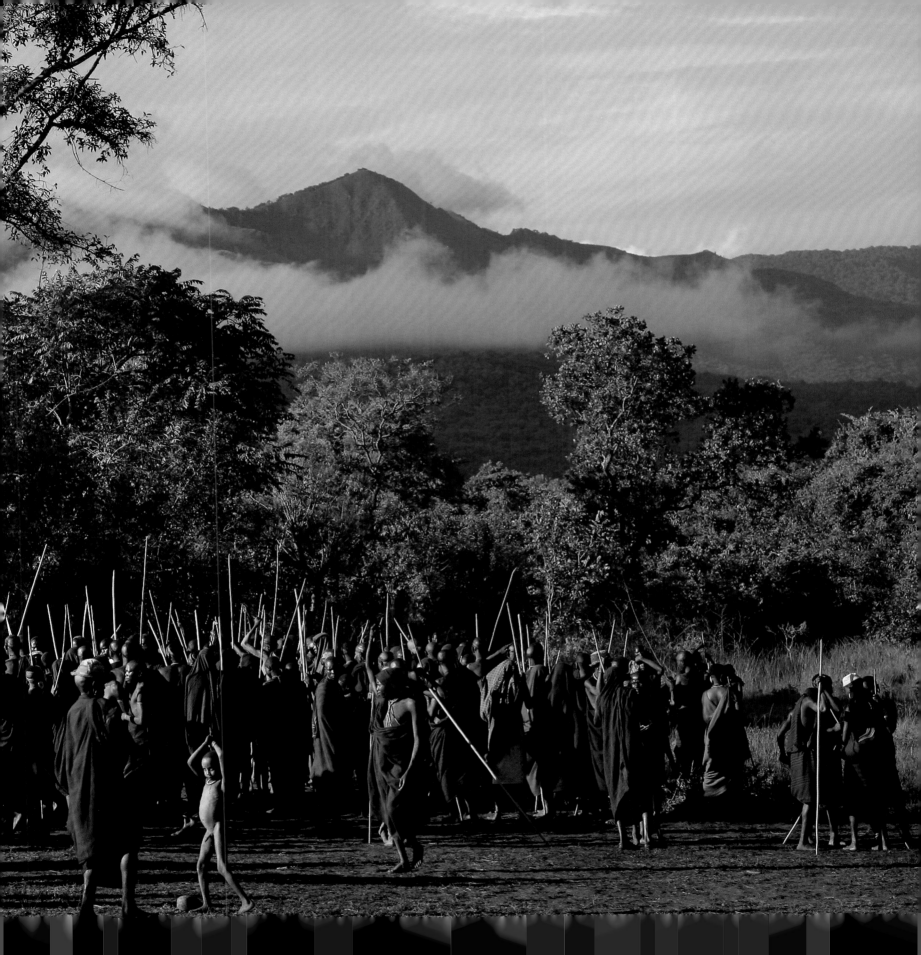

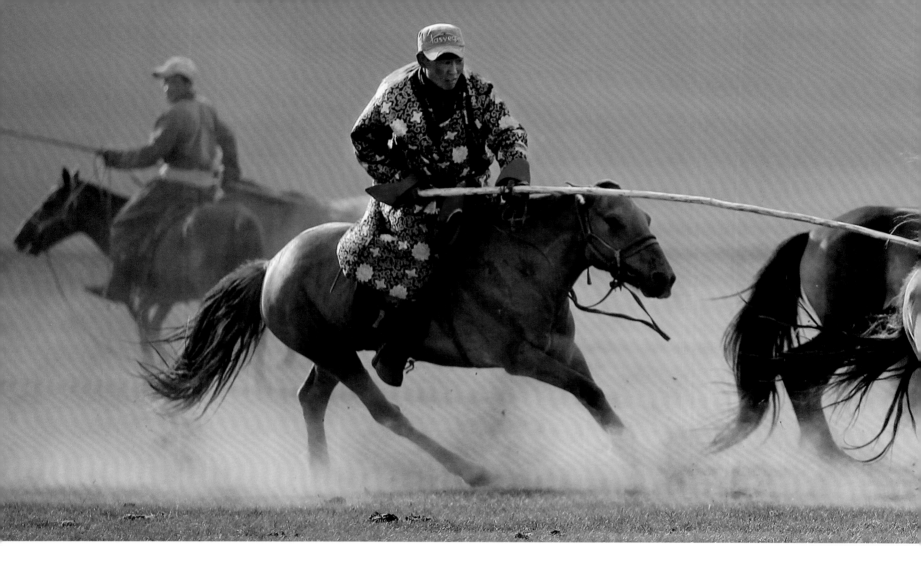

HERDS, HOMES AND HORSES

Rather than restrict themselves to grazing their animals in the region of their villages, Mongolian nomads carry their homes – gers – with them as they and their herds follow the grazing. They owe their success to another animal of the grasslands, the horse. A horse needs to graze often and regularly, and unlike a cow, it can't ruminate (regurgitate and then rechew vegetation), but it can run swiftly and for long distances. It is thought that the first people to ride horses did so about 6500 years ago, which gave them greater speed, endurance and strength on the plains than ever before. It also gave rise to terrifying fighting forces. The biggest empire in human history, stretching from Europe across central Asia and all of China, that of the thirteenth-century Genghis Khan, was built on a horse-mounted army. Today, Mongolians are no longer feared fighters, but the bond with horses remains.

54 TOP *Ulaana attempting to lasso one of the new season's foals – a chance to demonstrate his horsemanship. The horses run wild for most of the year, but after the foals are born, they are herded back to the family's ger.* RIGHT *Sersee about to drop a noose over a foal's head, skilfully enough not to hurt the animal.*

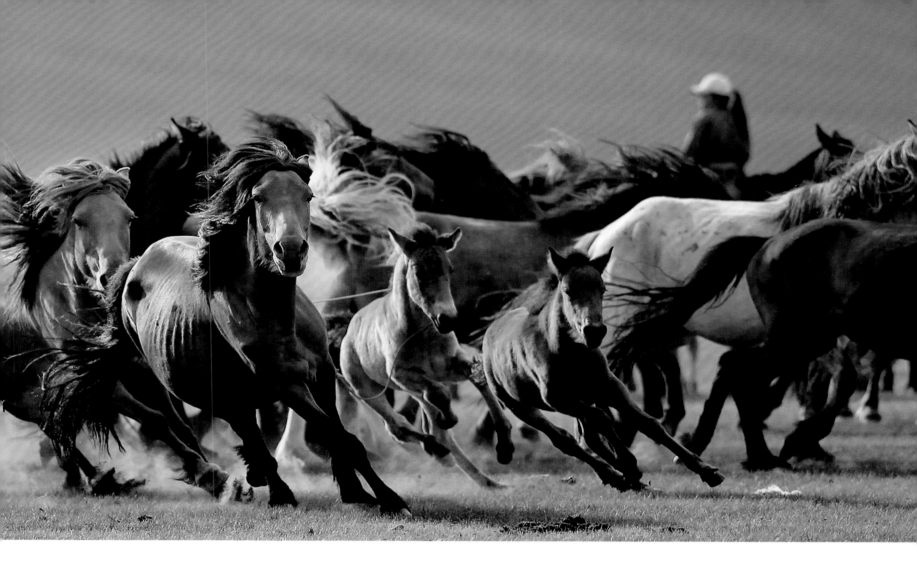

Mongolia is a land without fences, and though the horses are owned and branded, they are not corralled or shod and roam free in stallion-led herds. When it comes time to move to new grassland, they are driven along with the other livestock. They are ridden but also milked, and fermented mare's milk is still an essential summer food. First, though, you have to catch your mare.

In late June, when new foals are about a month old and the spring grass is vibrant green, riders from every family, some as young as nine, saddle up and head out to round up their horses – perhaps a small herd of 50 or one as large as 1000. Many of the people dress in brightly coloured silk deel coats that shimmer in the morning sunlight.

In Chuluun's family, six riders round up more than 100 horses. When the herd is brought to the ger, Ulaana takes on the task of catching a foal. Equipped with a larch pole about 6 metres (10 feet) long with a simple leather loop lasso at the end, Ulaana and his horse cut and twist through the herd at a canter, aiming to loop the delicate

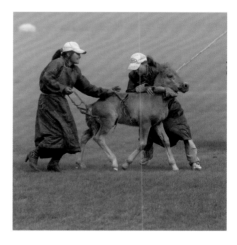

LEFT *Tungaa and Airag calming down a young foal, which will then be tied to a rope pegged into the ground – bait to bring its mother close. Once the mare is caught, she is hobbled next to her foal so it can suckle. Interrupting the suckling, Tonga will take milk from the mare to make arak, fermented yogurt.*

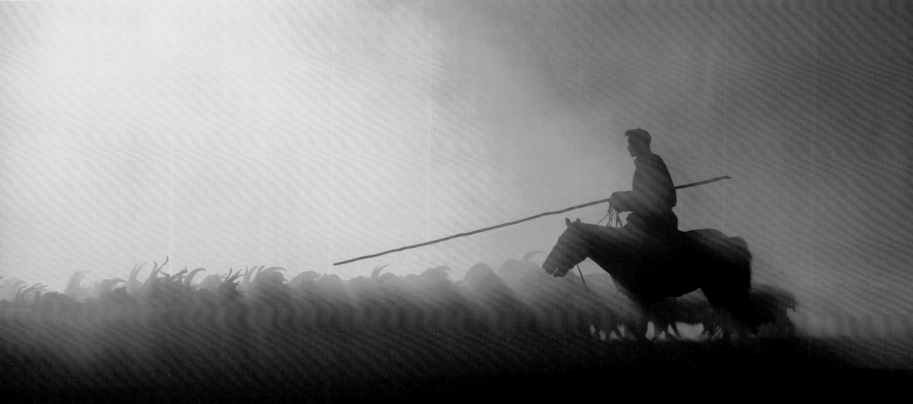

lasso around a foal's neck. Foals and mothers run together, doubling back through the herd, but Ulaana skilfully lassoes a foal, leaning back in his wooden saddle to hold the pole steady until his cousin Tungaa gets a halter on it.

Tungaa then drags the foal to a rope strung between two posts at ankle level and ties it up. They repeat the process until all the foals are tied up. The mares, meanwhile, stay close by, and now the boys turn their mounts in pursuit of them. These mares are not broken in, and for the three-year-old ones in their first season, there is a frightening surprise ahead.

The chase is wild, the dust flies and the mares lean as they turn and race ahead of the herd. Ulaana reaches forward, both hands on the pole while also holding the reins, and stands up in the saddle at a full gallop. With incredible horsemanship he lassoes the mare. But fear makes her strong, and she bucks and rears, and Ulaana needs all his strength to hold the pole. When she pulls free, the mare bolts back to the herd with the pole trailing along beside her. As she comes past him, Esee lurches for the pole, is pulled off balance and lands face down in the dust. Eventually the lasso noose loosens and falls open. The pole drops to the ground and is broken by the pounding hooves. They have to start over.

This time, the pursuit is swift and the catch is clean, but it takes a second noose before the trio of horses comes to a halt. The mare's eyes stare with fear and defiance as Esee approaches her on foot. He talks softly, with a halter held at arms length. Slowly, calmly, he slips the strapping around her head. Only then does he remove the lassos. With help from Chuluun he straps up her forelimbs and hobbles her back legs so she can only lurch towards her tethered foal. The two are left alone for a few hours before milking is attempted.

With encouraging murmuring, they bring the foal to suckle, then interrupt its drinking to milk the hobbled mare. With that done, the foal drinks again, and Tungaa takes the milk away to make the most treasured summer food, arak – a 24-hour-fermented yogurt.

At sunset, both mares and foals are released to suckle uninterrupted and spend the night together before the whole challenge begins again next morning, and the next – until autumn arrives and the family have to pack up their gers, made of canvas, wood and felt – and continue their search for grass.

This perennial quest has shaped the whole ger lifestyle, and though many Mongolian nomad families now have lorries to help with the move, others still use yak-drawn carts.

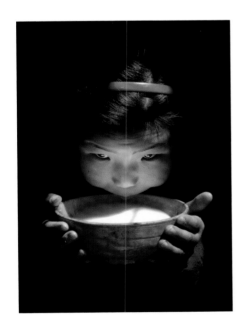

LEFT *The food of summer – arak. Milk for the yogurt comes only from horses.* OPPOSITE, TOP *A ger, about to be dismantled as the herders follow the new rains.* OPPOSITE, BOTTOM *On the move with cashmere goats, kept for their wool – a cash crop for the nomads. Increasing numbers of goats are leading to overgrazing.*

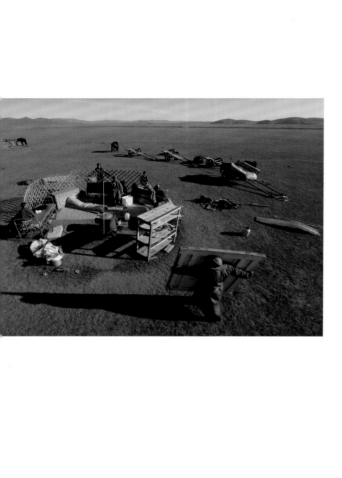

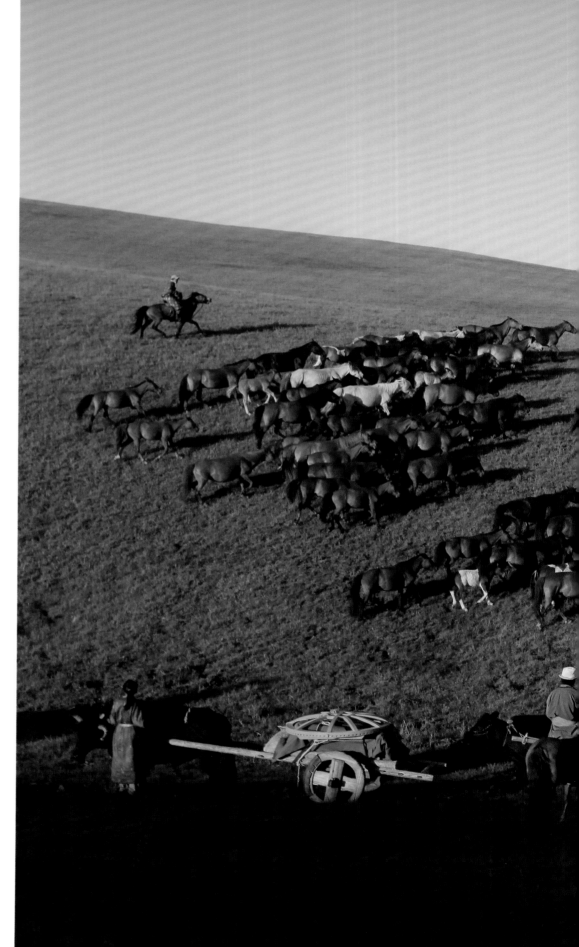

58

ABOVE *Dismantling a ger. It will take just a couple of hours to load everything onto four carts.* RIGHT *When the family moves to new pasture, the men ride the horses and the women and girls drive the carts, drawn by yak-oxen hybrids.*

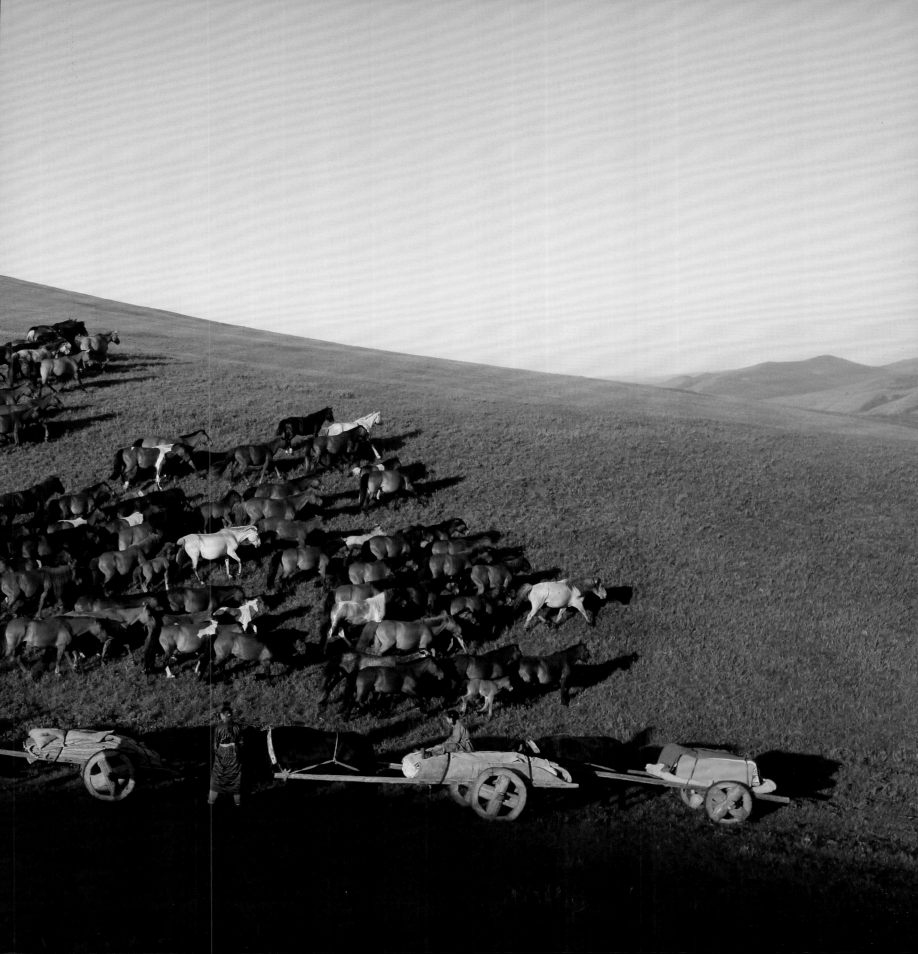

SNAKE HARVEST

In Cambodia, people living around the Tonle Sap Lake exploit the surrounding grassland in a unique way. The monsoon rains are so heavy that the water level of the lake rises by up to 8 metres (26 feet), increasing its size by four times and flooding the grassland. To keep above water, the grass grows fast and also floats in matts. The people cope by living on stilted or even floating houses. But there is a bonanza. The floodplain provides the perfect nursery for a myriad of small fish, which in turn are hunted by millions of amphibious snakes, including cobras. Living on narrow boats for days at a time, whole families net the snakes. They eat the guts and then sell the bodies at market. An average 6.9 million snakes are traded in a season – grabbed and weighed by the handful, skinned and eaten dried or fried, with a sprinkle of chilli, as a bony but protein-rich snack. In today's world, though, many also end up as fodder for the nearby crocodile farms.

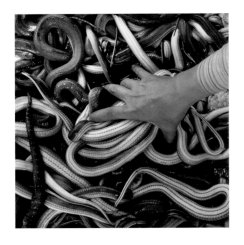

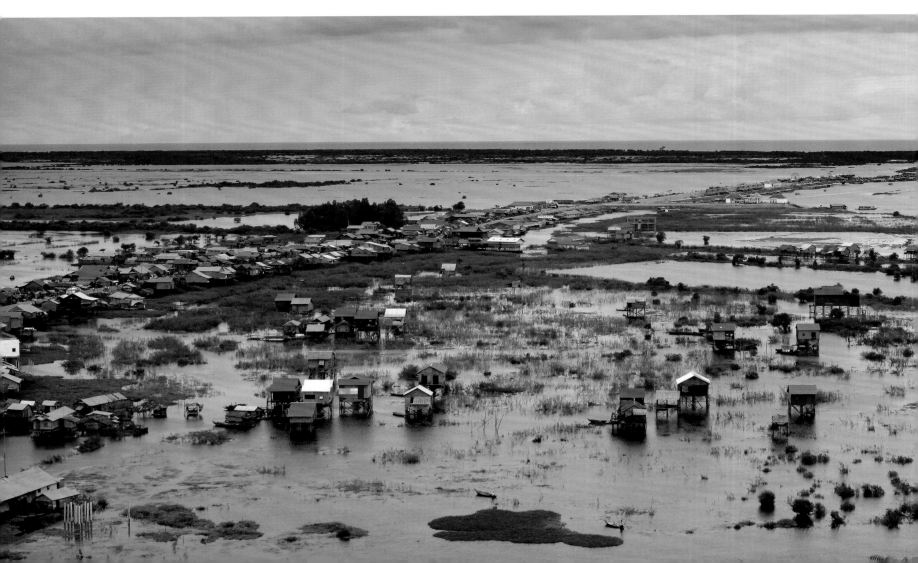

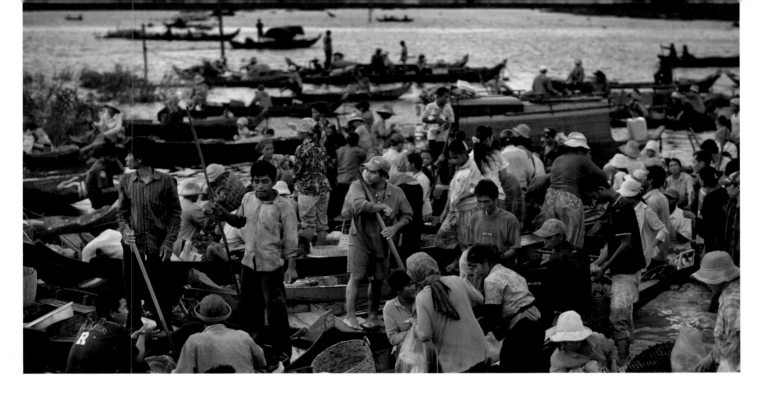

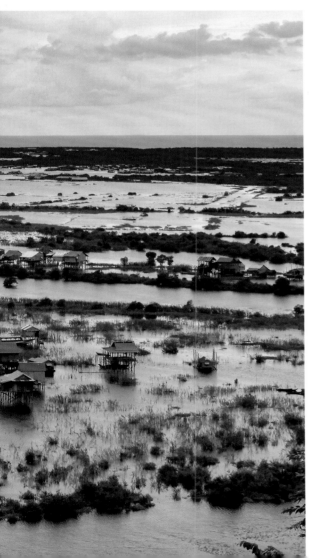

THE PEOPLE'S GRASS

The real exploitation of flooded grasslands in Cambodia and elsewhere in Asia comes with the damming of silt-rich floodwaters into paddies for the domesticated grass that we now know as rice.

We have been locked in mutual dependence with grasses for millennia. Rice, wheat, maize, barley, sorghum, millet, sugar cane – all are grasses that we've adapted for our uses, breeding them for plumper seeds, taller stems, earlier ripening and resistance to drought, rain, insects or germs. And it was grass that has ultimately tipped the balance towards urbanization. Our love affair with these cereals shows no sign of waning, and as the original grasslands have vanished, so the domesticated grasses have spread.

Together, grasses supply an astounding 75 per cent of carbohydrates and more than 50 per cent of protein to the human population. Pastures in the temperate world alone feed cattle that produce 80 per cent of the world's cow's milk and more than 70 per cent of the world's beef and veal. These are monocultures in which the number of plant species is reduced to just one. The land is boosted by fertilizers, doused in pesticides and sown, tended and harvested by machine. The industrialized grasslands of the US have a rural population density on a par with Arctic Greenland, with no more than six people per square mile. But the super-grasses remain a luscious temptation for grass-eating animals, and we are still locked in a never-ending battle against what we now call pests.

LEFT *The stilted Cambodian village of Chong Kneas. In the monsoon, the lake floods the grassland and the people take their boats out to catch water snakes, which emerge in their millions to feed on spawning fish.* OPPOSITE, TOP *A haul of harmless water snakes for sale.* ABOVE *The floating snake-market at Chong Kneas.*

INVADING ELEPHANTS, PLAGUES OF BIRDS

Wild species present a threat on a massive scale, from the smallest virus to the largest land animal. When the bamboo flowers in Assam, it sustains a plague of rats that then devour the rice. In Bengal, the last few wild elephants are still a problem, emerging from the forest at night to feast in the paddies. Some elephants have even developed a taste for fermented rice beer, creating havoc in the villages in their search for a drink.

In an attempt to discourage them, communities mount vigils to guard their rice at night, and if the elephants appear, the whole village rushes to the fields with pitchforks, pots and pans, firecrackers and flaming torches in an attempt to save their crop. It's a risky business. Frightened and angry matriarchs will defend their calves, and intoxicated elephants are unpredictable. In Bengal alone, about 80 people a year are trampled to death by elephants.

More devastating in Africa are the dark clouds of flying pests that swoop in, strip a crop and leave. Locusts are the biggest problem, but million-strong flocks of voracious quelea birds can strip crops in equally fast time. Though they prefer the seeds of wild grasses to those of cultivated crops, their huge numbers make them a constant threat to sorghum, wheat, barley, millet and rice.

Yelling and chasing does little to dispel them. Nomadic super-colonies can grow to millions, making quelea not only the most abundant bird in the world but also the most destructive. A quelea can eat roughly half its body weight in grain every day. The consumption of up to 10g (0.4 ounces) for each member of a 2-million-strong flock means 20 tonnes devoured in a single day. Farmers in the path of such a quelea plague will lose everything.

Quelea can breed at a phenomenal rate – up to three times a year, with three chicks per clutch – but to do so, they settle in grass nests for three to four weeks, which is when they are vulnerable. If farmers find the colonies, they set fire to them. In some cases they lay a network of cables that will trigger firebombs below the nest trees when the clouds of birds return to roost. The trees and birds ignite as fireballs, and in the morning, the farmers gather up the charred bodies for food. But despite this carnage, the quelea are thriving, with an estimated breeding population of up to 1.5 billion birds.

What seems hideously brutal is simply a dynamic illustration of what our weapons, poisons and pesticides do to any number of species that try to take advantage of our grain. Our drive to feed ourselves pushes other inhabitants of the grasslands to their death. Humans are murderous competitors.

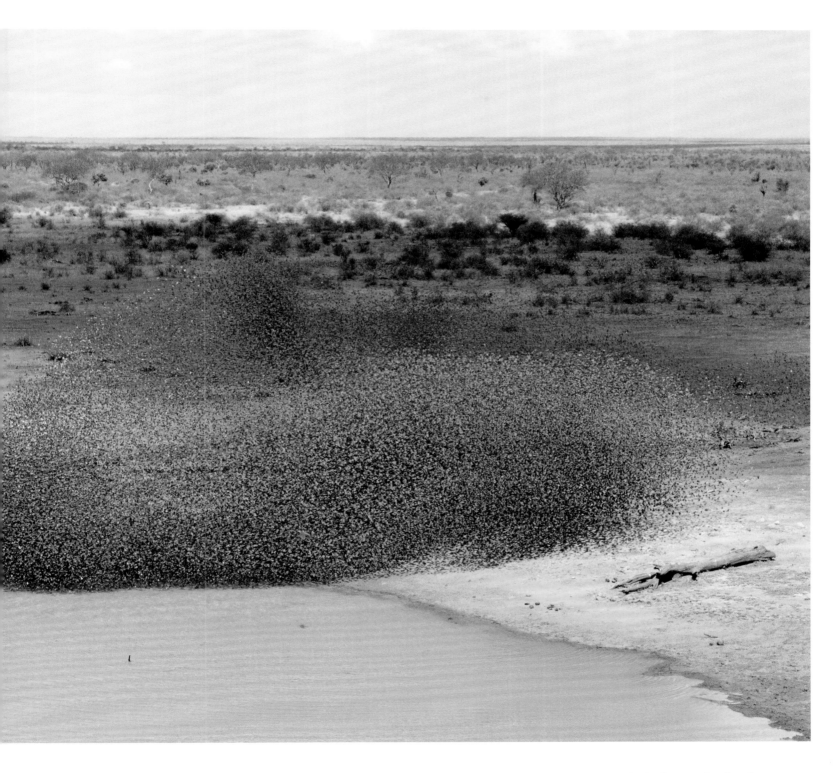

ABOVE *A flock of red-billed quelea finches descending en masse to drink. The species breeds and migrates in flocks of hundreds of thousands. The birds feed on the seeds of wild grasses, but where grasslands have been replaced by crops, they can strip large areas in hours, devastating the crops of small farmers.*

ULTIMATE DOMINATION

Human domination of the grasslands is getting ever more intense. We have made whole landscapes into monocultures and controlled herds so huge that we need helicopters to round them up. Among the biggest cattle herds are those in the Northern Territory of Australia – a continent where cattle aren't native but are 30 million strong. It is a mark of our ingenuity that we can shift grassland animals around the globe to meet our needs. For cattle stations that

have hundreds of thousands of animals ranging over immense pastures of 600 square kilometres (232 square miles) or more – bringing in the herd means taking to the air.

The helicopter cattle round-ups are immense spectacles. Their sound precedes them, as three helicopters fly in formation, driving several thousand cattle a day over the vast landscape. To keep the nervous animals moving towards the holding pens, the helicopters criss-cross the land, assisted by riders on the ground, often smothered in suffocating clouds of fine red dust. The pilots have to be excellent flyers, with lightning reflexes and able to manoeuvre in the dust clouds. They fly low and fast and need to read the landscape and understand cattle behaviour. When cows hide among the trees, the pilots may have to land and chase them on foot.

Hundreds of thousands of cattle are herded to collection points and loaded onto massive land trains that trail across Australia's Northern Territory to the ships waiting in the northern ports. This is a live-export trade, breeding and fattening cattle originally from one continent on the grass of another before exporting them to a third.

Outwardly it seems as if humanity has tamed the grasslands and crushed most of the competition. But will we become victims of our incredible success? Agriculture currently sustains a huge urban population. Yet by 2030, there will be more than 8 billion humans, which some estimate will require a 30 per cent increase in grain yields. As more and more people want to eat meat and drive cars powered by biofuel, we'll need to grow even more grain. Once again it is grasslands that will determine the future of mankind, and our intelligence will be tested to keep this crucial relationship in balance.

GRASSLANDS

TOP *Heli-cowboy mustering cattle in a remote region of the Kimberley in Australia's Northern Territory.*
RIGHT *Pushing cattle towards a giant holding pen. In the Northern Territory, cattle are left to fend for themselves, ranging semi-wild over huge areas. The only way to round them up is from the air.*

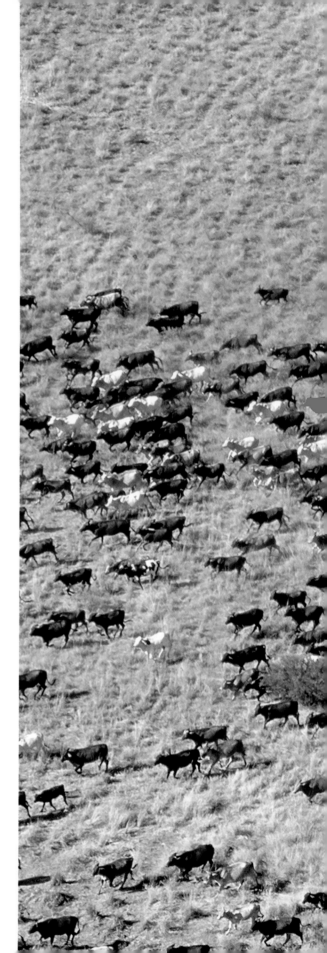

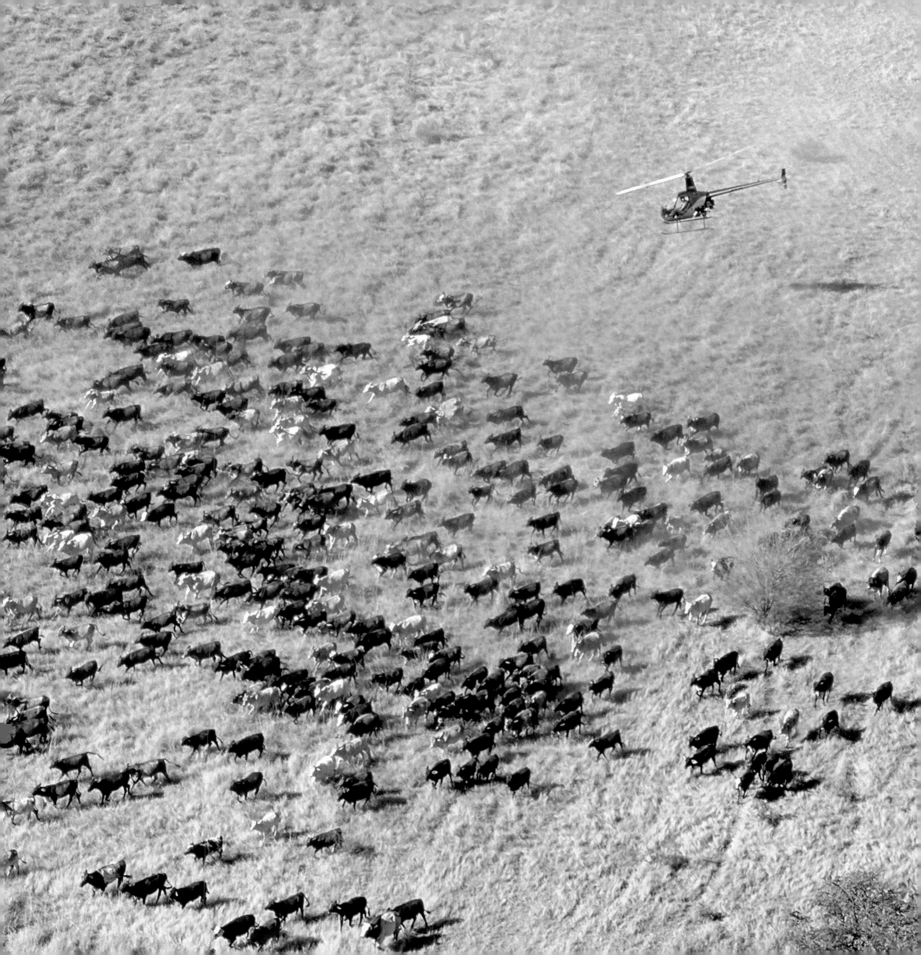

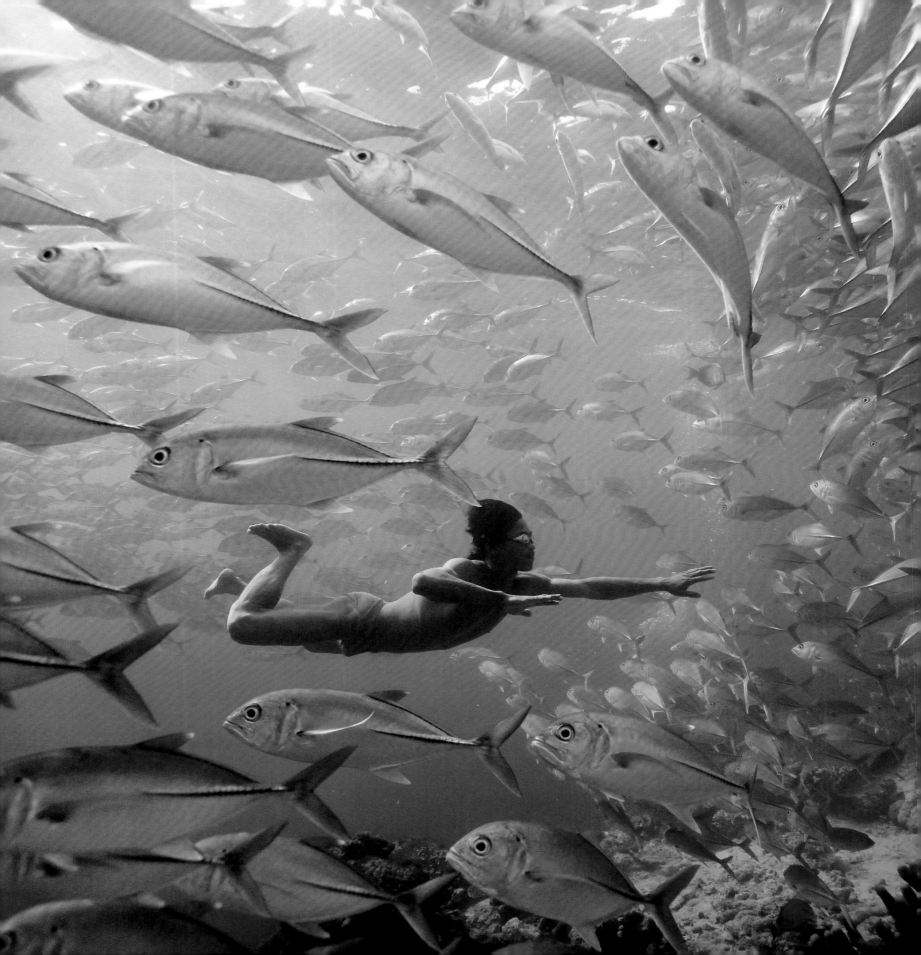

OCEANS
2

HUMANS HAVE A REMARKABLE RELATIONSHIP WITH THE SEA. MORE THAN HALF OUR POPULATION LIVES WITHIN 100KM (62 MILES) OF THE SHORELINE, AND EVEN MORE OF US RELY ON THE OCEANS TO MAKE A LIVING. WE OFTEN CHOOSE TO SPEND OUR LEISURE TIME ON THE COAST, AND WE EVEN CLAIM THAT BEING THERE HAS A CALMING EFFECT ON OUR BODIES AND MINDS. BUT DESPITE THIS APPARENT AFFINITY WITH THE SEA, THE OCEAN IS THE MOST DIFFICULT OF ENVIRONMENTS FOR US TO INHABIT. OUR BODIES ARE BUILT TO WALK ON TWO FEET, NOT TO SWIM; OUR LUNGS ARE ADAPTED TO BREATHE AIR, NOT WATER; OUR SENSES DON'T FUNCTION WELL UNDER WATER; AND THE SEA IS TOO SALTY TO DRINK. YET SINCE THE BIRTH OF MANKIND, WE HAVE BEEN PUSHING THE LIMITS OF SURVIVAL FARTHER AND FARTHER INTO THE BIG BLUE.

The first people to have a relationship with the sea would have had to adjust to this most alien of environments using nothing more than their wits and what they could find in their natural surroundings. Today, despite the dominance of modern technology and the resulting loss of traditional skills, there are still cultures living in ways that reflect the challenges faced by those marine pioneers. The lives of these people offer an insight into the incredible story of how humans have adapted to a marine environment.

The universal human need to find food has been the major force driving us to explore the ocean's opportunities: 80 per cent of all the life on Earth is found beneath the waves, and even at the ocean's edge there's a glut of seafood that we can harvest. With each falling tide, highly nutritious shellfish and other sea creatures are revealed, clinging to the rocks or buried in the sand. For many cultures, collecting shellfish is a reliable way to secure a major part of their diet. But while coastal foraging often makes for rich pickings, the pickings aren't always easy or danger-free.

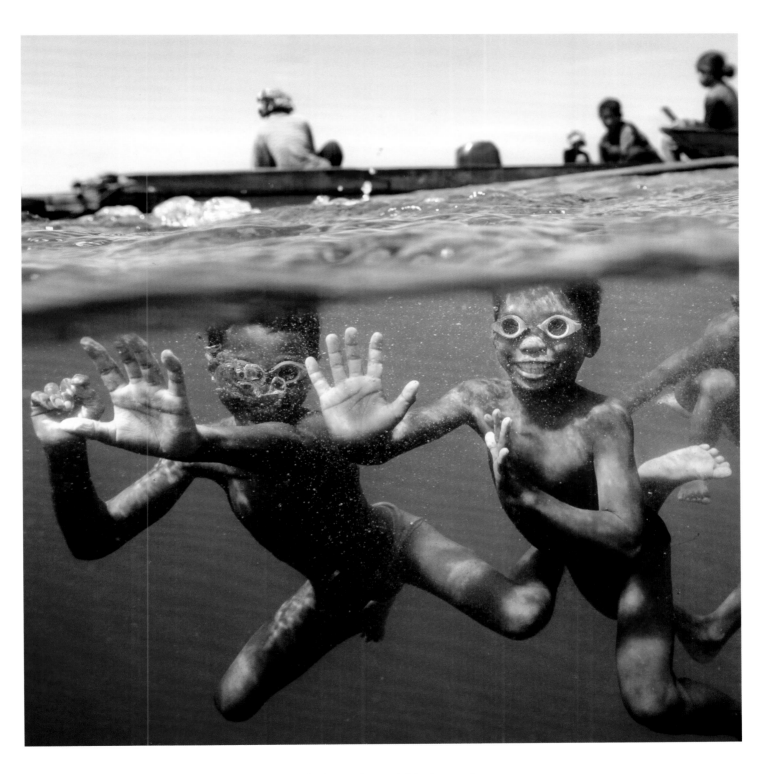

ABOVE *Sea-gypsy boys playing in the Sulu Sea, Southeast Asia. They live on a boat and their playground is the ocean. Those who swim without goggles develop better underwater eyesight than land children.*
PREVIOUS PAGE *A Bajau free-diver swimming among a school of jacks off the coast of Sabah, Borneo.*

THE DAREDEVIL PERCEBEIROS

The rugged Galician coast of northwest Spain has been shaped by powerful waves rolling in off the Atlantic. The sea here is notoriously treacherous, and yet it's these turbulent, oxygen-rich waters that make the coastline such a fertile place. Seafood is a major industry in Galicia, and there's one particular shellfish the region is famous for. With its strange scaly 'beak' and thick rubbery 'neck', a goose barnacle may not appear appetizing, but in Spain it's considered a gastronomic delight. Known in Spanish as percebes, goose barnacles can retail at €200 a kilo – a price that reflects not so much their rarity as the difficulty of their harvesting.

Goose barnacles prefer to grow on wave-battered rocks, where super-oxygenated water stirs up nutrients from the seafloor. In a three-hour window around low tide, the barnacle-encrusted rocks are exposed, which is when, all along the Galician coast, daredevil barnacle collectors, known as percebeiros, can be found plying their trade. Their method is simple: wait for a lull in the swell and then prise away as many barnacles as possible. But often this means a death-defying dash: predicting the pattern of the breaking waves, scrambling down the jagged rocks, frantically dislodging the barnacles and stuffing them into a bag tied around the waist and then clambering to safety as the next wave comes crashing in. Sure feet and an instinctive feel for the rhythm of the sea are essential skills; one slip can result in being swallowed by the waves and pounded against the rocks.

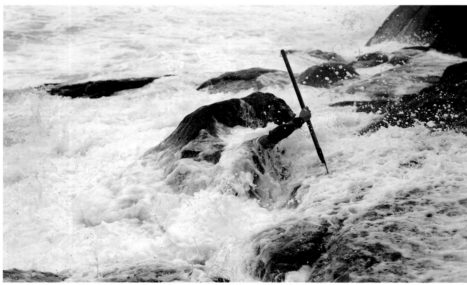

ABOVE *Angel ducking behind a rock to avoid being swept away. Collecting barnacles without a safety line allows him more freedom of movement.* RIGHT *Alberto dangles from a rope to get to the hard-to-reach barnacles. Both take huge risks in the pursuit of bigger, better-quality barnacles.*

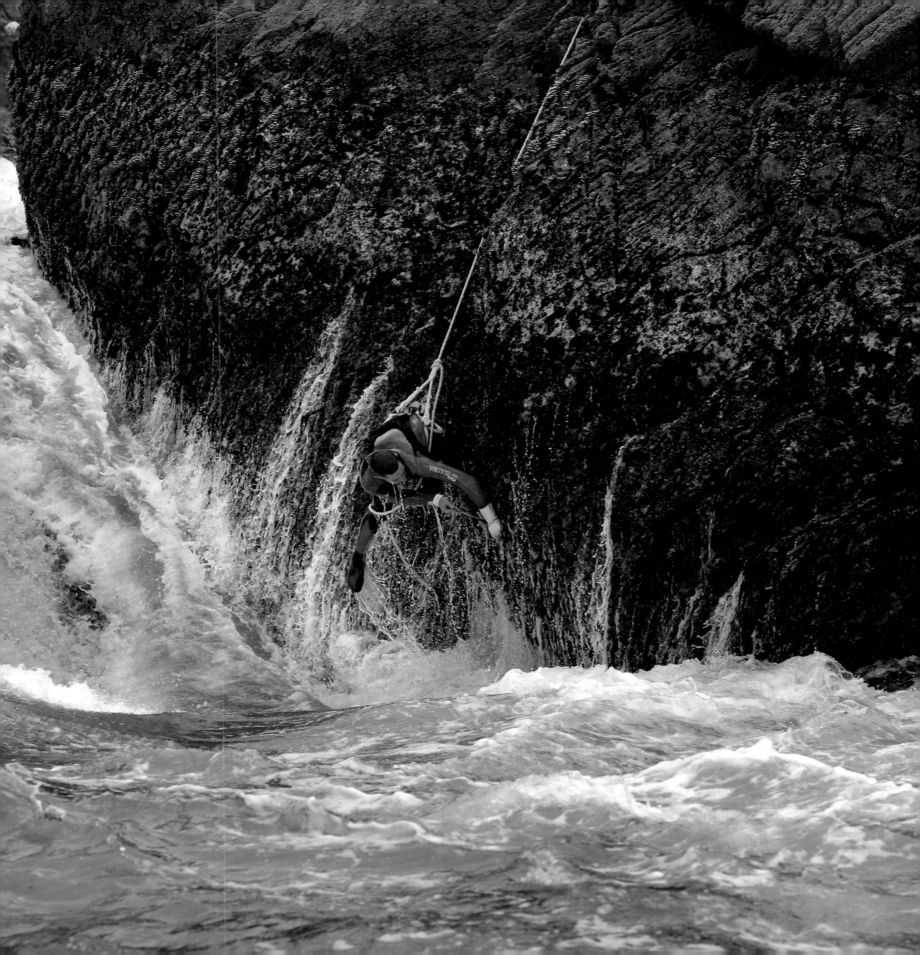

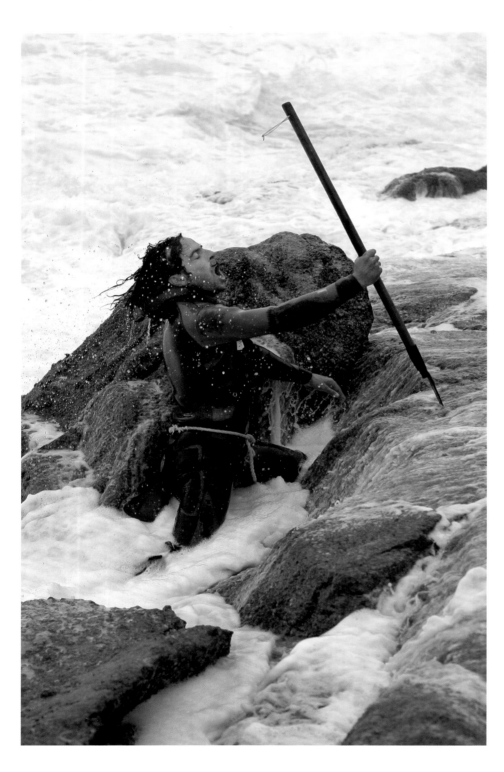

ABOVE *Angel, his collector's bag tied to his waist, using just a stick to negotiate the rocks. The only difference between his method and that of Galician percebeiros in centuries past is that he wears a wetsuit.*
RIGHT *Angel and Xavier climbing back up the cliffs with a sackful of goose barnacles to sell in the market.*

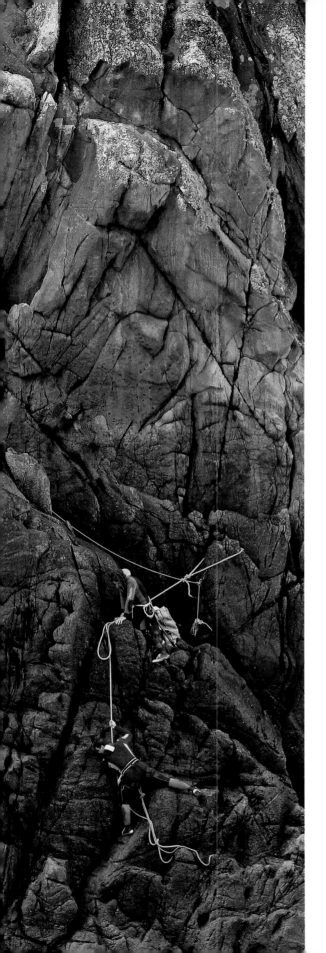

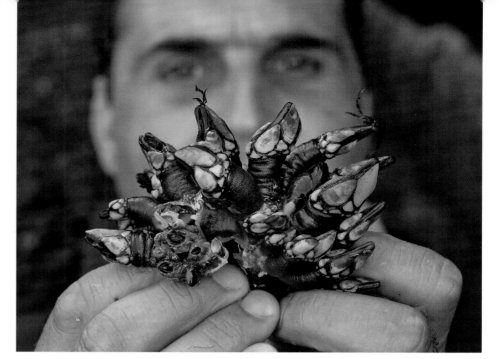

For those prepared to take the gamble, this physically demanding job offers a decent living and a certain macho appeal, but it doesn't pay off for all percebeiros. Considering that a number die each year, it's no surprise that this profession is renowned as one of the most dangerous in Spain. Most fatalities occur when inexperienced and often unlicensed collectors are tempted to push their luck, but occasionally even the most seasoned percebeiro can make a fatal error in judgement. Other factors also conspire to increase the incentive to take ever-greater risks. The biggest and most valued barnacles inevitably remain in the most inaccessible, precarious places. Also, when the ocean gets rough, fewer collectors dare work, and so the supply to the market drops and the price soars.

This dramatic method of harvesting goose barnacles has remained virtually unchanged over centuries, because there's little that can be done to modernize or mechanize it. Indeed making a living through foraging between the tides was probably how our relationship with the sea first began millions of years ago. It has been argued that adapting to survive at the sea's edge played a key role in human evolution. There's considerable evidence that our brains and bodies develop best with fatty acids and proteins most easily found in a seafood diet, and some even suggest our bodies have been partially shaped through a period of semi-amphibious existence.

Exactly how significant an 'aquatic phase' was to our development is debatable, but one thing is certain: it is our unique resourcefulness, ingenuity and ability to exploit new opportunities that have allowed us to survive at the edge of the sea. And once humans had discovered the marine environment, we soon began pursuing even greater sources of sustenance just a little further under the waves.

ABOVE *Xavier with a prize clump of percebes. The red fringe is said to indicate superior quality, which could lead to a price of up to €300 a kilo. They grow in the most turbulent, oxygen-rich waters – where the waves batter the most – perilous locations where the percebes have a better chance to grow before they are picked.*

THE DOLPHIN PARTNERSHIP

The seas are (or at least were) swimming with fish, but devising ways to catch them was a far greater challenge than prising sedentary shellfish from rocks. Discoveries of both scales and paintings in caves confirm that some people were already eating quantities of sea fish more than 40,000 years ago. Setting traps and spearing in the shallows are likely to have been the main ways they caught fish, but the reality is that we don't know. However, in the southern Brazilian town of Laguna, a group of fishermen provide a glimpse of one of the most remarkable ways in which we may have first fished.

Every day in May, as many as 50 men wade out into Laguna's shallow waters to form a long line parallel to the beach. They are here to capitalize on migrating mullet – so many that it's possible to catch a hundred with a single cast of a net. But the estuarine waters are so murky that their success is largely down to luck. The way the fishermen have overcome this predicament is by forming a remarkable alliance with the local dolphins.

Bottlenose dolphins also have a taste for mullet, and because they use echolocation to detect prey, poor visibility poses no problem. The fishermen have learned that by watching their behaviour they can better calculate where the fish are and where to cast their nets. The dolphins in turn benefit from the barrier of fishermen towards which they can chase and trap fish. But the cooperative interaction runs far deeper than just humans and dolphins opportunistically profiting from the presence of the other.

The alliance was first recorded in 1847 but is probably much older. Over time, the dolphins have learned to signal with characteristic rolls and dives when the fishermen should throw their nets. The direction of a dolphin's leap indicates which way the fish are swimming, and the vigour of the leap indicates their abundance. By synchronizing the fishermen, the dolphins increase their own catch, since when a long line of nets hits the water, any fish that escape scatter back towards the dolphins and can be picked off. It is the dolphins who initiate and control this relationship, and the fishermen appreciate how much they owe to them. They've become very fond of their local pod, have names for each dolphin and have learned to understand subtleties in each one's fishing style.

This alliance is one of few intact examples of this cooperative fishing method. Yet throughout history there have been numerous accounts of different cultures joining forces with dolphins. In Mauritania, until just ten years ago, the Imraguen people, who had no boats, relied on dolphins to drive mullet towards them, and in recent history, the Aborigines of eastern Australia employed similar strategies, using spears rather than nets. It seems highly probable that early people fished in similar ways.

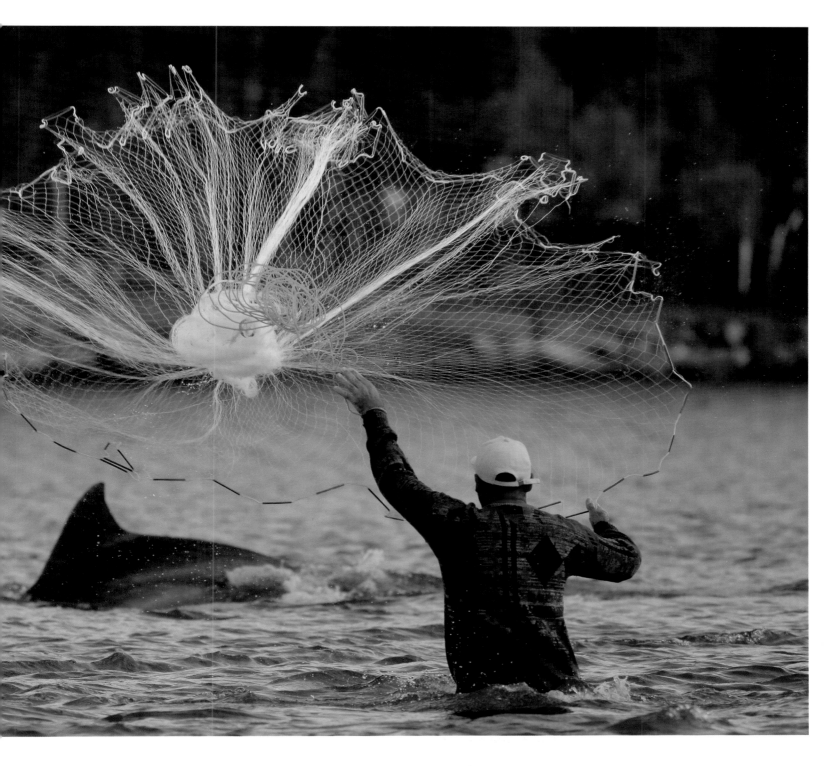

ABOVE A *fisherman casting his net to the cue of a dolphin's leap. In the shallow waters of Laguna,*
southeastern Brazil, the dolphins work with the fishermen, signalling when fish are in range of the throw-nets.
The dolphins benefit by picking off the fish that scatter away from the net and back towards them.

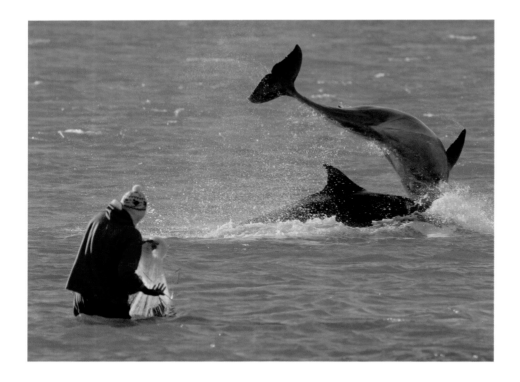

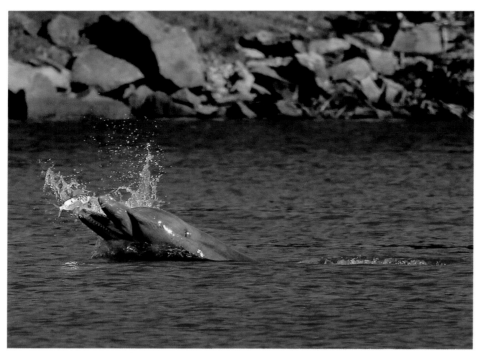

TOP *Watching for signals. The fishermen have names for each dolphin and can identify their different signal styles. The direction of the dolphin's roll indicates which way the fish are travelling, and the vigour of the porpoising action signals the size of the school.* ABOVE *Catching a mullet that is leaping to escape a net.*

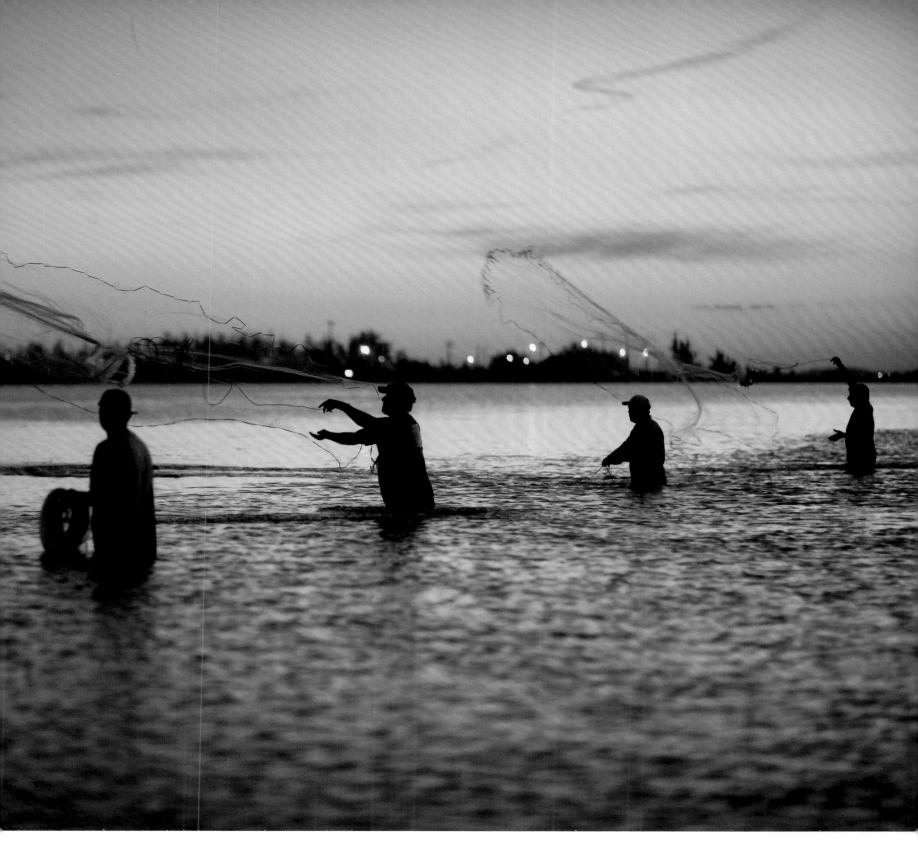

ABOVE *Laguna's fishermen casting their nets at the dolphins' signals. The water is so murky that it would be difficult to catch fish without the dolphins' collaboration. In April and May – the main fishing season, when grey mullet migrate through – both dolphins and people fish from before dawn to well after dusk.*

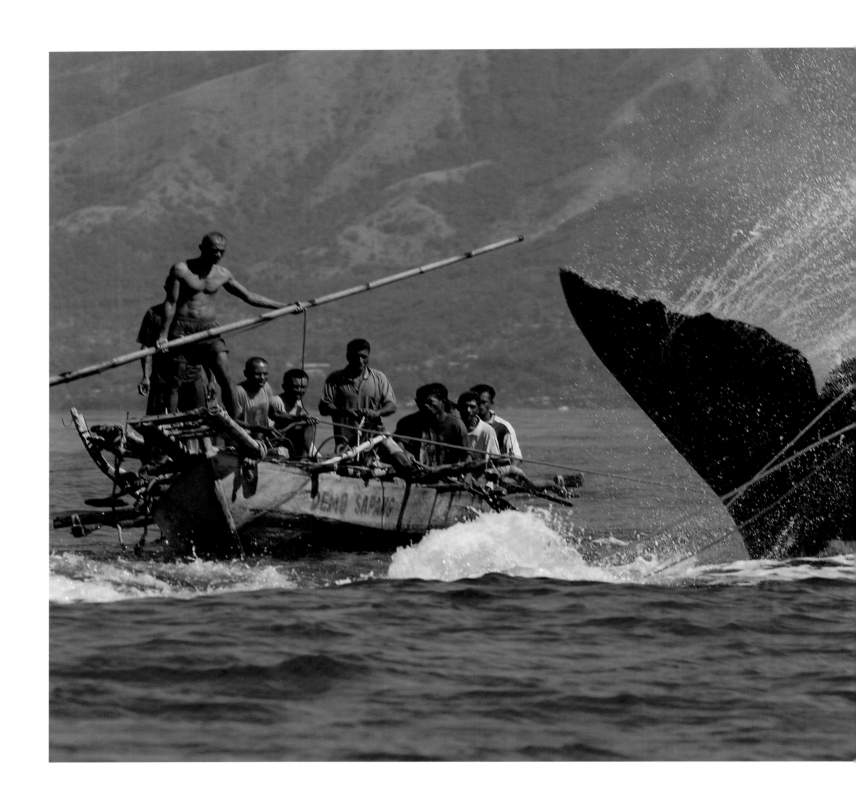

THE BIGGEST CATCH OF ALL

Over thousands of years of refining our techniques, we've become master fishermen. We've come to understand the habits of many different species of fish and tailored an impressive range of strategies to outwit them. As our competence improved, we began bringing in bigger catches and going after larger animals even further out to sea. It wasn't long before we turned our attention to hunting whales — the largest animals of all.

Most of today's whaling is conducted with powerful harpoon guns and huge factory ships to process the immense carcasses. Today, only a handful of countries hunt whales in significant numbers, Japan and Norway accounting for the majority. Other nations including the UK and the US used to take part in large-scale whaling, but the devastating effect the industry had on whale numbers has led most to ban it. There are, though, still a few communities that continue to hunt whales using ancient traditional methods. Aboriginal whaling villages remain in the Arctic and the Caribbean, but the most remarkable is the village of Lamalera on the Indonesian island of Lembata.

Posted at vantage points around the village, lookouts scan the horizon for signs of sperm whales. As soon as they call 'baleo, baleo', the hunters spring into action, launching their boats from the beach and rushing out to sea to chase down the whales. Once a boat manages to get close enough to a surfacing whale, a harpoonist leaps from the prow and uses all his bodyweight to thrust a long bamboo harpoon deep into its back. The speared whale dives to escape, pulling the boat with it and often dragging it under, forcing the crew to swim to a support vessel. But even submerged, the boats are designed to remain buoyant. Pulling the boat slowly tires the whale, and each time it surfaces to breathe, more boats move in and attack with more harpoons and spears.

The hunt can last for many hours, but eventually the struggling and blood-loss exhaust the whale. At this point, the men jump into the sea, clamber onto the enormous body and dispatch the whale, cutting deep into the backbone with a long knife. Such a drawn-out process can be gruesome and distressing to watch, but unlike industrial whaling, it's not a one-sided battle. At up to 20 metres (66 feet) long, the sperm whale is the largest toothed predator ever to have lived and is a powerful adversary. Getting caught in the ropes and pulled under by an escaping whale or being smashed by a thrashing tail fluke are just a couple of the potentially lethal hazards of this rudimentary form of whaling.

Once the hunt is over, oarsmen row back to the village with the carcass lashed to the boats. When the whalers reach shore, the villagers gather to butcher the whale and

LEFT *A sperm whale thrashes its tail fluke as it tries to escape the humans. The hunt takes place off the coast of the Indonesian island of Lembata in one of the last truly aboriginal whaling hunts, involving an age-old technique and an adversary which is the largest of all the toothed predators ever to have lived.*

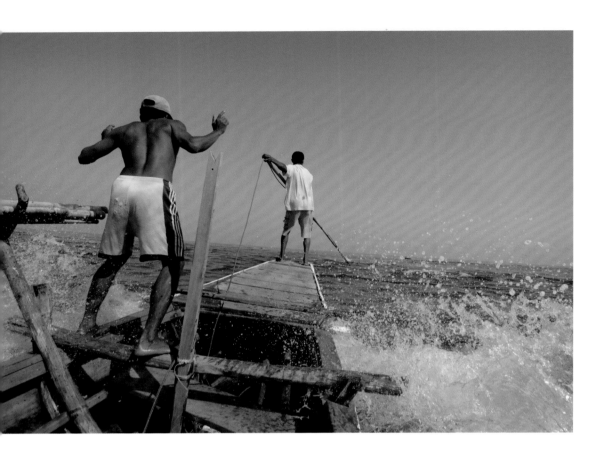

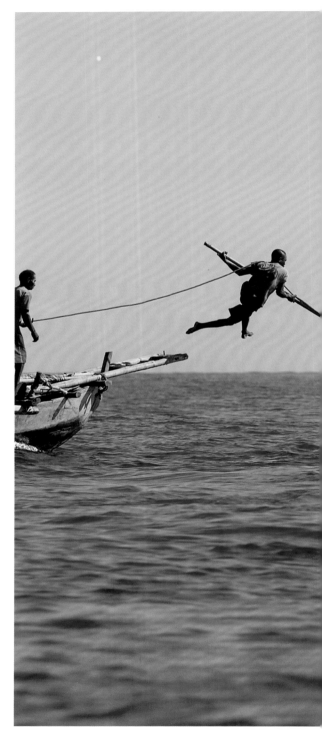

to divide it up among the families. Every last piece is used. Any excess meat is traded for other food or hung up to dry for leaner times, and the oil is used as lantern fuel. In 1973, the UN Food and Agriculture Organization sent a whaling ship and a Norwegian master whaler to help modernize the hunt. But within three years, the Lamalerans reverted to their age-old methods, realizing they had no way to repair the modern equipment and that they were catching too many whales for the hunt to be sustainable.

In some ways, the Lamalerans' whaling techniques are little changed from those documented in the very first evidence of whaling about 7000 years ago. Almost everything they use in the hunt is made by hand. The villagers still build their boats in the traditional way, entirely from wood and without nails or metal, weaving their sails from palm leaves and making ropes from plant fibre. The development of boat-building skills such as these was a pivotal turning point, allowing humans to travel further into the open ocean. This not only gave us greater scope to pursue our dietary demands, but also opened up new opportunities to colonize and trade around the world.

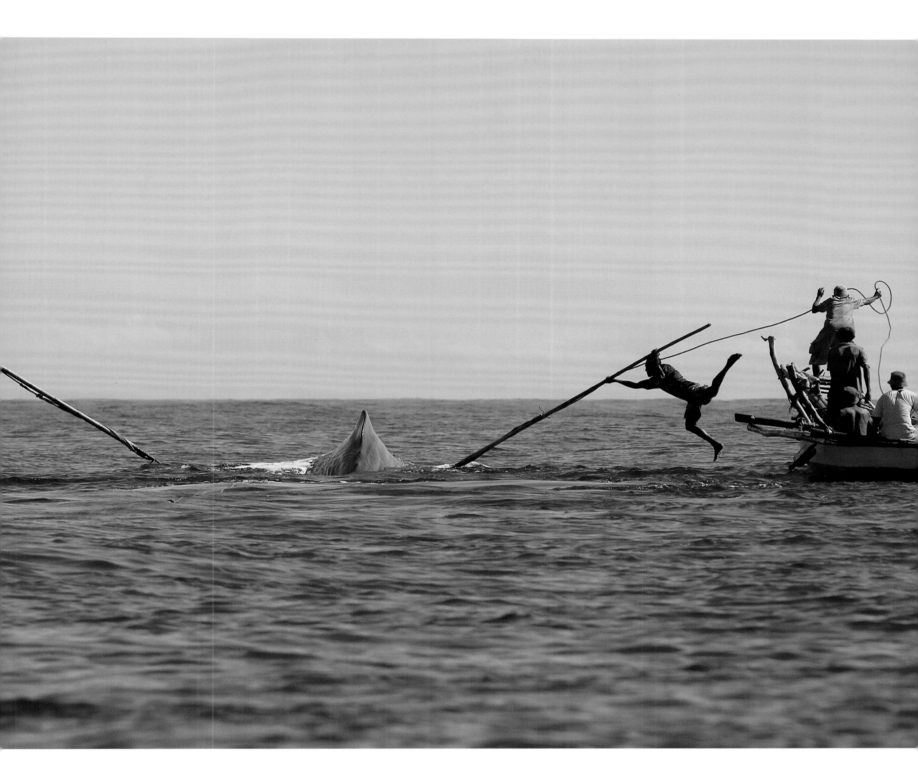

ABOVE *Two whalers simultaneously launch themselves from their boats' prows to thrust their bamboo harpoons deep into the back of the surfacing sperm whale. The harpoon ropes attach the whale to the boats, so that it must drag them with it.* OPPOSITE *Preparing to throw the harpoon from the precarious perch.*

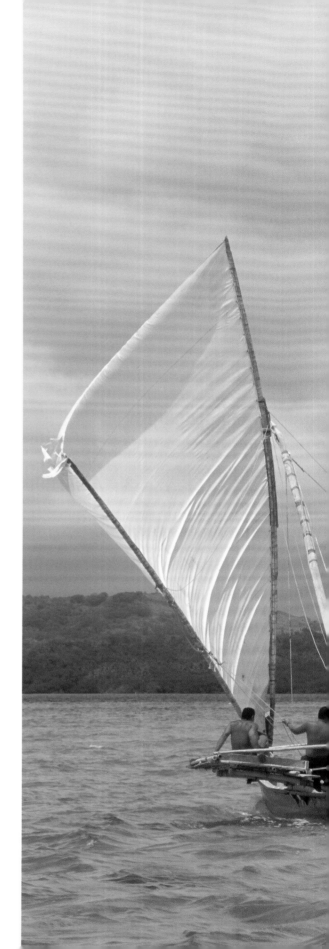

OCEAN NAVIGATORS

Since these times, the sea became an increasingly significant communication highway. Before the advent of aviation and electronic technology, oceanic travel was the only way distant countries could interact. Even today, the most economical way of transporting goods is still to ship them along ocean highways, though in vast container vessels. Almost all commercial vessels are now motorized and therefore faster and free from dependence on favourable winds, but a few sail-driven ones remain.

On the west coast of Madagascar, traders still rely on large sailing boats to transport salt and other goods. The small town of Belo Su Mer is the centre of an artisan boat-building industry, where schooners are crafted to a blueprint closely resembling that of the classic eighteenth-century pirate ship. These elegant schooners travel the last leg of what was once one of the world's busiest trade routes, along which vanilla and other produce from the spice islands of the Indian Ocean were exported.

But much earlier than the age of sail, long before the birth of Christ, people were already crossing the Pacific – the greatest ocean of all and one of the last regions to be colonized by humans. Polynesians began exploring the Pacific about 5000 years ago, and by about 1000 years ago, they had reached many of the most isolated islands on Earth. Hawaii is 3700km (2300 miles) from the nearest continent, and Easter Island is nearly 2090km (1300 miles) from the nearest inhabited island. Exactly how Polynesians managed to reach these remote new lands is a testament to the irrepressible human drive to push boundaries and explore.

The Polynesians were master seafarers who pioneered the world's first ocean-going technology. In their simple yet surprisingly seaworthy outrigger sailing canoes, they were able to negotiate vast distances with only the most meagre rations of food and water. But their most astonishing achievement was the development of incredible navigational skills, deciphering natural signs to calculate their position and where they were heading. The dangers were considerable, and for all those who survived these voyages into the unknown, there must have been countless others who perished along the way.

With the invention of compasses, charts and now GPS, the skills of the Pacific navigators have become largely redundant, but on one or two islands, the local people are determined to make sure they survive. Yap is a small atoll nation in the western Pacific region of Micronesia. Once, it was one of the most powerful of Pacific civilizations, partly because of its seafaring reputation, and sailing has been engrained in Yapese culture for millennia. But in more recent times, most islanders have lost interest in

RIGHT *Polynesian seafarers from Yap, in the western Pacific, using a traditional outrigger sailing canoe. The hull is hewn from a tree, and twine rather than nails is used so the boat flexes with the waves. It's designed to travel both backwards and forwards, the weight of the float balancing out any tendency of the boat to heel.*

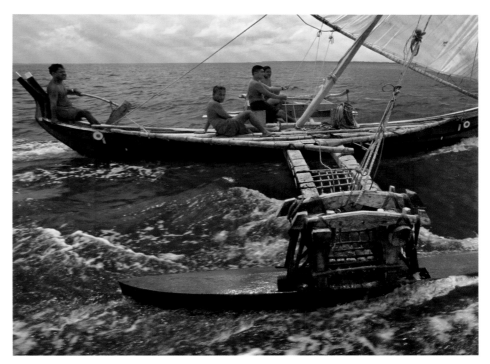

traditional navigational skills. In a bid to ensure the remarkable wayfaring expertise of their ancestors isn't lost for good, the island has re-established its navigation school.

Nothing is written down; everything is passed on through the teachings of the master navigator, so that when apprentice sailors are at sea, they will have only what is in their heads to guide them. His pupils have to learn to determine their direction and find their destination by the motion of sun and the stars, the patterns of waves and weather, and the movements of fish and birds. They have to memorize a map of how various islands are positioned in relation to each other and to acquire the mysterious skill of using their bodies to interpret the motion of the ocean into positional information.

The school regularly puts its pupils' progress to the test by embarking on sailing trips to neighbouring islands, sometimes over many hundreds of kilometres. These journeys not only challenge the novices' navigational skills but also everything else they've learned, such as how to maintain and sail their traditional sailing canoes, how to survive with few rations and little fresh water, and how to cope in stormy conditions. Incredibly, when the sea becomes too rough and their boat is likely to be smashed apart, the sailors are taught to intentionally capsize and ride out the storm in the water before refloating their vessel and continuing their voyage once the worst of the weather has passed.

ABOVE *Navigating at sea using nothing but the sun, stars and nature's signals – and a mental map of the region. In a storm, the boat can be capsized and turned into a raft. It was in boats like these that the Polynesian ancestors of the Yap islanders sailed huge distances to colonize distant islands, including Hawaii.*

RESPECTED HUNTERS

The adventures of the Yapese navigators provide a fascinating insight into the skills needed to colonize the Pacific. But getting there was by no means the only achievement of the first navigators; adapting to survive on small, isolated islands was just as great a challenge. The only cultures that flourished were the ones that found a way to make the most economical use of limited resources such as fresh water, trees and fertile land. Even today, the endless uses Pacific islanders have found for the humble yet ubiquitous coconut palm is a classic example of this resourcefulness. The wood is used in building work from houses to boats, the fibres are used to make clothing and twines, the fronds are woven to make mats and screens, and the nuts provide food and drink.

With such limited options on land, Pacific islanders have learned to depend on the ocean that surrounds their world, and many of the most remarkable examples of human adaptation to the ocean can be found among these isolated cultures. They utilize their surrounding waters much as agriculturalists work their land, understanding which areas can provide which resources and the importance of leaving areas to regenerate once they have been overexploited. And when disaster or famine has struck, they have relied on their navigational skills to trade with or evacuate to other islands.

The legacy of living this intimately with the sea is expressed in all aspects of Pacific life. When a culture's existence depends on the ocean to such an extent, it is inevitable that it becomes an inextricable part of the customs and beliefs. Sea creatures play an important role in the animist religions of the islanders, with the most impressive animals – in particular, sharks – commanding the most respect.

On the Papua New Guinea island of New Ireland, the villagers of Tembin and Kontu are famous for their relationship with the sharks that patrol their waters. They see them both as formidable predators worthy of worship but also as a reliable source of food. As a result, they believe that catching a shark requires a combination of great hunting prowess and good relations with the shark spirits. For these people, hunting sharks is not so much a case of chasing them down as calling them in.

Before Blais Soka sets out to sea in his outrigger canoe, he has to observe a ritual practice to ensure a successful hunt. He doesn't eat for a day, sleeps on the beach and abstains from sex. He prays and chants to both his ancestors and his gods. Only when all these trials have been completed is he ready to take to the sea. As the caller launches his canoe, he throws four or five rocks into the water to wake the shark spirit. Then once he has paddled out to one of his sacred shark-hunting sites, the ceremony continues.

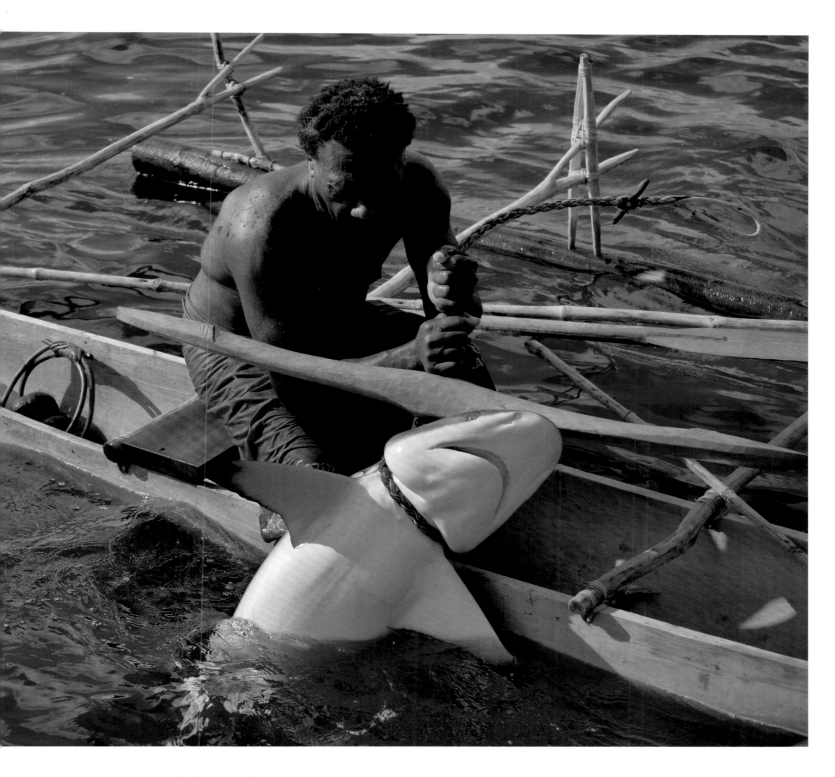

ABOVE *Blais, one of the last shark-callers, from the island of New Ireland, Papua New Guinea, catching a shark with a lasso after calling it in with his rattle. The practice was once common, but changing culture and the extermination of sharks by commercial fishing fleets mean that it is on the verge of disappearing.*

The shark-caller talks, chants and sings to the shark, trying to entice it closer towards him. He believes that the shark has to allow itself to be caught and will only do so if the spirits have been correctly appeased.

Though much of what the shark-caller does seems to be based in superstition, there is some real knowledge behind his actions. He uses a coconut rattle that he vigorously shakes in the sea. It's very likely that this action mimics the behaviour of fish feeding on a bait ball, which may well attract a shark to investigate. If and when the caller spots a fin circling nearby, he will try to tempt the shark closer still with fish bait tied to a stick.

It's a long, drawn-out process of patience, and it is often unsuccessful. Sharks are intelligent and surprisingly skittish creatures. They may swim up close but then suddenly swim away when something makes them nervous. Or they may not come at all. But just occasionally, a shark can be slowly lured in to swim right alongside the canoe, near enough for the caller to slip a coir noose attached to a propeller-shaped piece of wood over its head and to pull it tight.

The rest of the event is somewhat less ceremonious. The shark vigorously struggles as it tries to swim away, the caller lets it go, but the buoyant wooden paddle, now attached to its back, prevents it from diving. Eventually, when the thrashing shark begins to tire, the caller hauls it into his small canoe and dispatches it with a wooden club. He strikes the shark on its eyes first, as the belief is that blinding it will prevent it from biting back, and then he kills it by hitting it on the head.

If he has been successful, the shark-caller blows on a conch shell to tell the rest of the village that the shark has allowed itself to be captured. This sound is invariably met with great rejoicing, as it not only means welcome sustenance for the villagers but also reassures them that, for the time being, the spirits of the sea have been appeased.

Like so much of traditional Pacific culture that remained intact until remarkably recently, the practice of shark-calling is now rapidly dying out. This is partly because of a lack of interest from the younger generation – who fail to see the relevance of acquiring this difficult skill – but, more concerning, as a direct result of the dramatic fall in shark populations due to the lucrative but highly destructive shark-fin-soup industry.

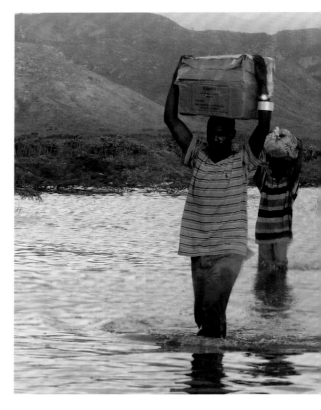

Though influences from the modern world have now reached all isolated Pacific people, most still maintain a profound respect and reverence for the sea. They know that the bountiful waters on which they depend also have the formidable power to take life away, that even the most tranquil of seas can turn into a tempestuous and highly destructive force.

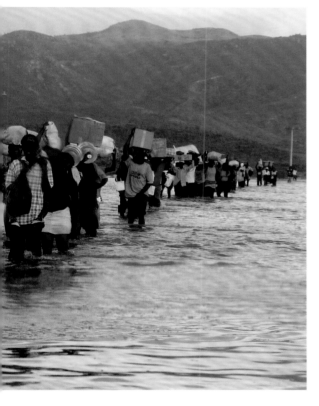

WEATHERING STORMS

Storms pose one of the greatest threats to people who live by the coast, with communities in the tropics enduring the most powerful ones. Cyclones, hurricanes or typhoons (the name depending on the ocean region) form when warm tropical waters fuel the intensity of humid storms brewing out over the ocean. As a storm cell intensifies, it begins to rotate, forming a clockwise spiral that causes winds of up to 322kph (200mph). It whips up giant waves that batter the shore, tear buildings apart and flatten trees. Debris becomes airborne missiles. Torrential rains cause severe flooding and landslides.

The death toll from these tropical storms can be huge, and the aftermath has long-lasting effects: floods damage any buildings left standing, crops are ruined, freshwater supplies become contaminated by sea water, and entire communities are left on their knees. As the world warms, cyclonic storms are predicted to become more frequent and more violent.

Known as Hurricane Alley, the Caribbean is battered from June to October. It's on the poorest islands such as Haiti that people suffer the most. Haiti's rickety shanty towns, along with the many badly designed urban developments to be found in other parts of the Caribbean, are seldom able to withstand a hurricane. Worse still, almost 100 per cent deforestation means that, when torrential rains fall, excessive run-off spills down from the hills and floods the overpopulated lowlands. And as the devastation caused by Katrina in New Orleans showed, hurricanes can wreak havoc in even the wealthiest countries. Yet there are some coastal communities that are far better prepared. When it comes to dealing with hurricanes, experience can triumph over wealth.

Dealing with cyclones has shaped Pacific cultures. For millennia, Polynesians have survived these storms with nothing but experience to protect them. On the isolated island of Anuta in the South Pacific, it's essential that the islanders are self-sufficient. When a severe typhoon hits, they must weather it on their own. By digging simple houses low into the ground and making certain that there is a through-draught, the Anutans' settlements remain standing in even the strongest winds. To ensure they'll have enough rations should their crops and the reefs be destroyed, the islanders stockpile food. Cooked manioc and taro are wrapped in banana leaves and then buried around the island. When disaster strikes, the food is shared around the community. In 2003, when Cyclone Zoë's 285kph (177mph) winds wreaked havoc in Anuta and ruined most of the crops, the buried food kept the population alive until the relief boats arrived.

LEFT, TOP *A hurricane approaching Florida's Gulf coast.* LEFT, ABOVE *Hurricane victims, Haiti, in 2004. More than a thousand people died in the subsequent floods. While many Caribbean islanders have learnt how to cope with regular hurricanes, the inhabitants of shanty towns always suffer huge losses.*

THE ART OF SURFING

Developing the skills to master the powerful sea has been essential to the survival of Pacific peoples, and on many islands, proving your oceanic prowess has become a central part of the culture. Perhaps the most compelling example of this is surfing. Surfing originally evolved among the tribes of Hawaii, but its origins are believed to go back thousands of years. To the Hawaiians, it was far more than a sport. Surfing was an art of the highest form, intertwined with religion. Men would demonstrate their ability to tame the sea by riding waves on carved wooden boards called *Papa he'e nalu*. Those who could ride the biggest breakers with the most flair were worthy of the most respect and prestige. Often the chief was the best surfer, with access to the top surfing beaches and the strongest trees from which to make his boards.

From these tribal origins, the sport has spread to become a worldwide cult, and though much has changed, its ethos remains. For many people, surfing is a way of life rather than just a sport, and champions are still given almost god-like status among the initiates of the worldwide surfing community. The quest to ride ever more challenging waves has pushed the sport to unbelievable extremes.

Big-wave surfers search the globe for the mightiest swells and will fly from all over the world to congregate at a particular location. The very biggest waves travel too fast to catch by paddling, but by using jet skis, tow-in surfers are able to pick up enough speed to keep up with the rapidly moving mountains of water. Often the largest swells result from cyclone activity out at sea and can produce breakers more than 24 metres (80 feet) high. Riding such monsters requires immense skill and intense training. An extreme surfer not only needs the expertise to negotiate colossal waves but must also be able to survive being pounded by the water and held up to 15 metres (50 feet) under water for minutes. To prepare for wipe-outs, big-wave surfers spend much time developing their lung capacity by weighing themselves down and running under water. Yet no matter how prepared an extreme surfer may be, the unpredictable nature of the waves makes this a hazardous sport. A number of big-wave surfers have died in pursuit of the ride of their lives, usually from being smashed into a reef or the seafloor or drowning as a result of being held under water by consecutive breaking waves.

Just as the ancient Polynesians intended, there can be few more visceral and spectacular demonstrations of how human endeavour can literally conquer the waves. And fittingly, though a number of places around the world have become renowned for their enormous swells, Hawaii – the spiritual home of the sport – remains the Mecca for big-wave surfing.

RIGHT *Big-wave surfing superstar Laird Hamilton drops into an enormous breaker at Peahi (Jaws) on the Hawaiian island of Maui. Hawaii is where the art of surfing was perfected and has been the location of some of the most impressive waves ever ridden, including a monster estimated at 25 metres (80 feet).*

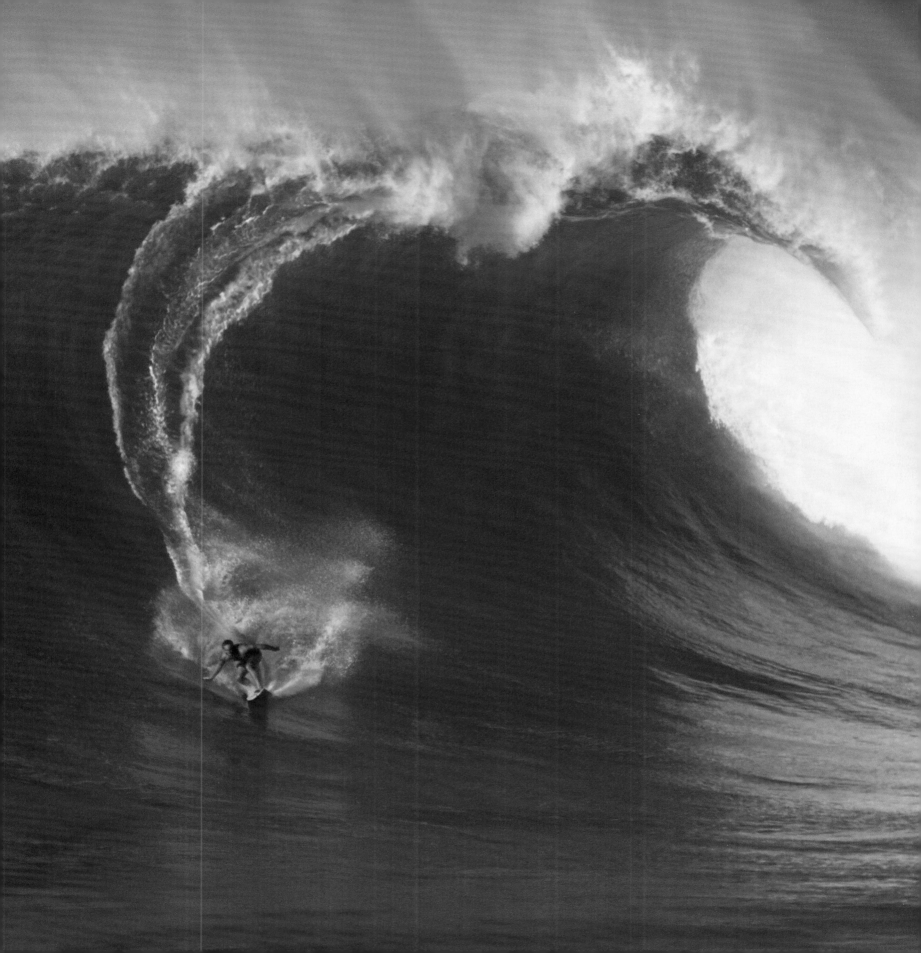

THE LIFE OF A SEA GYPSY

From navigation to surfing, the marine mastery of the Pacific-island cultures is unparalleled, but there are others who live still more intimately with the ocean. From the Moken people of Burma to the Orang Laut of Singapore and Sumatra, throughout Southeast Asia there are communities of ocean-dwelling people who have become collectively known as sea gypsies. It is thought many of these cultures originated when dominant clans forced communities to flee to the sea – the last place most people would choose to live.

There probably never have been any other cultures that spend so much time on the waves. In the most extreme cases, sea-gypsy people visit the land only to collect water and firewood, trade their ocean produce for rice, build boats and bury their dead. They are so accustomed to living with the rocking of the ocean that they claim to feel 'landsick' when they have to go ashore, and they try to keep any visits as brief as possible.

The children are born on their boats and grow up with the sea as their playground. Sea-gypsy children adapt to this aquatic existence in extraordinary ways. They can become extremely proficient at finding food beneath the waves, and studies have shown that their eye muscles even strengthen to allow improved focus under water.

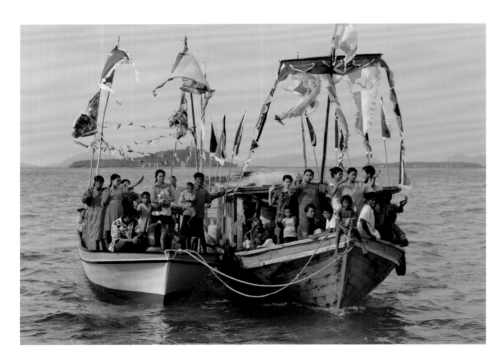

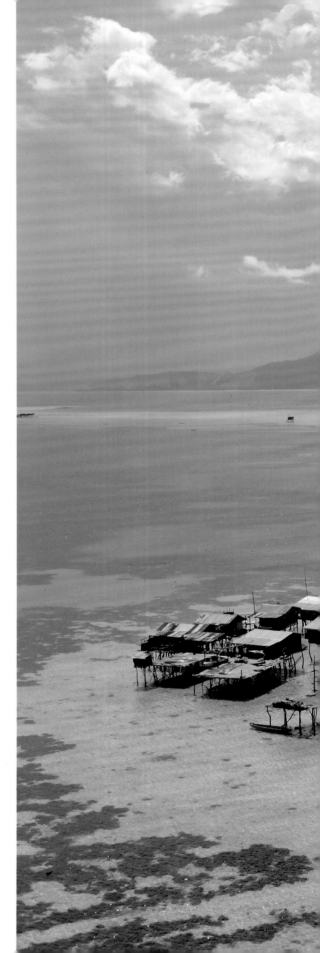

ABOVE *A Bajau Laut 'sea-gypsy' wedding ceremony. Many Bajau live entirely on boats and have no official nationality.* RIGHT *A stilted Bajau Laut village on a reef off Borneo. Seaweed farmers as well as Bajau people make their homes in the seas around the Philippines, Borneo and Sulawesi, often far from land.*

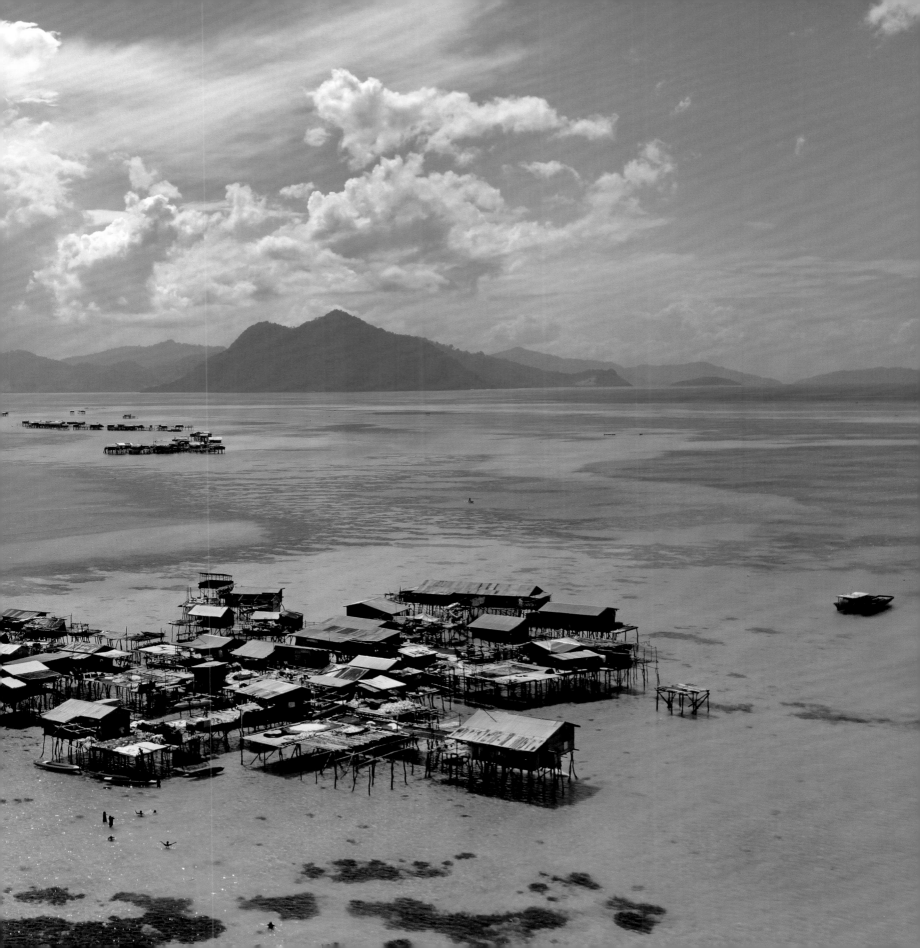

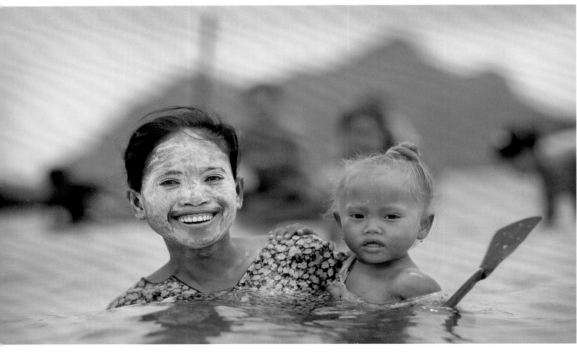

ABOVE *A Bajau Laut woman carries her child as she searches a reef at low tide, looking for shellfish and other seafood including sea anemones, sea urchins, clams and jellyfish.* TOP *A Bajau Laut woman looks out from her stilted hut. Her traditional face mask, made from seaweed, protects her skin from the sun.*

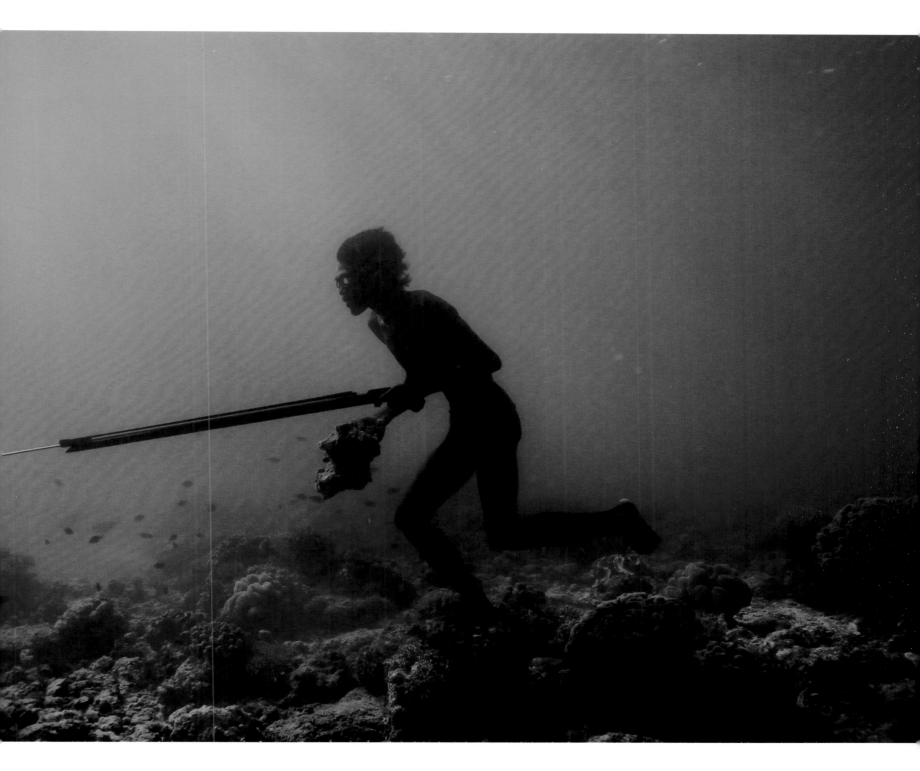

ABOVE *Sulbin, a Bajau Laut spear-fisherman, hunting for reef fish off the coast of Sabah, Malaysia. Sulbin doesn't wear shoes and so his feet are tough enough not to be cut by the sharp coral. He carries a lump of coral to counteract the buoyancy of the air in his lungs and can remain under water for several minutes.*

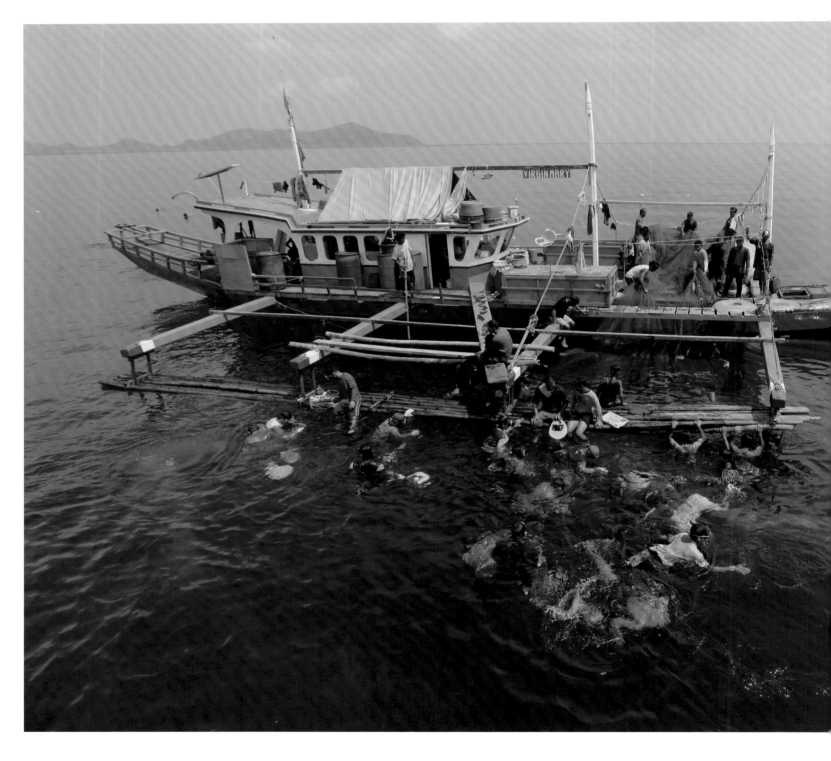

ABOVE *Divers off Palawan in the Philippine Archipelago hauling in a catch. The basic muro-ami fishing technique uses free-divers. Previously the nets would have been set at shallow depths, but as accessible reefs have been fished out, the divers have been using air tubes to catch the reef fish at depth.*

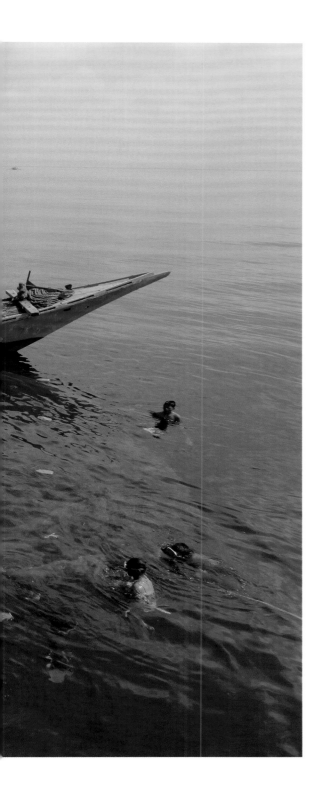

The Bajau Laut people of the Sulu Archipelago are by far the largest group of sea gypsies. Though most of the Bajau have now settled on land, many continue to live in stilted villages out on coral reefs, sometimes miles from the nearest island and in some cases on houseboats. The Bajau live according to the rhythm of the sea and rely on tides and moon phases rather than dates and hours to measure the passage of time. They have a prodigious knowledge of how, where and when to harvest different sea creatures. Today, the Bajau are increasingly using monofilament nets to catch their fish, but traditionally they were more ocean hunters than fishermen, experts at trapping and spearing fish, octopuses, dolphins and turtles, and collecting clams and sea cucumbers – a hugely proficient underwater hunter-gatherer culture.

Though renowned for their free-diving abilities, fewer and fewer Bajau now use this technique to collect food. Nonetheless, one or two skilled divers can usually be found in the more traditional Bajau communities. Without enough money to buy proper equipment, they fashion simple goggles by fitting clear pieces of plastic into carved wooden frames and make spear-guns from sharpened metal rods and the rubber from bicycle inner-tubes. Though a Bajau free-diver may not have the most up-to-date gear, and though he will invariably smoke copious numbers of cigarettes each day, he can dive to about 30 metres (98 feet) on a single breath and hunt under water for up to five minutes.

The Bajau Laut live in a triangular area of ocean formed by the islands running between Sulawesi, Borneo and the Philippines. Most have Filipino origins, and it's in the Philippines where these traditional diving skills have been used to develop a very effective but controversial fishing technique. The muro-ami technique was devised to harvest reef fish. It involves many free-divers working together to set up a huge purse-shaped net. Swimming down to hook the bottom of the net onto coral and rocks and then floating the top using air-filled plastic bottles, the divers create a vast trap suspended in mid-water.

More divers then jump from the boat to form a huge circle on the water's surface and, using rocks attached to long strings covered in plastic streamers, bang the bottom of the reef. The sound of the rocks hitting the coral and the sight of the curtain of streamers causes the fish and other reef creatures to flee. As the circle of swimmers closes in, the animals are corralled towards the gaping mouth of the net. At this moment, the divers swim down to pull it shut around the mass of fish and then slowly raise the huge bag up to the waiting boat.

With as many as 500 people working together, muro-ami fishing can be very productive. One sweep of a reef can reap tonnes of fish. Like an underwater ballet, the choreography of the divers creates a spectacle. But there are dangers: free-divers become

entangled in nets and drown, and most suffer partial hearing loss from frequently free-diving to such depths. Muro-ami is also very destructive. It can leave the reefs devoid of fish life, and the rock-banging also destroys slow-growing corals. But it was the accusations of exploitative child labour that finally led it to being banned in the late 1980s.

Some muro-ami boats nevertheless continue to operate around the islands of Cebu and Palawan. Other, similar fishing methods are also taking its place, such as Paaling, where divers receive air from long tubes connected to a compressor on a boat, allowing them to set their nets even deeper and stay down longer. But it doesn't make the practice safer. Compressor tubes can be dislodged, tangled or damaged, suddenly cutting off their air supply. More serious, as divers don't understand how to dive safely, they frequently surface too quickly, resulting in decompression sickness. Minor bends are so common that they are shrugged off, but all too often severe cases result in disability or death.

Though such fishing techniques have undoubtedly played their part in the plundering of the Philippines' once extremely rich reef systems, they remain a demonstration of the depths to which humans have conquered the marine realm. Even without modern equipment, we have an extraordinary ability to train our bodies and adapt our behaviour to live in an environment that we weren't designed to enter. Now, with ever-increasing technological innovation, our accomplishment in the ocean is even more impressive.

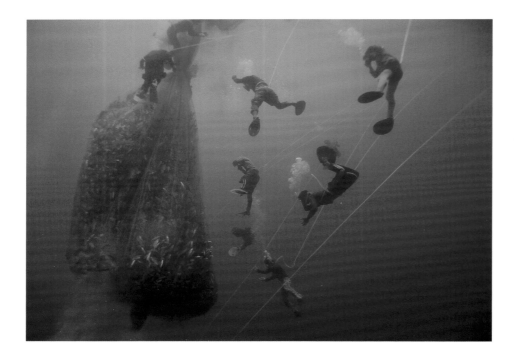

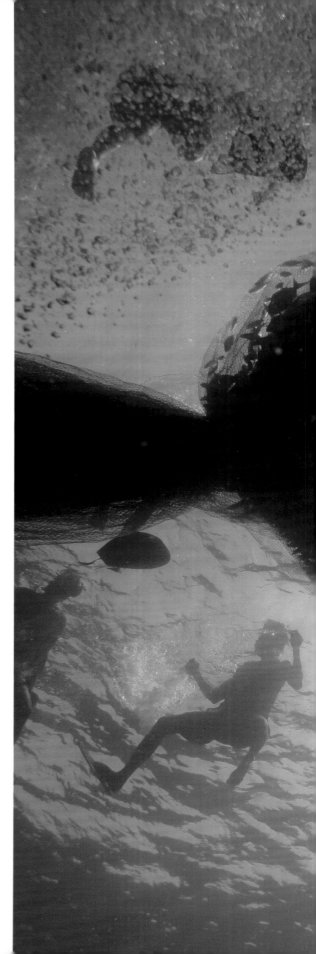

ABOVE AND RIGHT *Hauling up the fish. Catching them involves walking in a line on the reef and herding the fish into the open net using 'scare lines' – two ropes festooned with white ribbons. The technique is an old one, though now the divers have to work ever deeper, they take breaths using basic air pipes.*

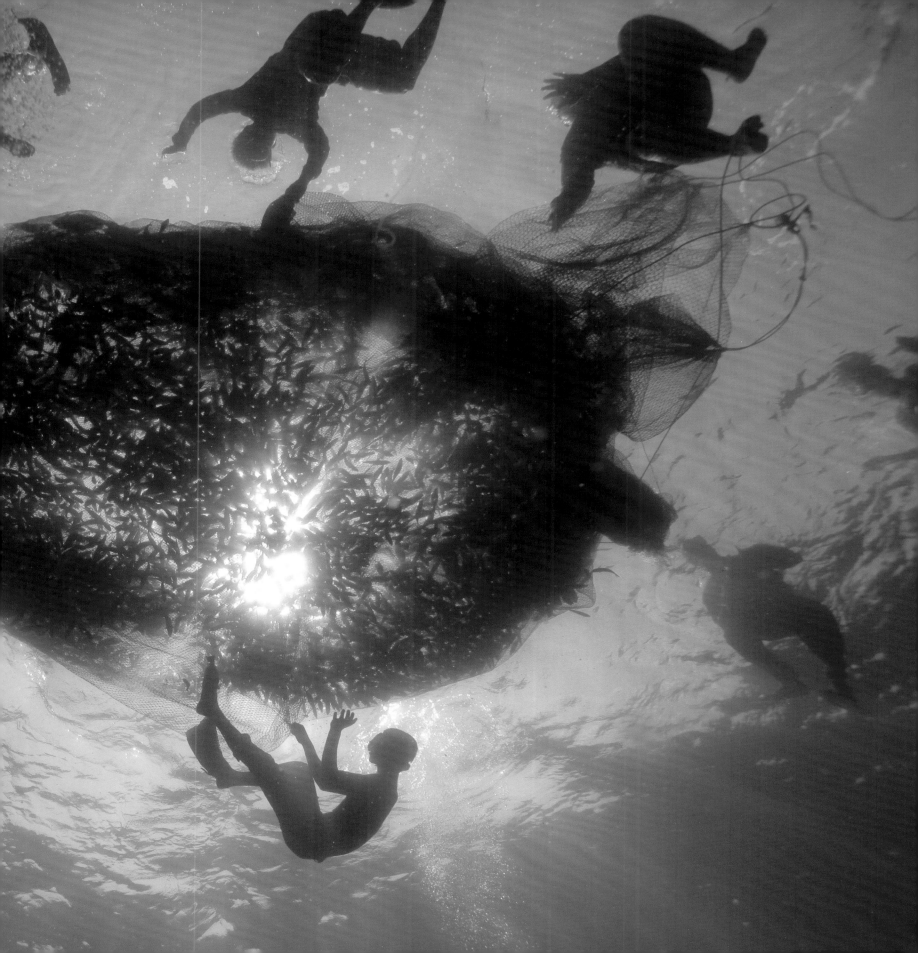

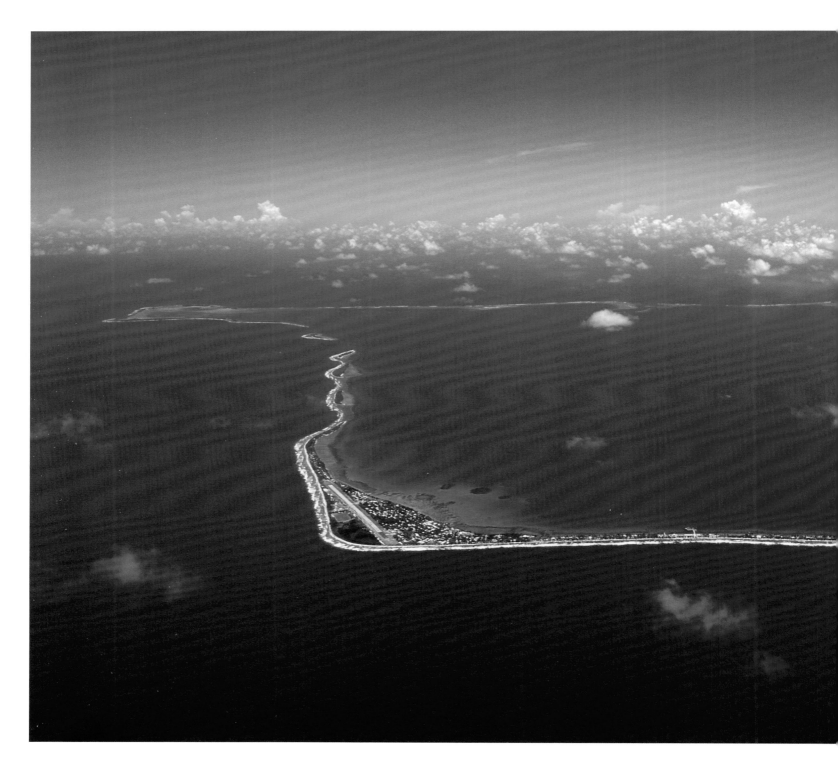

ABOVE *The Pacific island of Funafuti – the rim of an ancient volcano and part of the nation of Tuvalu.*
As the second-lowest nation after the Maldives, no more than 4.5 metres (15 feet) above sea level, Tuvalu is
likely to be engulfed by rising seas – possibly the first nation to disappear as a result of global warming.

THE OCEAN UPRISING

We know how to gather vast amounts of creatures from the sea, we farm seafood and cultivate algae in it, we build homes on the oceans, and we can even explore its abyssal depths. But we may have become too effective at exploiting the ocean. What goes on unseen under the waves has been ignored and unregulated. Overfishing and pollution are already thought to be causing mass extinction in the seas, and only recently have we come to appreciate that the health of the oceans is as critical as that of the atmosphere.

Humans may have become extremely successful at exploiting the marine realm, but the sea will always be the more powerful force. The tsunami of 26 December 2004 was a stark reminder. In a single moment, vast areas of coastline throughout the Indian Ocean were ripped apart by tidal waves of up to 330 metres (100 feet), and more than 200,000 people lost their lives. Yet the greatest threat the sea poses to humanity is a far more insidious problem of our own making. Accelerated global warming is causing sea levels to rise faster than ever before, and already the effects are being felt worldwide.

It's the most industrial, carbon-hungry populations of the world that are primarily responsible for global warming, but often the people who have lived most intimately and harmoniously with the sea are the ones who are most affected. Islands such as Tuvalu in the South Pacific and the Carteret Islands off Papua New Guinea are likely to be some of the first to disappear. The highest point of the tiny nation of Tuvalu – comprising a long, thin, crescent-shaped slither of eight low-lying islands in the vast Pacific – is just 4.5 metres (15 feet) above sea level. On peak tides, the land is flooded by seawater that soaks up through the porous coral rock, and each year the flood levels get a little higher. Many Tuvaluans have already been forced to evacuate, and it is estimated that in as little as 50 years, the entire nation will be rendered uninhabitable.

Soon rising seas will affect a far greater proportion of humanity. Venice, which was built almost in the sea, has always been a symbol of civilization's dominance over the environment. But that dominance has depended on sea levels remaining the same, and recently the city has suffered more frequent severe floods. From New Orleans to London, Belize to Bangladesh, sea-level rise will become a persistent problem for much of the world's population. But since humans have existed, we've had to adapt to changes in the environment, and we should ultimately be able to adapt to a planet with less land and more ocean. Before we're forced to do that, though, we need to take responsibility for the ocean's health. Otherwise, we'll not only be flooded, but flooded by waters that are polluted and depleted of life. And that could require an adaptation too far.

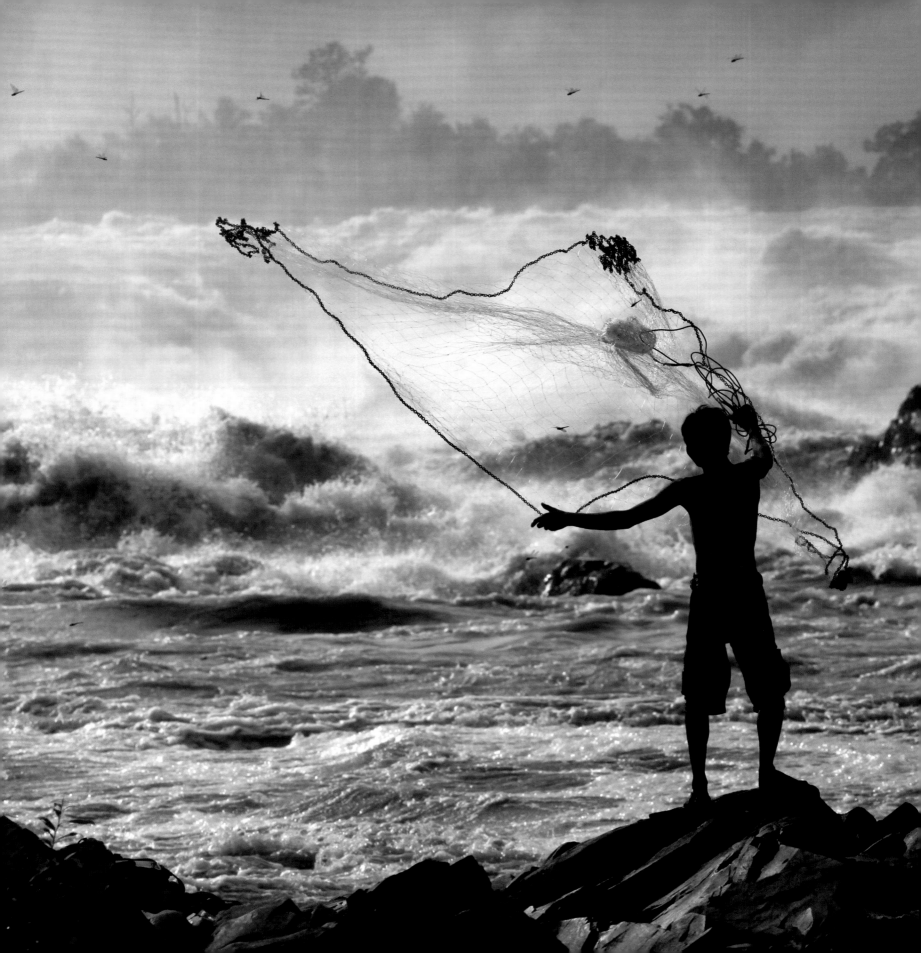

RIVERS

3

RIVERS HAVE PERSONALITIES. THEY DIFFER WITH EVERY COMBINATION OF WATERFALL, OXBOW OR BRAIDED DELTA. THEIR MOODS ARE FICKLE, RANGING FROM SERENE AND BENIGN TO ABSOLUTLY DESTRUCTIVE, CHANGING COURSE ON A WHIM AND ALWAYS SEEKING OUT NEW ROUTES. LIKE HUMANS, THEY POSSESS THE POWER TO SHAPE THE FACE OF THE PLANET – CARVING OUT CHASMS, WASHING AWAY EVERYTHING IN THEIR PATH AND LEAVING HIGHWAYS OF SAND WHEN THEY DISAPPEAR. THEY GIVE LIFE TO EVERYTHING ON THEIR BANKS AND CAN WIPE IT AWAY AT A MOMENT'S NOTICE. LIKE A HUMAN LIFETIME, A RIVER STARTS OUT SMALL – AS A DRIPPING SPRING IN MOUNTAINS OR A SIMPLE GROTTO – GAINS STRENGTH BY JOINING OTHER RIVERS AND WINDING THROUGH THE LAND, AND EXPIRES IN A LABYRINTH OF TENDRILS.

Rivers have always been at the heart of human civilizations. Since the beginnings of recorded human history on the banks of the Tigris and Euphrates, rivers have given us what we need to spread out and multiply around the world.

Fresh water is the cornerstone of our existence – without it we perish in days. The bounty of rivers feeds us with fish and other aquatic animals. Land animals congregate beside rivers to drink, providing us with easy prey. Harnessing the power of rivers has given us the ability to raise domesticated livestock, irrigate farmland and build dams for electricity. Rivers, in short, are human lifelines. But they're all as different from each other as the terrains they flow through and the communities they support. Intertwined and inextricably linked to the waters that they depend on, the people and their river environment have always had a turbulent relationship. While people are at once trying to tame a river and benefit from it, at the same time they are wholly reliant on the river's mood. In fact, change is the only consistent characteristic of rivers.

ABOVE *Children and their parents from the Ladakh village of Zangla making the 100km (62-mile) journey to school along the frozen Zanskar River. In winter, it's the only way out of their valley.*
PREVIOUS PAGE *Casting a net into the Mekong River. It provides life's necessities – food and fresh water.*

THE FISH CORNUCOPIA

Southeast Asia's greatest liquid asset is the Mekong. The river begins its epic journey among the glaciated peaks of Tibet and flows southwards for 4800km (3000 miles) before emptying into the South China Sea. The Mekong is multinational, crossing China, bordering Burma, Thailand and Laos and winding through Cambodia and Vietnam. With a total surface area of 79,500 square kilometres (30,000 square miles), the river's basin is almost the size of France and Germany combined.

So much water flows into the mainstream Mekong from the surrounding basin that, on average, 15,000 cubic metres (530,000 cubic feet) pass by every second. In many parts of the world, that's enough to supply the needs of 100,000 people – the population of a large town – for a whole day.

This water nourishes large tracts of forest and wetlands, providing habitats for thousands of species of plants and animals. It also supports an inland fishery with an estimated value of $2 billion a year – which the fishermen of Laos depend on for both sustenance and profit. The annual harvest, including that from fish farms, is 1–2 million tonnes – about twice the catch from the North Sea. In Laos, 70 per cent of rural households rely on fish as a vital source of protein and an income supplement.

After carving deep valleys through the Yunnan highlands, the Mekong changes character, flowing smooth and wide. But in southwest Laos, at Si Phan Don (Four Thousand Islands), over a stretch of 30km (19 miles), the otherwise smooth flow is violently interrupted and divided into a network of streams, channels and rapids that rage and boil like an angry ocean, entering Cambodia with a sudden plunge at the Khone Falls. Intimidating as these waters may be, the local fishermen have found ways to tackle them and harvest the bounty of fish. In fact, the Mekong and its tributaries yield more fish and boast more large fish than any other river system.

During the monsoon season, when the river floods the plains, the habitat for fish increases enormously, and many species, catfish in particular, rely on this to help them reach their spawning grounds. The giant catfish, the world's largest freshwater fish, which can grow to nearly 3 metres long (10 feet) and weigh up to 350kg (770lb), migrates upstream to spawn around Si Phan Don.

The local Lao fishermen watch the weather carefully and adapt their fishing techniques accordingly. During the dry season, they fish from the exposed rocks using nets and small fish traps. But they also take advantage of the low water levels to prepare for the fishing event of the year, building big wooden traps in the middle of the Mekong's

RIGHT *Catching catfish by hand on a wooden fish-trap, built in the middle of a channel of the Mekong. In the monsoon season, giant catfish migrating upriver to spawn become stranded on the bamboo structure, providing both food and income for the Lao fishermen.*

RIVERS

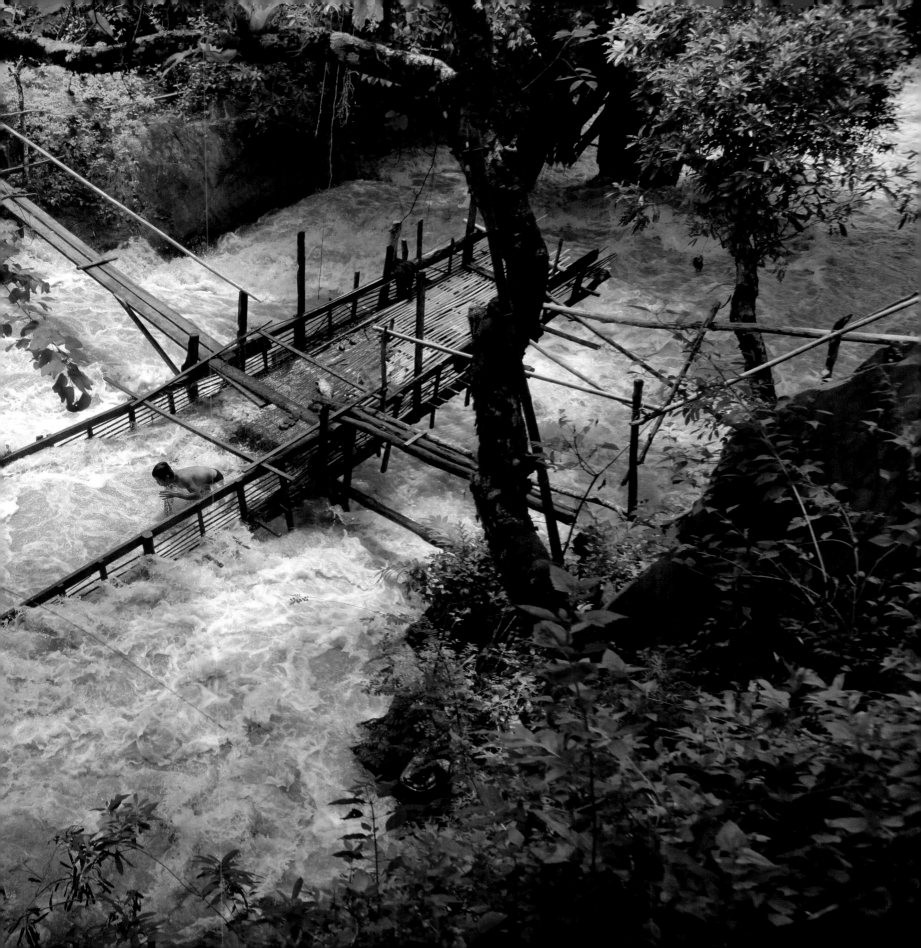

channels. With the arrival of the monsoon comes a deluge of fish. The traps are ramp-like bamboo constructions that capture the fish on the platforms but let the turbid water rush through. At peak fish-run time, massive shoals of catfish arrive, keeping the locals busy day and night. The men will even sleep out on the traps – and a year's fortune can be earned in this very short time.

The most death-defying fishing occurs at the rapids and cataracts where the fish gather. These areas are incredibly dangerous in the flood season, and access is by high wires strung precariously over the raging river and by bamboo scaffolding along the cliffs. The Lao fishermen are lithe, quick-footed and fearless, acutely aware of the river's moods. Every day they must reach the rocky embankments where they fish by crossing, hand over hand over hand, between two wires, their feet gripping the bottom wire in worn flip-flops. When they cast their nets into the angry giant, they constantly risk an overreach or a slip that could tip them into the furious waters. At the end of the day, they return on the same high-wire bridge, carrying heavy loads of fish slung over their shoulders, knowing all too well that one false move could end in death.

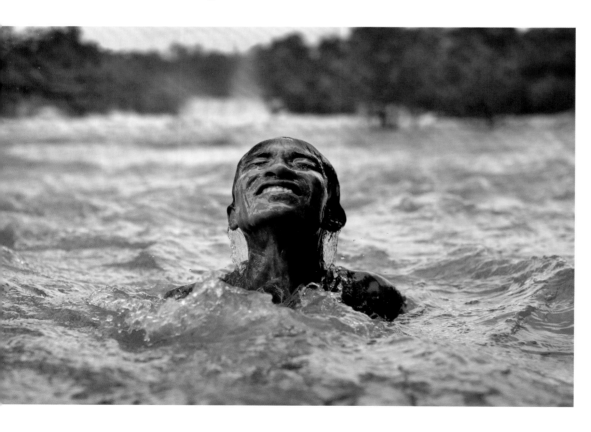

ABOVE *Lao fisherman Mr Samniang cleansing himself in the Mekong. At peak fish-migration time, he camps beside the river.* RIGHT *Mr Samniang crossing a high wire hand over fist – the only way to get to his prized fishing grounds. The river's bounty of catfish is worth the risk, enabling him to support his family.*

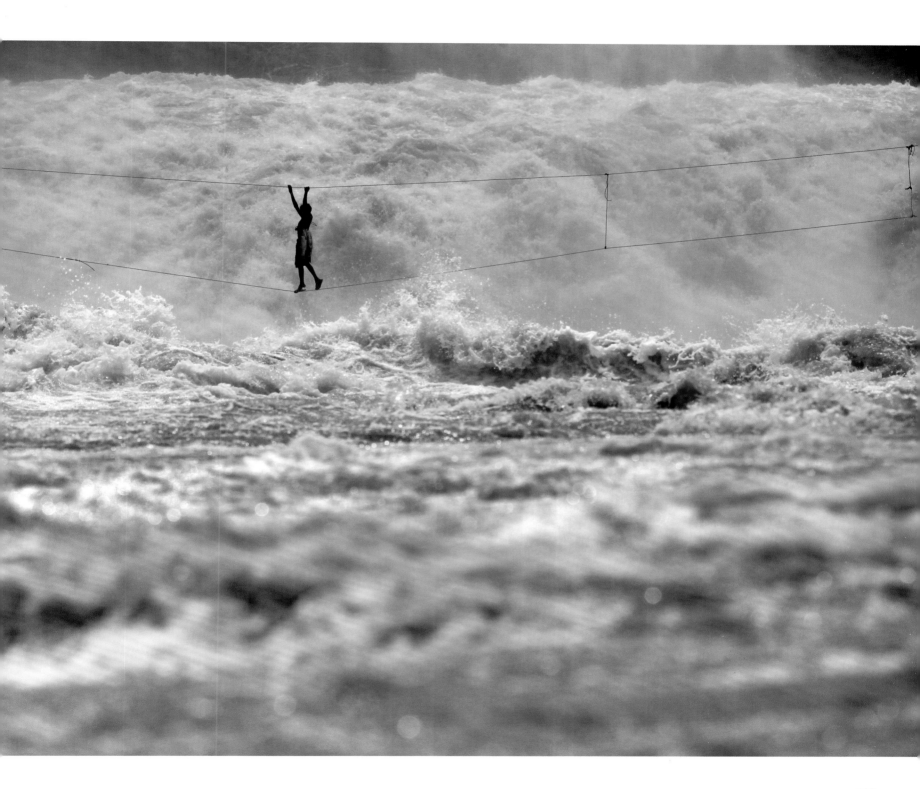

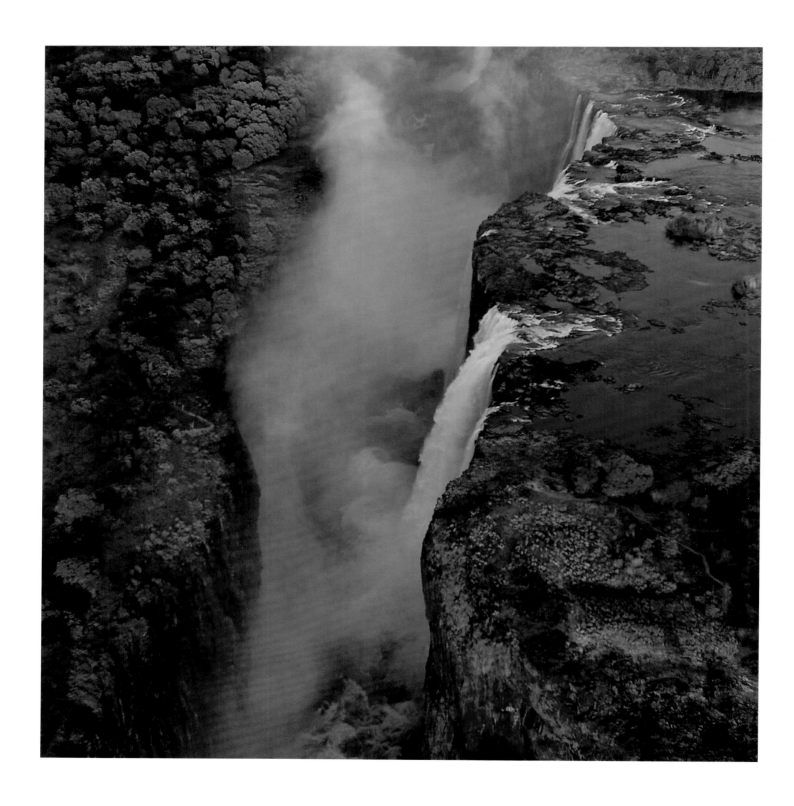

WATERFALL FISHING

One of the Earth's seven natural wonders is the largest waterfall in Africa – Victoria Falls – approximately twice as wide and deep as Niagara. The local Kalolo-Lozi people call it *Mosi-oa-Tunya* – the smoke that thunders – a reference to the curtain of mist that pulses upwards above the precipice over which the Zambezi River drops. It's the result of the incessant pounding of almost 935 cubic metres (33,000 cubic feet) per second of water onto the porous basalt outcrops. As the steady stream of vapour gets caught in the African sun, rainbows seem to leap out of the chasm.

Fully 1.3 million square kilometres (500,000 square miles) of the African continent are drained by this huge river. In the wet season, the floodwaters of the Zambezi create an impenetrable torrent pouring over the gorge. But after the rains recede and the river settles down, small islands and pools appear above the falls. Here, fishermen cast their lines for tigerfish. They wade barefoot into the water, their toes gripping the rocks, with the knowledge and experience of the river and its flow that only comes with practice. The simple implements they use are the same the world over – a line, bait and sinker. The fisherman hooks a tiny bait-fish onto a line, weighs the line down with a tied-on rock, and casts. The current carries the bait past the prey, and with a practised jerk, he hooks a fish when it bites. They are doing what people have done for millennia but in a most extraordinary location: on a precipice above a narrow cleft in the Earth's mantle, over which the massive drainage of the central African plateau plunges.

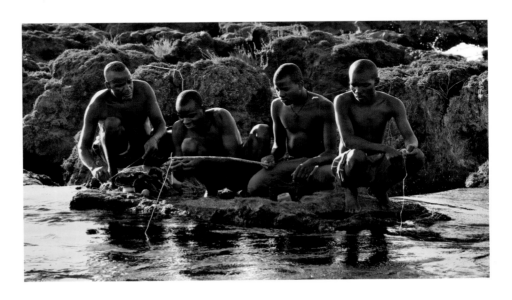

ABOVE *One of the seven natural wonders of the world – the Victoria Falls – at the end of the rainy season, when the torrent of the Zambezi River has receded.* RIGHT *Fishing for tigerfish. Braving the 108-metre (33-foot) drop, the men cross the river barefoot to fish in the pools using just simple lines and hooks.*

ELEPHANTS AS WATER DIVINERS

Just north of the equator, the Great Rift Valley opens up to reveal some of the most spectacular scenery in Kenya. Samburuland is home to tribes of strikingly adorned Samburu warriors and pastoralists – a vast patchwork of semi-arid savannah, rough highlands, dry riverbeds, forests of acacia and doom palms that cling to the riverbanks in hope of water. The area teems with wildlife, but for most of the year there is little or no rainfall. And when it comes, a whole year's worth will fall in one or two torrential downpours. Massive flash floods roar through the riverbeds, which will bake dry again within days.

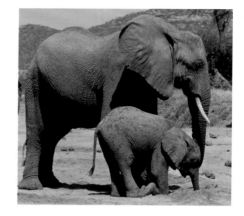

The Milgis Lugga is the largest seasonal river in Samburuland – a lifeline for stock-owners of the low-lying country of the east Kirisia Hills. For much of the year, the riverbed is a wide pan of sparkling sand. Life then is hard for both the wildlife and the Samburu, who rear cattle, sheep, goats and camels. The people have an emotional and economic commitment to their stock. The boys and women look after the smaller animals, and the herds of camels and cattle are the responsibility of the men. Camels and cattle represent a man's wealth and give him social standing, allowing him to marry and participate in ceremonies. His herd also provides his family's basic food – milk and fat, and blood taken from a cow's jugular. Livestock is rarely slaughtered, and the cows never are, since it is through them that a Samburu man can increase his social standing and wealth.

The dominant species in the area are humans and elephants, and they coexist in this barren land in a most extraordinary way. Elephants have an enormous impact on the ecosystem, clearing tracts in the thick bush and creating paths over mountain passes and across the dry riverbeds of the Milgis. These trails lead to the one precious thing that no living creature in Samburuland can do without: water. The elephants locate water by smell, and in a dry riverbed they can tell when water is close to the surface. Depending on the ferocity of the desert sun, an adult might drink 70–200 litres (15–45 gallons) a day. They reach the clean water, naturally filtered through the sand, by digging shallow holes with their legs and trunks.

In parched Samburuland, when the rivers disappear, people and wildlife share the life-giving underground resource in relative harmony. The Samburu find where the elephants have been drinking and dig their wells there. The lower the water table drops, the deeper a well must be excavated, until the elephants can no longer reach the precious resource. Knowing this, the Samburu provide water in wooden troughs for the elephants to drink – and for any animal that might need water, whether birds, bees, butterflies or baboons (it's a Samburu taboo to deny water to any living thing).

RIVERS

110

RIGHT, TOP *Elephants digging for water in a dry riverbed. They can smell where it is close to the surface.*
RIGHT, ABOVE *A Samburu woman drinking from a well dug in a spot where elephants have revealed an underground source.* OPPOSITE *Watering livestock. Once it's dark, the elephants, too, will be able to drink.*

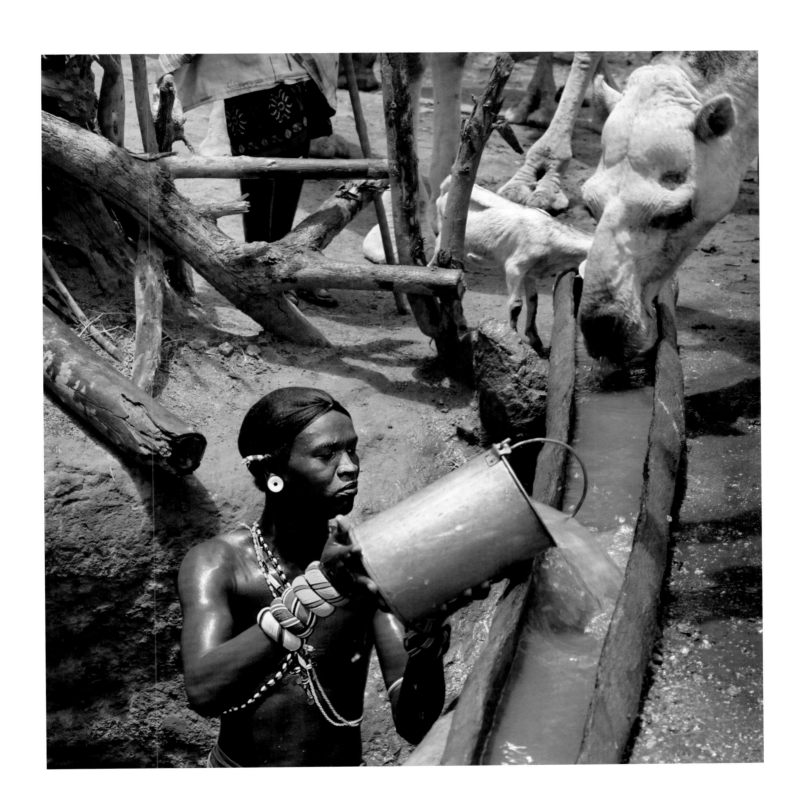

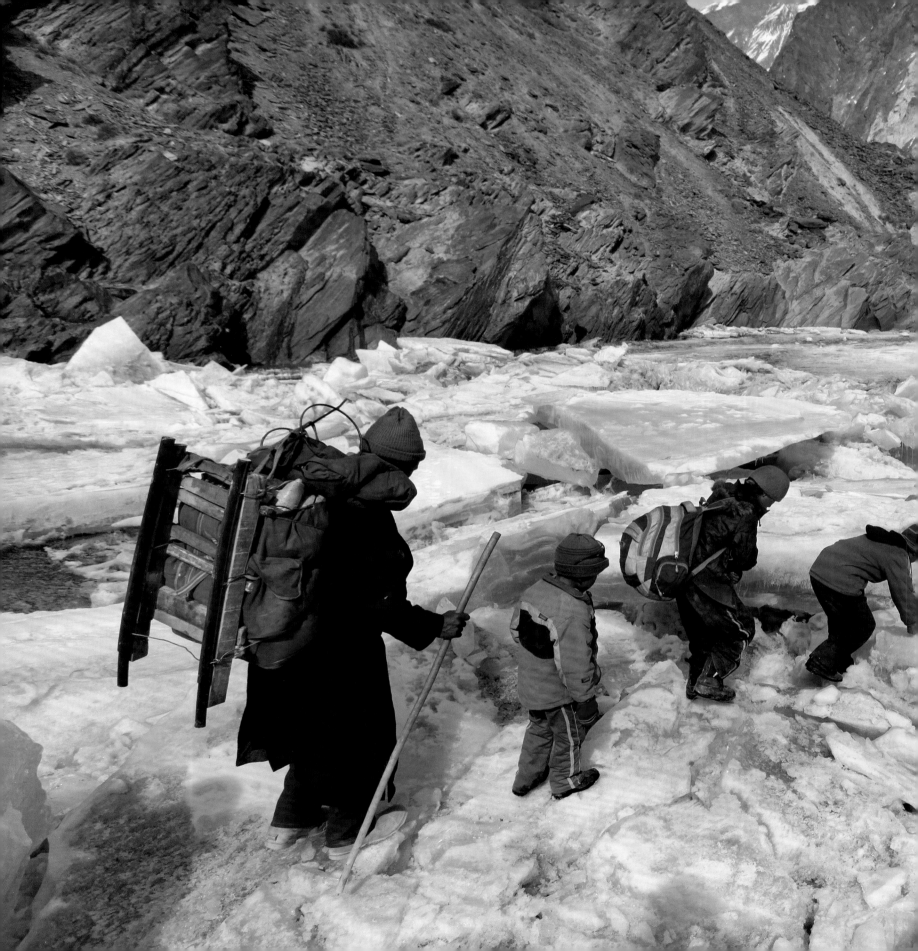

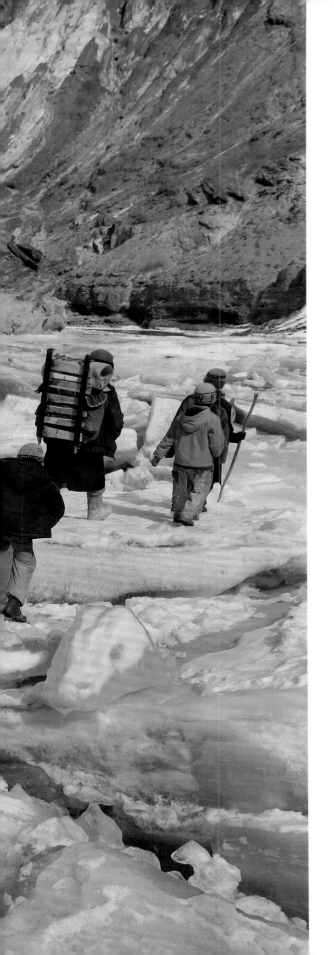

WALKING ON WATER

High in the Himalayas in Kashmir, near the border between India and Pakistan, are the outposts of a land more Tibetan Buddhist than Muslim or Hindu. The Zanskar Valley lies at 3500 metres (11,500 feet) between the towering mountains of the Ladahk range and the great Himalayas. It is home to about 10,000 people, living in scattered villages. Winter temperatures can plummet to -30°C (-22°F), making the valley one of the highest and coldest inhabited places on Earth. Peaks up to 6400 metres (21,000 feet) surround the valley. In the short alpine summer, lorries and 4x4 Jeeps bring goods and tourists over the Pensi-La Pass, which, at 4400 metres (14,400 feet), is open only between May and October. When winter comes howling back, the road is closed, and the Zanskar Valley is shut off from the outside world – except for six short weeks in the dead of winter when the Zanskar River freezes and the locals can walk on the water.

Spared by geography from the effects of the Chinese Cultural Revolution and closed to foreigners for much of the twentieth century (because of border conflicts), an unbroken lineage of Tibetan culture has existed here since the eighth century. Squat and semi-domed stupas, fluttering and colourful prayer flags and hand-carved stone tablets inscribed with religious figures mark the villages and the paths between them. Tibetan monasteries (gompas) cling to the mountainsides, seemingly hewn into the rock, housing red-robed monks ranging in age from 8 to 80, sacred mandalas (sand paintings celebrating the wheel of life) and massive golden statues of the Buddha, lit by flickering candles of yak-fat tallow.

Zanskari villagers survive by basic agriculture. Yaks walk in tethered circles, pounding the dried stems of barley, which are then threshed by hand. In the summer, vertical watermills pound the barley to make flour for tsampa – an energy-rich powder made of barley and yak butter. On a frozen-river journey, tsampa is the main sustenance, to be enjoyed with a salty brew of yak-butter tea.

But even in this isolated place, there are pressures of the modern world. When the short summer is over, parents who want the best for their children send them to boarding schools. And when they have to return to school after the winter break, the only way back is via the frozen Zanskar River – a six-day, 100km (62-mile) trek. At night the thermometer plummets to -30°C (-22°F). For both safety and companionship, all the local villagers who are planning to make the journey set out together. To them, the frozen river presents not an obstacle but an opportunity.

Ice conditions on the river change daily, sometimes hourly, depending on the temperature and position of the sun. Brave men venture ahead tapping the ice with a stick

LEFT *Hiking to boarding school along the frozen Zanskar River. At this point on the river, the ice has been smashed by a water surge upstream (the result of a series of avalanches) and refrozen, leaving a treacherous field of ice floes. Later on, it will be possible to use sledges to give the younger chidren a rest.*

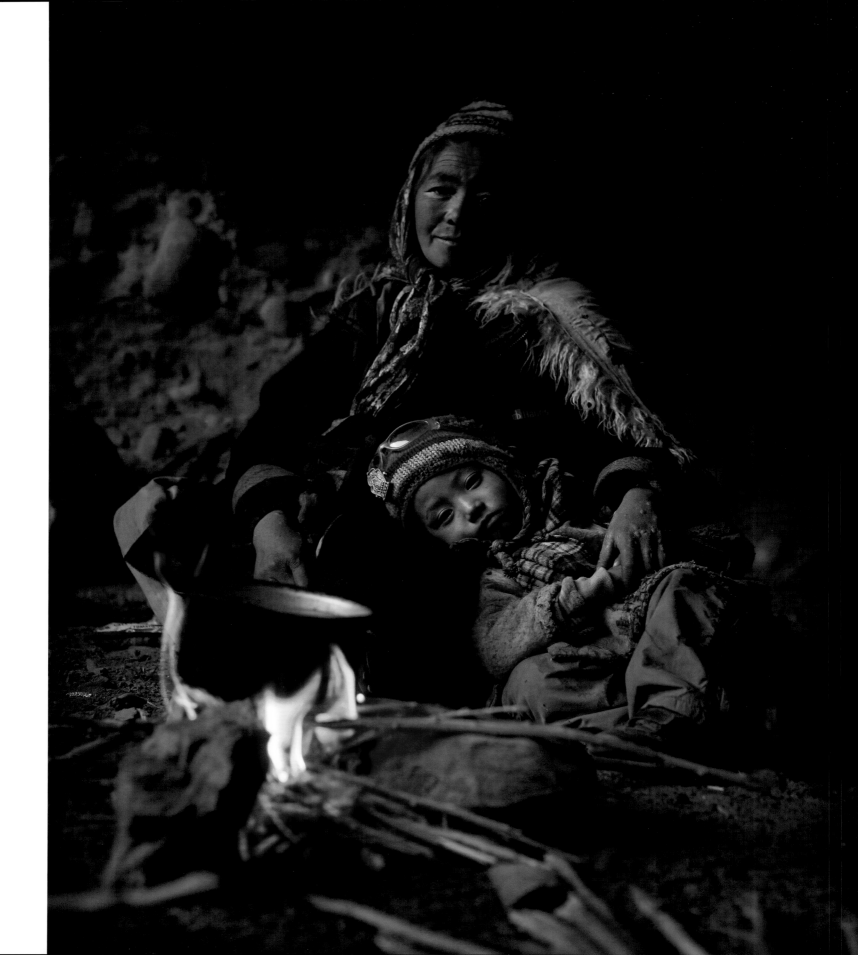

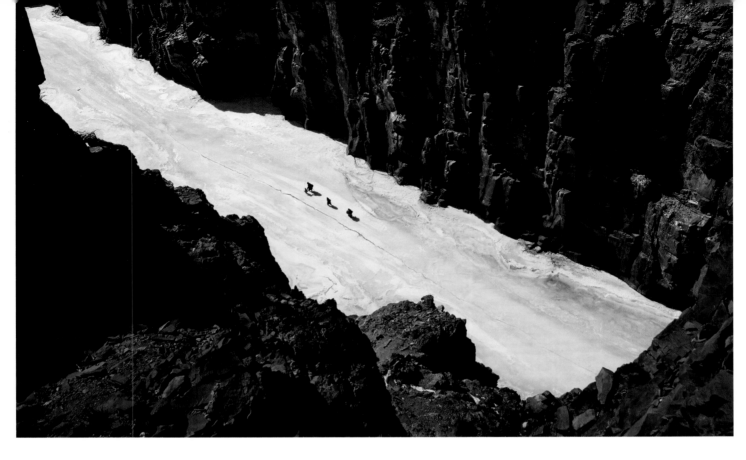

to determine its thickness and whether it can support the party's weight. The river narrows as it reaches the gorge, a few kilometres from the broad valley where the villages lie. Once in the gorge, the river canyon becomes otherworldly. Springs freeze into waterfalls of ice on the cliff walls. In places where the water has thawed the ice, there is no choice but to wade. The gorge narrows to 5 metres (16 feet) in some claustrophobic spots, and at times the water is so savage and the ice so thin that the group has to scramble up the rock-face.

Each night there is a race to reach one of the blackened caves where for centuries travellers have camped. Precious firewood is collected, either from flotsam washed up during the spring melt or cut from existing trees in such a fashion as to ensure they continue to grow. Children are given the choice positions closest to the fire.

After several days, the settlement of Chilling is in sight and the all-weather road to Leh. Boarding trucks or buses, the party departs for the city, where school is about to begin and the winter festival season gives the men a reason to linger. But they can't wait long. If they don't make it home before the spring thaw, they will be stuck in Leh until it is safe to trek over the mountain passes. But two modern pressures, in one sense linked, spell the end of this epic journey. Climate change is lessening the predictability of the ice, and a road is being blasted through the gorge from both ends of the Zanskar. Within a few years, the trek will be replaced by a five-hour car ride.

ABOVE *Walking in the narrowest part of the gorge on sheet ice, tapping the ice ahead to check its thickness.* LEFT *A tight squeeze between water and sheer canyon wall.* OPPOSITE *Cooking supper in a soot-blackened sleeping cave, built with flotsam from the riverbank. The sleeping caves have been used for centuries.*

ICE CONTROL

Ottawa lies at the confluence of the Rideau and Ottawa rivers on the border of Ontario and Quebec. Chosen as the capital of Canada by Queen Victoria in 1857, the unruly logging town was the only sizeable settlement on the border of what was then Upper and Lower Canada – the historic English-French divide – and was a compromise choice designed to satisfy Canada's two founding nations. The main reason for Ottawa's early growth is the famed Rideau Canal, built to bypass the St Lawrence River at a time when memories of the American Revolution and the War of 1812 were fresh in the minds of British colonial governments. Protecting the timber trade and military supply routes on Canadian rivers was of utmost importance. The canal was completed just as the border quietened down. Since then, the two countries have coexisted peacefully.

Ottawa is one of the world's coldest capitals. During the long Canadian winter, the waterways that define the city freeze, and the city landscape is one of ice and snow. By Christmas, the Rideau Canal has transformed from what was once the city's main commercial artery into the Skateway, the world's largest skating rink, 7.8km long (nearly 5 miles) – the equivalent of 90 Olympic-size skating rinks. An army of snowblowers, tractors and ploughs clears snow from the ice, sweeper trucks scour the skate shavings to the side and, almost nightly, work crews reflood the surface to create a smooth new 'rink'. Workers drill holes in the ice and pump canal water out, letting the night temperatures do the rest. On weekdays, diplomats and bureaucrats skate to work alongside university students racing to class, and on sunny weekends, crowds turn out to play.

The Rideau River also freezes solid, but come spring, it has to be completely cleared of ice, or some of the city's most expensive neighbourhoods risk being flooded. By the end of February, the ice barge starts crunching its way along the Ottawa River to the base of the Rideau Falls, cutting a path through the thick ice to the bottom of the still frozen cascade. Above the falls, long channels of water are sliced through the ice by giant buzz-saws, and ice blocks are wrestled by hand out of the channels.

The final and most delicate ice-clearing stage comes at the beginning of March. At the head of the falls sit key government buildings, including the Department of Foreign Affairs and the Prime Minister's residence. And when this last bit of river is cleared, it's done with explosives. The ice is blasted high into the air, and slowly the water locked in ice at the top of the falls begins to move, crashing over the top of the frozen falls. By the end of a week, the waterfall is completely moving again, and 11 kilometres (7 miles) of ice cascade harmlessly into the Ottawa River.

ABOVE *Ottawa city crews (in red) preparing to blow up the frozen Rideau River behind the dam and the iced-over Rideau Falls. Dynamiting the ice and releasing the floes through the sluice gates prevents a build-up behind the dam. If the ice floes jam, damming the meltwater, the city would be flooded.*

LIVING WITH THE AMAZON

To call the Amazon a river is almost an understatement. More appropriately, it's a river sea – the second longest river in the world and far and away the largest by volume. The drainage basin of the Amazon is the most massive on Earth – 40 per cent of the South American land area. In places, it is more than 40km (25 miles) wide when in flood, and at its mouth it discharges 30 trillion litres (8 trillion gallons) of fresh water a day – 60 times the discharge of the Nile. There are more species of fish in the Amazon basin than in the Atlantic. To date, there's no bridge that crosses the river. Its enormity cannot be expressed in verbal or visual imagery alone – it must be experienced. Ocean freighters can safely sail two thirds of the Amazon's length to the booming inland port of Manaus – a city of more than 2 million on the banks of the Rio Negro, one of the Amazon's two main tributaries. Vast fleets of riverboats line the docks, ferrying people and their goods back and forth.

Nine and a half kilometres (6 miles) from Manaus is the confluence of the Negro and the Solimoes – one of the world's great river spectacles. The Negro is a black-water river, with high acidity because of the decomposed organic materials from the innumerable swamps that the river drains, and the Solimoes is a 'white' river, rising from the Andean highlands and filled with silt. The waters meet in a distinct spot, where on one side the water is cloudy and grey and the other dark and tannic, and then merge to become the mighty Amazon, winding its way to the Atlantic.

Along the banks people have adapted to the endless ebb and flow of the river. Communities of floating houses have their gardens moored to back porches. Children peddle ice cream and cold drinks from canoes. In the town of Novo Airão, a woman named Marilda operates a floating restaurant where pink river dolphins, or botos, come to feed in front of the diners. Locals once killed the botos, fearing that they would walk among them at night and steal their women. But today, through efforts like Marilda's, a new appreciation has developed for these extraordinary mammals.

Seasonal change along the Amazon is as massive as the river itself. Up to 3 metres (120 inches) of rain falls in the Amazon basin every year, and the floods turn the region into a forested waterworld. The sheer volume and weight of the flood creates a 7.5cm (3-inch) dip in the Earth's crust. Yet people manage to cope with the annual inundation.

At the end of a 36-hour boat journey upriver from Manaus is the settlement of Daracoa – a collection of small houses on stilts perched a couple of metres above a sandy beach. Day-to-day life exists in the shade under the houses. Meals are eaten here, games are played, and there are long afternoon snoozes in hammocks. The 30 or so

LEFT *Amazonian river dolphins, or botos, in the murky dark waters of the Rio Negro. These are animals that river people see from their porches, sometimes regarding them as unearthly creatures, other times as competition for fish. In some parts of the Amazon, they are now valued for the tourism revenue they attract.*

people here are known as caboclos – descendants of both Europeans and indigenous tribes – and the way they live day to day is determined by the rise and fall of the river.

During the dry season, from September to December, daybreak sees the start of work – fishing and turtle hunting – and the clanging of a makeshift bell sends the children off to school. It's a subsistence life that leaves plenty of time for relaxation, socializing and play. At the end of the afternoon, the whole village gathers for a sundown football match – with both sexes and all ages taking part. A pet parrot flies just overhead, giving commentary on the game.

The villagers make their living from the bounty of the river – fishing for both trade and consumption. They have to paddle three hours to the fishing grounds (travel by motorboat is too expensive, as the profit margins are very small). The most valuable fish are the tiniest – cardinals, sold for about $6 per thousand. Up to their armpits in the black backwaters, they collect them, one by one, with a simple aquarium net. The fish are first sold to a middleman and then sold again in Manaus for shipment to São Paulo for distribution around the world.

One of the key ingredients of the villagers' diet is freshwater turtle. Now they have started a turtle conservation project. In the dry season, the villagers collect eggs buried by turtles in the sandy banks. Hatching the eggs in plastic boxes, they transfer the tiny hatchlings to water pens either under their stilt houses or in the river itself. By mid-March, when the rains begin to fall again and the vast beaches are in retreat, they release the baby turtles. This is also when the football pitch floods, the village pigs are moved to treetop pens and all the items of daily existence that sit on the sandy beaches are moved inside. About 10 per cent of the released turtles live long enough to reach maturity at about five years old. And when they are roughly 30cm (12 inches) long, the villagers hunt for them in the river with small spears.

By mid-June, the Amazon is in full flood, water rising to the doorsteps. School classes are relocated to a stilt building because the schoolhouse, the only building not on stilts, is submerged. It's a time of boredom. It rains all day, and the villagers are confined to their houses. To visit a neighbour or go to church means paddling a canoe. Mothers fear for the littlest children who have not yet learned to swim. The currents of the Negro run swiftly under the houses, and falling in could mean being swept away. Caimans also lurk close to the houses, but the surrounding rainforest is a water-filled wonder. You can paddle among the treetops, where the creatures of the forest are living in the canopy, and see fish swimming through branches. It's all part of the Amazon's yearly cycle, and it's only a matter of time before the land drains and it all starts again.

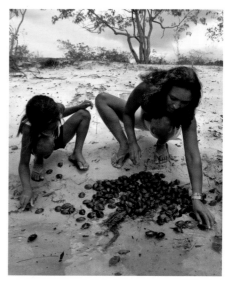

RIGHT, TOP *View from the riverside village of the Rio Negro, one of the the main tributaries of the Amazon.* RIGHT, MIDDLE *Mother and daughter releasing baby turtles into the river.* RIGHT, BOTTOM *Hatchlings just big enough to have a chance of survival. They were collected as eggs from the riverbank.*

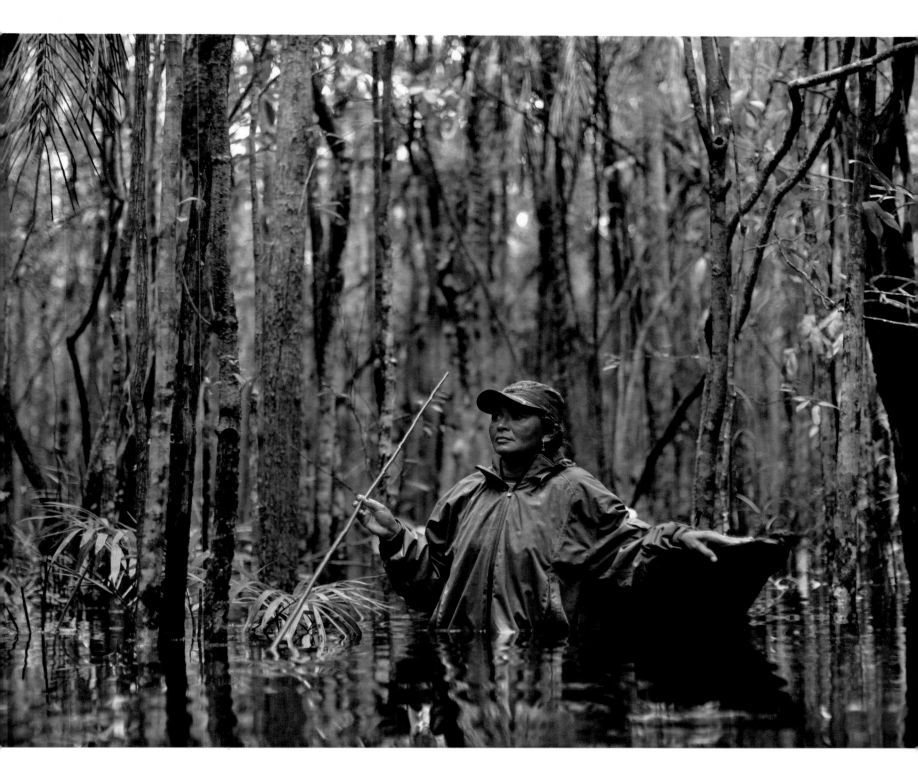

ABOVE *Dora hunting freshwater turtles in the Rio Negro flooded forest. She and the other villagers make a living from the river, catching fish for food and for sale. Turtles are considered a delicacy and were being overexploited until the villagers learnt how to rear hatchlings to restock the river.*

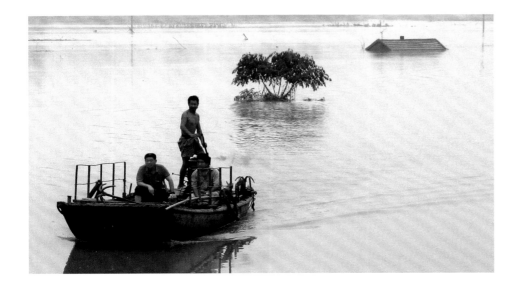

ANGRY RIVERS AND BOUNTIFUL FLOODS

A simple definition of flood is when a river overflows its banks onto dry land. But this doesn't reflect the destruction a river in flood can wreak on both the natural and man-made world. Of all natural disasters, floods are the most catastrophic. In 1931, the Yellow River in China overflowed its banks, leaving 80 million people homeless. Estimates of deaths from disease and famine range from 850,000 to 4 million. But this was just one chapter in the dreadful history of the Yellow. The river is thought to have flooded more than 1000 times since the second century BC. Vast sums of money have been spent and armies of engineers and labourers deployed in order to tame rivers and subjugate future floods. Every year, the US government authorizes the Army Corps of Engineers to spend some $240 million for flood control on the Mississippi. But floods still occur – either predictably when rain waterlogs the land or unexpectedly bursts from the sky.

Despite the massive devastation, there is a flipside to floods. For millennia, before the construction of the Aswan High Dam, the yearly Nile floods deposited a rich bounty of silted soil, creating a green ribbon of agriculture that allowed civilization to thrive in both ancient and modern Egypt. And now it is known that river floods act as great carbon sinks, carrying enormous amounts of organic material and depositing it in the oceans. Floods are the ultimate example of how a river is both friend and foe.

ABOVE *Looking for survivors in tree-high water after the Huai River in eastern China burst its banks. Whole villages were drowned, leaving 13 people dead and more than a million stranded.*
RIGHT *The flooding of the south China city of Liuzhou in 2009 after heavy rains.*

RIVERS

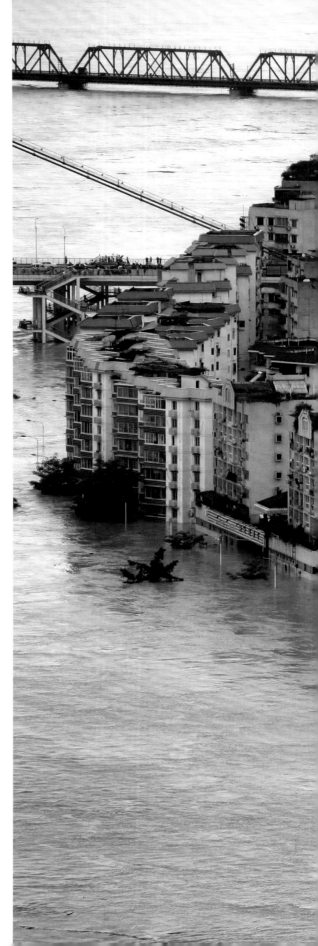

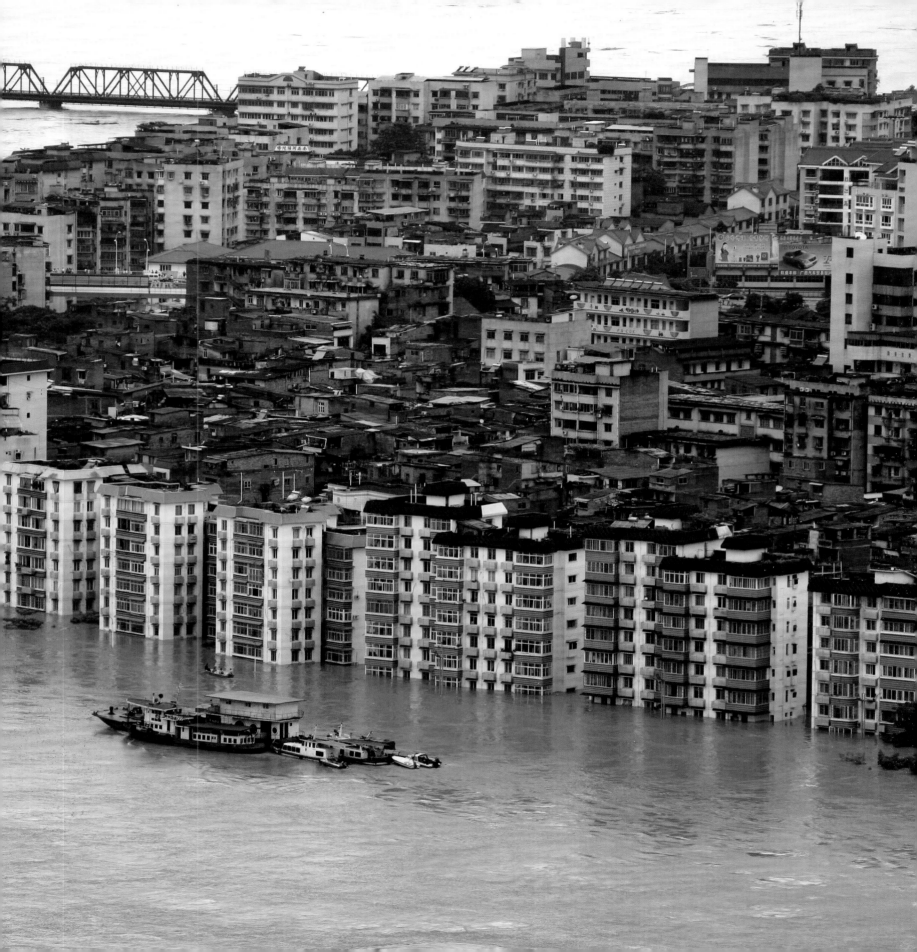

GROWING BRIDGES

The rainiest inhabited place on Earth is Cherrapunjee in the Meghalaya district of northeast India. In July, the average rainfall is 9.6 metres (378 inches). The source is the southwestern monsoon, which forms in May in the Bay of Bengal. Rolling over the waterlogged plains of Bangladesh, the giant, low-lying rain front is eventually stopped by the Cherrapunjee massif, and a deluge falls from the sky. Giant waterfalls pour down the hillsides, and the rivers swell to twice their normal size. Virtually all of the annual rainfall at Cherrapunjee is received in just eight months, from March to October.

So how do you cross a raging torrent when man-made structures of wood or concrete simply wash away? The Khasi people of Meghalaya have an organic solution: they grow bridges from trees.

The fig *Ficus elastica*, known as the Indian rubber-tree plant, is found in the gorges and along stream banks throughout Meghalaya. Its strong roots thrive in the rocky soil of riverbeds, plunging deep into the ground and allowing the trees to live perched on top of boulders, while hundreds of secondary tendrils grope towards the earth in search of greater stability and better purchase.

The Khasi look for a particularly well-situated fig tree and begin to train its roots in the long, slow process of spanning a river. The tree has to be high enough off the riverbed to keep from washing away during the 15 or so years needed for the roots to

RIVERS

ABOVE *A Khasi woman climbing a fig-tree-root staircase that scales the hillside from the plain below.* RIGHT *Washing clothes below a root bridge.* OVERLEAF *The Khasi Hills, rising up from the waterlogged plains of Bangladesh. It's where the southwest monsoon drops much of its water.*

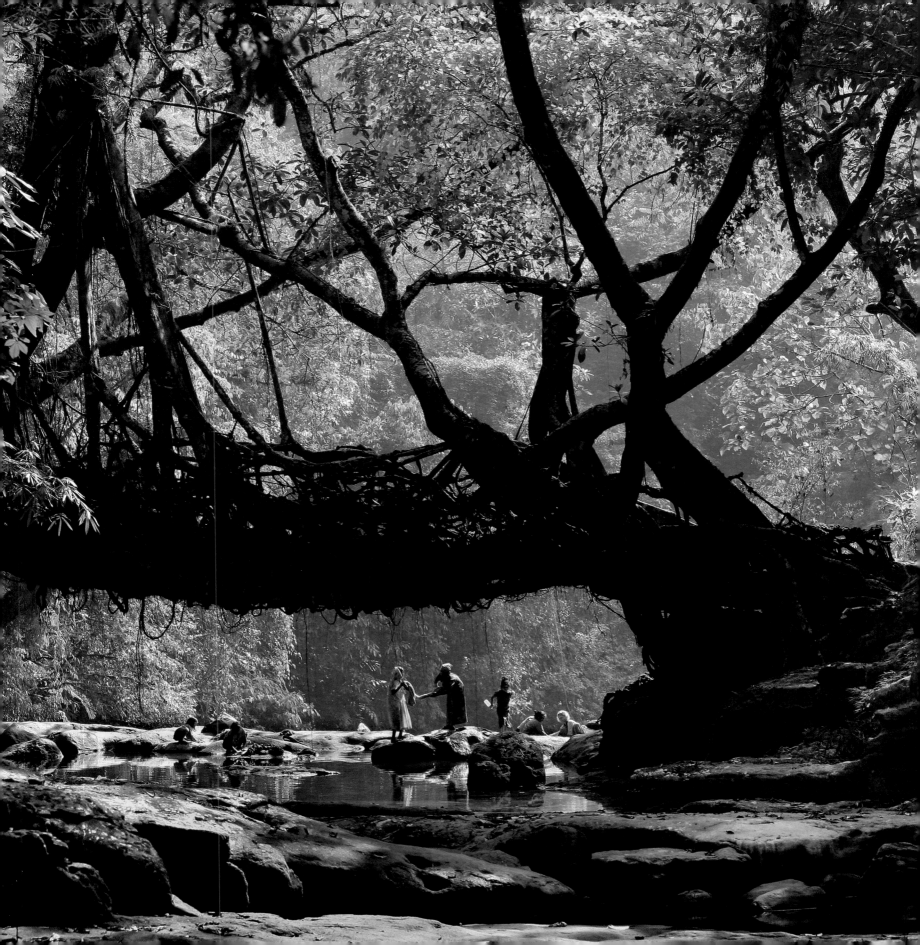

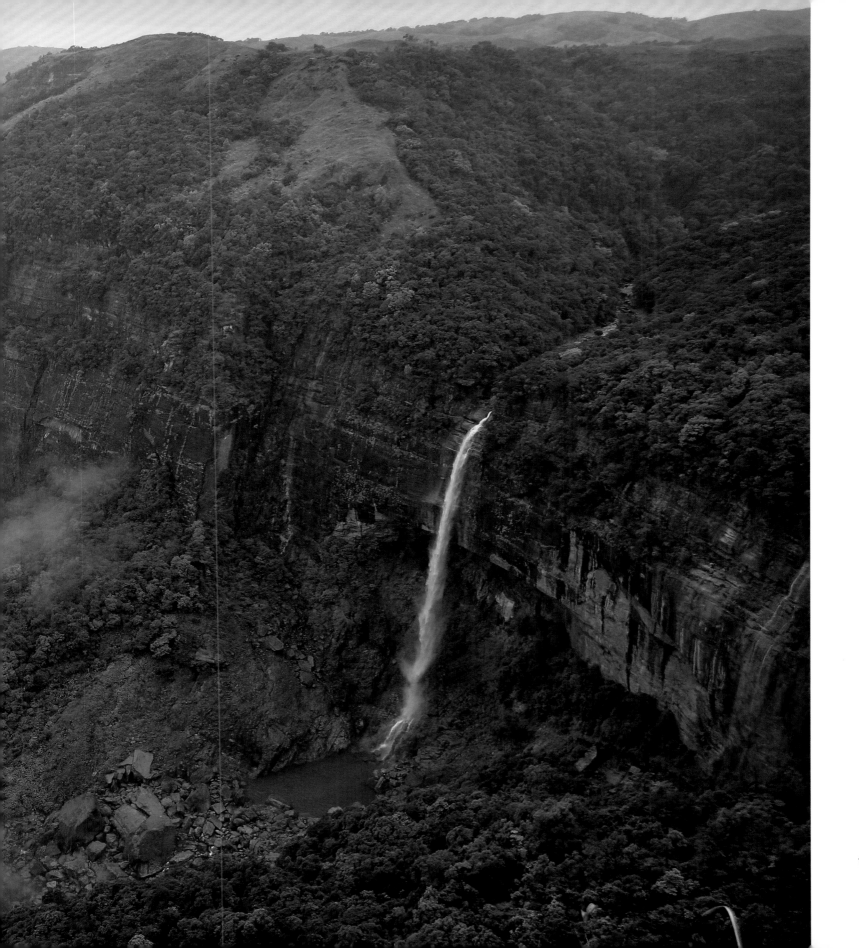

strengthen and take hold. Betel-nut logs are split in half and hollowed out to serve as training flumes for the roots. Inside the logs, soil and leaves are carefully placed to feed the shoots as they creep over and across the water below.

In the space of a human lifetime – 80 years, say – a root-bridge will solidify from a web of woven tendrils into fully grown horizontal tree. Khasi custom has it that, when passers-by cross over a bridge, they assist its growth by braiding tendrils together, thereby constantly rebuilding and fortifying the structure. Stones are placed into the latticed path, and the roots grow around them. The bridges are both functional and beautiful. In some cases, double-decker bridges rise above the misty streams carrying two levels of people. Each day the living bridge strengthens itself, reinforcing its structure as shoots thicken and become hard wood.

The Khasi say that an individual bridge, lovingly cared for and maintained, can last for 400 to 600 years. The root-bridges are strong; some can carry 50 or more people at a time. No one knows when the people started building these magnificent structures, but the bridges remain focal points of the riverside villages. Children bathe and play underneath, and women stop on them for the latest news and gossip. Men sit and laugh, chewing betel nuts and staining the well-worn bridge stepping stones bright red as they spit out the bitter juice. The bridges are one of the world's most astonishing examples of living architecture.

OLD MAN RIVER

We gain so much from rivers – food, fresh water, transportation, energy – that all the essentials of human civilization seem to spring from their banks. But they can also be tricksters. Rivers rage mercilessly. They dry up and disappear in extreme heat. They freeze solid in the cold and flood in the spring thaw and rainy seasons. We can only adapt to their moods, even as they form the heart of our twenty-first-century cities.

Rivers find their ways into all facets of our human creativity and ingenuity. Novels, films, paintings and entire genres of music have drawn inspiration from rivers. Great civilizations have risen and fallen along their banks, and in many places around the world the river itself is considered holy. It's perhaps because we see so much of ourselves in a river – a beginning, middle and end, always striving to reach its destination before finally expiring – that rivers resonate so deeply in the human experience. And like human life, a river is ultimately a cycle, with the next chapter in the story waiting to be written.

RIGHT *A Meghalaya root-bridge. It's a living, growing piece of architecture that can withstand floods where a dead-wood or concrete construction never could – a necessity in the rainiest place on Earth. As its woven roots grow, the bridge strengthens and solidifies into a structure that can last hundreds of years.*

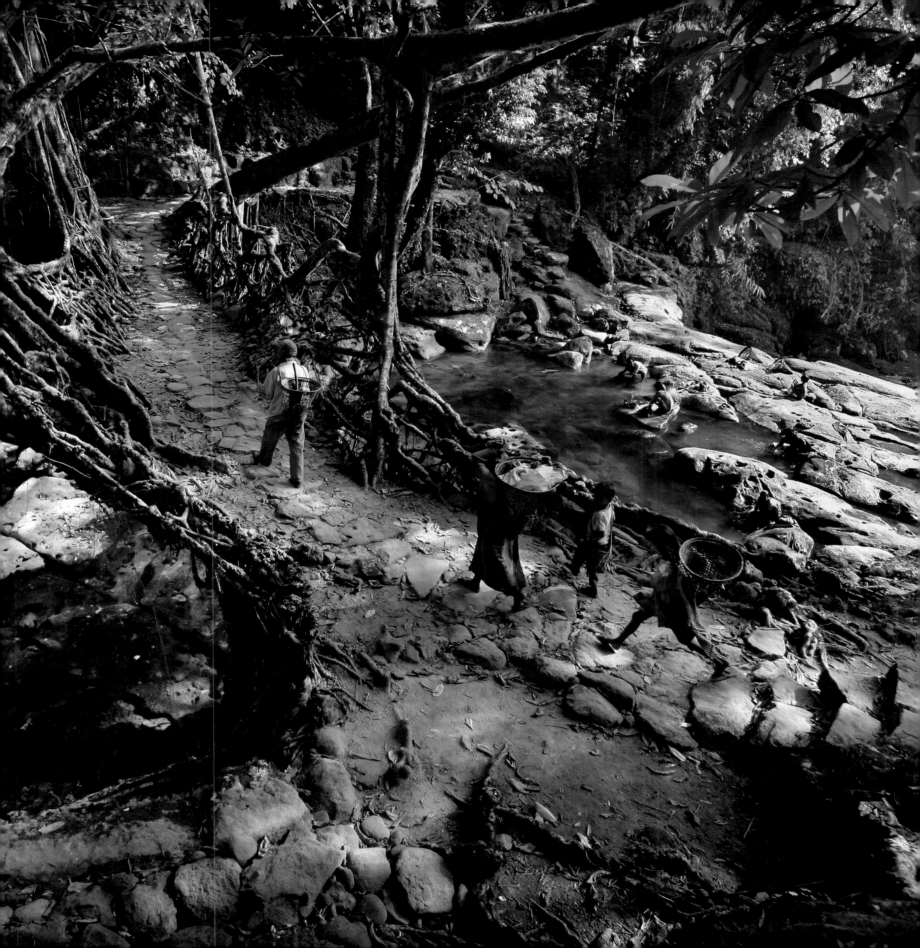

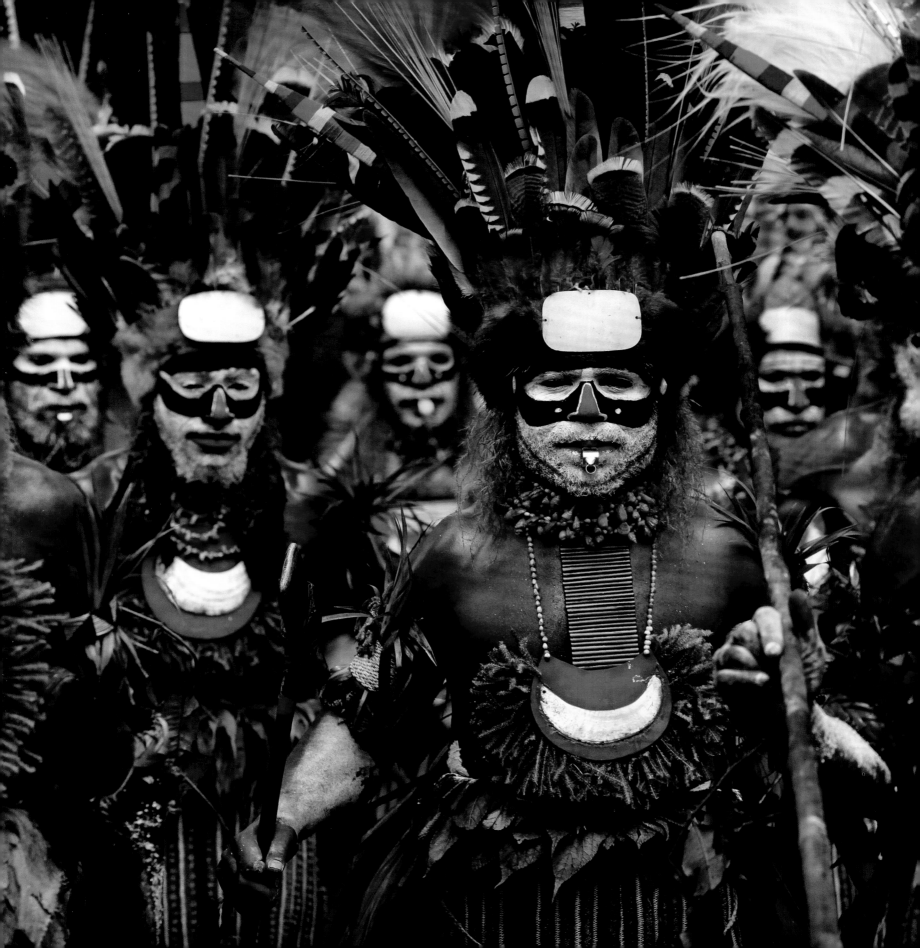

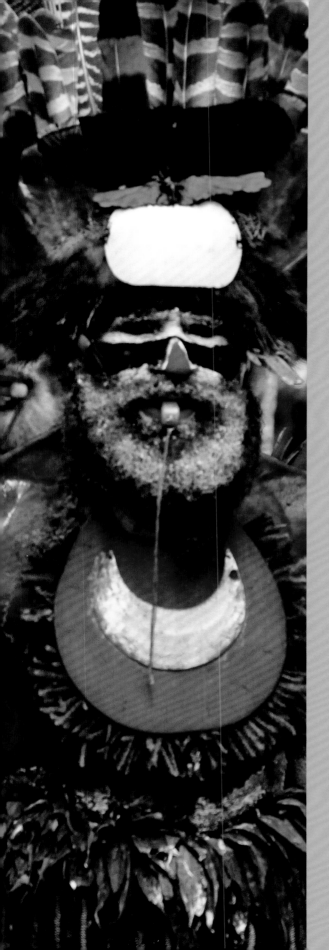

JUNGLES

4

TROPICAL RAINFORESTS DISPLAY NATURE AT ITS MOST VIGOROUS AND DIVERSE. YEAR-ROUND HEAT AND LIGHT FROM THE OVERHEAD SUN CREATE NEAR-PERFECT CONDITIONS FOR LIFE, AND AS A RESULT, MORE SPECIES ARE FOUND IN THIS TERRESTRIAL HABITAT THAN IN ALL THE OTHERS PUT TOGETHER. WITH THIS UNPARALLELED ABUNDANCE OF ANIMALS AND PLANTS, RAINFORESTS WOULD SEEM TO BE THE IDEAL ENVIRONMENT FOR PEOPLE. INDEED, ALL SPECIES OF GREAT APE ORIGINATED IN RAINFORESTS (AND LIVE IN THEM STILL), AND THE HUMAN LINEAGE ALMOST CERTAINLY BEGAN THERE, TOO. YET, THOUGH RAINFORESTS MAY BE OUR ANCESTRAL HOME, THEY ARE NO GARDEN OF EDEN. GREAT CIVILIZATIONS HAVE ARISEN WITHIN THEM, BUT ULTIMATELY THEY HAVE ALL COLLAPSED AND BEEN RECLAIMED BY THE JUNGLE. LIFE IN THE RAINFOREST IS INTENSELY COMPLEX AND COMPETITIVE, AND HUMANS CAN ONLY PROSPER HERE THROUGH A DEEP UNDERSTANDING OF HOW TO LIVE ALONGSIDE NATURE.

For the inexperienced, jungle conditions can prove hostile. The understorey vegetation hinders travel, the intense heat and humidity sap energy, and with no visible horizon it's only too easy to get lost in the sea of trees. An even greater ordeal is dealing with the multitude of other life forms found in these forests. There's a wide diversity of parasites waiting to suck our blood and infiltrate our bodies, alongside an array of tropical diseases and numerous poisonous and venomous animals ranging from the mildly irritating to the highly lethal. Even finding food is surprisingly difficult: though there may be plenty of life, most is either inedible or too widely dispersed because of the overwhelming biological diversity. Yet there are some people with such a comprehensive understanding of this environment that they can overcome the many challenges of life in the rainforest. As a result, it is among these cultures that we find some of the most intimate connections between humans and the natural world.

JUNGLES

OPPOSITE A Ta Prohm temple gate at Angkor, Cambodia – ruins from the Khmer civilization, reclaimed by the environment it exploited.
PREVIOUS PAGE Tribesmen at the Mt Hagen sing-sing, Papua New Guinea.

EATING THE UNTHINKABLE

Tropical rainforests are among the most productive ecosystems on Earth, but the majority of animal life is found in the treetops. The forest floor we humans inhabit is more a place of death and decay than growth. While the dank conditions are perfect for fungi and bacteria, with little light penetrating through the blanket of trees, relatively few plants flourish on the ground, and therefore surprisingly few animals live here. Nutritious food is scarce in this 'underworld', and people can't afford to be picky about what they eat.

Like most rainforest people, the Piaroa, who live along the banks of Venezuela's Orinoco River and its tributaries, have to be creative at securing sustenance on the forest floor. They've learnt how to identify a wide variety of edible leaves, roots and tubers, but most remarkable is the taste they've developed for a particular ground-dwelling animal – the goliath bird-eating tarantula. With a leg-span of up to 30cm (12 inches) and weighing as much as 150g (5 ounces), this is the world's largest spider. For many people, these oversize arachnids represent a nightmare of nature, but for the Piaroa, they are simply a valuable and an easy-to-find source of protein.

It is often the small children who are given the task of searching for the supersized spiders. Having grown up in the jungle, they have no fear of it and can navigate through dense vegetation with remarkable ease. The forest is their playground and the plants and animals their toys. From as young as three, the children are able to detect the telltale signs of a tarantula: a rodent-sized hole in the ground surrounded by fine webbing. Once a burrow is found, the spider now has to be 'fished' out. The child will carefully poke a stick down the hole in an attempt to stimulate the spider's predatory response. Mistaking the stick for food, the spider seizes it with fangs and front legs, and can then be gently pulled from its hole.

Tarantulas are often mistakenly thought of as highly venomous, and though they are known to kill animals as large as birds, this is more due to their size than their potency; their venom is rarely more painful than a bee sting, and with the right handling, the risk of being bitten is slim. A more realistic hazard is the irritating barbed hairs that the tarantula vigorously kicks from its abdomen towards any attacker, which can cause anything from a mild rash to a burning inflammation. The worst symptoms occur when the hairs are inhaled or get in the eyes, leaving people with persistent respiratory problems and, in some cases, permanently blind. Yet even this does little to put the Piaroa children off, and they have no hesitancy in catching the dinner-plate-sized spiders and wrapping them up in leaf parcels to carry them back home for cooking.

RIGHT *Piaroa children barbecuing goliath bird-eating spiders. Food can be surprisingly scarce in the rainforest, and so people have learnt how to eat the most unexpected of animals and plants, with fire being an essential tool. Cooked, these large tarantulas are, in fact, both tasty and an excellent source of protein.*

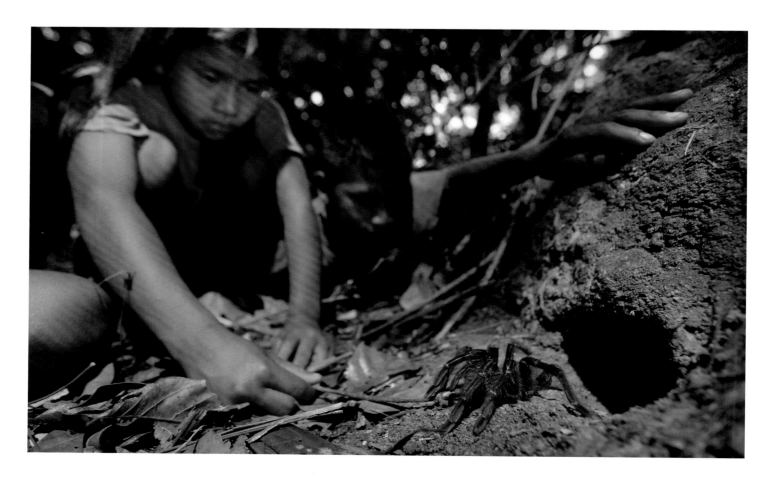

The recipe for barbecued tarantula is simple: build a fire, skewer the spiders and then lightly toast them – rather like marshmallows. If desired, they can be seasoned with salt and chilli. The most prized piece of meat is the large fleshy abdomen, which tastes a little like crabmeat, but almost the entire spider is eaten, including the hairy, crunchy legs. And if any bits get stuck in the teeth, the long fangs make ideal toothpicks.

Though the Piaroa happily dine on tarantulas and even believe that their consumption helps ward off death, there are plenty of other things they would rather eat. The problem is that many of these food sources are found in the canopy, and getting at them can be extremely difficult and energetically expensive. Physically, humans are poorly adapted to life in the treetops and so have had to invent other ways to access the riches. One of the most common solutions is a blowpipe, and a number of rainforest cultures still use blowpipes for hunting animals in the trees. Perhaps the most skilful of all blowpipe hunters are those of the Matis tribe of western Brazil.

ABOVE *Rosanna using a stick to lure a goliath bird-eating spider from its burrow.* RIGHT *Leaf-parcels of spiders to take home.* OPPOSITE *Orlando holding up his catch to show the size of the world's largest spider. Piaroa children handling goliath spiders know how to avoid the fangs and irritating hairs.*

DARTING INTO THE CANOPY

The blowpipe-hunting prowess of the Matis has been honed over centuries, and their weapons are a testament to their ability to make use of what they find around them. The 3-metre-long (11.5-foot) barrel is created from seven pieces of palm trunk hollowed out and bound together with twine and resin. It has to be made as straight as possible to give the accuracy needed to hit a target 30 metres (100 feet) up in the canopy. The mouthpiece is hardwood, and a capybara tooth stuck to the other end of the pipe acts as a sight. The Matis take great pride in their blowpipe-making abilities and elaborately decorate them using pieces of eggshell inlaid into the barrel.

The darts are fashioned from sharpened palm spikes. These are dipped in poison, which is collected from the curare liana by scraping it with a stick studded with monkeys' teeth and then heated to reduce the liquid and intensify its potency. The back-ends of the darts are wrapped in clay and kapok-tree fibre, which creates an airtight seal in the blowpipe and acts as a stabilizer in flight. Finally, the Matis score each dart with a piranha tooth so the poisoned head will break off inside the prey's body if the dart is dislodged.

The Matis use their blowpipes exclusively for hunting in the canopy, as they are too long and unwieldy to shoot at anything more than 20 degrees from the vertical. On occasion they'll dart birds and mammals such as sloths, but they mainly use blowpipes to hunt monkeys. Working in teams of up to six, they rapidly cover large distances on the trail of a troop of monkeys, using subtle cues such as scents, debris and monkey calls to locate their prey. They encircle the troop from the ground and begin driving them together by calling and banging on trees. Once the troop is concentrated, they fire rapid volleys of darts. If a monkey is hit, it may take several minutes for the poison to take effect, and the monkey has to be tracked as it tries to escape through the trees. On a successful hunt, the Matis can come back with five or more monkeys. Though shotguns are becoming the weapon of choice, the Matis still prefer to use blowpipes to hunt monkeys. The blowpipes are nearly silent, allowing them to pick off several monkeys before the troop flees, whereas the sound of just one gunshot will scatter them.

From food, medicinal plants, poisons and insect repellents to building materials, the rainforest can provide all we need, but identifying how the bewildering array of species can be best used takes hundreds of years. The rainforest is a web of symbiotic, parasitic and predatory interactions, and it's essential to understand how these intricate relationships work. It's through our powers of observation and extrapolation that we have developed the ability to interpret these relationships and to exploit the knowledge.

RIGHT *Matis hunter Kuini taking aim with his blowpipe. The Matis make the longest blowpipes in Brazil, used exclusively for hunting animals in the canopy. Being silent, they are ideal for catching several monkeys on a single hunt. It takes years of practice and good lungpower to be a skilled marksman.*

OUTSMARTING HORNETS

In Yunnan, China, the Dai people have learned to apply their awareness of rainforest systems to the way they cultivate. Understanding that rainforest plants have evolved to grow alongside each other, they plant a mix of crops in their kitchen gardens, using fruit trees to create a canopy for shade-loving vegetables and shrubs. One of the most productive crops is bananas, and it isn't just the fruit that the Dai exploit. They know that hornets like to feed on

the nectar of banana flowers, and despite the aggressive nature and agonizing stings of hornets, they are happy to attract them. But it is the hornet larvae they are after, considering them a delicacy, and the best way to locate them is to first find the adults.

Once a hornet has been spotted feeding from a banana flower, a cricket is tied to a long stick and slowly raised up beside the hornet. Though hornets love nectar, they're even more partial to animal flesh to feed to their young. The hornet quickly turns its attention to the cricket and becomes so engrossed in chopping it into portable pieces that it doesn't notice when a fine thread loop with a small white feather attached is slid over its abdomen. Once the first consignment of cricket flesh is ready, the hornet flies off towards its nest. The feather slows its progress and acts as a flag so it can be followed, though chasing the hornet usually involves crashing through undergrowth.

Once the nest has been located, usually up in a tree, the next hurdle is to get at the grubs without being attacked by an angry hornet defence force. A long sapling is cut, and a cotton rag doused in petrol is tied to one end, lit and raised to the hanging nest. When the hornets have been subdued with the smoke and flames, the hunters either climb the tree to retrieve the papier-mâché nest or whack it down, much like a piñata. The nest is then cracked open and the grubs plucked from their cells to be eagerly consumed alive.

Living in the rainforest often results in a deep understanding of nature, and it also has a profound influence on the customs and beliefs of forest-dwelling societies. Animals and plants feed not only their bodies but also their minds. And nowhere is this more evident than among the forest tribes of the island of New Guinea.

ABOVE *Slipping a noose around the abdomen of an Asian hornet. A feather is attached to slow down the flight of the hornet and make it easier to follow as it returns to its nest. Once located, the nest will be raided for its grubs – a tasty snack for the Dai people of rural Yunnan, China.*

HEAVENLY FEATHERS

There are striking connections between the many different jungle tribes of New Guinea and the various species of birds of paradise that inhabit their mountainous rainforests. The ornate plumes and bizarre courtship displays of these birds have always fascinated the local people, and they have become inextricably linked with the customs and beliefs of many of the island's tribes. Some tribes even believe them to be human spirits.

The exotic nature of the male birds of paradise is understood to have evolved through sexual selection, where the females choose to mate with those who sport the most beautiful plumages and perform the most exuberant courtship dances. Dramatic and colourful displays are indicators of status and fitness, and a strikingly similar situation has arisen among New Guinea's forest clans. These tribes use huge amounts of bird-of-paradise feathers to decorate themselves in their ceremonies, and they even dance in ways reminiscent of the birds' displays. Though both women and men are involved in these ritual dances, it is the men who are more preoccupied with dressing to impress. They decorate themselves with a wide array of ornate objects from the forest, including leaves, shells, beetle wings, clay and feathers from all sorts of birds, but the crowning glory of any outfit is invariably a splay of bird-of-paradise feathers in the headdress.

These outlandish rituals have long been used to display status both in and among tribes and also as a way for men to attract women. Today, most indigenous people are becoming ever more removed from their traditional forest lives, but the cultural value of the feathers has not diminished. From small, local affairs, ceremonies have become huge national festivals. The Goroka and Mt Hagen sings-sings are the two biggest events in the Papua New Guinea calendar. Hundreds of tribes congregate to display their costumes and perform their dances in a celebration of cultural heritage and a competition to be the most spectacular. Just as there are distinct species of bird of paradise (about 40), every tribal group has a specific way of dressing and dancing, but almost all use bird-of-paradise feathers as decoration.

The feathers have such significance they are treated as a currency and can be used to pay for all sorts of goods and favours. Headdresses are passed down through the generations, and people go to great lengths to preserve the feathers, but inevitably some become damaged or decayed. So there is always demand for new feathers and, though at a lesser rate than in the past, hunting birds of paradise continues. For those who still have the necessary jungle know-how, feather-hunting is a lucrative business. There are various techniques involved in catching the birds, depending on the habits of each species, but it is never easy: the

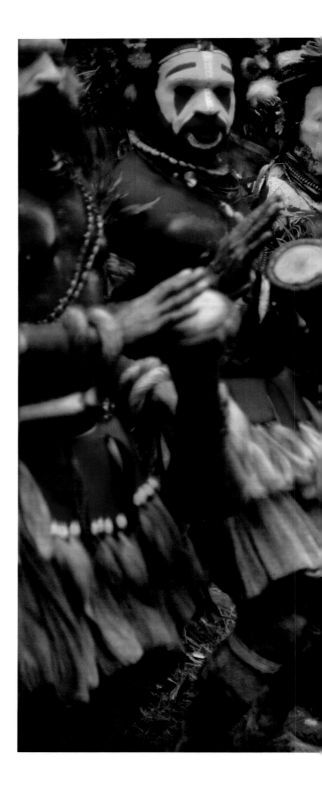

JUNGLES

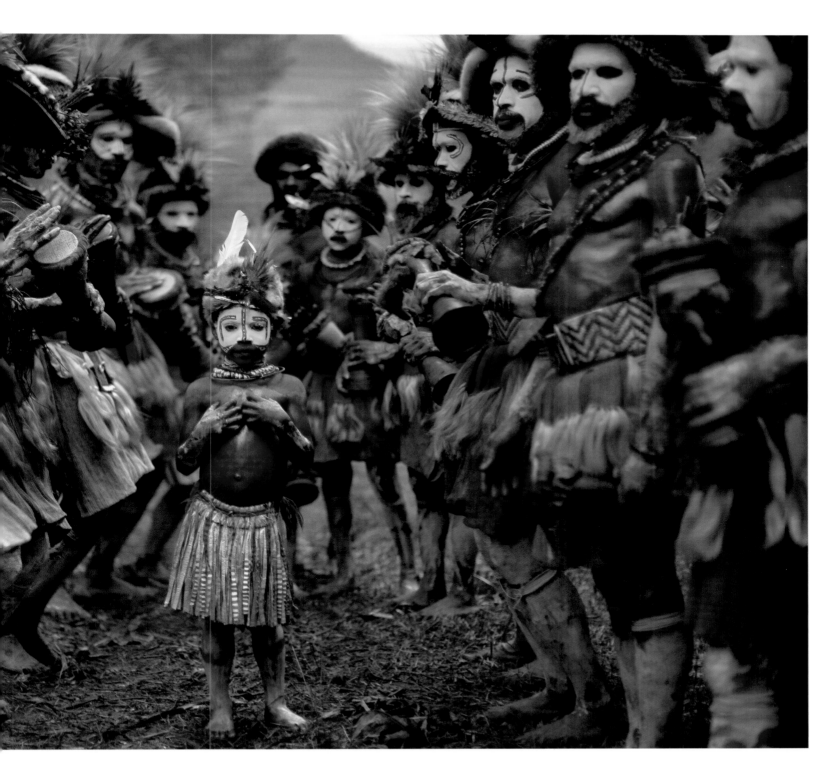

ABOVE *Evelyn and her fellow Huli dancers from the Tari Valley in Papua New Guinea at a sing-sing dance festival. The Huli make their wigs from human hair, intricately adorned with bird-of-paradise feathers (here mainly raggiana, superb and the King of Saxony) and other decorations gathered from the forest.*

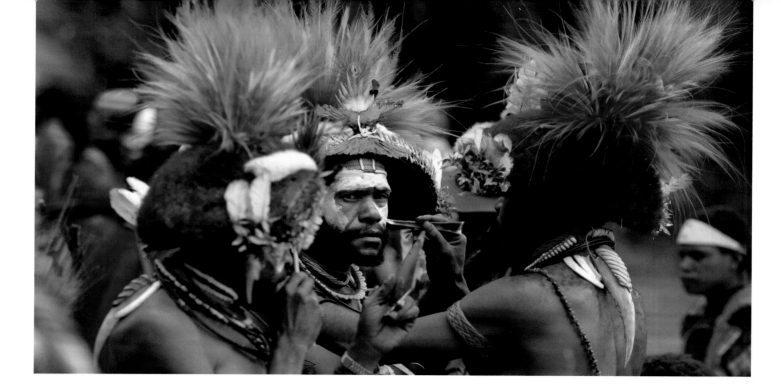

male birds only survive with such conspicuous plumage by being extremely cautious. The first step is to identify where their feeding and display sites are. Once the bird's territory has been discovered, the hunter makes a hide out of wood and leaves, hangs fruit on a stick frame in front of a small opening in the hide, patiently waits for the bird to come to feed and then shoots it at close range with an arrow.

Though the trade in bird-of-paradise feathers has certainly affected numbers of some species, most have shown remarkable resilience to hunting pressure. There's considerable evidence that the feathers have been traded in Asia for more than 5000 years. And after 1522, when Spanish explorers returned from Indonesia and presented their king with dried skins, there was great demand in Europe for the feathers of the fabled 'birds of the gods'. Though international trade in bird-of-paradise feathers is now strictly banned, many populations are still in decline, and some species are endangered – but this is more a result of forest destruction than hunting.

It is common among traditional rainforest cultures to place high value on colourful and decorative objects. Yet overall there is little room for materialism. Everything decays quickly, and most items derived from the rainforest are easier to replace than preserve. Even settlements can be surprisingly temporary. The wood from which they've been made perishes, and land cleared for cultivation loses its fertility. The solution is simply to move on and start afresh. The transient nature of life in the forest forces people to live in the present, and though they have little need to accumulate material goods, they can make extraordinary efforts in the pursuit of short-lived gratification.

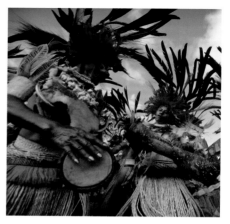

JUNGLES

TOP *Huli 'wig' men putting the finishing touches to their make-up. Their headdresses sport plumes from raggiana (orange) and superb birds of paradise (blue).* RIGHT, MIDDLE *Teeth and tusks add drama to the superb bird of paradise on his forehead.* RIGHT, ABOVE *Long plumes from mainly sicklebill birds of paradise.*

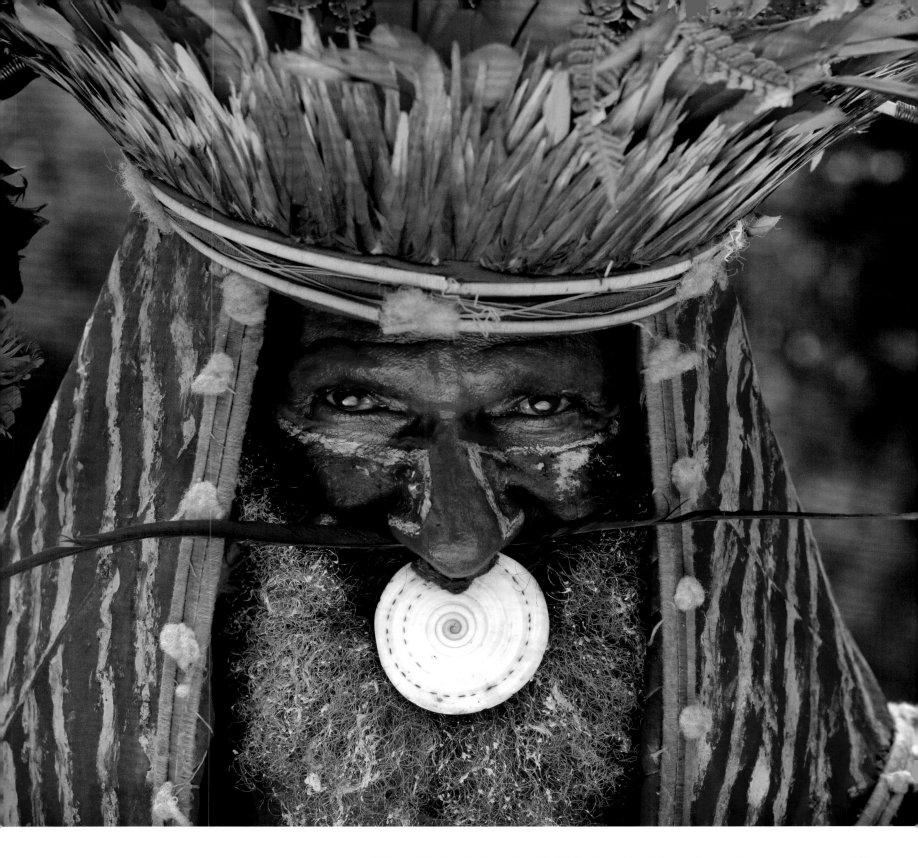

ABOVE *Geling, a bird-of-paradise hunter from Wagi Valley, Papua New Guinea, trying on a feather headdress for the forthcoming sing-sing. Though performers now use manufactured paints for more vibrant colours, most of what they wear are natural products collected from the forest.*

THE DEATH-DEFYING SWEET TOOTH

Naturally occurring sweet foods are hard to come by in the rainforest. There are abundant wild fruits, but many aren't edible, and most aren't nearly as nutritious or sweet as their domestic varieties. Honey is one of the only reliable sources of sugar, and it is much sought after as a delicacy by forest people. For the pygmies of equatorial Africa, the quest for honey is an obsession that they're prepared to risk their lives for.

The BaAka tribes that inhabit the rainforests of the Central African Republic and the Congo are constantly on the lookout for honey, but as forest bees often build their hives inside hollow branches in the canopy, it's hard to find. A honey-collector such as Mongonjé, from the village of Yandombé in the Congo, is amazingly adept at detecting signs of hive activity. He will listen for faint humming sounds, search for dead bees on the forest floor and can even spot bees flying around high up in the canopy. But locating a hive is just the start. Mongonjé then has to retrieve the honey, which he does with an astonishing display of agility, bravery and knowledge of forest-plant uses.

Hives in small trees pose no problem: Mongonjé will shinny up thin trunks or simply chop them down. Even a large tree can pose few problems if there are enough climbable lianas hanging from it or smaller trees growing alongside. Yet the biggest hives can be found at up to 40 metres (130 feet) in giant emergent trees whose trunks are too wide to get enough purchase on. In these cases, a more specialized approach is called for, and only skilled honey-collectors such as Mongonjé will take on the challenge.

The process begins by tying a particularly strong species of liana in a large loop that encircles both the base of the tree and his waist, allowing him to lean back against the liana and free his hands while maintaining his grip. With this improvised harness in place, Mongonjé begins to chop notched footholds into the trunk with a hand-made axe. Once he has ascended a little way, he shuffles the looping liana farther up the trunk and repeats the process, methodically ascending the tree. Great strength is required both to chop into a hardwood tree and haul himself up in the tropical heat, and it can take hours for him to reach the point where the trunk begins dividing into branches.

Now the most physically demanding work is over, but the danger is about to increase. Mongonjé has to leave the relative security of his harness and negotiate the tree's limbs to access the outer branches. Each tree requires a different approach. Sometimes Mongonjé will use lianas to create a ladder to bridge the gaps between branches; other times he may acrobatically swing between them. Once on the limb where the hive is, Mongonjé simply walks out along the branch. One slip could result

RIGHT *BaAka honey-collector Mongonjé climbing a 40-metre (130-foot) tree to get to a hive. His only lifeline is a liana wrapped around his body and the tree trunk. Once in the crown of the tree, Mongonjé will leave the safety of his harness and climb freestyle, walking out along branches to get to the precious honey.*

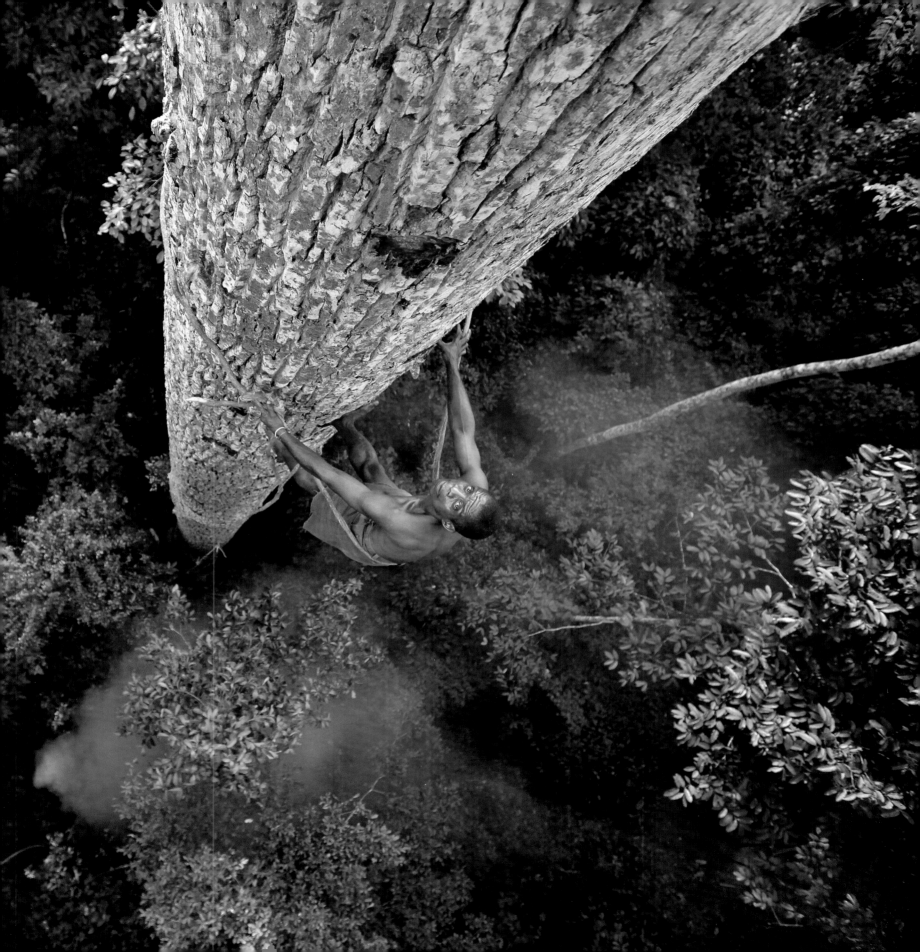

in death, but he is so experienced that he shows no sign of vertigo. Approaching the hive, Mongonjé now has to deal with a swarm of angry bees that sense their colony is under attack, and African bees defend their queen with great vigour. One or two stings are manageable, but the pheromones released by the bees rapidly calls more attackers, and so Mongonjé has to act fast. He lets down a long coil of vine to his assistant Tété on the ground, who attaches a bundle of leaves and burning embers and sends it back up.

Blowing on the leaves, Mongonjé creates a cloud of smoke that rapidly subdues the bees. Now he uses his axe to chip away at the entrance hole to the hive so he can plunge his hand in, pull out the first block of honeycomb and gauge whether he's struck gold or found only a small amount of poor-quality comb.

If the honey is good, Mongonjé sends his vine back down to Tété, who's been fashioning a bark basket lined with leaves. The makeshift container is hauled up and then piled high with honeycomb. By now, the news that honey has been found is likely to have spread, and an expectant crowd will be awaiting the bounty from above. It is

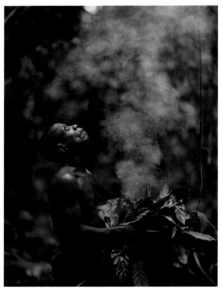

ABOVE *Tété climbing towards a hive carrying a bundle of leaves containing burning embers. As he approaches the hive, he will start to make smoke to pacify the bees, though they will still sting him.*
RIGHT *Below, Mongonjé advising Tété on the route and holding another smoking bundle to pass up to him.*

the climber's privilege, though, to take the first mouthfuls of the sweet honey, and after hours of hard work, the energy it provides is much needed.

On a good day many baskets full of honey can be collected from a single hive, and this goes a long way to satisfying the cravings of the community. The collector may, however, descend to find the rest of the honey has already been shared out. But honey is highly valued in BaAka culture, and though those able to collect it may not always get the biggest share, they earn respect and admiration. A woman will only marry a man who can bring her honey, and wives constantly badger their husbands to collect more. Yet this drive to gather honey can kill. Momentary loss of concentration, weak branches and sometimes overwhelming attacks from bees can all lead to fatalities, and every tribe can recall a number of people who have fallen to their death in pursuit of this liquid gold.

That something we simply pluck from the shelf in the supermarket could, in another culture, be worth risking death for is a vivid illustration of just how different the challenges of life in the forest are from our own. Many of the natural resources rainforest people depend on have little application or value in the modern world. Yet there are some rainforest products that are in huge demand around the globe, and the pursuit of these has led to massive exploitation. Substantial profits can be made from the rainforest, whether from poached bush-meat or the extraction of medicinal plant compounds, but the most coveted resources of all are the trees themselves.

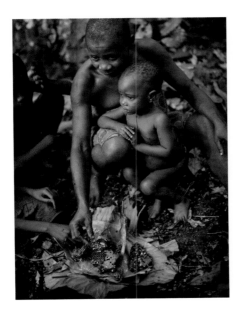

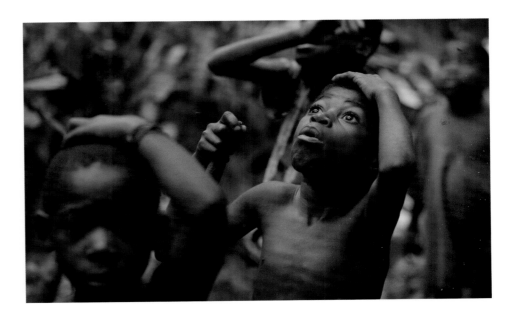

ABOVE *Children watching in awe as Mongonjé climbs even higher. Such skill commands great respect among the BaAka.* LEFT *Tété's wife and child feasting on the honey. Women consider honey-collecting an important skill for a man, and men know one of the best ways to please a wife is to provide her with honey.*

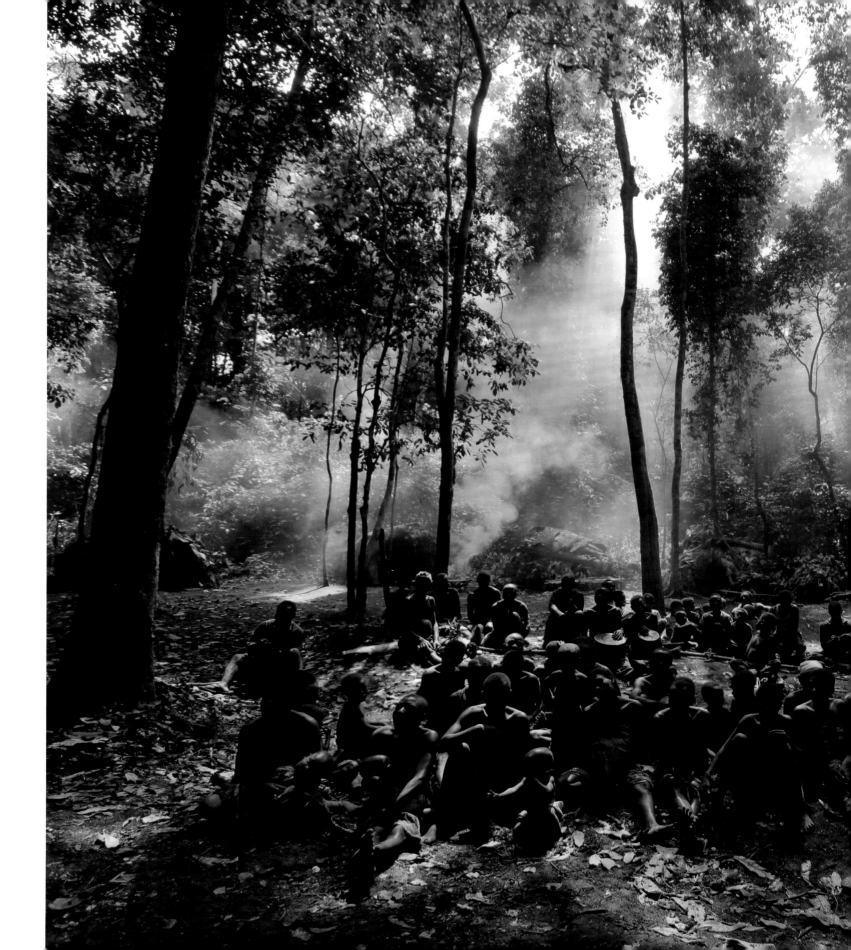

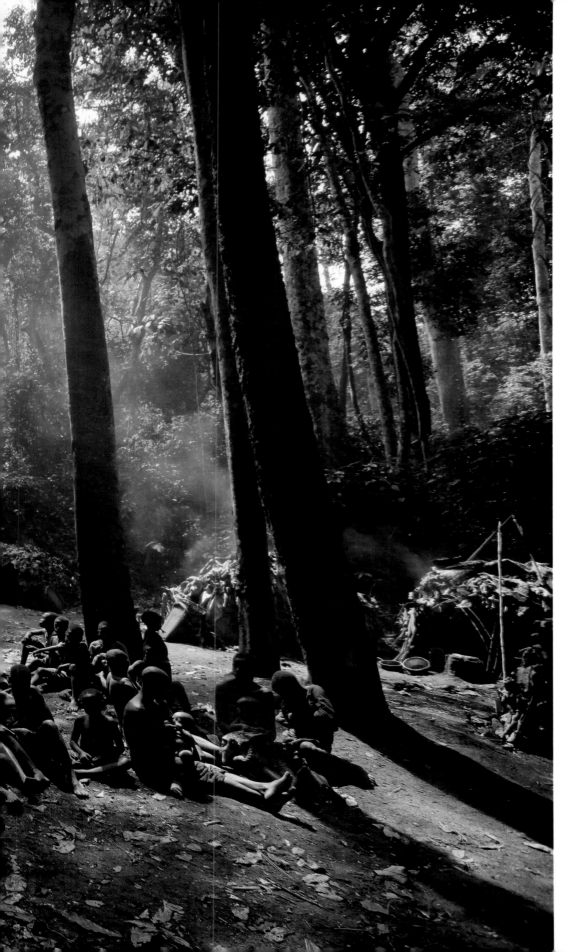

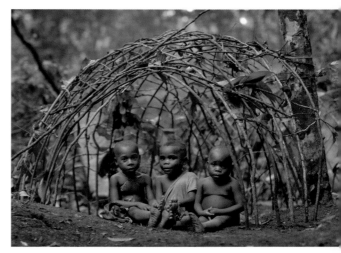

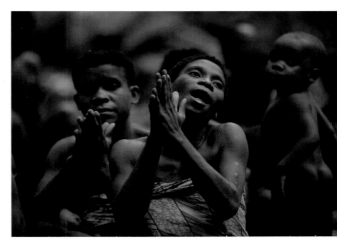

LEFT *A BaAka group from Yandombé gathered in a forest hunting camp for a ceremony of singing and dancing. Though they now live in a roadside village, this pygmy group is most happy when in the forest and will spend months in their hunting camps.* ABOVE *Joining in the rainforest-inspired music.* TOP *BaAka children outside a half-built hut frame woven from saplings.*

HARNESSING THE ELEPHANTS

Tropical hardwood extraction is big business, resulting in massive deforestation. The area of the planet covered by tropical rainforest has shrunk to about a third of what it was just a century ago, and the destruction continues at a rate of about ten football fields every minute. Many attempts to regulate the logging industry have been made, but the promise of profit usually outweighs any desire to protect the environment.

There are, however, ways to extract rainforest timber without clearfelling, which is the most destructive forestry of all. One of the best ways to log selectively also happens to be one of the oldest, harnessing the might of the forest's largest animals.

Asian elephants have been used as beasts of burden for many millennia, and even today, elephant logging occurs in a number of places, in particular the rainforests of Burma (Myanmar). The Burmese jungles are rich in teak trees, which are the country's second-largest export, and ever since commercial elephant-logging techniques were introduced by the British about 200 years ago, it has been the preferred method to harvest timber. Today, about 4500 elephants are employed.

Towards the end of the monsoon, truckloads of elephants are taken to the various logging concessions. Here the elephant drivers, known as oozies, and their families set up camp for the season, with up to 200 working elephants each. Extraction sites are deep in the forest, where selected teak trees are marked and then felled by chainsaw. The oozies and their elephants then begin the task of hauling the huge logs through the forest to the rivers or roads, where they can be floated or driven down to the sawmills.

Elephants are adapted to rainforest life and so make ideal logging machines. They have the strength to lift and drag timber weighing 2 tons, and yet they're nimble enough to manoeuvre through thick vegetation. By comparison, getting heavy machinery to individual trees necessitates clearing vast tracts of forest. Also, while elephants can negotiate rivers and mountain slopes to get to timber, convoluted road routes are needed to get machinery in. The more roads there are, the more poaching and slash-and-burn farming penetrates the rainforest. Elephants are also more practical because the only fuel they require is forest vegetation and they don't need spare parts.

But working with elephants is not without its problems. They rarely breed in captivity, and so young ones have to be captured from the wild and then trained. Taking a young elephant from its herd seems cruel enough, but breaking in an elephant – conquering its will so the oozie has total control – can last months and, at worst, is nothing short of torture. The oozie has to teach it how to react to different commands and, most importantly, forge

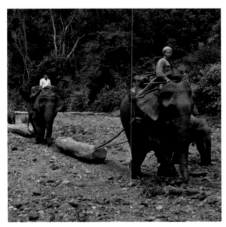

a bond of trust – if an elephant decides to turn on him, it could easily kill him. The sometimes tender, sometimes brutal relationship between oozie and elephant is one of the most remarkable partnerships between man and animal.

In many ways the elephants are well cared for, and they are even allowed to feed free in the forests at night, but it is undeniable that they suffer. Yet, in Burma, logging with elephants in preference to machinery has not only helped sustain the largest tracts of rainforest left in Asia but has also protected the habitat of the only remaining healthy population of wild Asian elephants. Now, though, new international logging operators are moving into Burma, wanting quick profits and destroying the forests at an alarming rate. It may not be long before Burma's elephant-logging industry disappears and, along with it, the largest remaining population of wild Asian elephants.

ABOVE *A Burmese oozie guiding his elephant as it uses its tusks to lever teak logs onto the riverbank.*
LEFT *Cows, followed by their calves, pulling logs down to the river. Using elephants to move timber is far less destructive than using machinery, but the relationship between elephant and human is often a brutal one.*

NO FOREST, NO PEOPLE

Devastation is happening in all rainforest regions, whether through timber extraction or clearance for agriculture. Once trees are removed, the ecosystem rapidly deteriorates. It's a lesson learnt throughout history: civilizations that haven't respected this have eventually failed. The causes for the demise of the Khmer empire of Southeast Asia and the Mayan civilization of Central America are still debated, but overexploitation of the forest and attempts to dominate nature are believed to be at the centre of both downfalls.

The spectacular Angkor Wat, Ta Prohm and other Khmer temples in Cambodia are remnants of what is considered the world's largest pre-industrial city, home to more than a million people and the centre of the Khmer empire. The metropolis of Angkor flourished for about 500 years, but excessive stripping of vegetation and re-engineering of the landscape to sustain the burgeoning population eventually caused its collapse.

The existence of the Khmer and Mayan empires proves that it's possible for humans to carve civilizations out of the jungle, but they also remind us that rainforest environments are finely balanced – even the removal of a single species can provoke unpredictable and far-reaching consequences. But whereas in the past such destruction happened at a relatively local level, today it is on a global scale. The continued loss of rainforest could be catastrophic for humanity. They create about a third of the oxygen we need to breathe and absorb carbon from our excessive emissions. They are also full of undescribed species, some of which could change the course of human history, whether through medicine or technology.

JUNGLES

ABOVE *One of many temples in the Angkor complex, Cambodia. Once part of the largest pre-industrial metropolis, they were overgrown by jungle when the civilization collapsed.* **RIGHT** *A monk entering a strangler-fig-covered doorway at Ta Prohm temple, Angkor – still used as a holy site by Buddhists.*

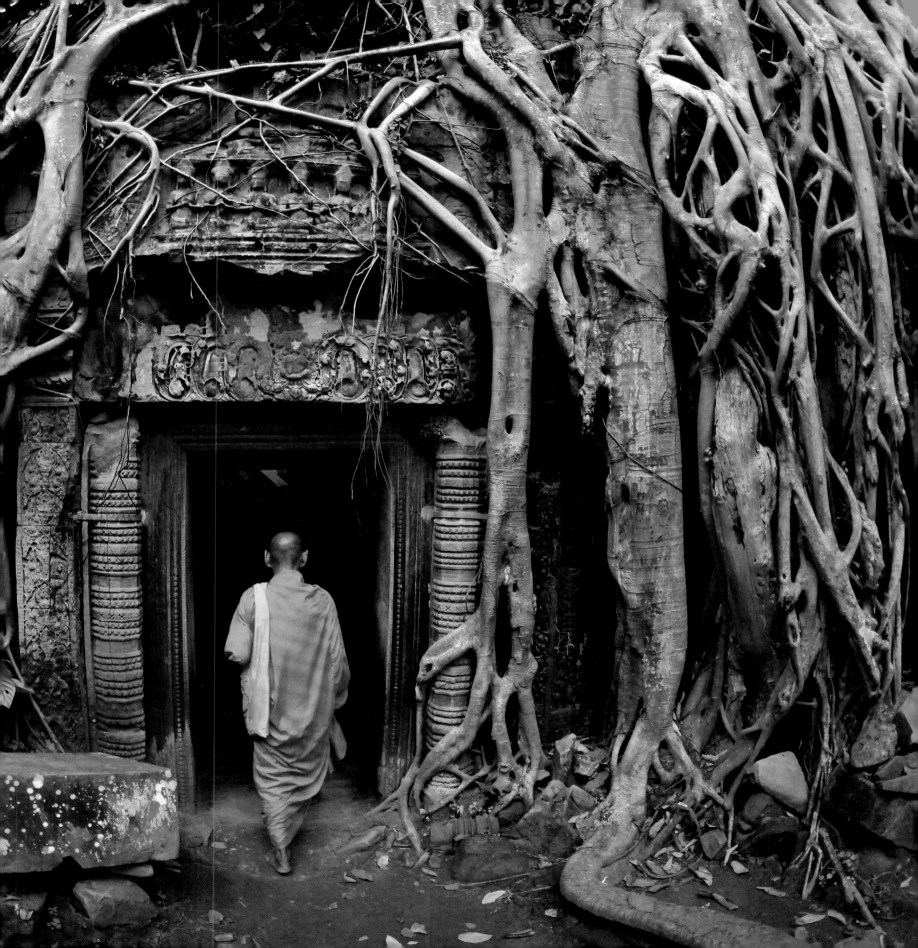

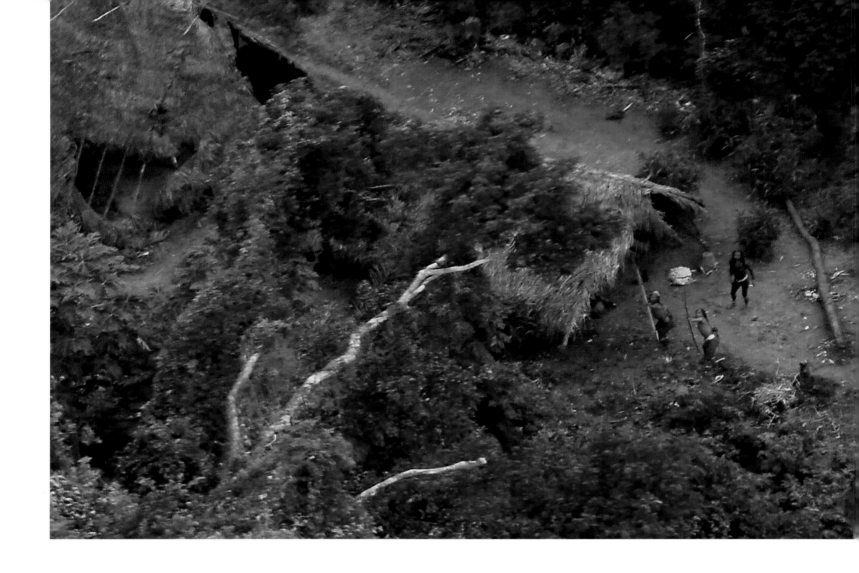

THE CURSE OF CONTACT

It isn't just new species that remain undiscovered in the rainforests. Incredibly, in the largest remaining rainforest areas, there are still isolated tribes whose cultures we know little or nothing about. In West Papua there are believed to be as many as 44, and in the Brazilian Amazon about 67. It's not correct to refer to them as 'uncontacted', as through history these people are likely to have had interactions with neighbouring communities and colonizing cultures. But for a variety of reasons, they have chosen to avoid interacting with the outside world. This situation is rapidly changing, though, as loggers, miners, poachers, ranchers and farmers penetrate ever deeper into the forests.

When contact is made, the results are rarely positive. Often treated as sub-humans with no rights and no powers to protest, they are at the mercy of the attacks of

ABOVE AND RIGHT Men from an 'uncontacted' tribe in warpaint, threatening a spy-plane. Little is known about this tribe, which lives in Brazil close to the Peruvian border, but photographic proof of its existence makes it possible to launch campaigns for the people's rights and protection of the rainforest where they live.

people who want to force them from the land so that it can be cleared. Once exposed to western culture, they are vulnerable to prostitution and drug addiction. But perhaps the biggest threat these tribes face is disease: having spent so much time in isolation, their immune systems are poorly adapted to cope with outside diseases. Almost all recently contacted tribes have thus suffered huge population losses – even a simple cold can prove fatal.

The plight of the Awa-Guaja tribe of eastern Brazil highlights the problems faced by tribes that have recently been forced to adapt to the modern world. They once lived in permanent settlements, but waves of European invaders in the nineteenth century forced the Awa-Guaja to flee back to the forest and adopt a nomadic hunter-gatherer lifestyle. They lived in this way for about 150 years until about 30 years ago, when logging, mining and the construction of a railway forced them back into contact with outsiders. Many were massacred by loggers and ranchers, and even more died during epidemics of flu and malaria. In an attempt to manage the situation, the Brazilian government tried to settle the tribe and assimilate the people into modern culture.

Though about 60 Awa-Guaja have managed to remain living as forest nomads, most have been settled in villages. All are scarred by persecution and are still struggling to come to terms with a different way of life. Yet their culture remains entwined with the forest, a legacy of the time when they depended on it for everything they needed.

MONKEY MOTHERCARE

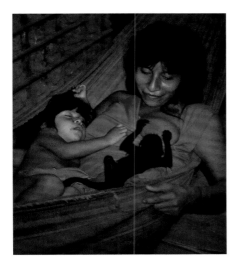

Like the Matis, and indeed many Amazon tribes, even the settled Awa-Guaja hunt monkeys for their main source of protein. When they shoot female monkeys, they often catch their young as well, but instead of killing them, they take them back to their villages and rear them by hand, nurturing the orphans almost as if they were human babies, even breastfeeding them. The Awa-Guaja see this as a way to rebalance the spiritual consequences of their hunting activity. But also, like many of us, they have an emotional attraction to baby animals, especially ones that look so human.

When the monkeys are old enough to fend for themselves – or become too troublesome – they are released back into the forest. It has been suggested the Awa-Guaja do this to maintain healthy hunting populations, but the effect would be minimal, as the monkeys tend to hang around the villages. They're useful sentinels, though, warning of intruders and also luring wild monkeys closer to the village.

ABOVE *A woman from the Awa-Guaja tribe in Brazil breastfeeding her pet monkey while her child sleeps. The Awa-Guaja are famous for their intimate relationship with monkeys. Though they hunt them, they also consider monkeys sacred animals, and any babies caught during a hunt are hand-reared and then released.*

CANOPY LIVING

The more isolated clans of the Korowai tribe of West Papua live as close to a true hunter-gatherer existence as any people today. They are one of very few societies that have retained the knowledge of how to get everything they need from the natural world. They are best known, though, for having taken human adaptation to the forest to new heights.

The Korowai and the neighbouring tribe, the Kombai, are the only cultures known to inhabit treehouses. These are built around large trees as much as 35 metres (115 feet) off the ground and are constructed with skill and the involvement of the whole community. All the building materials come from the forest, and different plants are selected for each stage of the construction.

The first stage is to clear an area around the chosen tree or trees (often iron trees, which are incredibly strong). Though some Korowai have acquired metal axe-heads, much of this work is done with stone axes. Long, thin saplings are then bound together with rattan twine to create a ladder up the tree. At approximately 10-metre (32-foot) intervals, wooden platforms are constructed onto which more wood and other materials are hauled up using strong vines as ropes. Once in the crown of the trees, the people begin to build the house itself, which can vary in size from a shed to a bungalow.

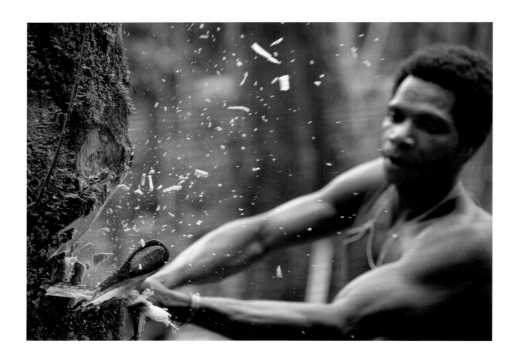

JUNGLES

ABOVE *A Korowai man chopping down a rainforest tree in central West Papua, Indonesia, in preparation for building a new treehouse. A Korowai clan will clear an area of trees, partly to provide enough wood for construction but also to improve the view and vantage points. Many still use stone axes.*

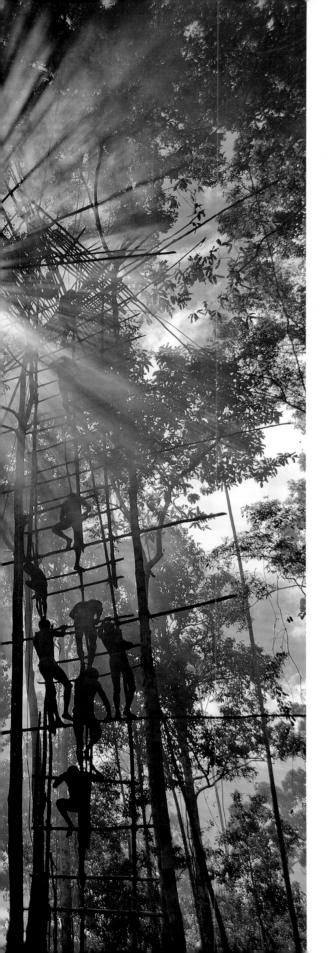

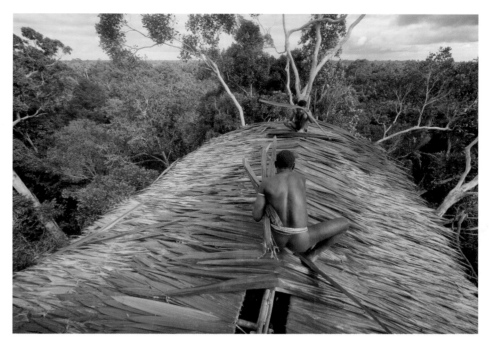

The Korowai build a frame, thatch the roof with palm leaves and make the walls out of rolls of bark stripped from large tree trunks. At one end of the house, they build a balcony where people can relax, have a smoke, enjoy the view and survey their territory.

These houses are remarkable feats of natural engineering, rendered all the more impressive by being constructed at such dizzying heights. There are practical reasons for these high-rise dwellings: the lowland rainforest is swampy and can get waterlogged after heavy rain, height can give relief from mosquitoes and other biting insects, and living in trees gives them protection from attack by neighbouring tribes. The Korowai also believe 'witches' haunt the forest floor. But perhaps the main reason is that treehouses express the tribe's status and prowess. The Korowai place great value on territory and like to display the fact that they can build dwellings in the far reaches of their land, both horizontally and vertically. Much like skyscrapers in cities, treehouses are symbolic of the tribe's dominance over their environment, and the larger the house and the higher it is, the more accomplished its builders have to be.

A treehouse usually takes between two weeks and a month to complete. Clay fire-pits for cooking are moulded, and then the first fire is lit as a house-warming ceremony. When an extended family moves in, so do their pigs, dogs and cassowaries, which quickly become accustomed to life 30 metres (100 feet) above the ground. Even more extraordinary is the

LEFT *Starting the construction. A treehouse can be up to 40 metres (130 feet) high. It's a symbol of a clan's status and a way to escape witches on the forest floor. Expert climbers, the Korowai work with no safety lines.* ABOVE *Young Korowai men putting the finishing touches to the sago-palm-thatched roof.*

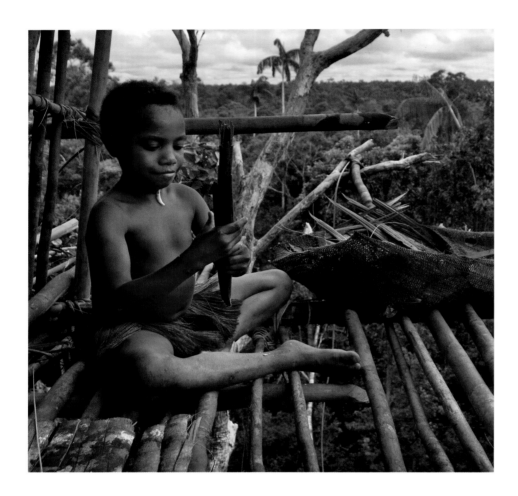

confidence with which children charge about their high-rise homes. Toddlers are given minimal supervision and often play precariously close to the edge of the balcony, but when life is reliant on being at home in the trees, the lessons have to start early.

The Korowai are no more evolved to arboreal life than we are, but they demonstrate how ingenuity and resolve enable us to adapt to almost any environment. The need to survive has forced the Korowai and other hunter-gatherer cultures to learn to live as an integral part of the rainforest. But it is this specialization that also renders them so vulnerable in an increasingly global society. As the rainforests are degraded or destroyed, they lose their only means of survival. It is remarkable that even among the homogeneity of humanity in the twenty-first century, there are still some people who have managed to remain living so intimately with nature, but unless the global community realizes the true value of tropical rainforests, this will not be the case for much longer.

ABOVE *A young Korowai girl, Dua, preparing sago by wrapping it in palm leaves on her treehouse balcony, 35 metres (115 feet) up in the rainforest canopy.* RIGHT *Dua's house. Food, water and firewood have to be carried up, along with the tribe's dogs, cassowaries and pigs.*

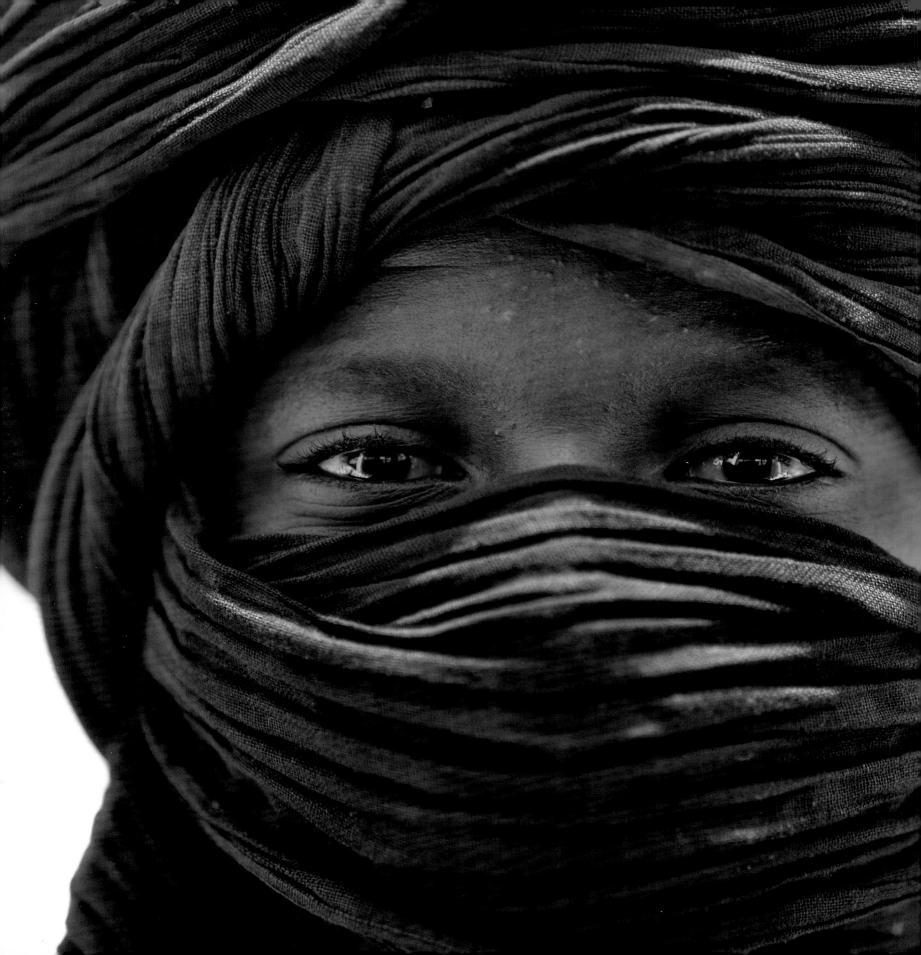

DESERTS

5

WHEN ASTRONAUTS FIRST LOOKED BACK ON EARTH FROM SPACE THEY SAW A BLUE PLANET. YET WHAT MADE THE STRONGEST IMPRESSION WAS NOT THE ULTRAMARINE OCEANS BUT THE GREAT DESERTS – THE GOLDEN CRESTS OF DUNES IN THE NAMIB AND THE EXTRAORDINARY REDS OF AUSTRALIA'S GREAT SANDY DESERT. THOUGH DESERTS MAY NOT SHOW ANY OBVIOUS SIGNS OF HUMAN POPULATIONS WHEN VIEWED FROM SPACE, AT LEAST 400 MILLION PEOPLE LIVE IN THESE ARID AREAS – MORE THAN THE POPULATION OF THE UNITED STATES. THEIR CULTURES ARE VARIED AND VIBRANT, BUT ALL ARE LINKED BY ONE THING: AN UNDERSTANDING OF THE VALUE OF WATER AND HOW TO LIVE WITH SO LITTLE OF IT. THE TUAREG NOMADS PUT IT SIMPLY: 'WATER IS LIFE.' AND IN ALGERIA THEY SAY, 'A MAN CAN OWN AS MUCH LAND IN THE DESERT AS HE LIKES, BUT WITHOUT WATER HE HAS NOTHING.'

It is the lack of water that defines a true desert: a place where less than 25cm (10 inches) of rain falls in a year, though many deserts receive far less than this and in a hugely unpredictable way. Our human quest to find and secure water underpins our fundamental relationship with nature. The challenges, ingenuity and endurance such quests demand, as well as the prizes and subsequent dangers that stem from their successes, are the subject of this chapter. Deserts are expanding faster than any other environment on Earth, and so it's even more important to learn from those people who know how to survive in the desert.

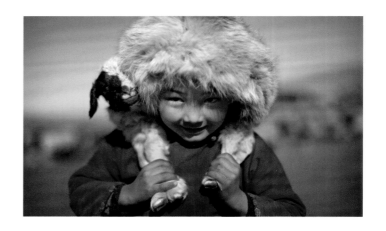

ABOVE *Young Mongolian nomad in charge of the baby goats.*
OPPOSITE *Tuareg nomad during a sandstorm in the Sahel, Mali. His turban* (PREVIOUS PAGE) *protects him from the heat and the sand-laden winds.*

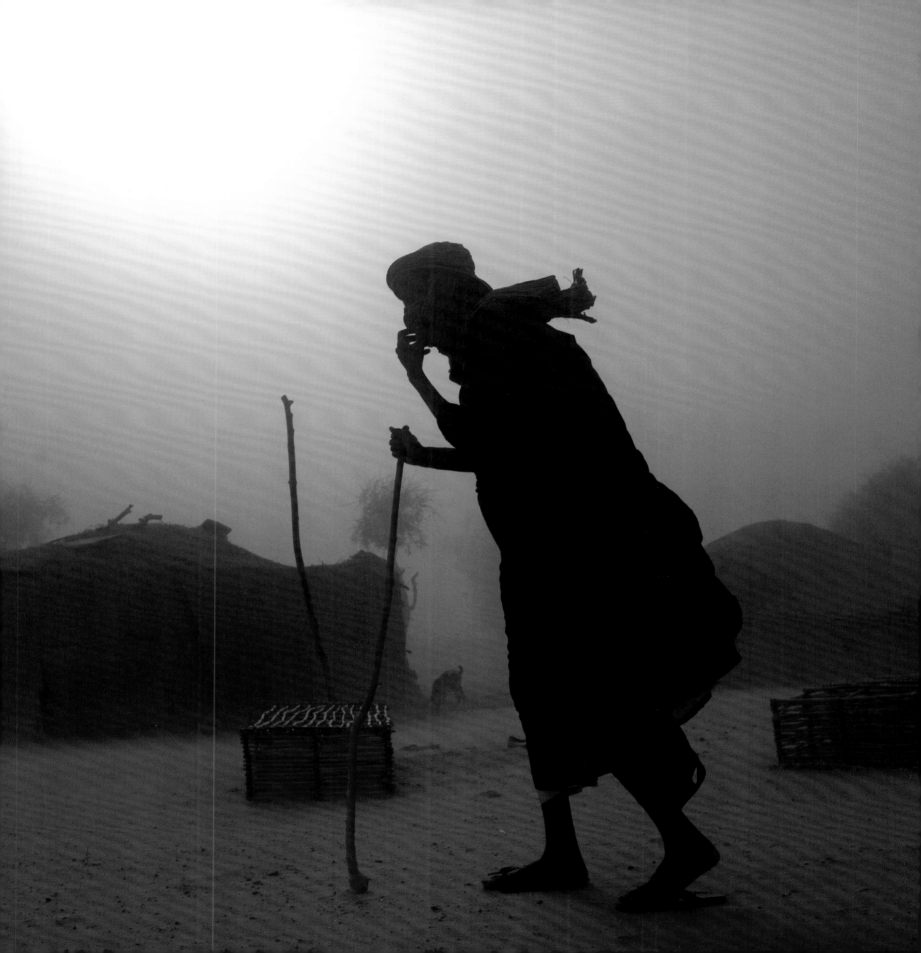

DRY, HOT AND DEADLY

For a baby born in the desert, birth is a stark transition from a world of water in its mother's womb to a world of water stress. Our bodies are 60–70 per cent water, and though we can go weeks without food, most people live only three to four days without water. It's not just the lack of available water. Heat robs the body of water, as do the hot, dry winds, which shrivel the skin and dehydrate nasal passages. A rise in core body temperature above 42°C (108°F) is lethal, and most cells die if exposed for just a few minutes to temperatures of 50°C (122°F). The hottest air temperature recorded is 57.8°C (136.4°F), in El Azizia, Libya, in September 1922, and in many deserts, temperatures routinely top 45°C (113°F). So how do humans survive the desert heat?

Sweating can increase heat loss almost twentyfold, and our great number of sweat glands gives us one of the highest sweat rates of any mammal – but at the expense of substantial water loss, up to 3 litres (5 pints) an hour. This can't be sustained for long in dry desert air. A 5–8 per cent loss leads to dizziness and fatigue; more than 10 per cent leads to mental and physical deterioration; 15 per cent is fatal. Death by dehydration is excruciating. As one experienced desert traveller put it, 'You feel as though you are in the focus of a burning glass. The throat parches and seems to be closing. The eyeballs burn as though facing a scorching fire. The tongue and lips grow thick, crack and blacken.'

But there are many ways to avoid dehydration. The most obvious is to seek out shade and rest in the heat of the day, and long, flowing robes keep the sun off the skin while allowing sweat to evaporate. Some cultures even live under ground. By these and other ingenious means, humans have inhabited every desert of the world, including the driest, the Atacama; the biggest, the Sahara; and the most extreme, the Great Gobi.

Deserts are not only hot. Without clouds to hold in the warmth, they can experience daily temperature fluctuations of 20°C (36°F), with winter frosts at night. Only specialized plants can survive such extremes, which means there is little humous and so soils are poor. Often plants germinate, flower and set seed very quickly, to coincide with the sporadic rainfall. People and their livestock are therefore forced to live in small groups on meagre resources spread over great distances. The Tuareg of the Sahara have a saying about the austerity of desert living: simplicity is freedom.

The lack of soil and plants to bind it mean that the dust can be swept up by the vicious winds, obliterating the horizon and wiping away tracks. Rain can come as flash floods, catching people or livestock unprepared and sweeping them away. Or worst of all, the rain may not come at all, forcing whole communities to migrate.

DESERTS

RIGHT *The great Erg of Bilma, in the southern Sahara. Seen from above, the dune ridges seem obvious, but the Tubu caravans that cross this sand sea only ever see it from the ground, making the topography far harder to read. Add to this the shifting nature of the dunes, and the Tubus' ability to navigate seems truly remarkable.*

THE WORLD'S MOST GRUELLING SHOPPING TRIP

In the desert even the most basic tasks require extraordinary determination. For the Tubu of the Sahara in northeastern Niger, there's not enough water to cultivate crops. So shopping for supplies means a three-month camel trek. It's the women who make the journeys, leaving their husbands at home to tend to flocks and the youngest children.

The first major expedition ten-year-old Shedi makes is with her mother Foni to the oasis town of Fachi over the great Erg of Bilma – a sand sea that takes eight days to cross. They are part of a caravan of 12 women, 4 children and 30 camels entering the dunes from the last rocky landmark. This is the start of her navigational education. Foni herself did it twice with her own mother, as a young child and a teenager, before she was considered to have the knowledge. Their journey is across sand dunes, with no landmarks or escarpment to follow. Their halfway goal is a well by a small tree between dune ridges. If they are just a few hundred metres out, they will miss it and the life-saving water that they need to complete the crossing to Fachi, a further four days' walk. The Tubu travel without a map, in a landscape that is constantly shifting. The sands are blown into a bewildering array of shifting shapes, and the dunes creep, grow or, with a turn of the wind, spread and die. In days they can dwarf a person, in a few weeks engulf smaller dunes or even settlements. All things become entombed, uncovered and reburied in endless cycles.

The Tubu know that the dunes migrate downwind, and though individual dunes might align themselves in several directions over the year as the winds shift, and grow or diminish, the dune fields or ridges tend to stay in the same place. Thus, on their 150km (93-mile) journey, Foni and her fellow travellers know that, after 2 days, when they reach the great sand wadi, they must count 33 dunes before they arrive at the Drayaska dunes. It's then just a one-and-a-half-day ride to Fachi.

Shedi has to learn not only the different routes but also the types of desert and how to describe them. *Sahar*: sand alone, without water or permanent paths. *Ghrud*: dunes or sand hills. *Serir*: gravel plains of rounded, sharp or polished rocks. *Hatia*: areas that may be fertile, with enough scrub and grasses for a camel to survive. Shedi must also be able to read the sand – its colour, texture and strength. Soft sand on the exposed windward sides of dunes could swallow a camel up to its belly, but the crest and leeward sand is more compact and can carry a greater weight. Some areas that look like flat, greyish rock are, in fact, dry clay beds and liable to crack, sending up smoky fine dust as a camel sinks into it to its knees. If you can see the grey, you can avoid such a trap, but often the clay has a thin dusting of blown orange sand disguising its surface. Other

sand in the dune shadow is a darker, richer gold with less distinct surface patterns; this is moist and heavy going for camels (and treacherous for a four-wheel-drive vehicle).

Foni and the other Tubu women travel light, taking camel cheese and fetid camel meat, green and crawling with maggots, as a delicacy to sell in Fachi. Their aim is to buy dates, which they carry south out of the desert to trade for millet, before returning home three months later. The group survives on sweet tea and porridge, setting up camp near areas of sparse desert grass to allow the camels to forage.

The qualities of the camels make their trading expedition possible. Unlike humans, a camel is unaffected by a 25 per cent water loss, enabling it to survive seven days without water. It can also store water in its body, partly as fat in its hump, and on reaching water can drink 120 litres (26 gallons) in just ten minutes. It can cope with fluctuations in its body temperature to avoid sweating, and it conserves water by producing dry faeces and tiny amounts of urine. Thick eyelashes and individually closable nostrils keep out sand and dust, and splayed, padded feet enable it to walk on hot sand or freezing snow.

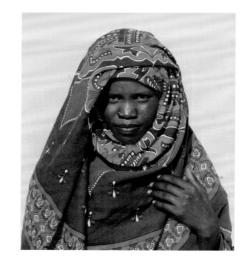

For Foni and her caravan, the footprints of camels that have travelled before them are important signs, and one of their greatest problems is the winds that obscure such tracks, blot out the horizon and disorient the senses. These winds are caused by the rotation of the Earth and air heated up by the massive furnace of the desert. In each desert they have characteristic patterns, and the worst winds have names. The hated Saharan wind is the Harmattan, which blows north and west, and is the strongest, driest and hottest of them all. The Tubu call it *shai-halad*, the mother of storms, and it is the most feared by desert caravans. Such a sandstorm can create a massive wall of sand 3km (1.9 miles) long and 100 metres (330 feet) high, overwhelming everything in its path. It can whip up gales of 145kph (90mph), travelling with a hiss or rumble like thunder. The air is oven-hot and charged to the point where camels' tails have been seen to spark and crackle and objects spontaneously combust. It strips the air of moisture and scours exposed skin like hail. Camels kneel with their backs to the wind and close their long-lashed, double-lidded eyes. The Tubu will also hunker down and wait out the storm.

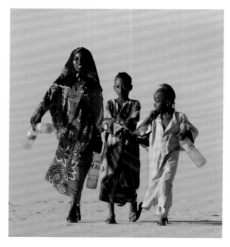

Foni's camel train cannot afford a delay. They have enough rubbery-tasting water in truck inner-tubes to get them to the well, with a little spare – but not enough to get them home. Every evening they fine-tune their route by alignment to the North Star, and on the fourth day, they come over the ridge to see a distant tree on the other side of the dune valley. Below it is the little well. Four days later, when the women and children enter Fachi through the date palmeries, they have the glint in their eyes of shoppers looking for a bargain. For a while, the rigours of the desert are over for them.

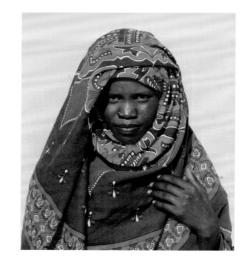

RIGHT, TOP *A Tubu teenager on her second desert crossing. She is now regarded as knowledgeable enough to lead her own caravan.* RIGHT *Shedi (centre) on the way to the well. Every container is precious, whether recycled plastic bottle or truck inner-tube.*

DESERTS

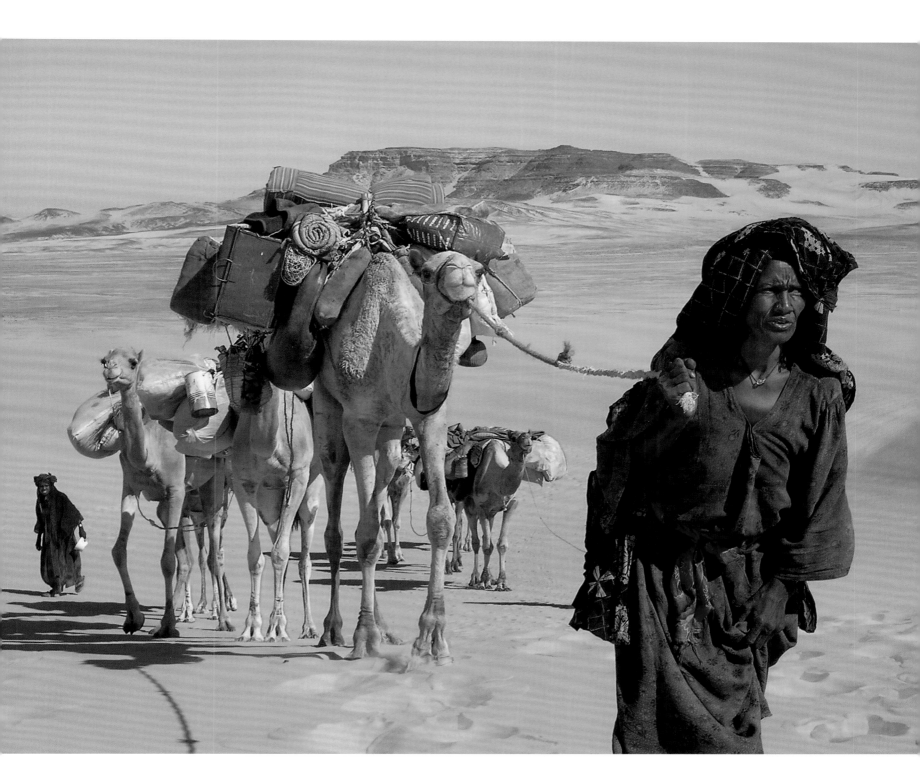

ABOVE *Making the long desert crossing south to the oasis settlement of Fachi. Here the women trade camel cheese and camels for dates. They travel with few possessions, water being the main baggage, along with bedding rolls and a little firewood for making camp, and they won't return home for three months.*

WATCHING THE POOLS DRY

Few desert tribes attempt to enter the sand seas. When they find water, they don't stray far from it. The nomadic Fulani cattle herders of western Africa will stay by a pool for as long as the meagre pasture or water holds out, before moving on. In Mali, the Fulani share the desert with the last nomadic Sahelian elephants, which will cover 56km (35 miles) in a day to find water. In general, the herders and elephants tolerate each other and drink at different times. But as the fierce heat of the dry season presses on into May, the temporary pools turn into fired earth.

The herders and their livestock and the 350-strong elephant herd eventually end up at the oasis of Lake Benzena. But at the height of the 2009 drought, there wasn't enough water for all. It was a situation that tested the herders usual tolerance beyond the limit.

The herders have to run the gauntlet of thirsty elephants. Mamadou needs to make a way through for his cattle, which will die if they don't drink. He warns off the elephants by shouting, banging, throwing sticks and clapping his sandals together. In the uneasy stalemate, the elephants stand their ground, with the ever-present threat that they will charge. But Mamadou gets his cattle through. Mamadou and the other herders do, however, also benefit from the elephants. Elephants can smell water over great distances and know when distant rain has fallen. When they leave Lake Benzena and head south, the Fulani follow, in the hope of finding new pasture.

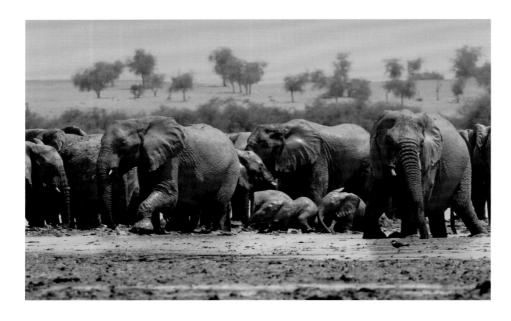

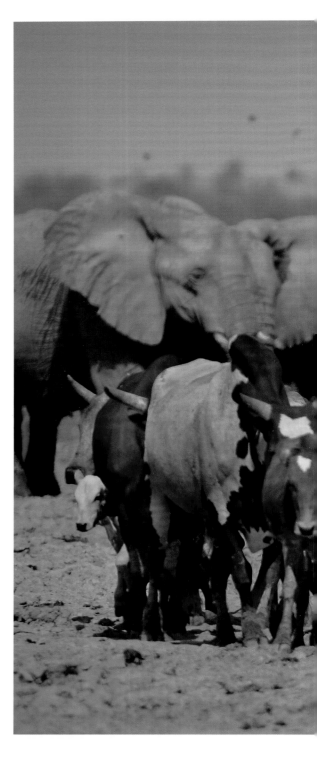

ABOVE *The last remaining herd of Sahelian desert elephants making the most of the dwindling water in Mali's Lake Benzena.* RIGHT *Driving the cattle back from drinking at the lake. Fulani cattle herders must water their herd daily, but as the lake dries, they are forced to compete with the elephants.*

DESERTS

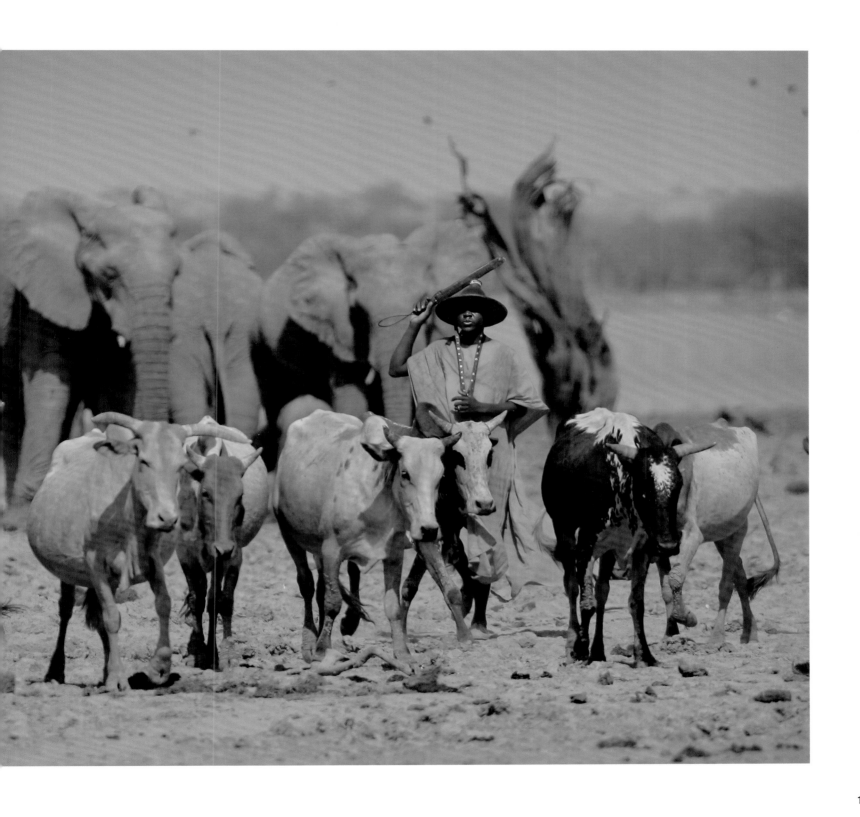

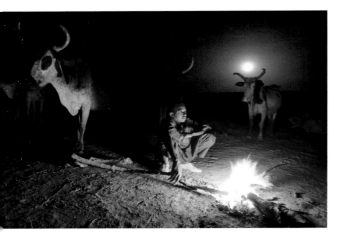

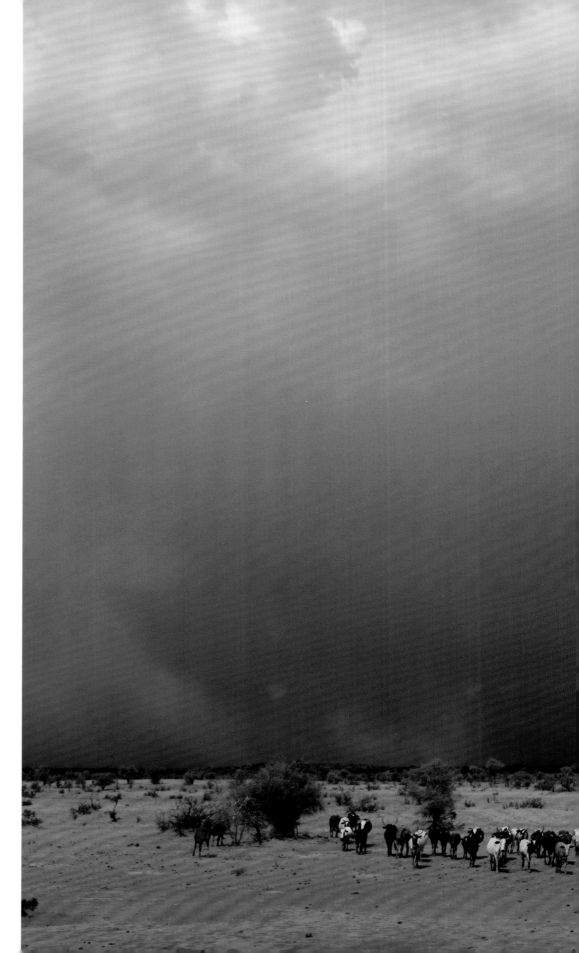

ABOVE *Mamadou guarding his precious cattle. Firewood is a scarce resource in the desert, but not as scarce as water. In recent years, droughts in the Sahel have become more severe, leading to occasionally conflicts between the cattle herders and the elephants. But the elephants can also smell distant rain and so can lead the herders to new water sources.*

RIGHT *Mamadou pushing his cattle away from the wall of sand building up behind. Reaching great heights and stretching many kilometres, such sandstorms may last days. Mamadou has no shelter, and once he is engulfed by the swirling sand, he will just have to sit it out. Endurance is an essential part of desert life.*

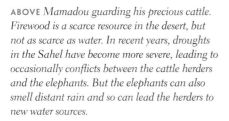

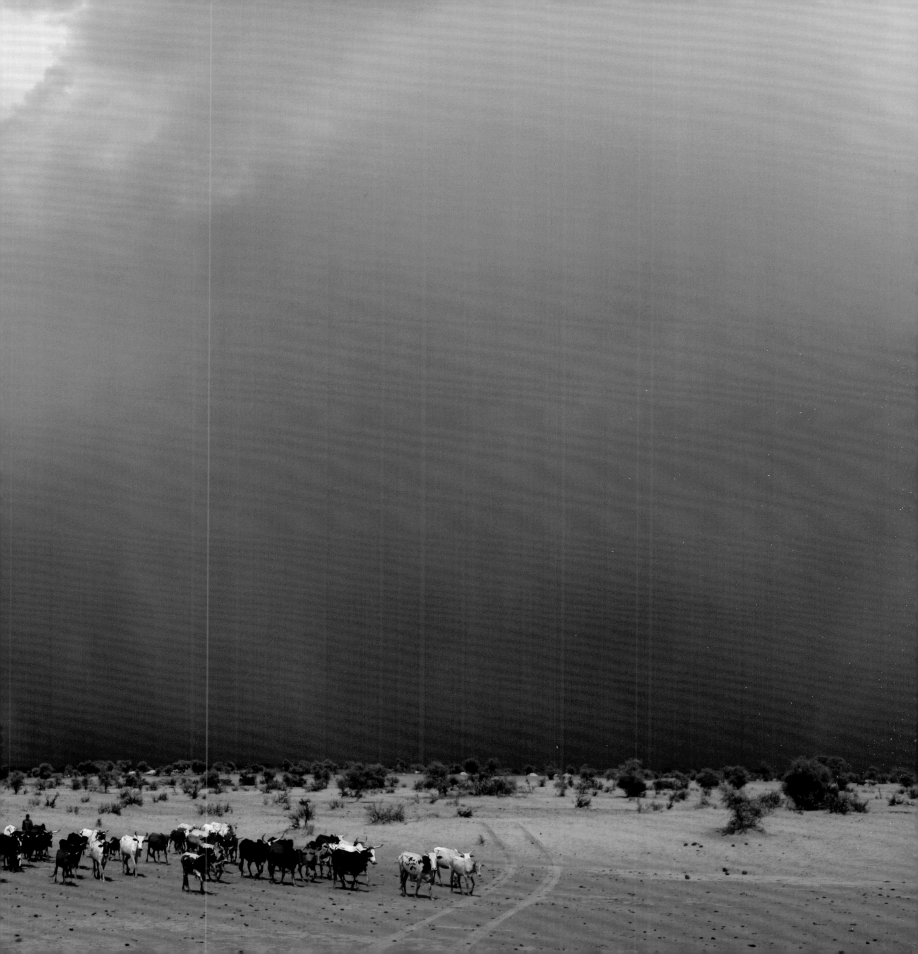

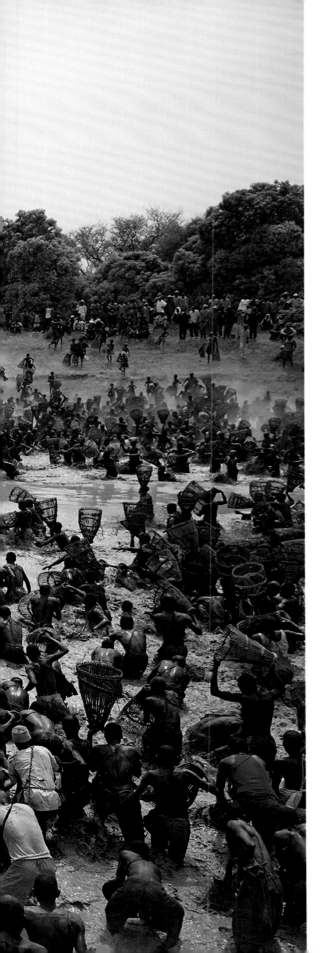

THE DESERT FISHING CONTEST

As the water dries further, the fierce heat builds up above 40°C (104°F), scorching the earth and making food scarce. Tributaries of the Niger River shrink to isolated lakes, then evaporate into muddy pools. But the Dogon people of Mali know how to turn it to their advantage. The catfish that have spawned in the tributaries have become trapped and concentrated in the pools, nowhere more so than in Antogo, a lake protected by the Dogon elders and fished only once a year.

At dawn on the day of the great fishing expedition, the men, carrying their conical traps, walk to the lake in a procession behind the elders. Thousands of men and boys, stripped to the waist, ring the small expanse of water. Incantations and gunshots excite the crowd, but then there is a hush. At the priest's signal, up to 3000 people go fishing in the desert. They work shoulder to shoulder, each trying to catch the most. As they force their traps into the water, the pool turns into a mudbath. In the frenzy, mud flies, fish slither out of muddy grips, and catfish are stuffed live into the leather fishing bags. In just 15 minutes, the lake is nearly empty. Then, in contrast to the competition in the lake, the catch is shared out between every family in preparation for a great feast. Such cooperation provides protein for all in this season of famine. When the rains come, the lake fills up and the river flows in, and Antogo is once again replenished with fish.

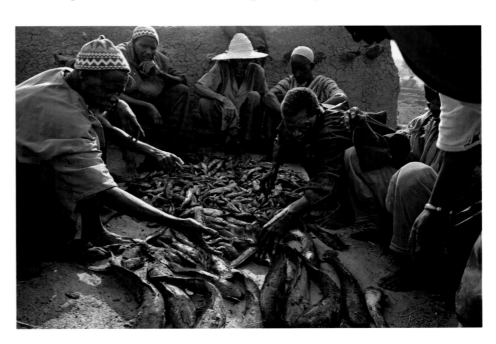

LEFT *The desert bonanza of Lake Antogo, Mali. The fishing frenzy takes place once a year for 15 minutes when, at the elders' signal, the Dogon men rush into the shrinking pool for the prize of catfish.*
ABOVE *The catch is shared out between the village families – a feast before the dry-season famine.*

THE HERDSMEN WHO CHASE SNOW

The last water is not always liquid, especially when the deserts are not hot but cold. In the Mongolian Gobi Desert, the surface water is long gone before winter. Chilling snows bring brief relief from the heat of summer but also challenges for the camel herders who chase the snow. There are no permanent water sources, summer temperatures of 45°C (113°F) drop to winter lows of -40°C (-40°F), and the land is whipped by 80kph (50mph) winds from Siberia, making this one of the world's harshest deserts. In the depths of a freezing desert spring, moisture can be found as flakes of snow, covering the grey, pink and orange landscape with a blanket of white.

As in the Sahara, the camel is the key to life, but here, rather than the single-humped Arabian dromedary, it is the twin-humped Bactrian that has been domesticated. The camels are used as both transport and pack animals, their shaggy winter coats provide wool for blankets and rope, and their milk is a staple for drinks, fermented into cheese and even distilled to make a vodka. For herders such as Ganbold, the snow waters his flocks, and he shifts his mobile ger home to take advantage of it. Yet no sooner does life-giving snow arrive than vicious winds blow it away. The dune crests shed drifts of sand and snow. Where new sand covers snow, the wide, padded feet of the camels push through the sand and kick up snow beneath. The intense sun evaporates the snow at such speed that no meltwater ever forms. So Ganbold and his camels have to chase the snow.

ABOVE *Gobi Desert camp. In winter and spring, the herders must follow the snow to keep their livestock watered – snow that quickly evaporates or is blown away.* RIGHT *Ganbold on his favourite camel. A Bactrian camel takes five years to train, but it can travel anywhere in the dunes and mountains, unlike a vehicle.*

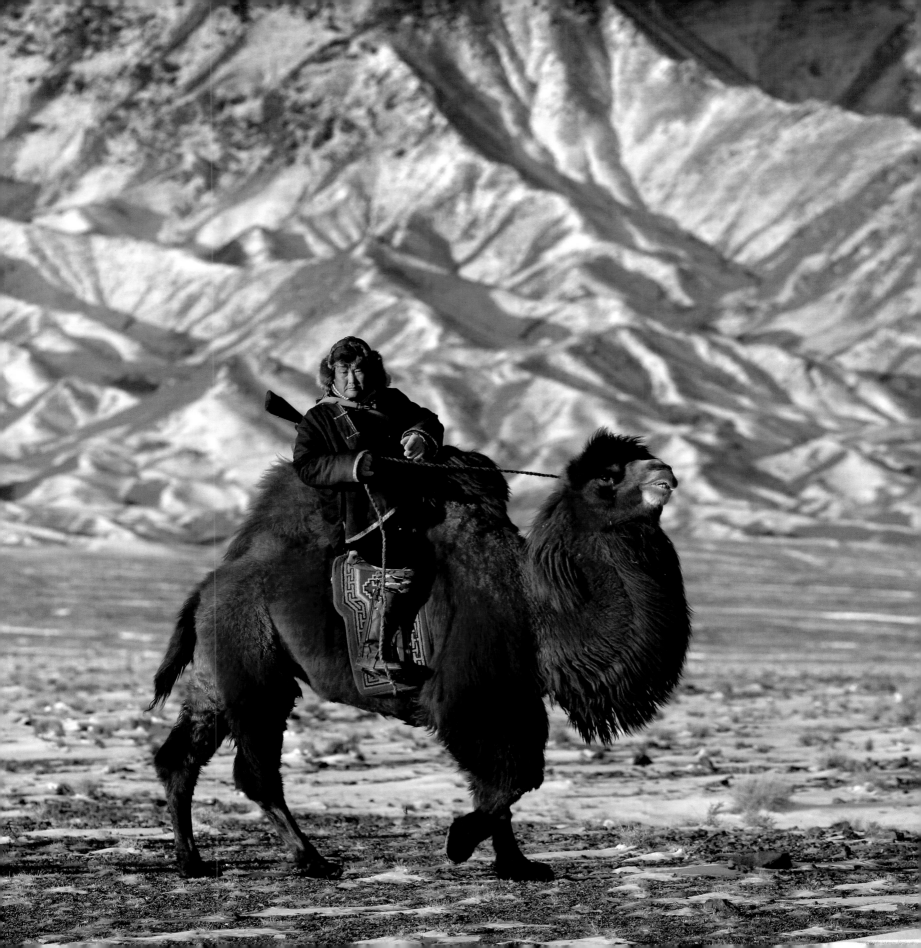

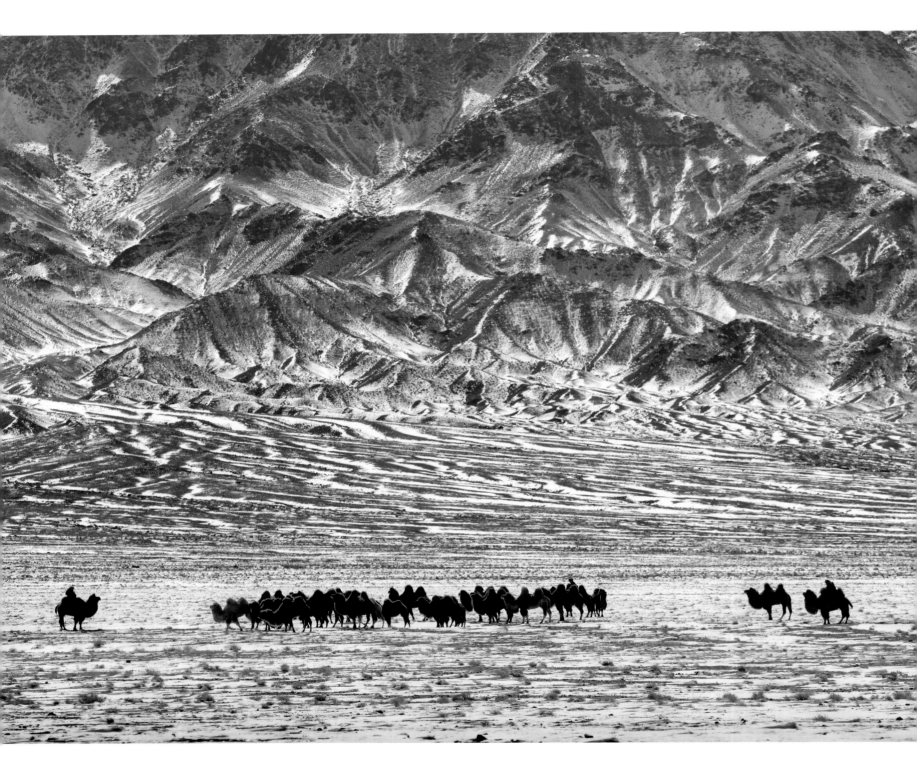

ABOVE *The herd entering a valley with plentiful snow but also wolves, which may prey on young camels.*
OPPOSITE, TOP *Ganbold's son Otgonbayar with his goat kids.* OPPOSITE *Kids and their young carers on a computer-game break. When temperatures drop to below -10°C, newborn lambs are allowed into the ger.*

Snow lingers on the northern faces of the arid mountainous valleys, but to venture here brings with it the danger of Gobi wolves and even a few remaining snow leopards. Entering the valleys is risky, made even more so by the fact that this is the season when Ganbold's camels give birth. The success of his camels will determine his family's future.

The birth of a baby camel is the culmination of 13 months of care. These long-lived animals mate only once every two years and bear a single calf, which will take three years to train as a riding animal. Camels are valuable, but the relationship is more than economic. Ganbold's connection is emotional, and the threat of wolf attack, especially on his pregnant females and newborns, keeps him on alert – a challenge made harder by the desire of pregnant camels to give birth alone, especially in bad weather. Any camel that wanders away from his ger is vulnerable. They won't leave their newborns – dead or alive – and wolves will kill a calf first and then the grieving mother.

In daylight, while Ganbold takes the herd away to eat snow, the wolves might take young camels from his homestead. Or a pack might follow a herd for hours, waiting for an opportunity to attack. Working together, they can take down an adult camel. Ganbold can only relax when the temperature rises and he can move from the mountains, since once the snow is gone, there is no reason to remain in the danger zone.

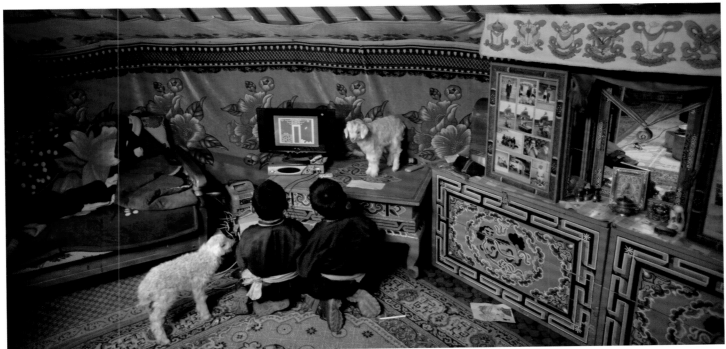

DESERTS

RIGHT *Ganbold and his companion returning to their temporary hunting ger. Their stove is fuelled with a mixture of dried dung and scrub.*

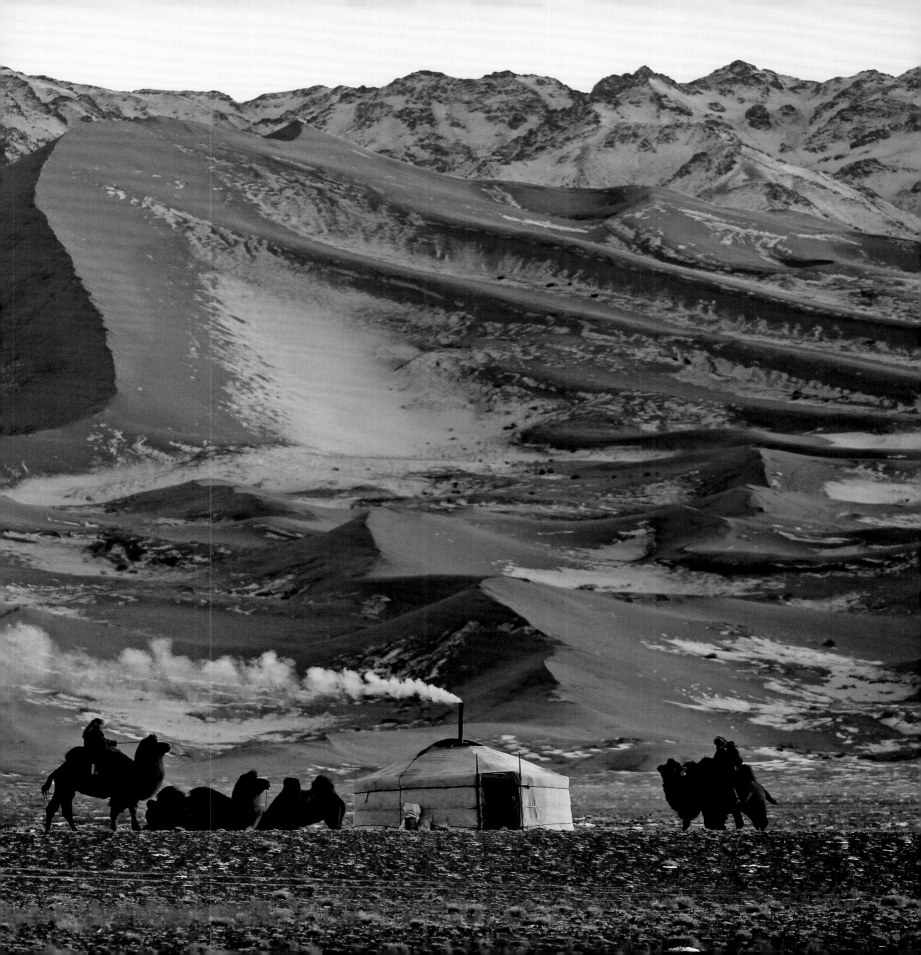

WILD ANIMALS AS HONOURED GUESTS

The arrival of rains means fertility for the deserts, and when they come, most cultures rejoice at having survived another year. There is also a tradition of hospitality in deserts, even towards wild animals, and nowhere is this stronger than in the Thar Desert of western India. Here thousands of demoiselle cranes migrate between the rain-filled pools on their great journey to the Himalayas. The villagers of Keechan give up their precious grain to feed these visitors for no more reward than the spiritual satisfaction of seeing such symbols of fidelity (demoiselle cranes mate for life) safely on their way. But in the case of the Bishnoi of Rajesthan, their culture of compassion is truly extraordinary.

The Bishnoi follow a 500-year-old ecological philosophy that sees them giving 10 per cent of their harvest to feed the wildlife and refusing to eat any animal product or cut a living tree. When the rains come, the blackbucks and chinkara gazelles give birth, and if the Bishnoi find an abandoned fawn, they will care for it. For the Bishnoi to pass an animal in need and not help it would be like denying assistance to an abandoned human child.

When a Bishnoi priest, Swami Vishudha Nand, was brought a very young orphaned chinkara gazelle, he knew that the gazelle needed something he was unable to provide. So he gave the fawn to a man with a young family. That man's wife allowed the fawn to suckle from her breasts over several weeks, sharing the milk between the fawn and her baby. When the fawn was strong enough, it was released among the other gazelles that live around the temple.

The Bishnoi care for the whole desert environment in many other ways, too, planting trees and keeping them watered, and only using dead trees for wood. Studies have shown that the desert ecology in regions where the Bishnoi live is more diverse and more abundant. The sheer power of a cultural philosophy has a direct effect on the environment, and in general, the mental strength of these desert people is the key to their success.

DESERTS

ABOVE *Bishnoi women harvesting millet by hand. Part of the harvest will go to the animals (whether gazelle, blackbuck or peacock) – a way of maintaining balance in the desert. They follow the teaching of Guru Jambheshwar, who believed that people should protect the desert and love and take care of wildlife.*

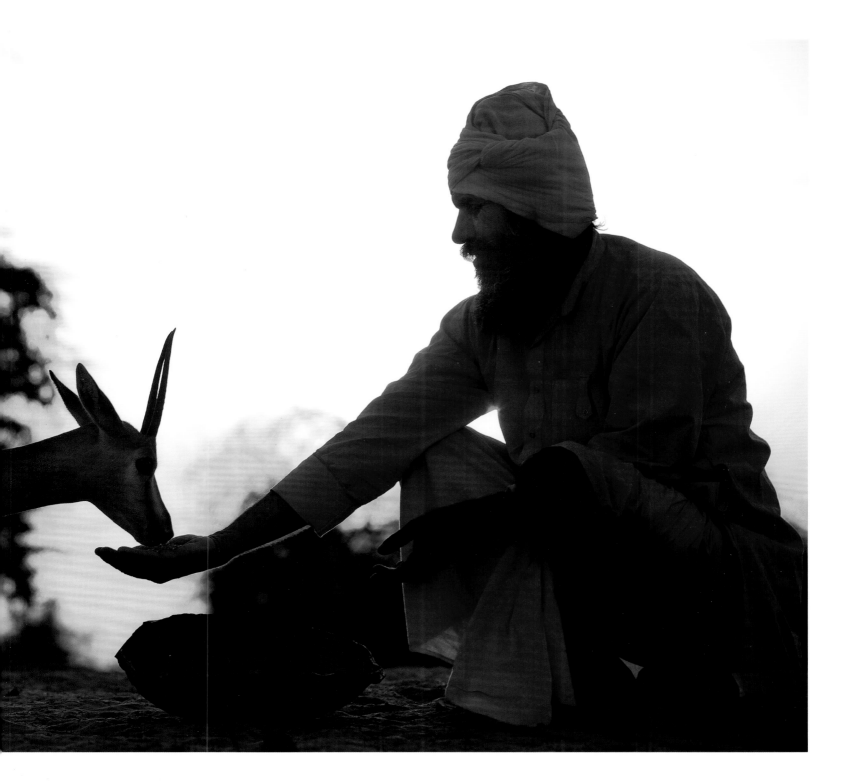

ABOVE *Feeding a gazelle. The Bishnoi share part of their harvest with the wild animals. If one is killed, they will track down the culprits, and the women may even breastfeed orphan fawns. Trees are also cared for. The Bishnoi won't cut the wood of a living tree, and they plant and nurture saplings around their villages.*

GARDENING WHERE IT HAS NEVER RAINED

The Atacama of South America is a 20-million-year-old desert, 50 times drier than California's Death Valley. In fact, it is the driest desert in the world, lying in the rainshadow of the mighty Andes and running to the Chilean Pacific coast, which is washed by the cold Humboldt current. The land is virtually sterile, and soil scientists compare parts of the Atacama to the lifeless surface of Mars. Some areas have never seen rain, and geologists believe its riverbeds have been dry for 120,000 years. So how can there be any life here?

Nature's strategy is to harvest the Camanchaca, the fog that creeps in from the coast. It is created when the cold Humboldt current collides with the warm air brought south from the equator. The heat of the desert draws this mist onshore, and as it climbs the cliffs and cools, it becomes thick fog – the lifeblood of the desert. Fine hairs of a *Eulychnia* cactus condense water from the air, and the Chanaral community nets do the same. The guanacos and birds can then drink the droplets that swell and hang from the spines and collect on the ridges of the plants. The intricate mesh of the stretched nylon nets does the same, and the droplets trickle down channels and then into pipes. This may be low-tech engineering, yet it delivers on average 1250 litres (275 gallons) of water every day. Tapping into the fog has enabled villages to flourish, and the water is enough to nurture small gardens from these desiccated soils.

THE UNDERGROUND EDEN

Fog and mist can only form where a desert meets the cold sea. In the Saharan heart of Algeria, there is no such conjunction, but people here harvest another source of water. They dig down and tap into the landscape the Sahara once was. Here, water is measured by the same unit as gold. Tens of thousands of ancient, hand-dug wells, dating back some 7000 years, stretch in lines to the horizon.

In the 1980s, NASA's Earth Observing Synthetic Aperture Radar was able to look below the surface of the dunes and reveal what had lain hidden for millennia: a vast network of ancient riverbeds filled with rainwater that fell perhaps tens of thousands of years ago. This, together with the discoveries by archaeologists of hippo bones and shellfish and of cave paintings of swimmers, provided evidence that the Sahara was a grassland steppe landscape as recently as 30,000–5000 years ago.

About 5000 years ago, the climate began to change. As the land above dried out, the water trapped in ancient aquifer rocks below was occasionally forced up through cracks to provide desert springs, or oases. In central Algeria, the water table was near enough to the surface to be tapped by wells. These ancient water tunnels, foggaras, were dug at the exact angle that allowed water to flow with gravity across the desert to reach villages.

Each well puts a little more water into the system, but with only a trickle from each, the foggaras have to link together thousands of wells, and new wells are added annually. The system of vertical shafts linked below the surface by a gently sloping river tunnel also creates airflows that encourage condensation, which further adds to the water collection. A foggara can deliver 100 litres (30 gallons) of fresh water every minute, but maintaining it is a challenge. Desert sands are blown into the shafts, threatening to clog the wells, and if one is blocked, the entire system stops flowing. Yet the shafts cannot be capped, since the increased humidity would destabilize the fragile tunnel walls, risking collapse. So this engineering feat and maintenance responsibility are taken on by the families who benefit from the water. They use the fogarras to nurture impressive date palmeries, and they know that if the water stops flowing, their villages will die.

Nature is quick to adapt to these brilliant man-made Edens in the sand. Colourful birds fly between the palms, the croaks of frogs and the whirl of dragonfly wings surround these channels of prosperity, and blind cave fish and bats shelter in the dank, cool foggara tunnels, protected from the extreme heat and desiccation of the desert surface.

LAS VEGAS: ODDS ON EXTINCTION

With reliable water, desert life changes. Gardens and towns, even civilizations become possible, from the past glories of Petra to the neon splendour of Las Vegas. Yet desert cities are expensive in terms of resources, living beyond what the desert can naturally support, and the most valuable resource is water. Las Vegas is financed by gambling, but the odds are against the city, one of the fastest-growing in the US. Its citizens are among the highest consumers of water in the world, using on average 800–1000 litres (176–220 gallons) of water a day, and so Las Vegas is a city running on borrowed time. The lakes that supply its water are drying up, and the mighty Colorado River is so depleted and manipulated that it no longer reaches the sea. Las Vegas's extravagance has made a new desert of the Colorado River Delta, and the city is likely to become a deserted monument to human folly.

LEFT *Date palms growing in the central Algerian desert. Ancient aquifers tapped by a well system called a foggara have supplied water to Algerian date palmeries for hundreds of years, maintained by the communities they support. These man-made oases provide food and shelter for wildlife as well as people.*

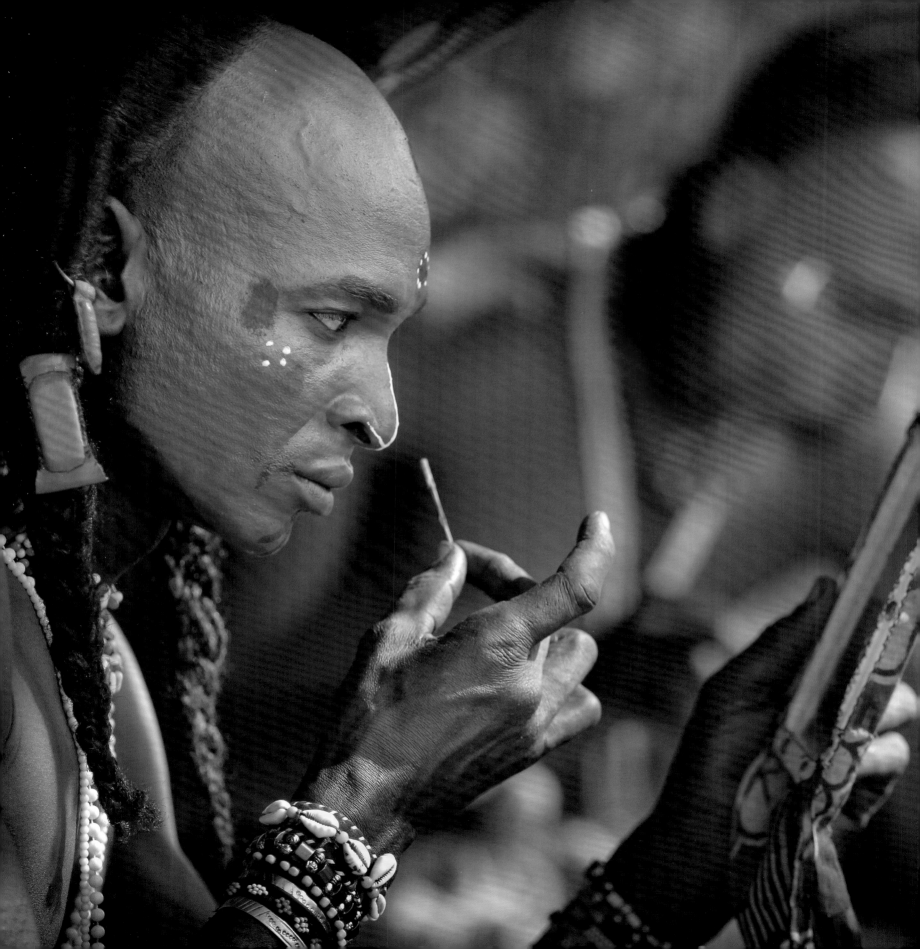

THE MOST GLAMOROUS HUSBAND

As the planet warms, the rains are becoming less and less predictable. In the African Sahel, Lake Chad is drying up, and for the Suudu Suka'el Wodaabe nomads, life is getting tougher. But perhaps once every seven years, good rains bring enough water and new grass to sustain a gathering of the clans. After surviving in their small isolated communities for years, passions rise in anticipation of the chance for a young person to meet a lover who might last a night or a lifetime.

When the rain turns the desert green, the Wodaabe's cattle can feast and provide bountiful milk, and so the people become healthy and are at their most beautiful. It is then that they come together for jeerewol. It's a competition of dancing and beauty, and it begins with natural make-up – but for the men only.

Their faces are coloured with a saffron-coloured earth collected from a specific desert mountain many days walk from the festival site. The young men also use red earth and charcoal black to ring their eyes, with white make-up from doobal – the dried and crushed excrement of the Sudan bustard. Perfume is gathered from desert plants, and ostrich plumes bob from their colourful hats.

With these adornments, the dancers make comparison between themselves and wild birds. The young men begin a dance marathon, the boisterous, welcoming Raume dance, which goes on until dawn. When they dance the Yaake, the men flutter their throats and lips and mimic the proud postures of the white egret. (Magical power is gained by capturing the egret and blackening its bones in the fire; the charred, ground bone is mixed with butter to make a bird-lipstick.) They may be inwardly passionate, but their exterior has to remain poised as they dance on tiptoe, wide-eyed and showing white teeth within quivering lips.

The most beautiful man is chosen by a jury of three girls, as an opinionated crowd looks on. Every Wodaabe girl and boy is betrothed in marriage, but there is always the possibility of a second love marriage. So jeerewol is a dangerous time. Not only may flirtation lead to romance, it may also be when your husband is stolen by another woman. All the girls remain on their guard. Such love marriages give a man enhanced sexual and social status. They might last for a week, a month or a lifetime and carry no social stigma.

For the Wodaabe, a jeerewol is an important opportunity to come together. Normally they live in isolated family groups, moving nomadically with their cattle across the Sahel, and meeting other groups rarely. The abundance that the rains bring means there is a surplus of food that allows such a feast. There needs to be water for the

LEFT, TOP *A girl plaits her lover's hair in preparation for the all-male dance display, the jeerewol.*
LEFT, BOTTOM & OPPOSITE *A Wodaabe man beautifying himself. The jeerewol brings the nomadic Wodaabe clans gather and happens after the rains, when good grass has made healthy cattle.*

guests and their livestock, as well as pasture. And at least five cattle will be slaughtered. But such extravagance cannot be sustained for long. After four days, the families drift back into the desert and into their existing marriages with relief or new expectations.

AQUA VITAE

The desert is where austerity and serenity come together. The lack of material wealth of the people who live there allows them huge freedom compared to a culture of accumulation. They also have knowledge of and reverence for water. Without this, the greatest of human triumphs will crumble to nothing. From the people who know how to live life with so little, there is much to be learned about the true value of the precious liquid we all depend on for our prosperity and survival.

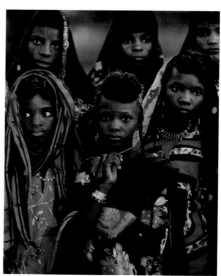

DESERTS

TOP *One of the jury of three women selecting the most beautiful man.* RIGHT *Looking for love. Though every Wodaabe girl is betrothed or married, the jeerewol is a chance for a love marriage or at least a flirtation. The liaison may last for just a night or forever. Either way, it is socially acceptable.*

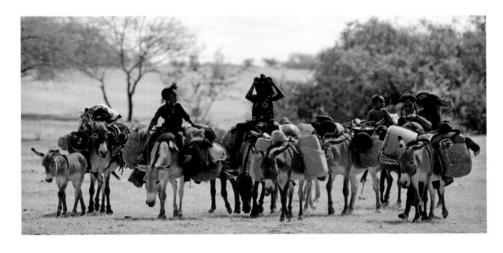

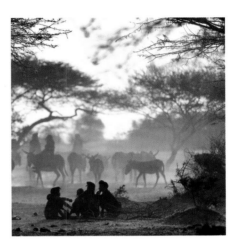

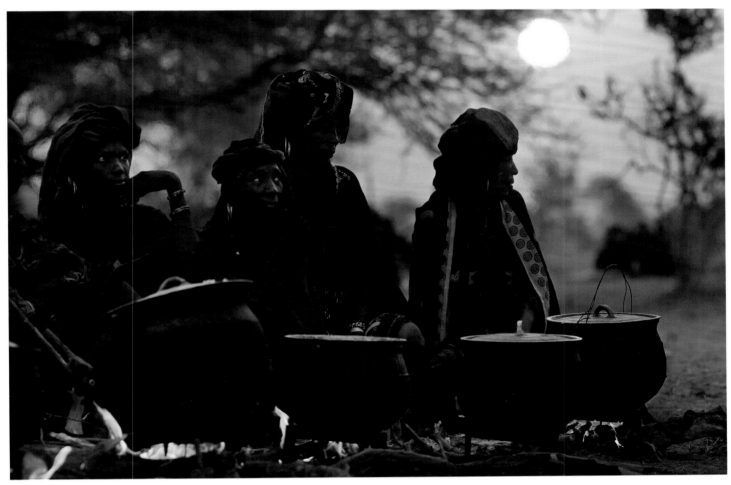

TOP, LEFT *Moving into the camp. Donkeys driven by the children transport their belongings.*
TOP, RIGHT *Girls gathering to gossip.* ABOVE *Two cows must be slaughtered over the three days of the festival, to be shared with all. If the drought is bad, no chiefs will have cattle to give and there will be no jeerewol.*

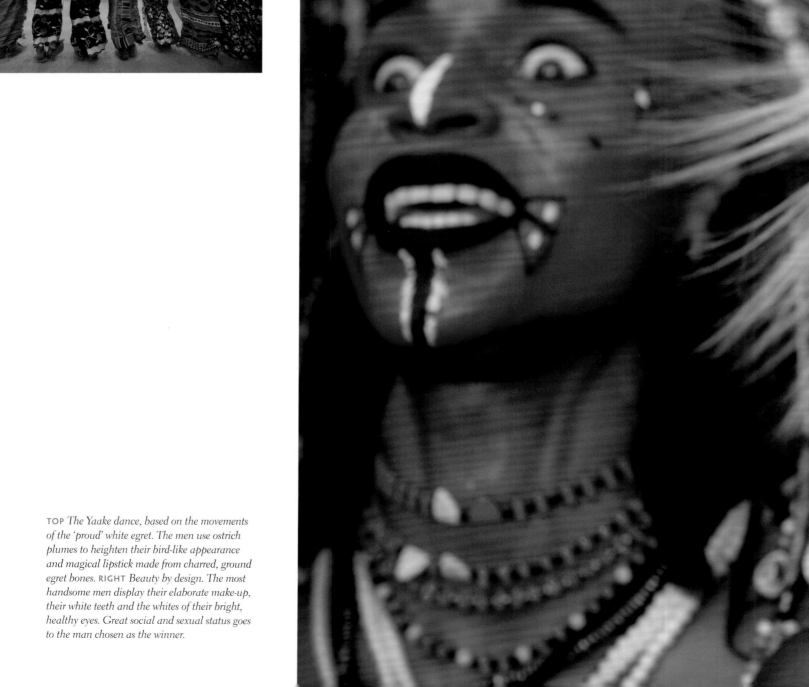

TOP *The Yaake dance, based on the movements of the 'proud' white egret. The men use ostrich plumes to heighten their bird-like appearance and magical lipstick made from charred, ground egret bones.* RIGHT *Beauty by design. The most handsome men display their elaborate make-up, their white teeth and the whites of their bright, healthy eyes. Great social and sexual status goes to the man chosen as the winner.*

188

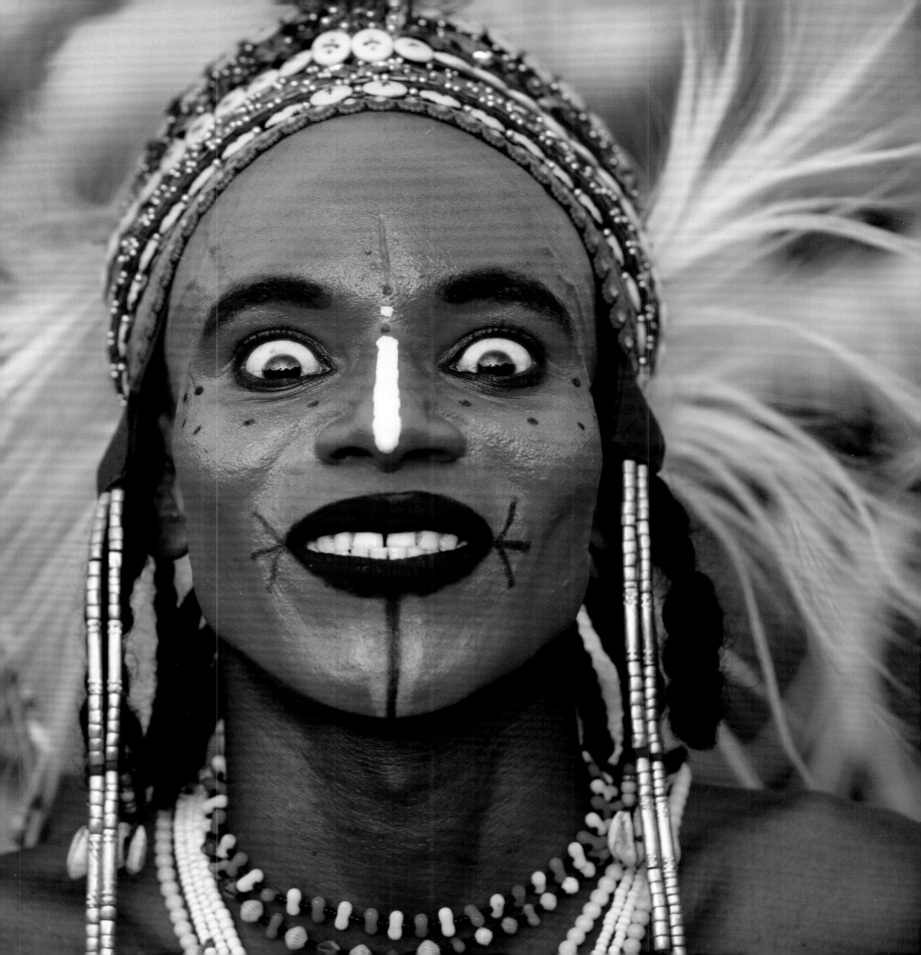

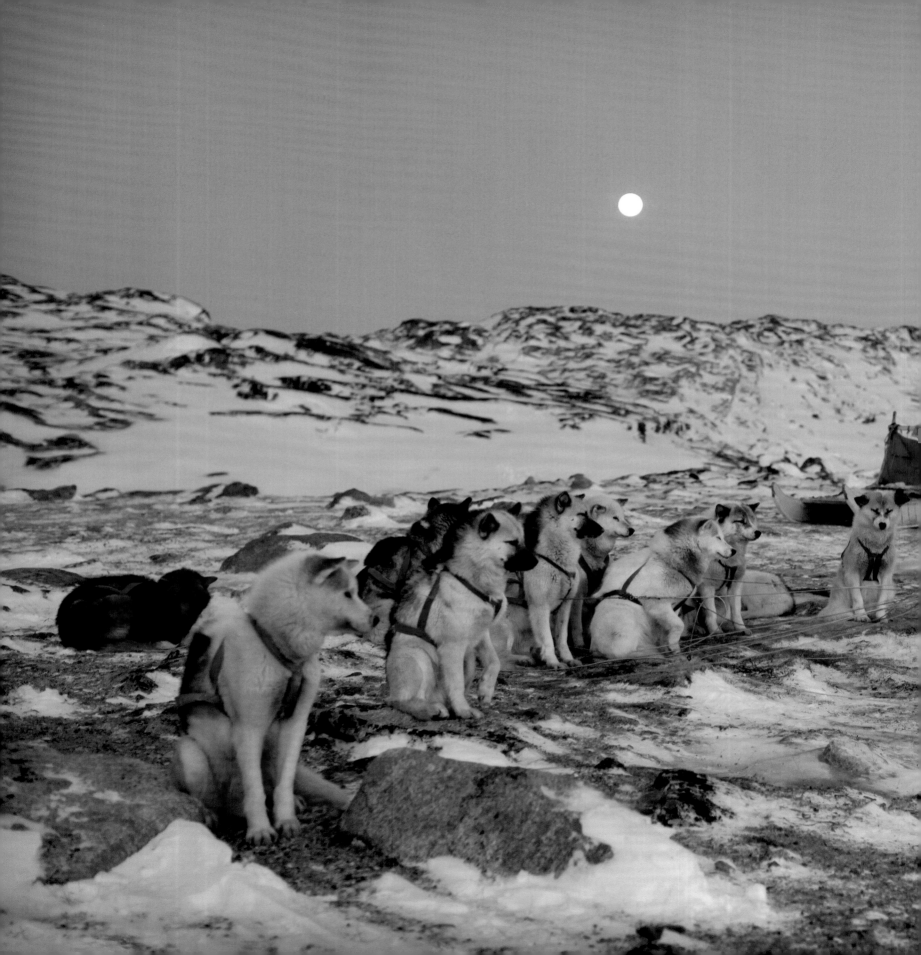

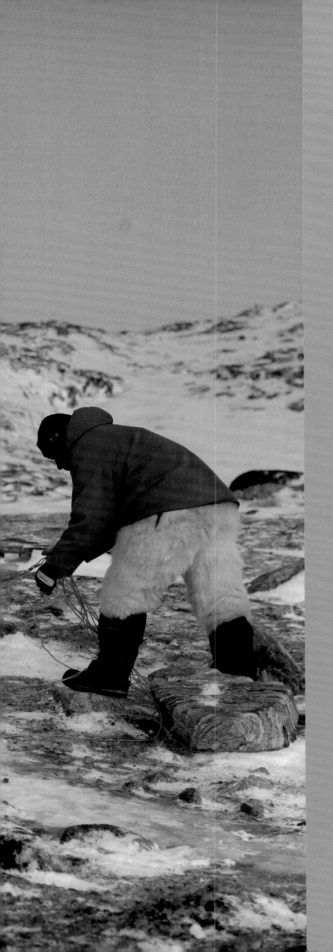

ARCTIC
6

THE ARCTIC – EARTH'S ICY CROWN. DURING WINTER, A FLOTILLA OF SEA ICE IN THE MIDDLE OF THE ARCTIC OCEAN JOINS THE SURROUNDING LAND MASSES INTO A FROZEN WHOLE. THE COLD KILLS ANYTHING NOT ADAPTED TO LIVE HERE. ANIMALS SUCH AS POLAR BEARS, SEALS, CARIBOU AND MUSKOXEN ARE WELL EQUIPPED WITH LAYERS OF FUR AND FAT TO KEEP THEM WARM. HUMANS DON'T HAVE THAT, THOUGH – WE EVOLVED IN THE HEAT OF EQUATORIAL AFRICA. AND YET MORE THAN 4 MILLION OF US CALL THE ARCTIC HOME. THE FIRST QUESTION, OF COURSE, IS 'HOW?' BUT THE SECOND HAS TO BE 'WHY?' – IN A LANDSCAPE MADE UP OF NOTHING BUT ICE AND SNOW.

Maybe the question that needs to come first is 'what is the Arctic?' There are several valid definitions. The most common is that the region is everything north of 66 degrees, the latitude where there is at least one day when the sun doesn't rise and one when it doesn't set. But there are places below 66 that should be called Arctic. Churchill, Canada, for example, at 64 degrees, has all the Arctic characteristics – polar bears, sea ice, Inuit people and very cold temperatures. But there are also areas north of 66 that, because of the warm Gulf Stream current, don't appear Arctic and even have fruit trees. So another definition is land north of where trees grow. Other definitions exist, but if you live in the Arctic, you're in no doubt where you are, and you have to face certain facts of life.

ABOVE *Reindeer and their Sami herders moving to winter pasture.*
OPPOSITE *Melting polar sea ice. The freezing and melting of ice determines the rhythm of life for Arctic people.* PREVIOUS PAGE *Transport, the Greenland way.*

At -40°C (-40°F), a common enough winter temperature, uncovered human flesh rapidly freezes, turns black and falls away. If that's not enough of a problem for humans, a vital variety of food is hard to find. Vegetables don't grow naturally – in fact, relatively little vegetation grows in the high Arctic. And depending on how far north you are in winter, it stays dark for weeks or months on end. The Arctic summer can be inhospitable, too. Some regions have mosquito and blackfly swarms severe enough to kill caribou. And when the Arctic tundra thaws, the mud is so thick that, unless you have wings, you're pretty much stuck where you are.

Despite these drawbacks, people have been doing well here for at least 40,000 years. These people have learnt to survive in a world dominated by ice by understanding the opportunities offered by its melting or freezing. There has been physical adaptation, too. Some native Arctic people have physiological advantages over the rest of us. Among the Inuit – a group of Arctic people spread across Russia, Alaska, Canada and Greenland – are individuals who can increase their basal metabolic rate 30 to 40 per cent more than control groups. This means their bodies chemically warm without having to shiver. Inuit also seem capable of warming their extremities more quickly, facilitated by their high-fat diet. But these advantages are marginal. The only way for a human to survive here is by being clever. Arctic people have learnt to protect themselves from the cold by wearing the hides of animals. Reindeer skins, for example, are so insulating that if a reindeer dies, even in the extreme cold, its organs won't freeze – they'll ferment. Hunters in Greenland swear by polar-bear trousers, which keep them warm down to -60°C (-75°F). That, of course, is 60 degrees below the temperature at which water freezes (0°C, 32°F) – the main fact of life in the Arctic. (Oceans, because of their salt content, freeze at about -1.9°C, 30.2°F.) To grasp this is to begin to understand the way things work in the Arctic. The freezing and melting of ice determine the rhythm of life up here.

The Arctic Ocean sits at the centre of it all. You can walk on it. Even in summer, there is a flotilla of sea ice nearly the size of Europe floating in its centre. This ice fluctuates, and by winter an additional area four times the size of the United Kingdom freezes over (though global warming is causing the amount of sea ice to shrink noticeably, and there are predictions that in the next decade, it could disappear entirely during Arctic summers). And along most of the Arctic coast, especially in the calm bays and fjords, the winter sea is covered with ice. The ice connects North America with Russia, and Russia with Europe.

The freezing and thawing of the ice drives the entire food chain. Bacteria, algae and crustaceans use the ice as a platform similar to the way plants use soil – and polar bears, seals, walruses and birds all follow the movements of the ice. On land, nesting birds and vast herds of caribou and reindeer follow the movements of another form of frozen water – snow.

Humans have no choice but to fall into step behind these natural shifts and migrations. Windows of opportunity open for a brief time and then slam shut. In fact, the cold months of winter are not necessarily the hardest. Sea ice, for example, makes it possible to walk on the ocean and hunt seals. Once it melts, the seals are very difficult to catch in open water. In certain ways, it's in winter, when the water is frozen, that living is easier.

RIGHT *Greenland fisherman Niels Gundel preparing his boat in the perpetual darkness of midwinter. Warmer temperatures mean that Ilulissat harbour is seldom ice-bound and* (OPPOSITE) *he can venture out in search of halibut.*

HIGHWAYS OF ICE

An ocean covered in ice has certain advantages for people. Being flat and smooth, it's a perfect travelling surface. Ice just 5cm (2 inches) thick can support a skilled Arctic traveller (12cm – 5 inches – for the rest of us), and ice a metre thick can support a Boeing 747. So any coastal village that has sufficient sea ice is instantly connected to any other village by a multidirectional, high-speed highway. For some people, this means racing across the ice on snowmobiles or even cars and trucks. But for many Greenlanders such as Amos Jensen and his son Karl-Frederick, the preferred method of travel is dogsled. Amos's ancestors have been using the breed known as Greenlandic dogs to pull them across ice and snow for at least a thousand years.

Amos and his family live in Saattut. The town is on an island deep inside Uummannaq Fjord – an inlet off Baffin Bay. Everything here is on a giant scale. Spectacular cliffs jut nearly a vertical mile (up to 2000 metres or 6000 feet) straight out of the ocean. In summer, Saattut is often cut off from the rest of the world, and twice a week a helicopter brings supplies and passengers. But in winter, it's just a quick journey across the ice to the other towns in the area.

Amos prefers travelling by dogsled because dogs don't need petrol, which has to be shipped in from far away, and he doesn't need to call an outside expert to fix his dogs should they break down. Amos's dogs are special – he was once the Greenlandic dogsled champion. His dogs can get him where he needs to go nearly as quickly as a snowmobile. But more crucially, his dogs always know the way home. Even in a total white-out, their incredible sense of smell can guide them home.

Because he can go dog-sledding, winter is Amos's favourite season. The sense of freedom is exhilarating. Dogs are like the pick-up trucks of the Arctic – each animal can haul twice its own weight. This means that when Amos and Karl-Frederick take long trips that require them to stay overnight on the ice, they can tow a hut behind them. In -40C° (-40°F), a hut with a stove is essential for survival.

Even though Amos's sled is not motorized, his dog team still needs fuel. Fortunately, there are filling stations everywhere for dogs, and Amos knows exactly where to look. When he's found a good spot, he cuts a hole in the ice, which only takes a few minutes. Standing over a hole in the middle of a frozen fjord is an extraordinary experience. You realize that you are on a relatively thin platform over extremely deep water. To add to the sense of precariousness, sometimes a swell comes in from the ocean, and the surface of the ice bends and ripples.

OPPOSITE *Ice-highway transport. In a land of almost perpetual ice and snow, a dogsled remains an effective way to travel, requiring no petrol, little maintenance and few spare parts. It can also be the safest way, since it weighs little and can move over relatively thin ice, and the dogs can sense dangerous cracks ahead.*

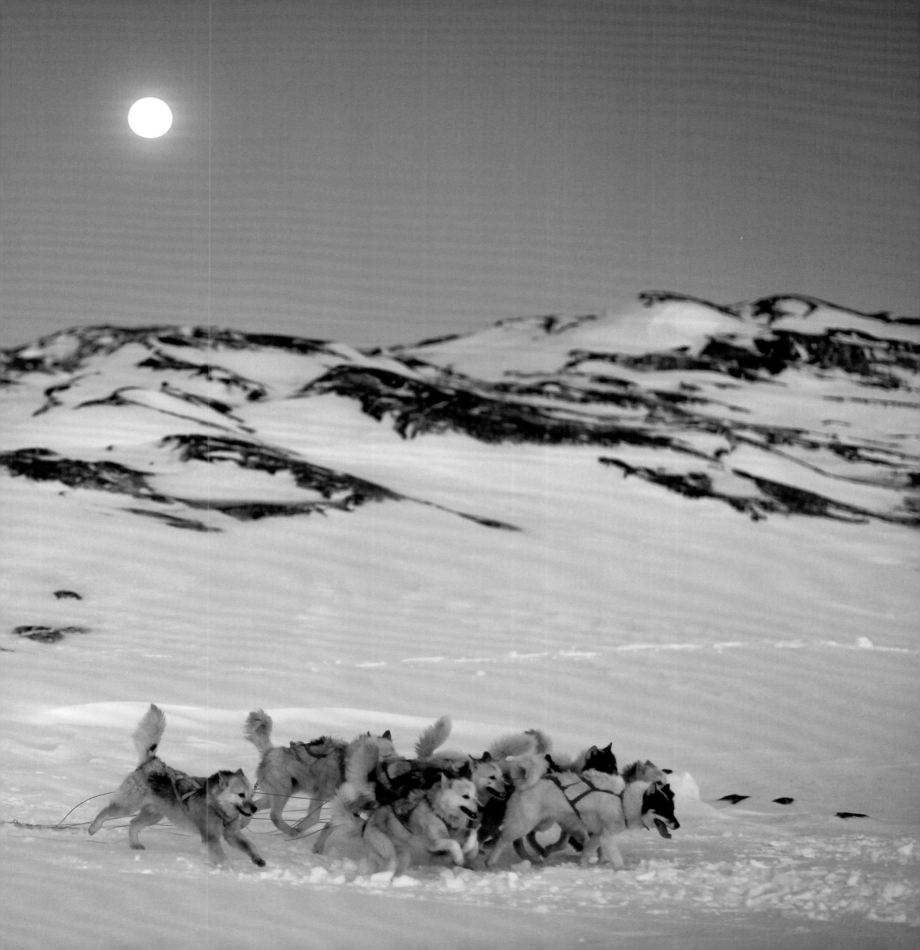

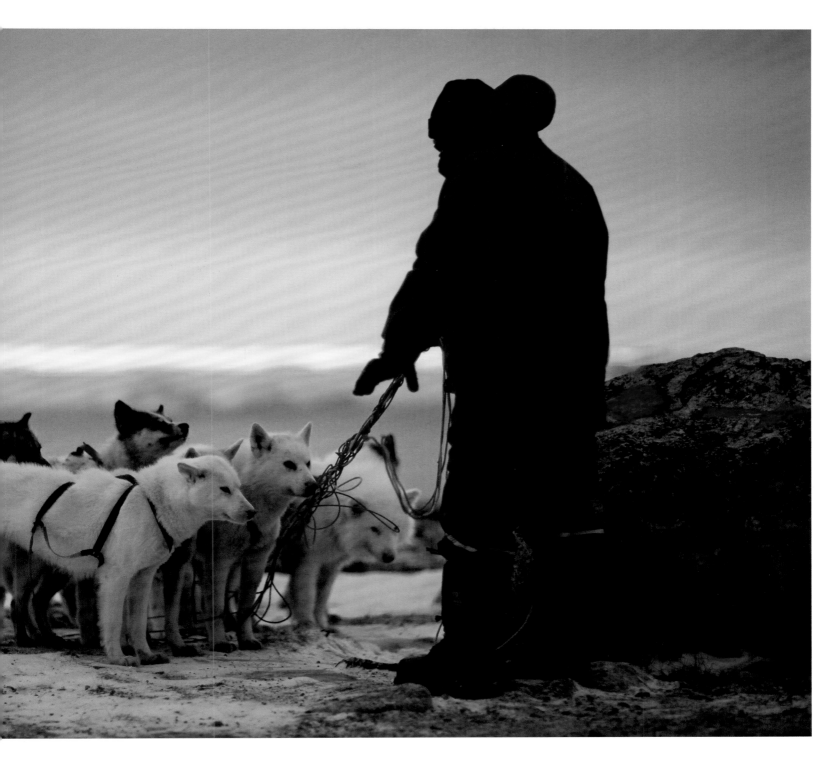

ABOVE *Harnessing up the dogs in the glow of the first sunrise of the year. A team comprises six to twelve dogs, linked in a fan formation (as opposed to the linear pair formation used by sled drivers in North America). The dogs seem to have an almost infallible homing sense, even in a snowstorm.*

SHARK FUEL

Beneath the ice, the ocean teems with life. Amos and Karl-Frederick usually fish for halibut, but sometimes they go for bigger fare. The Greenland shark is one of the world's largest, capable of growing to 6.8 metres (22 feet), which is as big as a great white. Researchers have found reindeer, horses and even polar bears in their stomachs. But the Greenland shark isn't generally considered dangerous to humans, though the Inuit tell stories of kayakers being attacked.

To catch this shark, Amos has to fish deep. His favourite spot is 800m (2625 feet) down – that's nearly twice as deep as the Empire State building. And Greenland sharks can live at even greater depths. If a shark swallows the bait – Amos uses narwhal meat on giant hooks – it will take almost an hour to haul it up. After all, Amos needs to pull up nearly a kilometre of fishing line. By the time a shark is at the surface, it doesn't usually put up much of a fight. This could be because the change in pressure puts it to sleep. If it's a large shark, though, Amos and Karl-Frederick won't be able to pull it onto the ice on their own. The sharks are neutrally buoyant in the water, but a 4-metre (13-foot) one will weigh half a ton on land. So they sometimes enlist the help of their dogs.

Eaten raw, the flesh is poisonous. It's saturated with trimethylamine oxide, which during digestion produces effects similar to extreme drunkenness – even in dogs. So when he gets home, Amos will dry the meat on large racks for a number of months

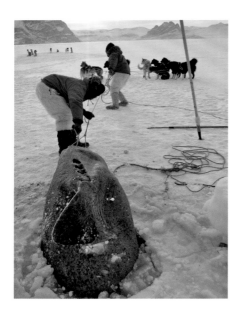

to allow the poison to leach out. Some people consider shark meat a delicacy, but not Amos. He, like most hunters, uses it for dogfood.

To catch a Greenland shark, Amos needs stable ice. And he is quick to point out that, these days, the ice is less stable than usual. Global warming is not a subject he claims to know much about, but he knows that ice conditions have changed in his lifetime. Fewer and fewer hunters are bothering to catch Greenland sharks, and he himself now feeds his dogs more often with dry dog food shipped in from Denmark.

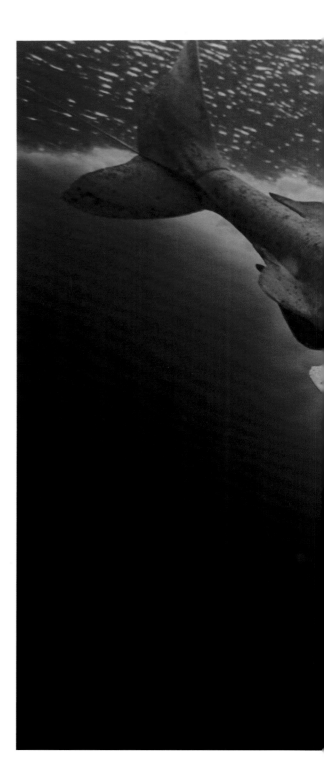

ABOVE *Amos and Karl-Fredrick Jensen hauling up a Greenland shark, for use as dog food. Though these sharks catch live prey, they will eat carrion and come to bait (here, narwhal meat). Winter is the best time to fish for them, when the ice forms a strong, stable platform from which to haul them up.*

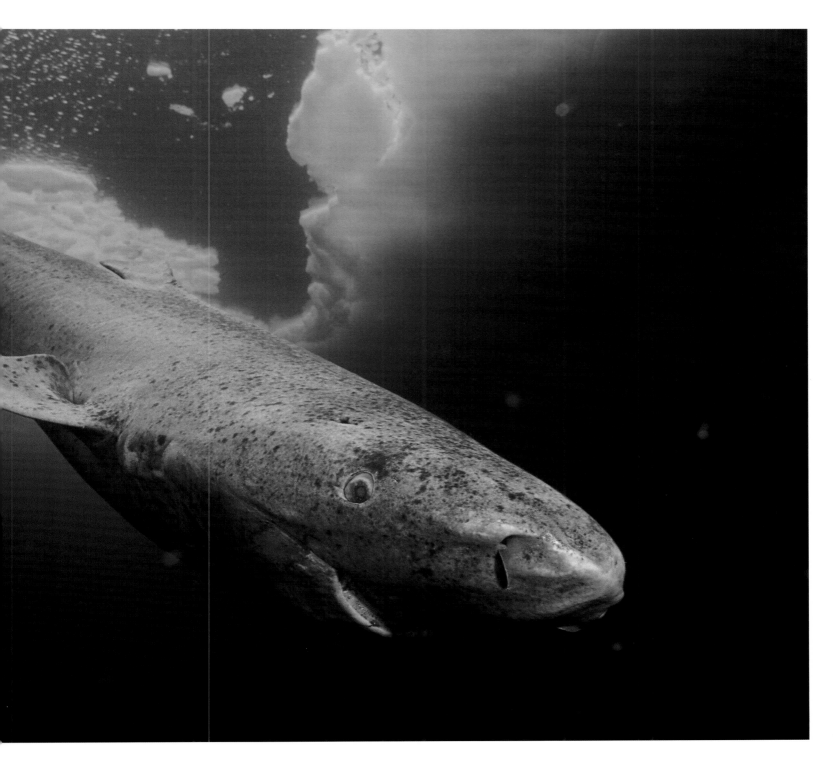

ABOVE *A Greenland giant – the only native Arctic shark. This species can reach up to 6.8 metres (22 feet) in length, but individuals grow remarkably slowly, and researchers have difficulty determining their age. It's possible that a 4-metre-long Greenland shark (such as the one Amos Jensen caught) could be centuries old.*

THE BOUNTY BELOW

Along the Arctic coastlines, people see the ocean beneath the ice as their garden. But ice is far more treacherous than land. It is always moving, getting thicker or thinner, shifting up and down with the tide. If a hunter is to survive, he must be aware of how and when the ice will transform. But it isn't all bad news – sometimes sudden changes to the ice can open up opportunities. Nowhere is this more spectacularly true than in Kangiqsujuaq, northeastern Canada. Here, hunters such as Lukasi Nappaaluk actually visit the dangerous world beneath the ice.

This region is infamous for extreme tides. The tide changes on average every six hours, and the ocean can rise and fall 16 metres (53 feet), lifting and dropping the sea ice with it. This violence takes place in slow motion, ice splintering apart with immense force. The shoreline gets buried under blocks of broken ice the size of houses.

Lukasi knows that in March, at the equinox, the tides will be at their most extreme. For about three days on and around the full moon, the ice will fall to its full extent. And as the tide goes out, a bounty is revealed on the seafloor. The only trouble is, to reach it Lukasi and his fellow hunters have to get under the ice.

On the windswept surface, Lukasi searches for a weakness in the top layer. When he finds one, he cuts downward with a crowbar, opening up a deep blue cavern shimmering with ice crystals. He uses his sled like a ladder to climb between enormous ice blocks. On the seabed lies seaweed, urchins and his favourite – mussels. But the instant Lukasi enters the ice caverns, a clock begins to tick. The changeover from outgoing to incoming tide, called slack tide, lasts just 15 minutes. The returning water moves deceptively swiftly, and as it returns, it floats the ice blocks above his head. Once floating, these giant slabs can easily shift together like a rubbish compactor. As he makes a hasty retreat, the ice is creaking and splintering around him. At that time, Lukasi probably remembers stories of hunters in the past who stayed too long and were crushed or drowned.

Lukasi believes that the mussels are worth the risk to him and his family, who together gather as many as they can, snacking on them raw as they go. The shellfish are a welcome change to the winter diet of meat and fish, and they taste a great deal better than the processed foods found in the local stores. The excess can also be shared among neighbours. But the window for mussels is desperately short – just days before regular tides reclaim the mussel beds. So as one window closes, Lukasi and his family must watch for the next one to open.

ARCTIC

RIGHT, TOP TO BOTTOM *Mussel-gathering under the ice in Wakeham Bay, Canada.* OPPOSITE *The seabed entrance, cut through a fissure in the ice. The harvest is possible only around the spring equinox, when the tide can drop 16 metres (53 feet). It must be gathered as fast as possible before the tide returns.*

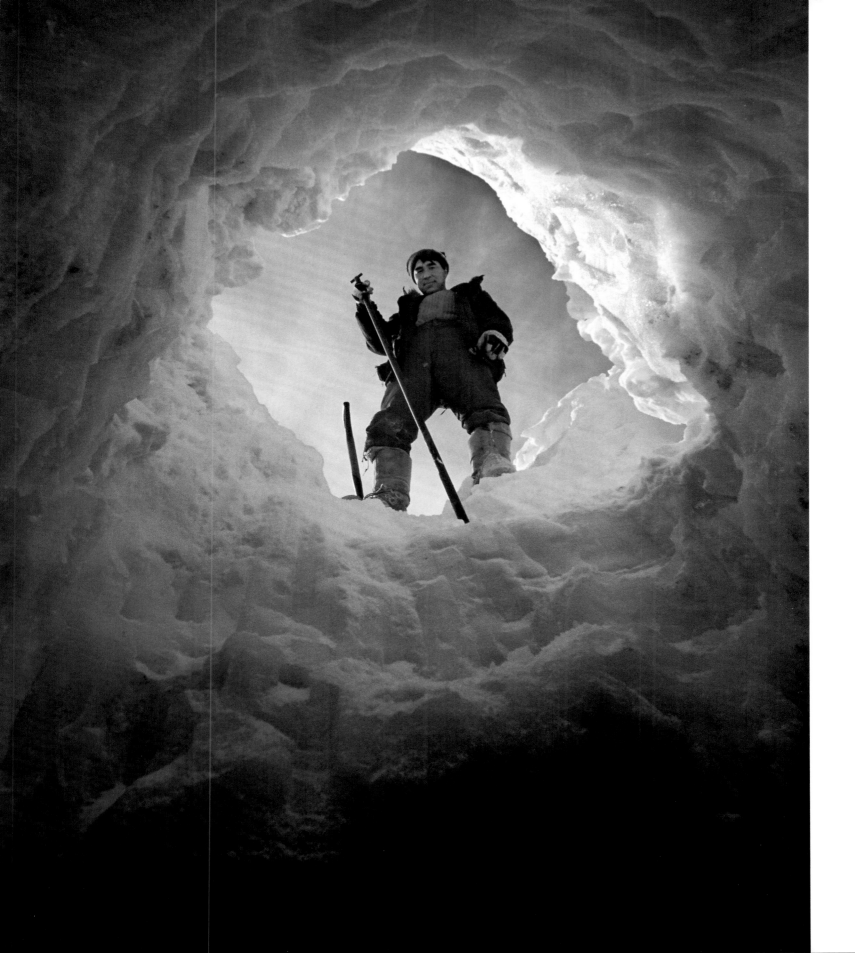

HUNTING THE UNICORN

Spring is around the corner, and big changes are taking place across the Arctic. The increasing hours of daylight have brought the temperatures above zero, and the ice is starting to melt. Great migrations are beginning. As the ice breaks apart and retreats into the bays and fjords, creatures great and small will follow behind it. For humans, these migrations are too great an opportunity to miss.

The Kristiansen brothers – Mamarut, Mikele and Gedion – are local celebrities. They live in Qaanaaq, Greenland, on Inglefield Bay, and are descended from a long line of famous hunters. They are Thule Inuit, and because of their hunting techniques, many consider the Thule to be the most intact Inuit culture left in the Arctic. But what makes the Kristiansen brothers famous is their hunting prowess – they are narwhal hunters.

Narwhals are among the most intriguing whales on Earth. They are unique to the Arctic, and males (and occasionally females) sport a long, spiralled tusk formed from one of their two front teeth. Throughout history, these tusks have fascinated people. In the sixteenth century, Queen Elizabeth was given a carved and bejewelled narwhal tusk worth enough money to buy a castle. She may have been led to believe it came from a unicorn. Today the narwhal remains the most valuable prey in the Arctic, but not just because of its tusk. Narwhal skin is rich in vitamin C – ounce for ounce, it contains more than lemons. Without vitamin C, humans risk getting scurvy. In the past, sailors who spent too long in the Arctic would bleed from their eyes and fingernails and haemorrhage internally until they died. In a land devoid of edible vegetation, a rich source of vitamin C can mean the difference between life and death. Native people may not have been aware of vitamin C, but they clearly craved narwhal skin and developed many specialized techniques to hunt these reclusive whales.

Riding across the ice, the brothers have kayaks strapped to their dogsleds. The Inuit invented the kayak at least a thousand years ago – the perfect craft for hunting along the ice edge. In the rest of the Arctic, the use of motorboats and rifles have led to overhunting and many narwhals being killed but never recovered. In response, the Thule Inuit, including the Kristiansen brothers, enforce laws preventing hunting narwhals in Inglefield Bay using anything but kayaks and harpoons (once harpooned, a narwhal can be shot with a rifle for a swift death). The brothers await the narwhals on the ice edge. This is a dangerous, shifting place, and often the hunters have to make a break for the mainland before the ice cracks up and carries them out on floes to the open ocean. In recent years, the ice has been much thinner than normal, making narwhal season shorter and more perilous.

RIGHT *Mamarut Kristiansen hunting for narwhal in Ingllfield Fjord, Greenland. His ancestors have used kayaks to hunt this way for at least a thousand years. A kayak is the perfect craft for hunting sea mammals, being silent and light to transport to the sea edge. But to become a narwhal hunter requires years of practice.*

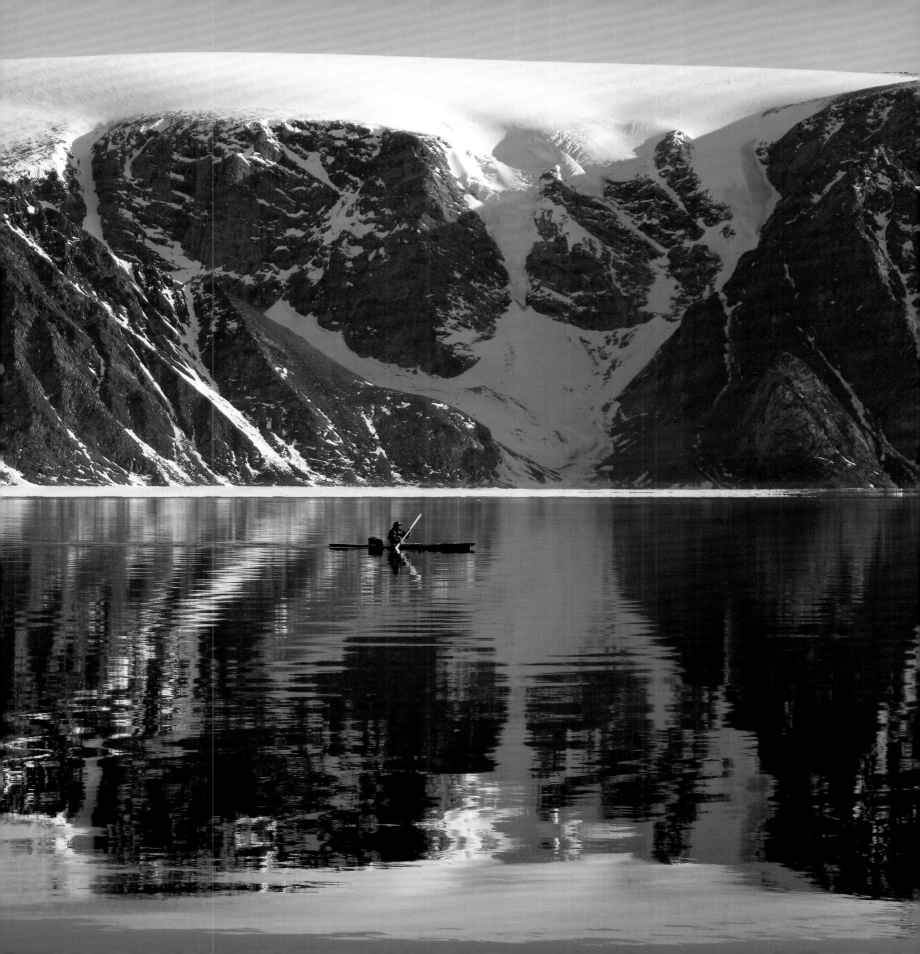

The narwhals are famously shy, and it can take weeks for a pod to swim close enough to be harpooned. While they wait, the brothers have to be silent, and so do their dogs – narwhals have exceptional hearing. In camp, each hunter's sled is a bed. Unless it snows, they sleep in the open, and in the narwhal hunting season – May/June – the sun shines 24 hours a day over northern Greenland. Sleep is fitful, and one of the hunters must always stay on watch for narwhals but also, more importantly, to check that the ice doesn't break up underneath them. Giant icebergs also roam the bay, and if one comes too near, the hunters have to retreat or risk being swept to sea by the huge wave it can cause if it capsizes.

When the narwhals finally come, they travel in pods of up to a hundred. The brothers usually hear them before they see them, though to the untrained ear, the sound of narwhals breathing blends into the sound of small waves splashing against the ice. Moving fast but stealthily – even stepping in old footprints to avoid the sound of crunching snow – they slide their kayaks into the water and wait. The narwhal pod comes within 15 metres (50 feet) of them, but they remain still. If they strike too soon, the pod will dive in unison. They wait for the stragglers – hoping to find males, with the long tusks. Because they can be so selective, they will only target one or two at a time.

Once a hunter spots the right narwhal, he has to make the right approach. Often the top layer of water is very clear, being made of freshly melted ice. Narwhals have good vision, and so the hunter has to sneak up from behind. He's able to do this silently, helped by the special design of the Thule kayak paddles, which are pieces of wood carved to almost paper thinness at the blade, so they slice into the water without a sound. Every movement with the harpoon has to be fluid and silent. Bump the shaft on the top of your boat and the narwhals will dive. Harpoon poised to strike, a skilled hunter won't throw unless he's sure he'll hit. Throwing and missing could spook the whole pod.

When he finally lets loose, he uses an extension arm that gives him more power and distance. The tip of the harpoon is barbed. Once it sinks into the narwhal's flesh, it detaches from the shaft but remains connected to a buoy via a strong rope. Inuit make buoys – called avataqs – from inflated sealskins. It's crucial that the hunter throws so that the rope and the avataq don't get snagged on his body or his kayak. A diving narwhal could easily pull both hunter and kayak under water. And a harpooned narwhal always dives when struck, with the avataq sinking behind it. The whale might stay down for half an hour, but eventually it has to come up for air, and the avataq will pop up and betray its location. Very few narwhals escape if they have an avataq attached. The killing blow can come from a gun, but often a final harpoon throw is quicker and easier. Once the animal is at the ice edge, a chunk of skin is cut off and laid on the ice with

ARCTIC

RIGHT The final harpoon. The first one hit the narwhal as it surfaced to breathe, its tip tied to a buoy made from an inflated sealskin. When the whale eventually resurfaced, so did the buoy, betraying its position for the killing blow. RIGHT, TOP Narwhal prize, killed for its meat, its tusk and its skin, rich in vitamin C.

the fatty side up to provide a frictionless pad that the rest of the body can be slid up and over – with the help of a dogsled team if there aren't enough people.

Strict, ancient rules apply to the division of meat, with the choicest bits going to the hunter who threw the first harpoon. The meat is prized, but what really gives the narwhal its value is the highly nutritious skin. Called magtaaq, it is considered a great delicacy and is the most expensive meat in any Arctic butcher's shop. The tusk is also valuable, though the sale of narwhal ivory outside Greenland is now prohibited.

Narwhal hunting requires relatively thick, stable ice. In recent years, warm temperatures have shortened the window for narwhal hunting. But for the species, this is bad news. Global warming won't benefit the narwhals. They are adapted for life in the Arctic and depend on sea ice, and scientists fear that the huge loss of their habitat will endanger their future survival.

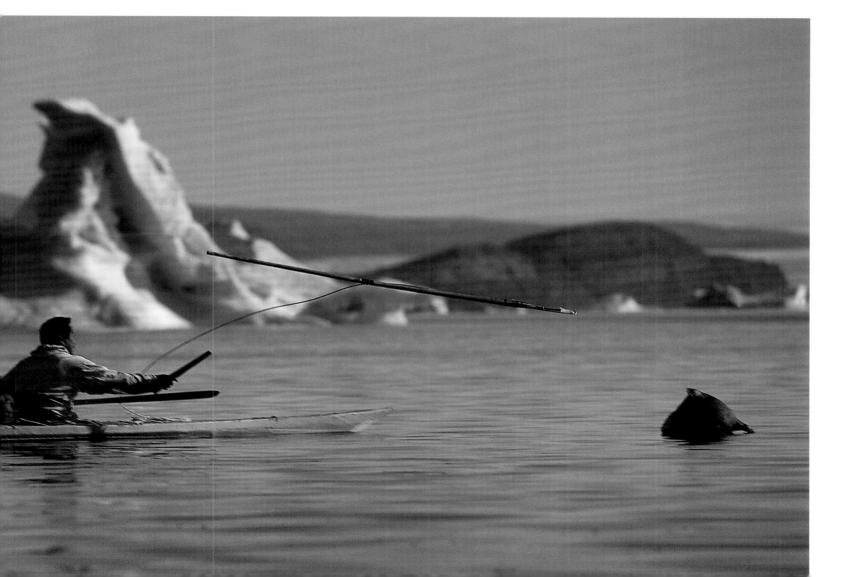

A MESS OF AUKS

By late summer, even in Siorapaluk, Greenland – the northernmost native settlement – the sea ice melts completely. Without sea ice, many creatures have little choice but to migrate onto land. This includes polar bears, Arctic foxes, seals, walruses and various bird species. It also causes humans to turn their attention to terra firma.

The little auk, or dovekie, is one of the most numerous birds on Earth. Auks spend the winter on the sea ice but return in May to nest along the coastal cliffs of eastern Canada, Greenland, Scandinavia and Russia. Billions darken the skies, their flocks making fluid, geometric shapes pointing towards their destinations. Remarkably quiet at sea, they make up for it on land, their shrill chirps echoing across the fjords at decibel levels similar to a rock concert's. They don't leave until the young chicks are ready to fly in August.

Such a concentration of protein is simply too good an opportunity for a hungry predator to miss. Magssanguaq Oshima and his family live in Siorapaluk – also one of the best places to catch little auks.

Hiding among the rocks in sites used by his ancestors, Magssanguaq is almost invisible. You only realize he's there when he raises a special three-metre (10-foot) pole with a net on the end. The auks come, flying low over the cliffs, looking for landing spots, and Magssanguaq snatches them out of the sky. It's a little like playing tennis, using a giant, bendy racket.

He brings a bird down in the net, grabs it and hooks both wings behind its back. With a swift snap, he breaks its collarbone into its heart, and the bird dies instantly. Little auks are by no means easy to catch, but they are so numerous that a seasoned hunter can take 500 or, on an extremely good day, even 1000 birds.

It is important to keep the freshly caught birds out of direct sunlight or they will spoil. After 24 hours of cooling in the shade, the birds are ready. They can be boiled and eaten right away, but a knowledgeable hunter might make kiviaq. This ancient dish could easily have been inspired by the Arctic fox, which will often bury its prey under rocks and dig it up again when hungry.

The recipe goes like this. Take the skin of a seal and sew it together so that only the neck-hole is open. Stuff it with as many birds as possible – usually about 500. Sew up the neck-hole and press out any remaining air by repeatedly jumping up and down on the whole package. Smear seal fat on all the seams – be generous because seal fat repels flies. Next, put a large rock on top to press out the remaining air. Finally, bury the whole thing under rocks and let it sit for about six months.

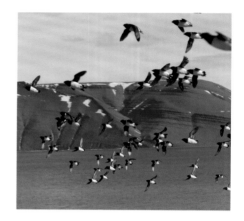

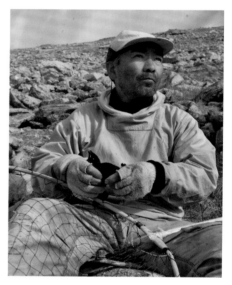

RIGHT, TOP TO BOTTOM *Little auks returning in summer to nest in Siorapaluk, Greenland – just 1368km (850 miles) from the North Pole. A bird is killed instantly by breaking its collarbone into its heart. Fermented little auks (considered a delicacy) are prepared by being stuffed into a sealskin and buried for months.*

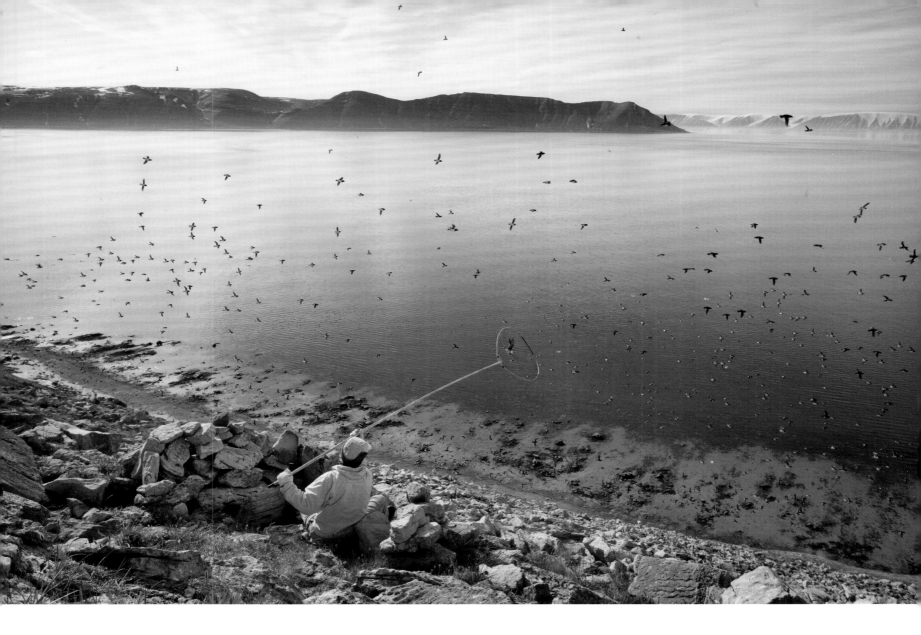

In the lean times, around December, when it is dark and there is nothing much to hunt, dig up your kiviaq and serve the birds raw. The feathers should have disintegrated into slime, and all parts are edible, including skin, skull and bones. As for the taste (and smell), the closest comparison that non-Greenlanders who've tried it can offer is very ripe Gorgonzola cheese – times a hundred. It is not recommended to eat it indoors, as the odour might cause dizziness.

Greenlanders think of kiviaq as a delicacy (some become almost addicted to the taste) and usually save it for weddings or birthdays. But always make sure your kiviaq comes from a reputable source, because a spoiled batch can kill. The famous Greenlandic explorer Knud Rassmussen reputedly met his end after eating spoiled kiviaq.

ABOVE *Ikuo Oshima scooping little auks out of the sky from a traditional hiding spot; white clothes help camouflage him. The birds are so numerous that it's possible to catch three in one swipe of his net. A skilled hunter can collect 500 to 1000 birds in a day, which will provide welcome, luxury food in midwinter.*

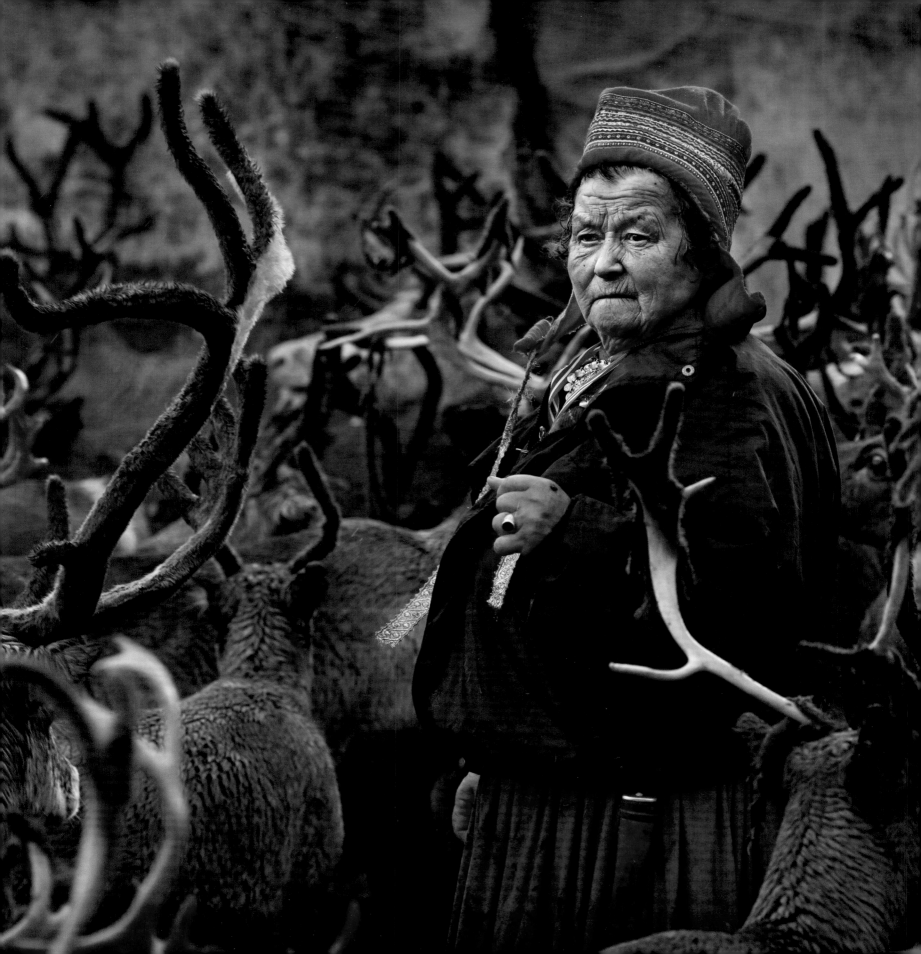

PEOPLE OF THE REINDEER

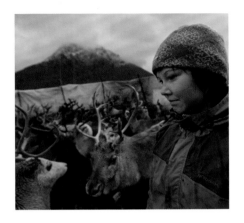

In the Arctic, hunters are usually on the lookout for their next meal, and it pays to have food cached in the ground – the Arctic's natural refrigerator. But one group of tribes got around the problem of hunting by living right alongside their prey.

The Sami of northern Europe and Russia, like several other herding peoples, travel with large numbers of reindeer. They have done this for at least 500 years along traditional migration routes. They say the first herder was the person who first castrated a male reindeer, a practice that traditionally involved biting its testicles (using a knife is frowned upon because it too often leads to infection and death). Castrated males are compliant and can be used to manipulate the herd – which remains, in most other respects, wild.

Though the Sami have solved the problem of finding food, they are still at the mercy of the seasons. Reindeer have to migrate between summer and winter pastures, and the sea ice and especially the snow dictate how and when they can travel.

Elle-Helene Suri is a Samish herder from Kautokeino, Norway. Over summer, she and her family graze their herd of about 3000 reindeer on Arnoy Island. Arnoy boasts rich grassland, but come winter, it lacks lichen – which is what reindeer need when the grass is dormant. The nearest lichen they can access is 450km (280 miles) away. So in September, the Sami and their deer have to migrate. Before they set off, the herders corral the reindeer into smaller groups of about 500 animals to check them and administer medicine. Ask a Samish herder how many reindeer he or she has, and you will get a curt reply: 'How much money do you have in your bank?' It's considered a rude question, but the herder will know the answer, because all reindeer have identity earmarks.

As soon as they set off on migration, they run headlong into a huge barrier: the open ocean. Arnoy is an island, and the winter pastures are on the mainland. The reindeer have to swim. The strait between Arnoy and the next island is 5km (more than 2 miles) wide. This is a long swim for an adult reindeer, but for a calf it's a marathon. Having lived only one summer, the calves have never swum before. So for them, and for the Sami looking after them, it is a stressful time. Elle-Helene waits in a boat as other

Sami herders Elle-Helene Suri (ABOVE) and her great aunt Karen Anna Logje Gaup (LEFT) rounding up their clans' herds of reindeer on Arnoy Island, Norway. They will begin their long migration back to winter pastures on the mainland, where they can find enough lichen to graze when the deep snows of winter fall.

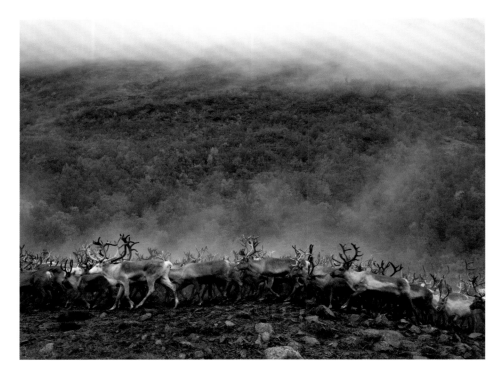

family members, using quad bikes, force the deer to the water's edge. Because the herders have already set up fences, the deer have nowhere else to go. Elle-Helene stresses that it's important for the reindeer to be as calm as possible before they enter the water – any sense of panic will only escalate as they start swimming.

The use of modern technologies such as motorboats and quad bikes makes the migration easier, but modernity is a two-edged sword. The Sami have to close roads to get their deer across. Worse still, while swimming the channel, the deer have to cope with dangerous boat traffic. Wakes from some of the larger cargo ships can swamp the young animals and induce panic. The calves are clearly the weak link. It doesn't take long before the herd is strung out in a long line, with the calves at the back.

Elle-Helene follows behind them in her boat, gently encouraging them onwards. If a young calf looks as if it might drown, she will haul it onto the boat. She remembers the time when 150 calves panicked and swam back to Arnoy. As the herders caught them and began to ferry them across in their motorboats, the mother reindeer, having lost their young, started to swim back to Arnoy. The whole migration nearly failed that year.

Once across, the reindeer still have weeks of walking ahead of them, but the trickiest part is over. In a few weeks, the snows will be falling but the reindeer will have lichen to eat.

ABOVE *The start of the migration from Arnoy Island.* RIGHT *Swimming to the mainland. To reach their winter pastures, the reindeer must be guided across 5km (more than 2 miles) of ocean. It's a busy shipping lane, and the Sami family have to watch out for boats' wakes, which can drown the calves.*

ARCTIC

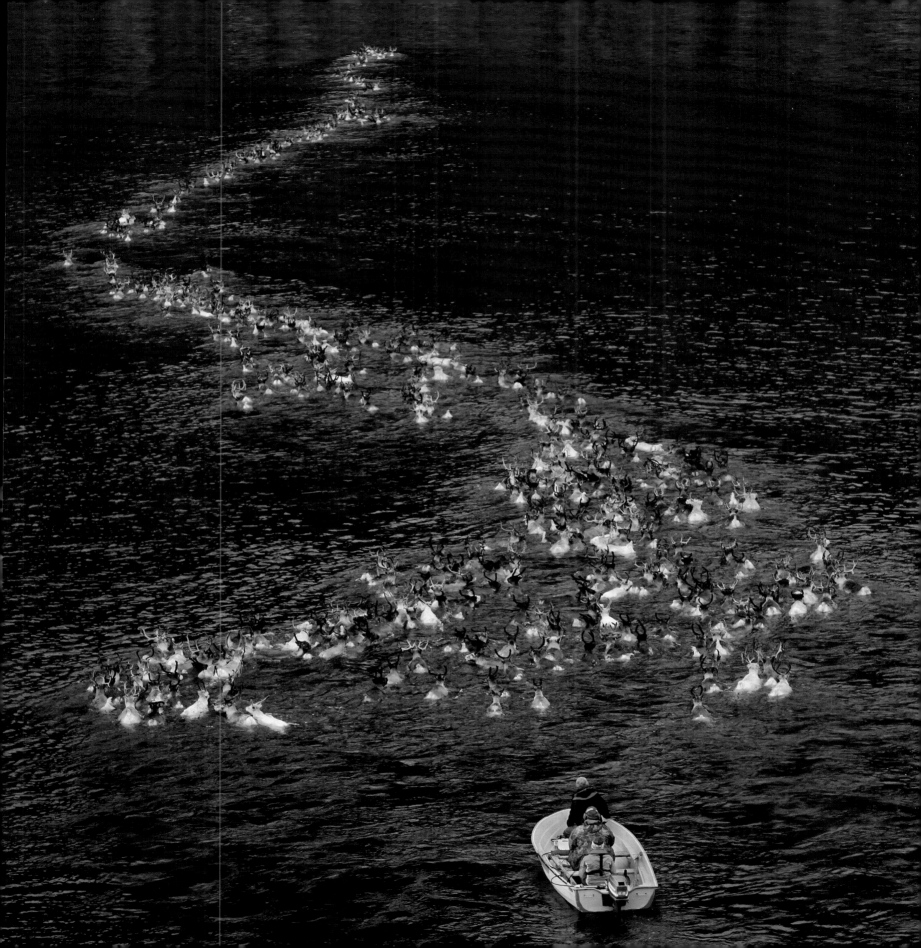

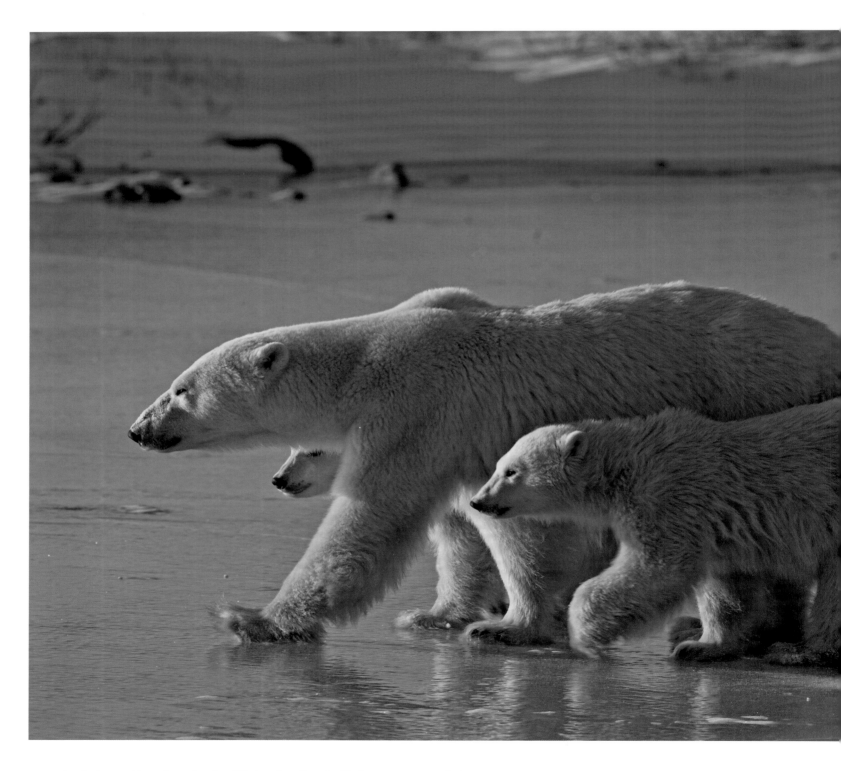

214 ABOVE *A polar bear and her cubs on the edge of Hudson Bay, Canada. She has not eaten properly since the ice melted in summer and is waiting for the bay to freeze so she can hunt ringed seals again on the ice. But where she and many other bears have gathered is where humans have built the town of Churchill.*

BEAR LAW

Reindeer aren't the only animals that migrate every autumn in search of food. Along Hudson Bay, Canada, polar bears will not have had a square meal for up to six months. They are eager for the sea ice to form again, so that they can use it to hunt seals.

Churchill is the biggest town on Hudson Bay. It was built at a strategic location for trading and hunting, and it also happens to be one of the first places on the bay where the new ice forms. So, as temperatures drop below zero, hundreds of polar bears come to the place where they have always found ice – only now Churchill is in the way. Being bears, they are opportunists, and humans do appear on their menu: the polar bear is one of the only land predators that will (though rarely) actively hunt people.

The residents of Churchill have adapted to this threat in several ways. First, they've encircled the town with a number of polar-bear traps – the first line of defence. Should the bears get through, the official town polar-bear patrol, driving in pick-up trucks and armed with noisy firecrackers and tranquillizer guns, will try to drive them off.

Nevertheless, bears often breach every defence and can be found rummaging through rubbish bins or loitering around the recycling depot. People who lived in Churchill in the eighties remember the time when a man was devoured on Main Street. He'd just emerged from a burnt-out hotel, where the contents of the freezer had begun to thaw. Evidently, his pockets were stuffed with raw meat, and the bear smelled the meat and killed the man before the police or the polar-bear patrol could get there.

The story remains part of Churchill folklore. Every Friday, the residents hold a raffle for meat – a modern version of the Inuit tradition of meat-sharing, when the chief would hand out food to those unable to hunt. Winners of the modern meat raffle are warned to keep their meat well wrapped up when they walk home.

The most dangerous night of the year, though, is Halloween. Children are warned not to dress up as polar bears because they might end up getting shot by residents or darted by the polar-bear patrol. Trick-or-treaters travel together in packs, their parents driving nervously behind them with headlights on, eyes peeled for rogue bears to come charging out of the darkness.

Sometimes multiple bears are darted and trapped in a day, and so Churchill now has a bear 'prison' that can hold up to 28 'inmates'. During their stay, the bears can't be fed, as that would merely encourage them to return next year. But when the sea ice is firm enough, the polar-bear patrol sedates the animals and carries them in nets below helicopters to a place far away where they can hunt seals.

ARCTIC

HERE COMES THE SUN

By November, all the Arctic migrations slow down. The icy crown is once again enveloped by 24-hour darkness and extreme cold. People still hunt and fish, but the fading light shortens the days.

Niels Gundel and his family live in a pretty A-frame house in Ilulissat, Greenland (the Inuit don't live in igloos anymore, and in fact few can remember how to build one. Some, mainly in Canada, will make a smaller form of the igloo to use as a temporary storm shelter.) In late November, Niels will watch the sun dip behind the horizon for the last time – it won't return until the second week in January.

The darkness isn't always pitch black – during the day, a kind of twilight arises. Even so, the lack of sun can be oppressive. Arctic people have a simple cure. They socialize and hold coffee and gossip sessions that last hours. Aside from that, life goes on pretty much as if the darkness wasn't there. As January approaches, children make paper suns that they put up in their windows to encourage the sun to come back soon.

On 13 January, on the thirteenth minute before the thirteenth hour, the locals of Ilulissat gather on the site of the ancient settlement of Sekinarfik to greet the first 'dawn' of the year. A choir sings:

The sunlight lit my soul which had been in darkness,

And drove away the cold by shining on me.

It is in this moment that the answer to the question 'why live in the Arctic?' becomes clear. This is a community of people, friends and family, who stick together. Together, and with other animals, they learned how to survive in the harshest of environments. And together they continue to learn it all over again as the environment changes.

The sun rises for just a few minutes, and then will set again. For a brief time, it lights the faces of the Arctic people who stare at the horizon.

What will the new dawn bring? Data shows that though temperatures are rising globally, the poles are heating up much faster than anywhere else. Sea ice is melting and sometimes not even forming anymore. Animals are changing their migration patterns, and hunting seasons are disrupted. The knowledge that sustained people for centuries might become obsolete.

There is little doubt that Arctic people sit on the front line of climate change. But these are people bred on change – change in seasons, change in weather. Their environment has trained them to cope with the unpredictable. If there is one group likely to adapt to the changes ahead, it is probably the Arctic people.

RIGHT *Niels Gundel watching the sun rise on 13 January – the first sunrise in more than a month. He wears polar-bear trousers – warmer than any synthetic ones. Even though Niels is a thoroughly modern Inuit, he also has knowledge from the past that enables him to survive on what a frozen natural world has to offer.*

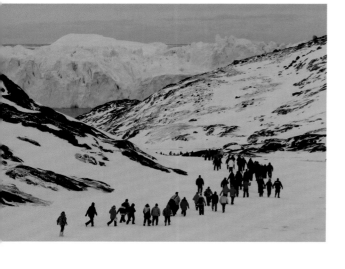

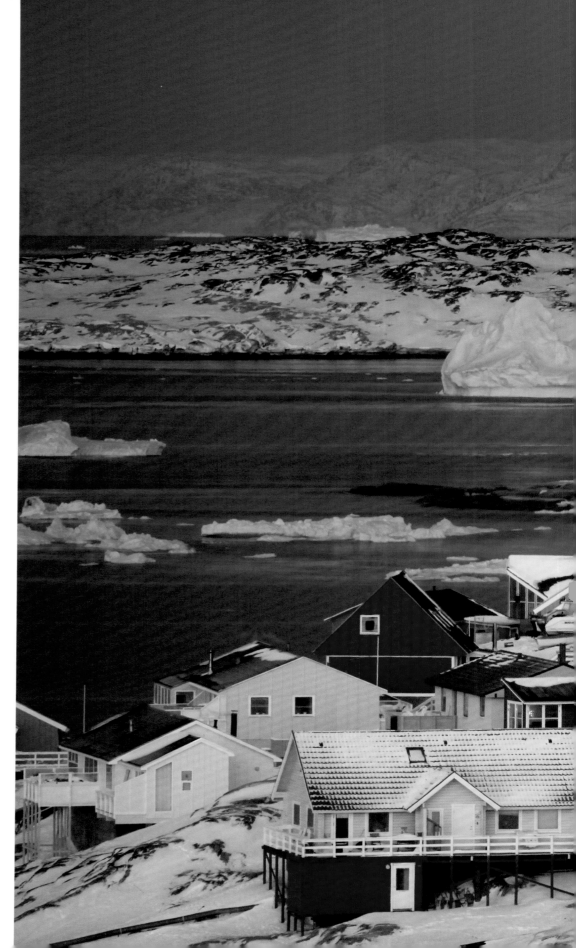

ABOVE *The residents of Ilulissat gathering on the hills of Sekinarfik to celebrate the returning sun.* RIGHT *Ilulissat means iceberg in Greenlandic, named after the icebergs that drift past, calved from the Jacobshaven Glacier – a glacier that is fast retreating as Arctic temperatures increase.*

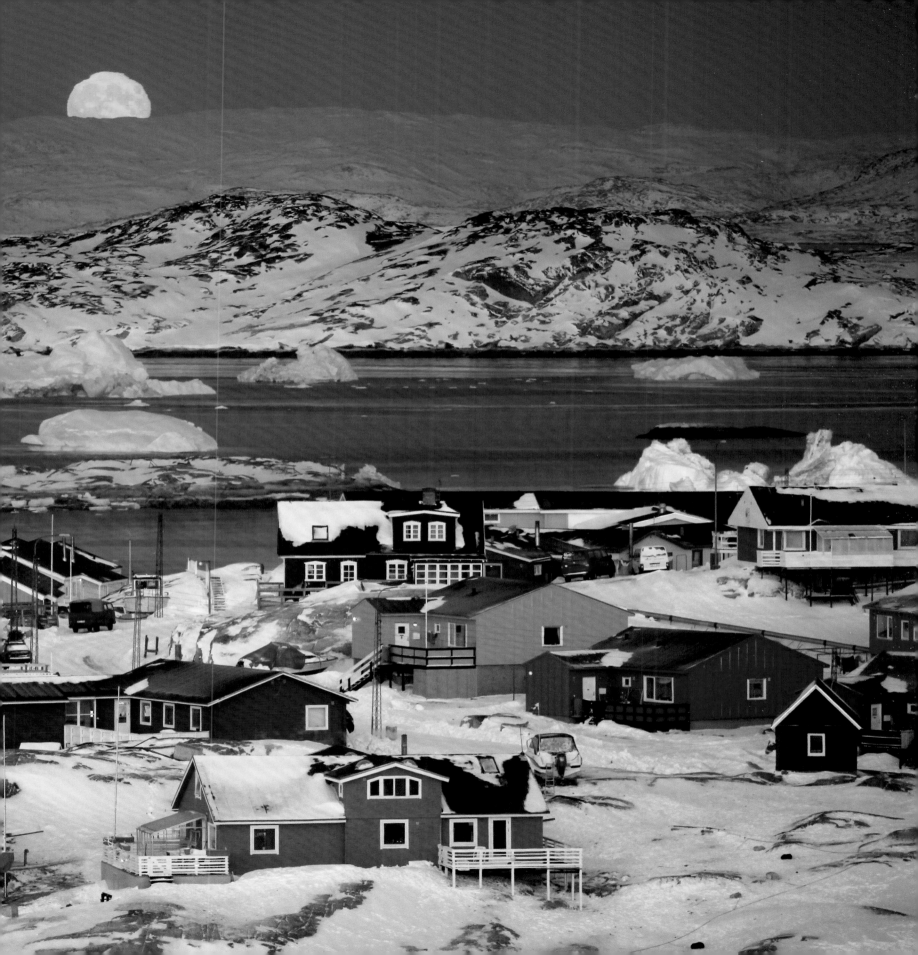

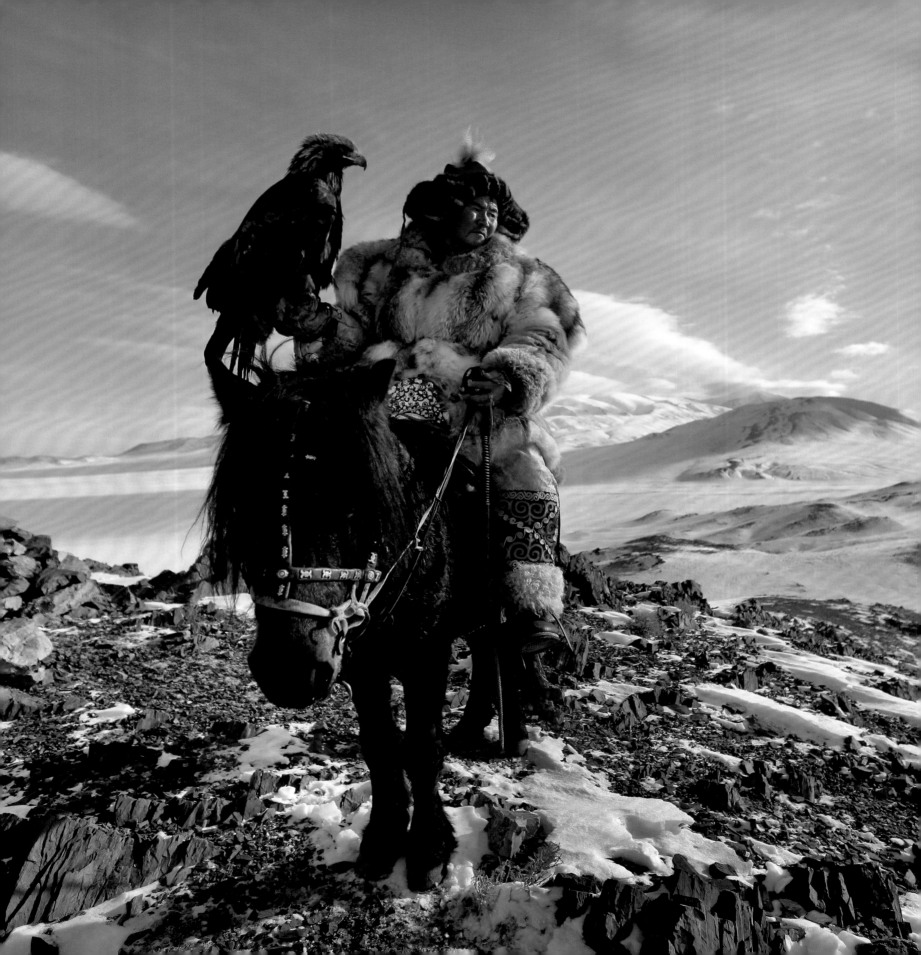

MOUNTAINS

7

SOME SAY THAT ON A MOUNTAIN YOU ARE CLOSER TO HEAVEN. THIS IS TRUE IN THE SENSE THAT MOUNTAINS TOWER ABOVE THE CLOUDS, AND OUT OF MOUNTAINS FLOWS MOST OF THE WORLD'S FRESH WATER, AS WELL AS MOST OF THE TOPSOIL – GIFTS THAT ARE EASY TO SEE AS HEAVEN-SENT. BUT IS LIVING ON A MOUNTAIN HEAVEN OR MORE LIKE HELL?

MOUNTAIN COMMUNITIES ARE AMONG THE POOREST, MOST MARGINALIZED PEOPLE ON EARTH, ENDURING SOME OF THE GREATEST OF HARDSHIPS. THE PROBLEM IS THE SHEER VERTICALITY, WHICH HAS A PROFOUND EFFECT ON EVERY ASPECT OF MOUNTAIN LIFE. YOU HAVE TO CLIMB UP OR DOWN TO GET ANYWHERE, AND ROCK-FACES FORM A BARRIER TO THE OUTSIDE WORLD. THE HIGHER YOU GO, THE HARDER IT GETS.

Air pressure decreases as altitude increases, leaving less oxygen to breathe. Above 3050 metres (10,000 feet), many people fall ill, sometimes fatally, but some indigenous mountain people have developed adaptations to the thin air. In the Andes, some people have extra haemoglobin in their bloodstream, allowing a better uptake of what little oxygen there is. In the Himalayas, there are people who have greater blood flow and can breathe more efficiently than those at lower altitudes. But above 7000–8000 metres (23,000–26,200 feet), it's not possible for humans to survive for long. Yet people still risk their lives to stand at 8848 metres (29,030 feet) on the summit of Everest. Humans, it seems, are drawn to mountains.

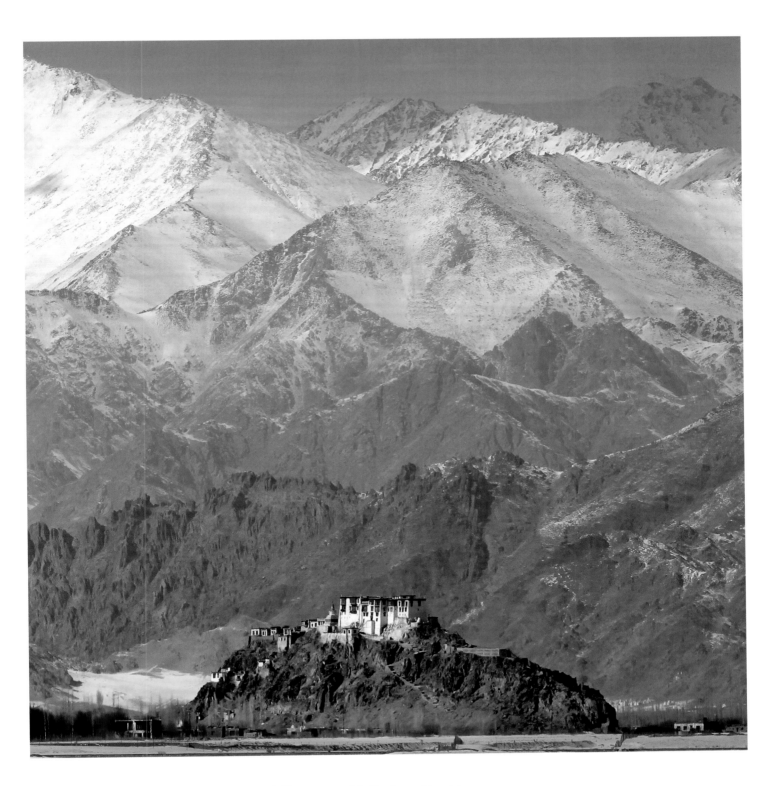

ABOVE *Stakna Gompa, a Buddhist monastery in the Ladakh range, part of the Karakorum Mountains bordering Pakistan, India and China.* OPPOSITE *An Ethiopian farmer harvesting barley on a cliffside field in the Simien Mountains.* PREVIOUS PAGE *A Kazakh hunter wearing furs of animals his eagle has killed.*

MINING THE INFERNO

If proof were needed that mountains can be hell on Earth, you don't have to look farther than Indonesia. This story begins at the bottom.

Deep inside a volcano, a human shape emerges from billowing clouds of poisonous sulphur. It's a scene from Dante's *Inferno*: the man struggles with his devilish burden, bent over by the weight of the huge basket overflowing with large spikes of bright yellow sulphur. His clothes are rags, his eyes bloodshot, his exposed skin blistered by the toxic gas. Ahead he faces a steep climb out of the caldera, followed by a long walk down the mountain to deliver the sulphur to the company paymaster.

Like most Indonesian sulphur miners, the man's toil may shorten his life. Evidence of the sulphuric ruin to his lungs can be heard in his voice. But he is living proof that humans can survive in the most extreme conditions, and he laughs at the health risks. He can support his family, and unlike some he knows, he doesn't need to beg. He is a proud miner who competes with his colleagues to carry the heaviest load. He knows how to navigate inside a rumbling volcano and avoid the toxic clouds. Not every man can say he works in a place as dramatic as this. Once he has collected his wages – higher than average for the region – he lights up a cigarette and walks home down the rice terraces.

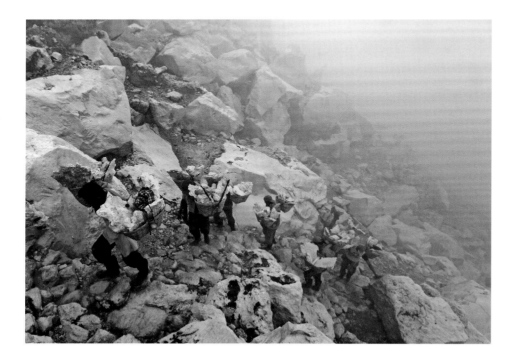

ABOVE *Climbing out of hell. Indonesian labourers carrying their sulphur loads out of Kawah Ijen Crater, Java. They are paid by the weight.* RIGHT *Solidified sulphur being dug from the active volcanic vent. The fumes affect the lungs of the workers, and the water in the crater is acidic enough to dissolve clothing.*

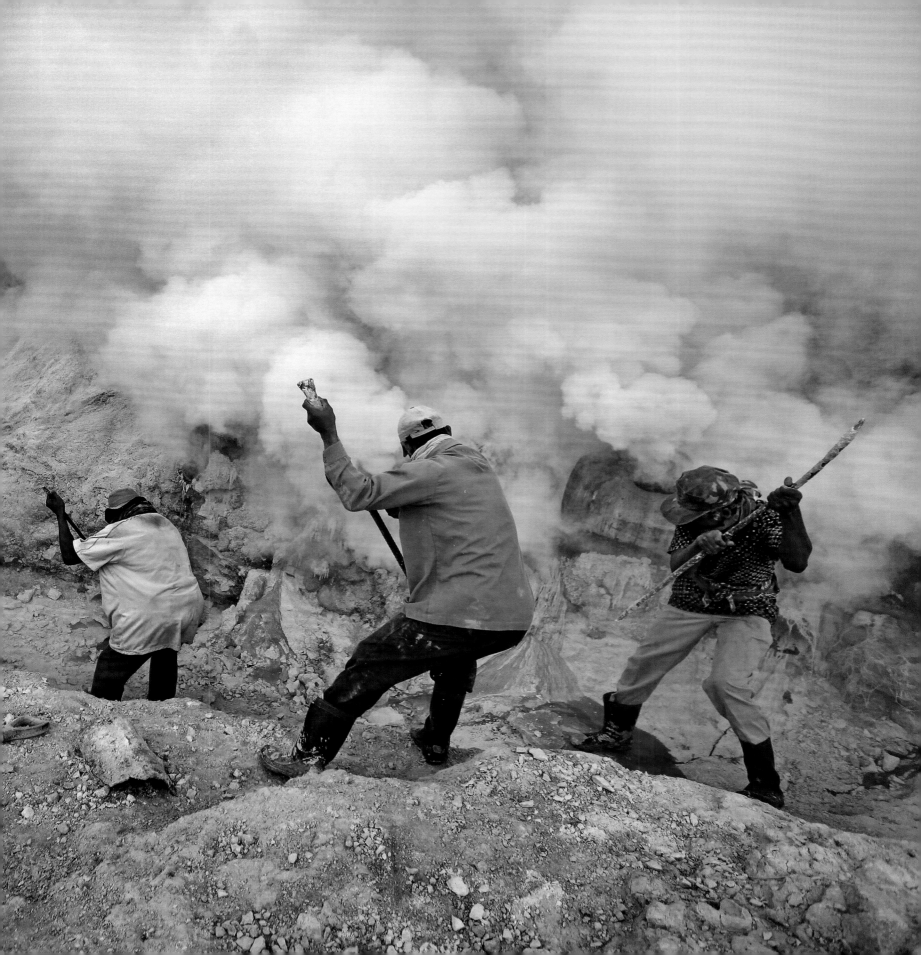

THE BAT-NETTERS

Indonesia is one of the most active volcanic regions on the Pacific ring of fire – a circular band of volcanism that includes countries as diverse as Japan and Costa Rica – and the rich volcanic soil is the primary wealth of the region. Not all the world's mountains are volcanic, though. In fact, the majority, including the Himalayas and the Rockies, were created by land masses pushing against each other and crumpling up near where they met. But whichever way they were created, most mountain ranges continue to shape human history. One of the most striking examples of this can be found in New Guinea.

Mountains dominate the island – the world's second largest and more than three times the size of Great Britain. And down every mountainside, rivers gouge valleys. This rugged geography has given rise to an anthropologist's dream. A different group of people has settled in almost every valley system – some 700 distinct groups, cut off from one another by the mountains. They have developed different cultures and languages. Some of the languages are as different from each other as English is from Mandarin.

Marcus is a Yangoru Boiken hunter from the Prince Alexander coastal mountain range. Like mountain people everywhere, he faces steep slopes every day of his life. But far from being oppressed by the mountains, the Yangoru Boiken people have turned the ridge lines to their advantage. Centuries ago, they observed that, in at least one respect, bats and humans are similar: both look for shortcuts. With this in mind, Marcus makes his way along the top of a ridge. He climbs a tree to assess the spot. It meets his criteria, and he begins to chop. Only a few trees need to come down. Seen from the side, the ridge now has a rectangular notch cut out of its top, like a doorway – and that's exactly what it is.

As the sun goes down, Marcus sits by the opening and listens. On their journey between their roost and the fruit trees they feed on, they must fly up and over the ridge. Marcus's newly created gap is a handy shortcut – it saves them a little wing-power.

Marcus allows them to get used to the new route before springing his trap. He's made a huge net specially to snare the bats – it's loose enough to be invisible to their senses, but tight enough so that they can't escape once caught. In the black of night, several giant fruit bats crash into the net. Marcus is alerted to their presence by a tin can full of seeds that he's fixed to the net. He rushes to lower both net and prey using pulleys and rigging he's created from vines and canes. He then dispatches the bats with a club.

Once he has a few, he brings them back to his village. He sears off the fur over an open flame and then boils the bats in a pot, with local leaves for flavour. He serves this rare source of protein with rice and vegetables. Each bat can feed up to five people.

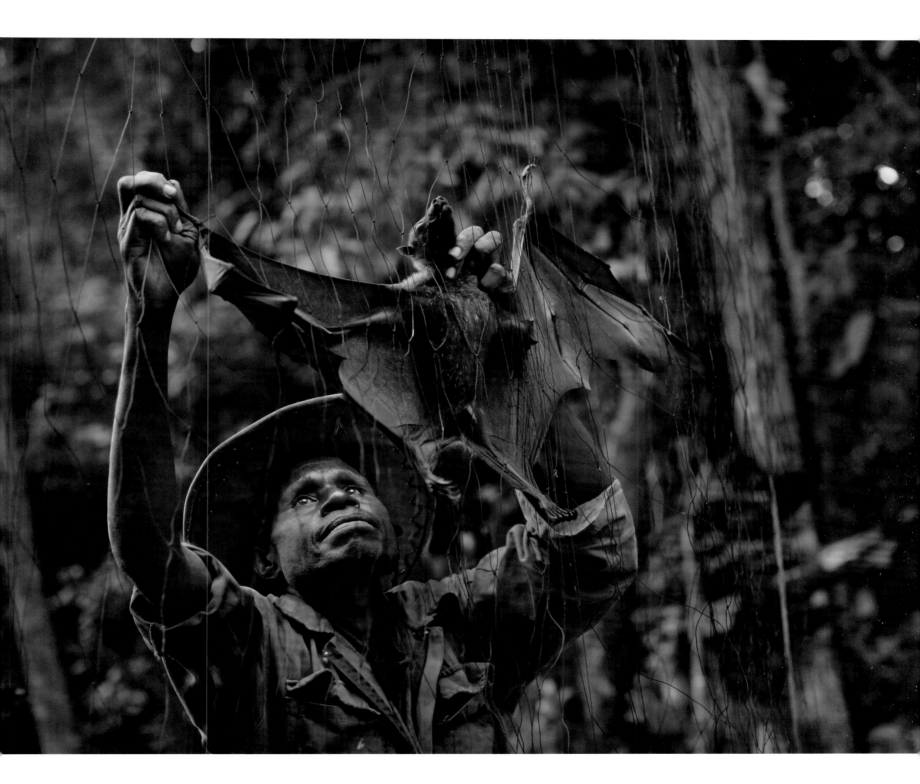

ABOVE *Unhooking a giant fruit bat. Marcus's net is raised and lowered by home-made cane pulleys. Bat-hunting has run in his family for generations.* OPPOSITE *A gap cut out of the tree line on a ridge. The fruit bats use it as a short cut from their roosts on the coast to reach fruiting trees in the next valley.*

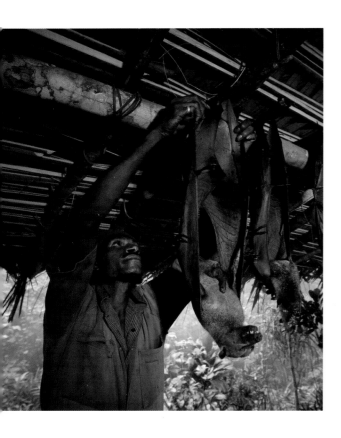

ABOVE *Hanging up the night's haul of bats in preparation for cooking. Bat-hunters are proud of the rare source of protein they provide for their families.* RIGHT *The bat-net, rigged like a sail across the ridgetop. This particular method of hunting fruit bats with nets is rarely seen outside the Mt Turu region of Papua New Guinea.*

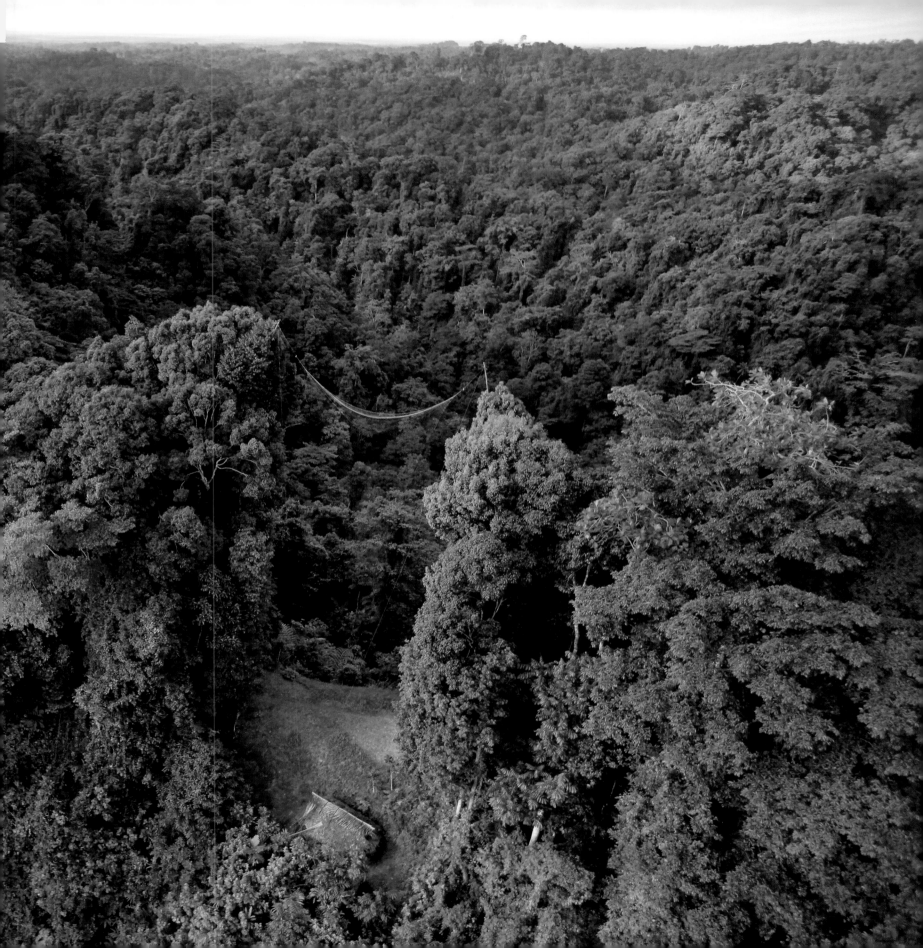

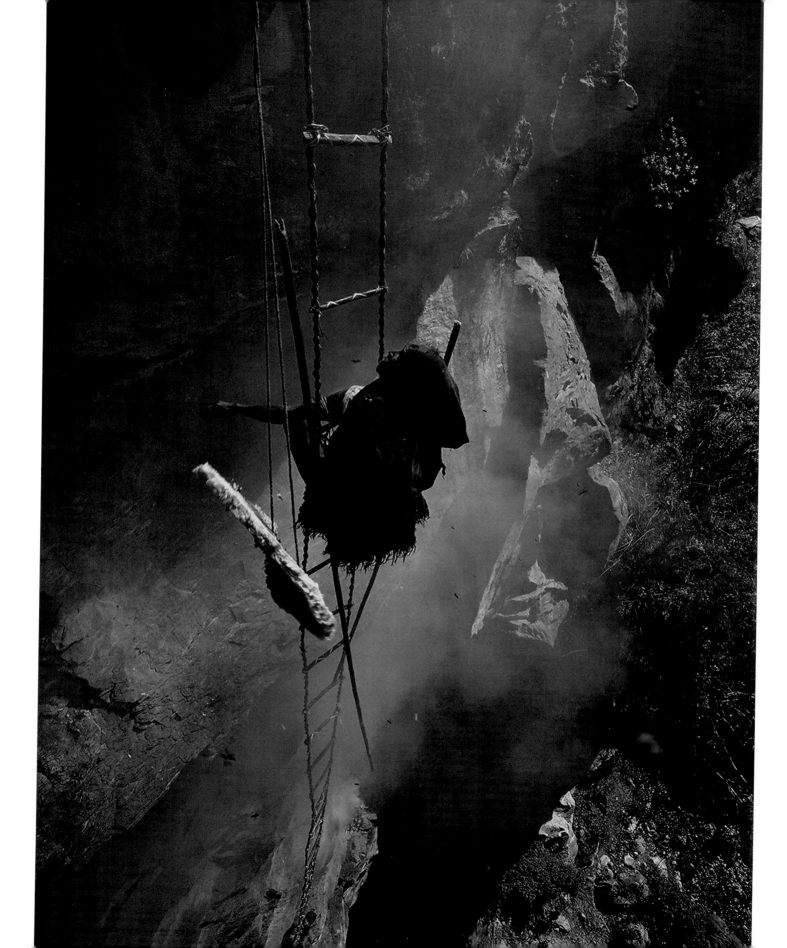

SWEETNESS FROM THE SKY

The Himalayan mountains of Nepal are much higher than those of New Guinea, but like them, they are bisected by an endless succession of valleys, often so isolated from each other and the world at large that they contain species found nowhere else.

Animals adapted to these heights include the world's largest honeybee, *Apis laboriosa*, which lives at altitudes up to 3600 metres (1180 feet) and may forage even higher. To keep its honeycombs out of reach of predators such as bears, it hangs them from cliffs, including those found in the Annapurna region. It can be a shock to look up at a cliff face and see a hive the size of a postbox dangling from a ledge. Just one hive can contain 30kg (66 pounds) of honey. For the people of Taprang village, such a bonanza is worth risking a precipitous climb and possible death.

Twice a year, villagers gather at the base of the cliff and offer up a prayer and gift of flowers, fruits and rice. Then they light a fire. The smoke rises to the hive above. Thinking it to be smoke from a forest fire, most of the bees evacuate. The honey-hunters then approach from above, descending on ladders suspended from the top of the cliff. When a honey-hunter reaches the level of a hive, he is likely to be attacked by the giant guard bees that remain on the combs. So he has to work quickly, sometimes protected by just a blanket. He wields a long pole with a flattened end like a paddle blade to carve off chunks of comb. These fall down to the waiting men below.

OPPOSITE AND TOP *Hacking at the cliff-hanging comb. A honey-gatherer needs to be both athletic and brave. He has to cut the comb with his pole and manoeuvre it into the basket while hanging from a rope ladder and being stung by giant bees.* ABOVE *The bounty – 30kg (66 pounds) or so of honeycomb.*

THE MEN WHO TEACH EAGLES

The honey-hunters' resourcefulness highlights a human shortcoming when it comes to life in the mountains – people can't fly. But flying is a skill that some people have attempted to co-opt. The dry climate of Mongolia's Altai Mountains and the high winds mean that there is virtually no cover, which for a human hunter poses a problem. How do you catch an animal when it can see you coming from far away? Even on horseback and armed with a rifle, a man is lucky to catch a rabbit, fox or wolf.

By comparison, the golden eagle is a supreme hunter in this environment. With a wingspan of 2 metres (7 feet) or more and a capability of diving at 150kph (92mph), this predator has little trouble ambushing prey. Mountains don't restrict its movement – in fact, the uplift of air over ridges gives eagles the height they need to cover a vast range. Three thousand years ago, bronze-age hunters in the Altai Mountains chronicled their extraordinary relationship with hunting birds by carving drawings on rock walls. The glyphs have been interpreted as the birds riding on men's forearms. It's a practice that continues to this day. The key is to catch a fledgling eagle at the right age, before it has learned to fly.

Sixteen-year-old Berik is suspended by a rope from a cliff. He has waited his whole life for this moment. Above him, his father Sailau's face is full of concern, his knuckles whitened by his grip on the rope. 'Slack,' shouts Berik. 'I'm nearly there.' Just beneath his feet, two baby golden eagles regard him with surprise rather than panic. Once safely on the ledge, Berik picks up the fledglings and inspects them with the expertise of a trainer inspecting a racehorse. He stretches out their talons, looking at the lines etched above each claw – the scutes. Three scutes are good but four are better.

Berik needs a female, which is larger and more aggressive than a male. Both of these fledglings are female, and both have four scutes. So he takes the larger bird, reasoning that she has been more active than her sister at feeding time. He wraps his chosen bird in a blanket and slings the bundle over his shoulder. Climbing back up to his father, he unbundles his catch. Sailau approves: 'A queen of the Altai!'

Sailau and Berik are Kazakhs, and Sailau is teaching his son to become a Kazakh eagle-hunter. Over the next six months, Berik and his eagle train almost every day. The bird learns to fly and to dive onto a fox skin pulled on a rope. Berik rewards her with chunks of meat. As the bird's skills improve, Berik learns the importance of patience and discipline. If he changes the routine just once, the bird could lose faith in him as a reliable master.

In November, the first snows fall. Sailau can't contain his excitement. At first light, he and Berik set out on horseback. Each has a golden eagle perched on his left arm

RIGHT *Sixteen-year-old Berik about to fly his female golden eagle. He must launch her from a high vantage point and take the hood off only when the fox is spotted. Six months ago he captured her from a nearby cliff, and he has trained her every day since. Now she will fly to his arm when he calls her.*

MOUNTAINS

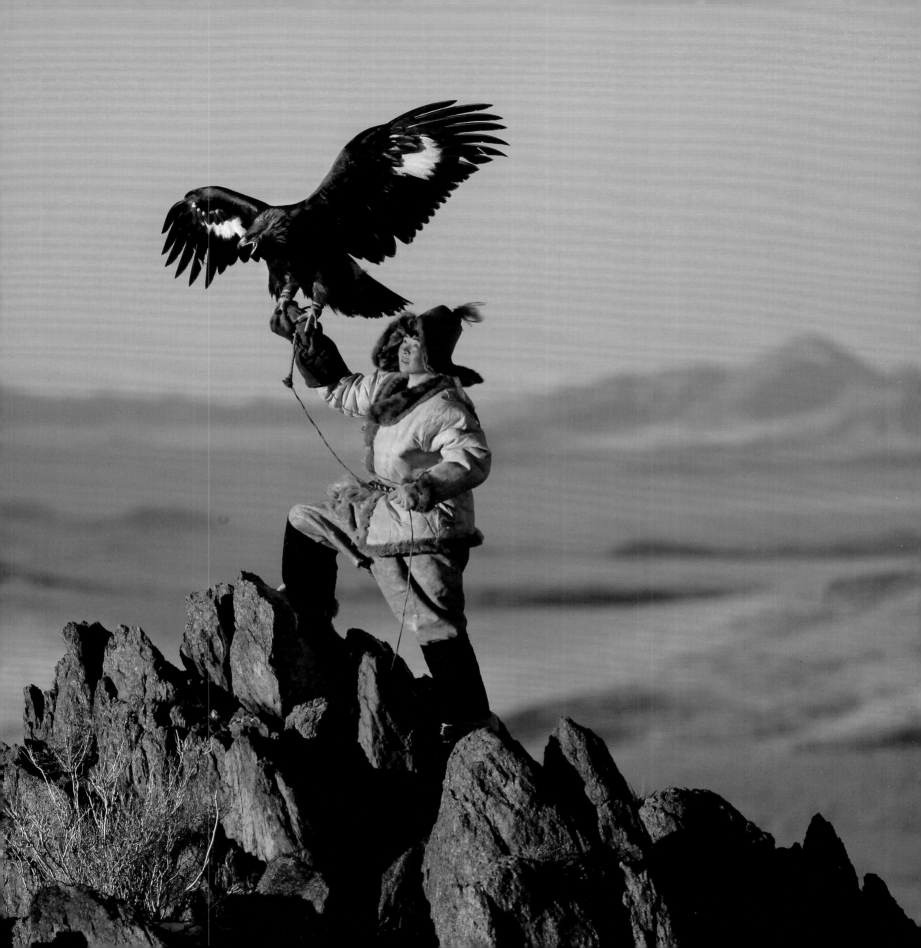

and is clothed in heavy fur for protection from the cold – now averaging -20°C (-4°F). They ride up a canyon to gain height. It doesn't take long before they find fresh fox tracks in the snow. Sailau points to the ridge above. He tells Berik to find a place with a commanding view and to wait there. When he hears Sailau's signal, he has to remove his bird's hood. With her acute eyesight, she will be able to see the fox, even if Berik can't. If she does, Berik has to release her.

Moments later, a fox bolts out into the open. As Berik releases his eagle, he shouts the same command they've used all summer. The eagle is emboldened by the sound and knows just what to do. She circles once to keep her altitude. Then she folds her wings into her chest and drops like an arrow unleashed from a longbow. Even at full sprint, the fox has no chance of reaching cover. Just above the fox's head, she flares her wings to control her speed. The fox wheels around and gnashes its teeth and inflates its fur to increase its size. The young bird is utterly surprised – this fox is not behaving like the furs she's been used to. She veers away at the last second and settles nearby.

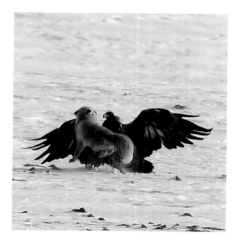

Sailau has released his eagle as well, but too late. The fox escapes into the rocks. Both eagles rest on the snow, waiting for their masters to ride down. Once in range, the men call their eagles, which obediently fly onto their arms. As the sun sets, the hunters return to their gers (tents). Sailau consoles his son, explaining how a young eagle that has never seen a live fox before can be startled. 'But,' he adds, 'it won't happen twice.'

The following morning they again find the trail of a fox. Sailau flushes it out. As Berik releases his bird, he can sense her excitement. The fox runs. The bird traces its movements. Flying high above, she suddenly dives. As she strikes, her left talon closes on the fox's haunches above the tail. The fox turns to bite its assailant, and the eagle's right claw closes on its jaws. Eagle's claws have tremendous crushing force, but this eagle has been trained to refrain from killing the prey and tearing into its vital organs with her beak – at least for a short time. And so it is important that Sailau gets to her quickly, before she shreds the valuable pelt. He coaxes her to let go with a chunk of goat meat and then dispatches the fox with a crushing blow.

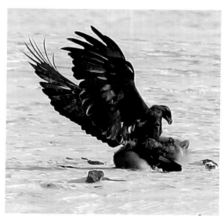

This is the first kill for Berik's bird, and the tradition is to allow her to eat the fox's lungs. Its pelt will be made into a hat that Berik will keep for many years. For Kazakh boys, a successful hunt is a rite of passage. Sailau seems even more pleased with the outcome than Berik – his greatest pleasure is to see his sons grow up the Kazakh way.

The partnership between man and eagle is a dramatic illustration of how humans living in the mountains depend on partnerships with other animals. And the higher they live, the truer this becomes.

ABOVE RIGHT *The first successful catch. Though the eagle could kill the animal quickly, she waits for her master to kill it in a way that means the pelt isn't shredded. The fur will either be used as clothing or sold when Sailau and Berik next travel to the town of Ulgii, a three-hour drive away down the valley.*

MOUNTAINS

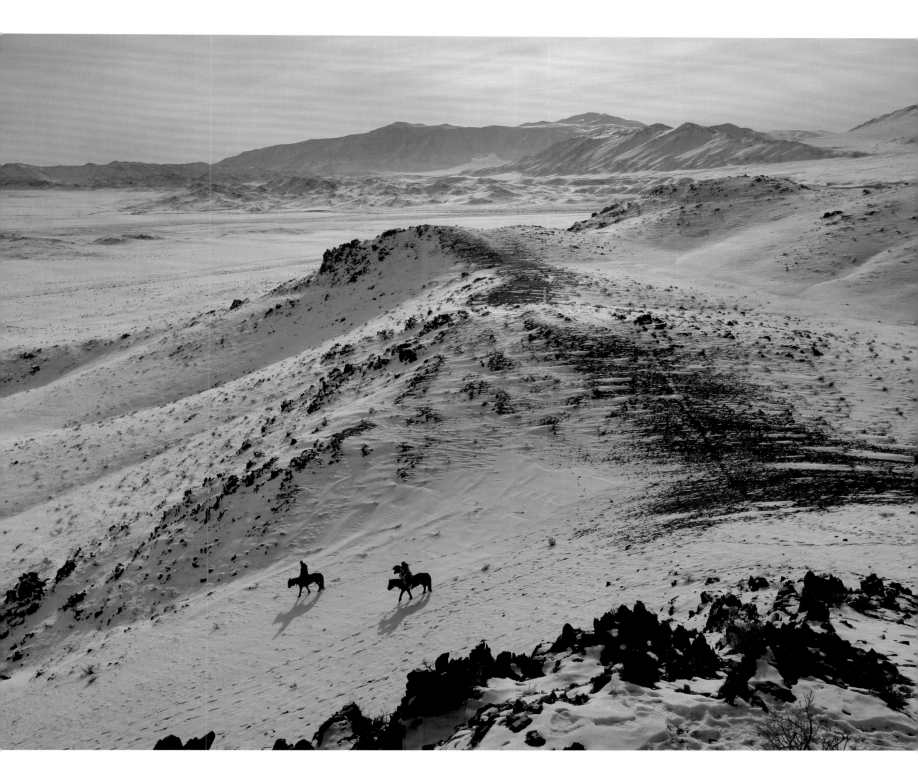

ABOVE *The hunters returning to their gers in the valley below. In temperatures of -20°C (-4°F), furs are by far the best insulation, and in this landscape, the best way to get your fur is by partnering with a golden eagle. Nearby rock art reveals that people here have practised this skill for thousands of years.*

GELADAS AND GRASS

In Ethiopia's Simien Mountains, people live higher than anywhere in Europe or North America – and more than twice as high as the Kazakh eagle hunters. But these mountains, with their spectacular spires, giant lobelia trees and unique wildlife, are distinctly African. For Aweta and his family, carving out a life in this rugged landscape is a challenge. Like so many mountain people, they depend on a combination of livestock and crops. But here there is precious little flat ground for cultivating wheat or barley. Like his ancestors before him over thousands of years, Aweta has ploughed or planted on every available cliff ledge, even if it means he must use ropes to get there. This is extreme farming, with drop-offs that make even experienced mountaineers feel giddy.

But in the Simiens, humans aren't the only primates that like to eat cultivated crops. Geladas are mountain specialists found only in the Ethiopian highlands – the only surviving species from a once-widespread genus of grass-grazing primates. They mainly eat native grasses, but probably ever since humans have planted domesticated grasses, geladas have helped themselves to their crops.

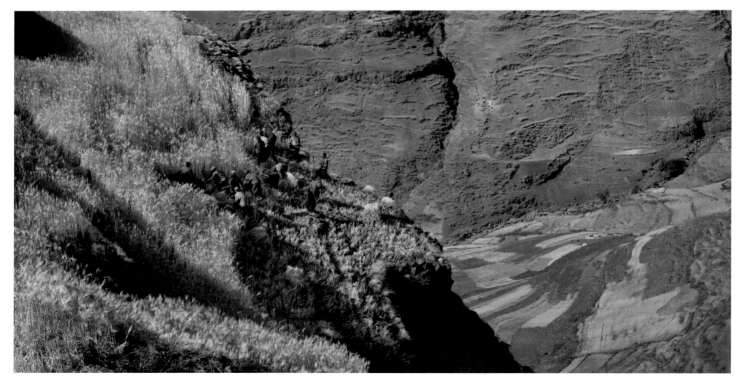

ABOVE *Friends, family and neighbours harvesting Aweta's clifftop field of barley, singing as they go. With little flat ground, every cliff ledge is a potential field.* TOP RIGHT *A male gelada caught in the act of eating Dereje's barley. Geladas eat mainly native grasses, and so domestic grasses are irresistible.*

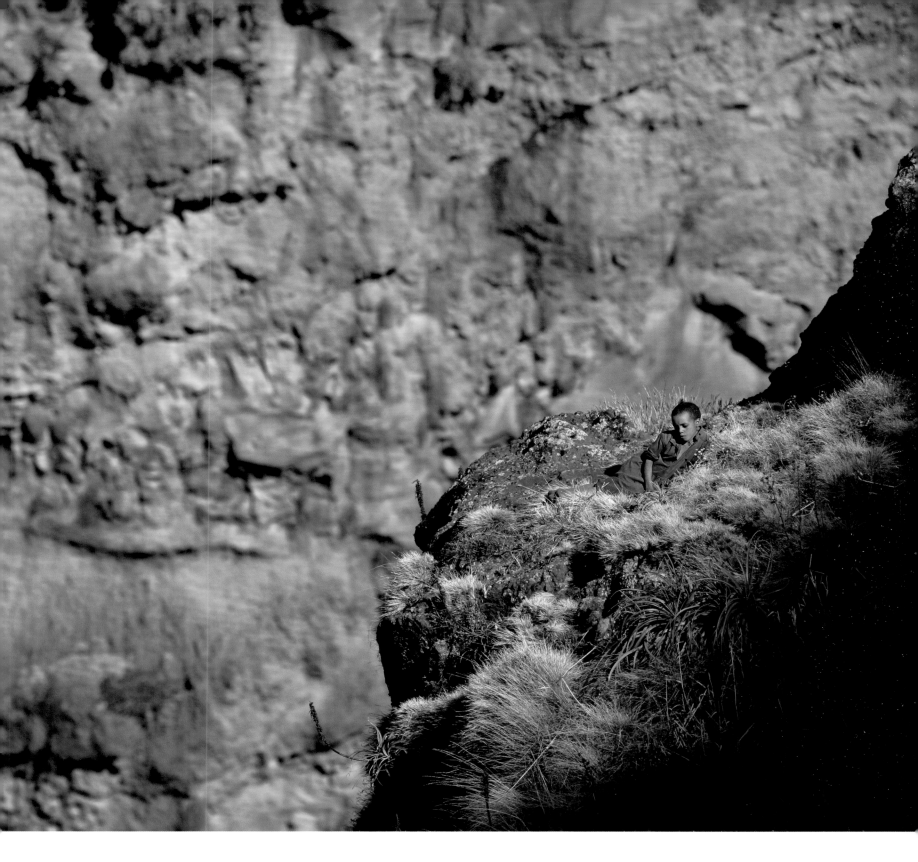

ABOVE *Aweta's sister Maza keeps watch on geladas below. At just six years old, she spends her summer days in the mountains, protecting the crops and herding her family's goats, just like her other brother Dereje. On moonless nights, she daren't risk the descent to the village and must stay with her animals in a cave.*

Geladas are easily distinguished from baboons by the bright patch of skin on their chests. The brightest chests are those of the alpha males, who also have long tufted tails, sabre-like teeth and flowing manes, giving them a lion-like look. Geladas roam the highland grasslands in groups of a hundred or more (groups as large as 800 are regularly recorded) and are natural climbers, scaling rock faces with abandon.

For Aweta's family, saving their crops from raiding geladas is a major challenge. The species is protected by Ethiopian law (killing them is punishable by huge fines and prison sentences), and so hill farmers have no choice but to employ full-time guards – a job that most often falls to children such as Aweta's younger brother Dereje, aged 12, aided by his sisters Debre, 10, and Maza, 6, who also tend the livestock.

Dereje has a wide area of crops to watch over and must use his wits. At night, the geladas take refuge from possible predators, mainly hyenas, by clambering down the cliffs to ledges. But if there is no moonlight, the children daren't risk travelling home. Instead they shelter in caves, herding their goats and cows in with them and cuddling together for warmth – temperatures often drop below freezing at night. In winter, the Simiens are one of the few places in Africa that regularly see frost and sleet, and even snow.

As soon as the sun hits the cliffs, the geladas are on the move. Using the cliffs for cover, they can appear almost anywhere in a field and then dive off again. To fend them off, Dereje throws rocks. He's an expert in making slings out of grass and can throw 30 metres (98 feet) with accuracy. And he doesn't rely just on his own observations to spot a raider. If a neighbour or goat herder in the valley below sees geladas, he will relay a series of alarm calls that echo off the cliffs.

The alarm goes off – a faint yodel-like sound from the valley below. Dereje springs to his feet and replies, 'Left or right?' Again the reply is faint, but Dereje can hear 'left', and he sprints off, pausing only to scoop up a rock and load it into his sling. Avoiding trampling the barley, Dereje runs so close to the cliff edge that he dislodges pebbles that tumble hundreds of metres onto the boulders below. 'Away, away,' he cries, and in the field in front of him, gelada faces pop out of the barley, their cheeks puffed with stolen

ABOVE *Young geladas being chased down the cliff by Dereje. Adept climbers, they can scale sheer rock faces and overhangs to reach cliff-edge fields.* RIGHT *Dereje keeping vigil as the sun sets over the Simien highlands. He would like to go to school, but his family depends on him to protect the crops and livestock.*

MOUNTAINS

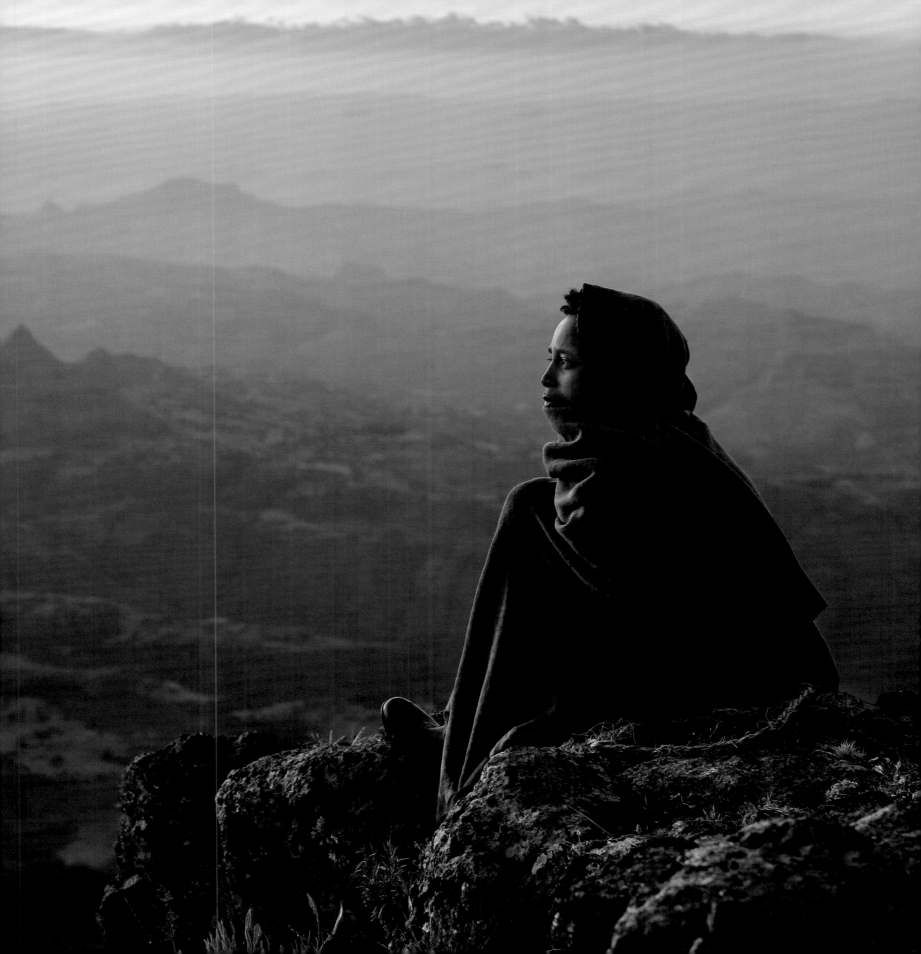

goods. They screech and run off, the babies swinging onto their mothers' backs. The males stand their ground, but a whirling rock from Dereje's sling changes their minds. His charge wasn't a moment too soon. A large troop of geladas can strip a field bare.

As the geladas disappear over the cliff edge, Dereje catches his breath. The battle has been going on for months but is most intense now, just before the harvest. It's as if the geladas can sense this is their last chance. 'They're so clever,' he marvels, before returning to the field. Below him, he can hear harvesters singing as they cut the stalks and pile them into stacks. They have already begun threshing and winnowing, and when Aweta comes to do the same up here, Dereje's work will be finished.

Scaring off geladas has been Dereje's full-time occupation, including holidays and weekends, since April. He's missed a lot of school, and he can't wait to return. He misses his friends, and he dreams of learning English and getting a good job that can bring in money and an easier life for his family.

ABOVE *Using a sling made out of grasses, Dereje propelling a stone at a crop-raiding gelada. He can be accurate at up to 30 metres (nearly 100 feet), and a slingshot is all that's needed to frighten off even the biggest males.* RIGHT *The village, home for Dereje and Maza and their livestock.*

MOUNTAINS

ANIMALS THAT GIVE EVERYTHING

The Andes of South America are the world's second highest mountain range. Here at altitudes above 4000 metres (13,125 feet) humans depend on the llama. A domesticated member of the camel family, the llama has a long neck and an expressive face reminiscent of its desert cousins. But its body is stout, more like a very large goat, and along with its South American relatives – guanacos, alpacas and vicuñas – it has soft fur that can be woven into amazingly soft, warm wool.

The uses for llamas are endless. They can carry nearly a third of their body weight on their backs and are surefooted even on the steepest cliffs. Their meat is nutritious, and their milk can be drunk on its own or made into dairy products. Even their dung, once dried, makes excellent fires – critical for life above the treeline, where wood is non-existent. It's little wonder that the llama features heavily in Andean folklore and religion.

In the Himalayas, people have an analogous partnership with the yak – a shaggy, long-horned relative of cows. It is so adapted to high altitude that it doesn't fare well at lower elevations. As in the Andes, Himalayan people depend on their domesticated yaks for everything – transport, food, fuel, clothing and even shelter. Without yaks, it is hard to imagine how some Himalayan villages would survive.

But not all relationships with mountain animals are partnerships. In many cases, people are in direct competition with wildlife.

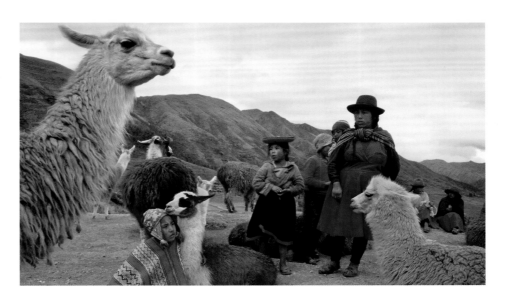

ABOVE *Quechua Indian children taking care of the llamas in the high Andes, Peru. Their clothes are woven from llama wool and their shoes made from llama hides. Llamas and their domesticated close relatives alpacas also provide meat, grease, fuel and fertilizer and serve as beasts of burden on the mountain slopes.*

MOUNTAIN BLINDNESS

Mountain life is always full of hardships. They can come in the form of marauding animals, sudden hailstorms or crop failures. But some of the most insidious dangers are invisible ones, caused by the altitude itself.

Titini went blind two years ago. She lives high in the Himalayas – a treacherous place to be without sight – and describes her affliction as a shadow that crept into her sight over three years. First one eye went and, not long afterwards, the other. Now, her journey to fetch water up the steep bank outside her house is a tense drama. Titini is 65, and though her body is still wiry, the blindness makes her teeter close to steep drop-offs. She knows they are there, just not precisely where. To reach the village pump takes more than half an hour – it took less than a minute when she could see. Once there, she struggles to aim the water inside her pitcher. Her husband died many years ago, and her only son lives in a village miles away. He comes most days to look after her, but sometimes – be it work or illness – he can't make it. Tears roll down her face as she talks of days she has spent without food. Her frustration is palpable. All her life she has been a proud, capable woman. Now she is almost completely helpless.

Titini is not alone. Men and women all over the world share her fate. And though it is not the only cause, there is little doubt that altitude plays a role. Mountains reach high into the atmosphere where there is less air. So more harmful solar rays get through to the eyes, and in winter, the snow reflects these rays back up. Both contribute to cataracts – a fogging of the crystalline lens of the eye. The eyes of someone with cataracts appear coated in a yellow cloud, which obscures light until eventually all goes dark.

Titini now sits with hundreds of fellow villagers lining the compound of the Doramba regional school building. Like everyone, she has come to have her eyes tested at the 'eye camp'. If her condition is treatable, she will be ushered into surgery. The rumour among the villagers is that the man who has come to cure them is a miracle worker. The people of Doramba aren't the only ones who think highly of Dr Sanduk Ruit, the eye surgeon from Kathmandu. Western eye surgeons, especially from the US, fly across the world to see him work. No one has cured more cataracts than Dr Ruit. He is not only the first Nepali surgeon to cure cataracts with surgical implants, he is also the first to operate in the most remote parts of Asia and Africa. He can take his eye camp anywhere. And when the pharmaceutical companies wanted to charge too much for the implant lenses, he learned how to manufacture his own. His costs per eye, which include pre- and post-operative care, are about $20 (free for patients). In the US, the same procedure can cost more like $4000.

MOUNTAINS

242 RIGHT, TOP *Titini being carried by her son to the Doramba eye clinic – a long journey up and down steep slopes.* RIGHT *Titini before surgery. The white disks in her eyes are the cataracts that have made her blind. Experts believe high altitude (where the sun's rays are more intense) plays a role in causing cataracts.*

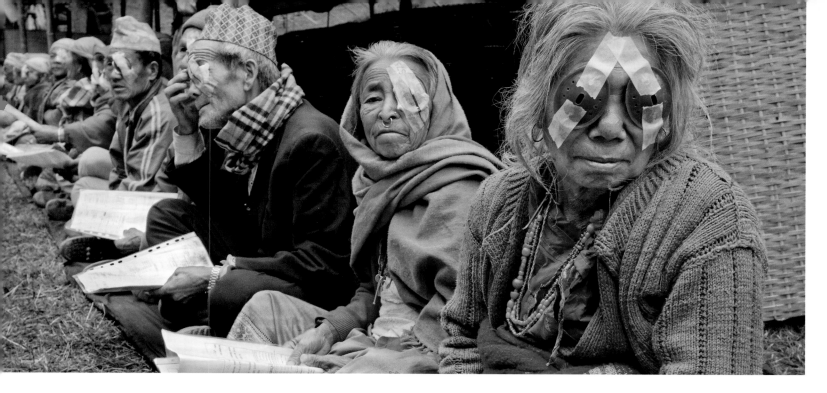

When Ruit meets Titini, she is frightened. Ruit's voice is soothing, and he puts her hand on his face so she can feel him. She begins to relax. He asks her, 'Titini, what would you most like to see once your eyes are cured?' She replies, 'My cow.' Ruit laughs. 'But what about your son – the one who carried you on his back 14 miles between your house and here?' 'Oh yes,' she says, and then becomes emotional. 'I want to see him get married.'

Though the hospital is cobbled together from converted schoolrooms, it is managed with upmost professionalism. The assistants are garbed in fresh scrubs, and anyone entering the building has to don cap and mask and wear plastic bags on their feet. After consultations, the patients are cleaned, given anaesthetic and led into the surgery room. Ruit runs one operating table, and the other is run by Western 'volunteer' doctors who want to observe Ruit's methods. Ruit works 12 hours a day and operates on hundreds of people. All the treatment is paid for by government and charitable donations.

After a day's rest, Titini's bandages are ready to come off. As Ruit lifts them, the incoming light overwhelms her. Gradually, she is able to focus. At first she is mesmerized by all she sees. Then there are tears. She and the other patients start an impromptu dance and make up songs in praise of the eye clinic. It is a joy beyond words to regain sight once it has been lost. Titini describes it as 'finding my old self again'. It is not a stretch to say that Ruit's eye camp has literally snatched her from the jaws of death.

Sudden death is, in fact, common in the mountains, and in winter, the risks are highest, especially when too much snow falls.

ABOVE *Titini and other villagers on the day after the cataract operation, waiting for the bandages to come off after Dr Ruit's 'miracle' operations. In the mountains, disability such as blindness can be fatal, especially in winter, and so a culture based on hospitality and neighbourliness is crucial to survival.*

AVALANCHES TO ORDER

Martin and Andreas make small talk on the first gondola car up the mountain. Martin looks out of the scratched plastic window to scan the north face of the Eiger, one of Switzerland's most notorious mountain walls. He watches the spindrift blowing off the top and notes the direction of wind. 'The snow will be here soon,' he says in a matter-of-fact tone. Andreas nods in agreement.

By the time they take their skis off the gondola and walk to the patrol hut, Martin has been proved right. Large, delicate flakes smash into their patrol jackets. After opening the door and turning on the lights, Martin hits the power button on his computer. While it automatically logs onto his favourite website, he makes coffee. Weather charts and graphs spring up on the screen, detailing the storm. Though the satellite suggests the snow won't hit for a few more hours, the whiteness outside proves otherwise. Martin laughs – mountain weather is still too unpredictable even for the best forecasting equipment in the world. 'Over a metre today, Andreas, I reckon.' Again, Andreas nods.

Later in the day, while the skiers yo-yo up and down the slopes, the snow keeps falling. Martin and Andreas find a spare moment to prepare their weapons. Martin produces a special key and then types in a secret code. He swings open the heavy door of the safe and lifts out what look like giant sausages made from bright red PVC. This is what modern dynamite sticks look like – just a little fatter than those drawn in cartoons. He assembles various safety devices and finally attaches a long fuse. Explosives armed, Martin puts them back in the safe. They are ready for tomorrow's battle.

By the time it's dark, Martin and Andreas ski home, sweeping for any missing skiers. More than 45cm (18 inches) of fresh snow has accumulated. Later that night, an additional 60cm (24 inches) falls. The patrolmen get up extra early – all bombing has to be finished before the ski runs can open. It's still dark when the snowcat drops them at the highest point. By the time their skis are on and Martin has made the final check on his bombs, there is enough light to move.

Even in the white-out, they recognize the drop zones by the large red and white patrol poles, the only things visible on the mountain. Martin pulls out a dynamite stick and lights the fuse. With an underarm slinging motion, he tosses it into the whiteness, over the edge of an unseen cliff. He chats casually to Andreas for a moment and then glances at his watch – all of Martin's fuses are timed for two minutes, but it isn't an exact science. He counts down, 'five, four, three, two, one,' and both men cover their ears and turn away.

The explosion is followed a few seconds later by a thick thudding sound, as the snow settles and cracks in a line along the ridge below them. The newest layer of snow begins to slide, picking up momentum as it goes. It builds into a roar and then hisses to a halt – that's the point of setting off avalanches: you keep them small so that they never get big.

The Alps – and especially these peaks around the Eiger – are famous for avalanches. Even some of the nearby medieval churches have old avalanche walls to protect them when 'the big one' sweeps into town. As recently as 1999, an avalanche smashed into Montroc, France, killing 12 people and destroying 20 buildings. It was a wake-up call to everyone in the Alps: don't let avalanche zones build up too much snow – destroy them when you have the chance.

Martin and Andreas work their way down the ridge, setting off avalanches as they go. Most of the chutes they blast will protect the ski area, but as the men return to the hut, a helicopter awaits. It will lift them to a peak whose avalanches threaten not just the skiers but roads and the town as well.

Hanging out the side of a helicopter, buffeted by the wind, Martin has a harder time lighting the fuse. But he is experienced enough to keep a cool head. He leans inside the door and gets it working. Then it's bombs away. The avalanches from higher up are larger and leave a cloud of snow hanging in the air for minutes after they've discharged. Finally, Martin drops the last bomb. He radios the ski-patrol hut: 'You can open the ski area now.' As they ride the lift, the skiers are blissfully unaware of the drama that has taken place this morning.

Mountains can be dangerous places, and for some, that's part of their allure. Mountaineers regularly risk their lives in the hope of reaching the summit. But it's not enough to dismiss mountain-climbing as simple thrill-seeking behaviour. Mountains speak to our spiritual side. All over the world, mountains are revered as sacred places. Spiritual leaders build monasteries, if not on mountains then on places with commanding views. It's almost as if mountains might help us see into a world beyond this one.

Death comes to us all, no matter where we live. But in some mountains, death brings extra hardship – and this question: what to do with the body once the soul has left it?

LEFT *An avalanche crashing down the Bernese Alps, Switzerland. Every winter, avalanches claim lives.*
ABOVE *Patrolmen throwing dynamite on a rope over the edge to release an avalanche. Because the stick contains no shrapnel, the men can stand within sight of the detonation if they need to (they prefer not to).*

FUNERAL IN THE SKY

Namgyal Lama is in meditation in Ribumba Monastery, Dho Tarap, when the acolyte enters the chamber and whispers in his ear. He rises without saying a word to his colleagues and keeps chanting even as he steps outside the door.

In the courtyard, the boy has already saddled Namgyal's horse. The news hasn't surprised him: Bharmah Nombe is dead. Namgyal Lama was his priest, but he was more than that – he was also the man's doctor. It is typical here in the Dolpo, one of the most remote regions of the Himalayas, for lamas also to become *amchi* – healers of body as well as soul.

Modernity has barely touched Nepal's Upper Dolpo. There is no electricity – there aren't even the aluminium roofs found in more accessible areas of the Himalaya. People here still build roofs out of wood and mud, protected by a black mass of brushwood. In the valley there is a single phone, which is often left unattended because nobody calls.

The 8km (5-mile) ride to Nombe's house gives Namgyal Lama time to contemplate what to do with the corpse. Above him, the mountains are still covered with snow, though in the valley, dust rises behind his horse. It is April now, and soon the valley will be carpeted with grass. As he rides, Namgyal passes a few men carrying giant wooden beams on their backs. They have been walking five days to bring that wood here; trees don't grow in this region.

To burn the body would be extravagant, and Nombe's family isn't rich. Digging a grave isn't likely either. To begin with, the ground is partially frozen at this time of year. But even after it thaws, every reasonable grade of soil in this rocky landscape is ploughed for crops. Long ago, bodies would be placed in the river to be washed away by floods, but this has never been considered hygienic – especially for people living downstream.

Namgyal knows what must be done. But he has to discuss the option with the other lamas and with Nombe's family. The first order of business is to help Nombe's soul be reborn. The question of his corpse will have to wait.

When he arrives at the house, Nombe's relatives are outside building a tent for mourning. His widow, a regal-looking Tibetan woman with deep wrinkles creasing her face, is chanting to herself and spinning a prayer wheel. Before he steps inside, Namgyal greets another man standing outside. Bharmah Furba is Nombe's nephew. He is also a cutter – a non-Buddhist who makes his living butchering meat. Furba's skills are what are needed for the burial. Inside, the other lamas are already in prayer. A place is hastily laid out for Namgyal, who is the most senior lama in attendance.

RIGHT, TOP A lammergeier hovering over the sky-burial site. Its job will be to deal with the bones, once the griffin vultures have eaten the flesh. Buddhists have an affinity with vultures, which eat meat but don't kill prey. RIGHT, BOTTOM Dho Tarap Monastery, close to the heavens. The sky-burial site is higher still.

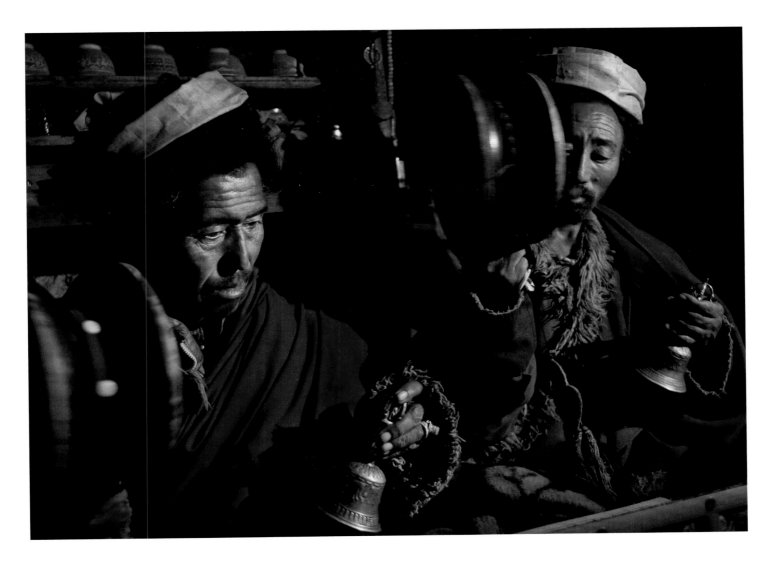

From his satchel he pulls out scrolls, a drum and a flute-like instrument made from a human thighbone. He joins the prayer mid-flow. Time is of the essence, as Buddhists believe that the minute the man dies, his soul begins searching for a way to be reborn. They hope to help the soul cease its suffering or at least find the best place for its rebirth.

The rituals carry on through the night. The following morning, after a short sleep, the lamas begin praying once again. Near the end of the ceremonies, a dancer comes in and using a knife begins a battle with any evil spirits that might wish to enter the dead man's body. Nombe's corpse lies in a corner of the room behind a curtain. A selection of candles and statues of the Buddha surround his body.

ABOVE *The lamas conducting the pre-burial prayer ritual in Nombe's room, where his corpse is, using instruments as well as prayer wheels. The prayers are to help his soul be reborn, and the mourning period will last for 40 days.*

MOUNTAINS

Finally the lamas' chants end, and Namgyal has a quick word with the others. They all agree on the method of disposal. Namgyal ushers in Bharmah Furba – the cutter. He is in charge of the body now. They pull back the curtain, and Furba drags out the corpse. It is naked, and though Nombe was an old man, his skin is now smooth – a side-effect of the swelling that follows death.

The dead man had three sons. Furba enlists their help, despite their obvious grief. Together they wrap the body in clean white cloths. Then they wrap it in a series of woollen blankets. By now a procession of musicians is gathering outside. A stream of mourners pay their last respects to Nombe, now bundled in a foetal position and wearing a ceremonial crown over the layers of cloth covering his head.

The sons have agreed to carry their father to the burial site, which will be a huge physical challenge. Furba helps them lift the corpse onto the first son's back: the dead weight makes the young man's legs buckle and shake. As they proceed out of the house and through the village, the colourful entourage stretches out in a long line, snaking through the streets between the mud buildings. They stop frequently to allow the corpse-bearers to swap.

Once they cross the river, the musicians and most of the mourners remain in town. Only the lamas, the cutter and the three sons bearing their father's body proceed up the mountain. It is steep and hard going. They need frequent rests. Getting to the snow, they continue ever higher.

An hour and a half later, they reach the sacred site. Already alerted by the sound of the chanting and the thighbone horns, huge griffon vultures circle in the air above the site. The birds know what's coming.

The sons set the corpse down by a boulder. Furba drinks heavily from a flask of chhaang, a drink of fermented barley. The three brothers say goodbye to their father, tears streaming down their faces. Then they walk off down the mountain. This place is high enough to be several degrees cooler than the valley below. The view of the surrounding mountains is impressive, made more so by the soaring vultures. A couple of lammergeiers (bearded vultures) have joined the group of aerial inspectors.

Furba takes out his tools – knives and hatchets. Some 45 metres (50 yards) away, the four lamas chant and twirl drums with two pellets attached by twine. The result is a rapid machine-gun-like rhythm that heightens the drama of what is about to happen.

Having removed the blankets and carefully folded them to one side, Furba stands over Nombe's naked corpse. Then, with a long butcher's knife, he removes flesh, throwing it to all sides. The vultures take their cue. First the griffons, whose

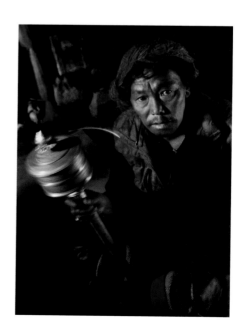

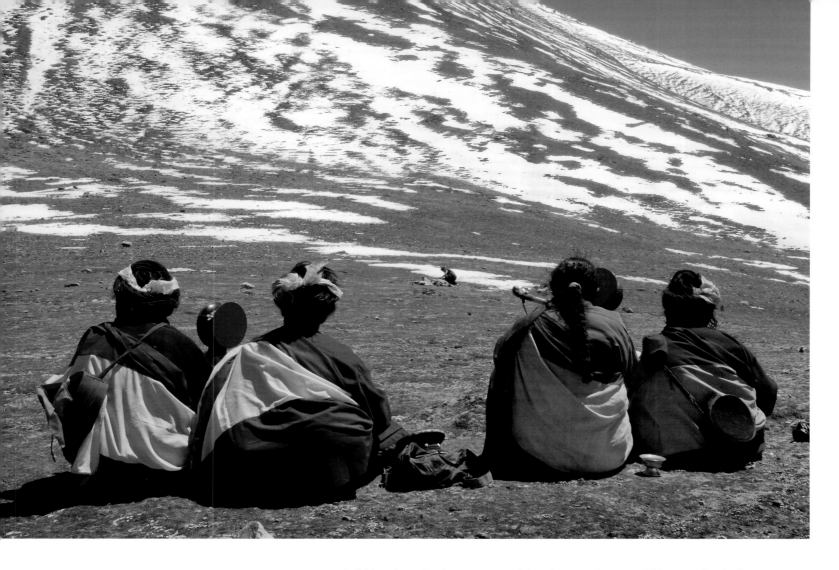

bald heads make them appear old and wise. They squabble over the flesh as it comes their way, swallowing it whole. The lammergeiers, with their yellow under-feathers and 2.5-metre (8-foot) or so wingspans, still hover in the breeze above. They don't settle until bones are on offer.

At the end, nothing remains of Nombe except the folded cloth. From a satchel, Furba produces a stone inscribed with 'Om Mani Padme Hum', the holiest of Tibetan mantras. He pauses to remember Nombe, who was more than his uncle. Nombe was also a cutter and taught Furba his trade – including this most sacred of cuts. Cutting animal flesh makes it impossible to be a Buddhist, but cutting human flesh during a sky burial elevates the cutter to a status close to that of a lama.

He takes a last drink of chhaang and pours the rest for his fallen teacher. Then he walks down the mountain. The birds – bellies full – carry what is left of the man over the snowy Himalayas.

OPPOSITE *Bharmah Furba using his prayer wheel the night before the burial, preparing himself mentally before the cutting.* ABOVE *Furba dismembering his uncle's body. He is the butcher for his community, but through this sacred task, he achieves a status similar to a holy lama.*

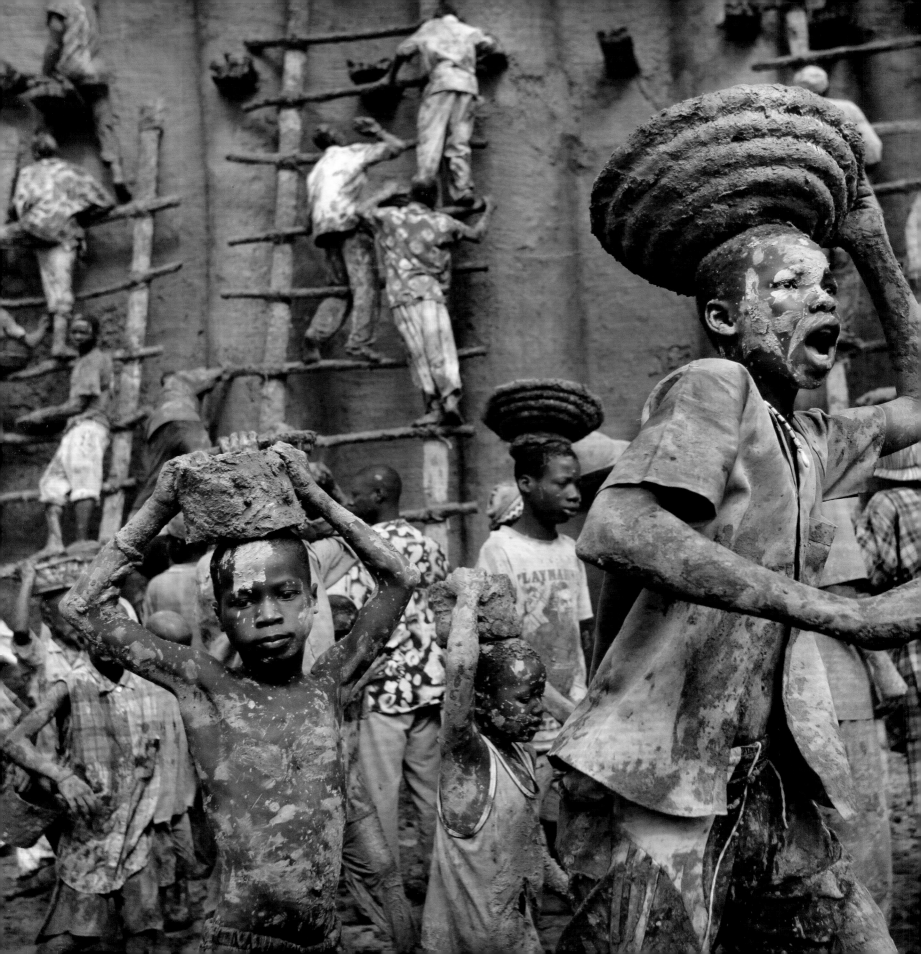

URBAN
8

THROUGHOUT THE ANIMAL KINGDOM, VERY MANY SPECIES –
FROM TERMITES TO PRAIRIE DOGS – RESTRUCTURE THEIR
ENVIRONMENTS TO SUIT THEIR PARTICULAR NEEDS. BUT NO
SPECIES DOES IT AS DRAMATICALLY AS HUMANS DO WHEN WE
BUILD CITIES. IN OUR MAN-MADE WORLD, WE STRIVE TO BE
GOD AND GATEKEEPER, TO CHERRY-PICK THE ELEMENTS OF
THE NATURAL WORLD THAT WE LIKE, WANT, NEED OR CHERISH
AND BANISH THE BITS WE DON'T. THIS IS AN ENVIRONMENT WE
DIDN'T ADAPT TO BUT CONSTRUCTED FOR OURSELVES.

It's been this way for more than 5000 years, since the first cities and civilizations sprang up in Mesopotamia, between the Tigris and Euphrates. Their evolution can be linked to our ingenious manipulation of two other environments: grasslands and rivers. The domestication of grain in the rich soil of the alluvial plain and the proximity of rivers gave the Sumerians the ability to irrigate and trade edible vegetation. Since those days of tailoring nature to our needs, we have barely looked back, creating a man-made environment that has enabled us to live virtually anywhere on the planet.

Today, for the first time in history, more humans live in the urban environment than outside it. The UN estimates that, every day, 180,000 people move to an urban enclave – the annual equivalent of seven times the population of New York. More people live in metropolitan Tokyo than Canada. The explosion of the urban environment has led to unparalleled achievements, from the inconceivable to the trivial. We build artificial islands on which to land our jumbo jets, disgorging passengers and goods from all corners of the Earth. Whenever we crave an exotic item, we simply go round the corner to the supermarket or restaurant,

where the products of the globe are there for our choosing. Cities are constantly changing pole position in a never-ending race to build the tallest megastructure, redefining what it means to have a building scrape the sky. The list of urban marvels is endless. It seems that the urban world is truly the pinnacle of our ingenuity.

So is there a role for nature in the man-made world beyond parks, gardens and pets? In fact, our relationship with nature is as vital in the urban environment as in any other, not least because we need fresh water and food from outside our man-made confines. We have seen how nature can wreak havoc on a city in moments, from Katrina's devastation of New Orleans to the earthquake that levelled Port-au-Prince. And the effects of cities on nature have always been equally powerful – traces of lead from Roman smelting have been found in Greenlandic ice cores. Cities today emit 80 per cent of greenhouse gases, and despite occupying only 3 per cent of the Earth's surface, they consume up to 75 per cent of the world's energy needs. Our crowning achievement, the urban world, has always required a delicate dance with nature. But are we sure that we are calling the tune?

ABOVE *Sunrise from the heights of the Burj Khalifa in Dubai, currently the tallest building in the world. Cities can appear to be the ultimate expression of our dominance over nature, but they can't escape it.*
PREVIOUS PAGE *Men and boys racing to the mud mosque in the mud-plastering festival of Djenne, Mali.*

OUT OF THE MUD

On the floodplain of the Niger and Bani rivers is the oldest-known city in sub-Saharan Africa – Djenne, in Mali. Founded in 800 AD, it resembles a combination of the *Star Wars*' planet Tatooine and a mud Manhattan island. Since there is no readily available stone or wood on the edge of the Sahara, the city has been built from what the environment has provided: mud and straw. Mud is cured to a liquid clay-like consistency in ponds, chopped straw and dung is worked into the mud with a hoe to give it texture and strength, and the mixture is moulded into bricks, hardened by the sun. Mud-brick by mud-brick, the city has been built from the elements that surround it.

The city was also built to protect the inhabitants from nature. The thick brick walls keep the interiors of buildings cool under the ferocious sun. In the rainy season, the rivers spread out across the floodlands, lapping at the edges of the city. The old neighbourhoods, which contain more than 2000 traditional homes, are built on small hillocks where the Inner Niger Delta floods won't reach. But as the rains fade and the hot African sun bakes the floodplain, the rivers dry up, leaving Djenne in the middle of a desert. Dust storms blow in, coating everyone, everything and seemingly even the sky in a layer of grit. Choking winds whip up the dust, reducing visibility and blending

ABOVE *Gardening in the dry season on the outskirts of Djenne city on the Niger-Bani floodplain. The river provides not only water but also the mud that has built the city.* RIGHT *Djenne's market in the heart of the city, selling everything its citizens need. It surrounds the mosque – the largest mud structure in the world.*

URBAN

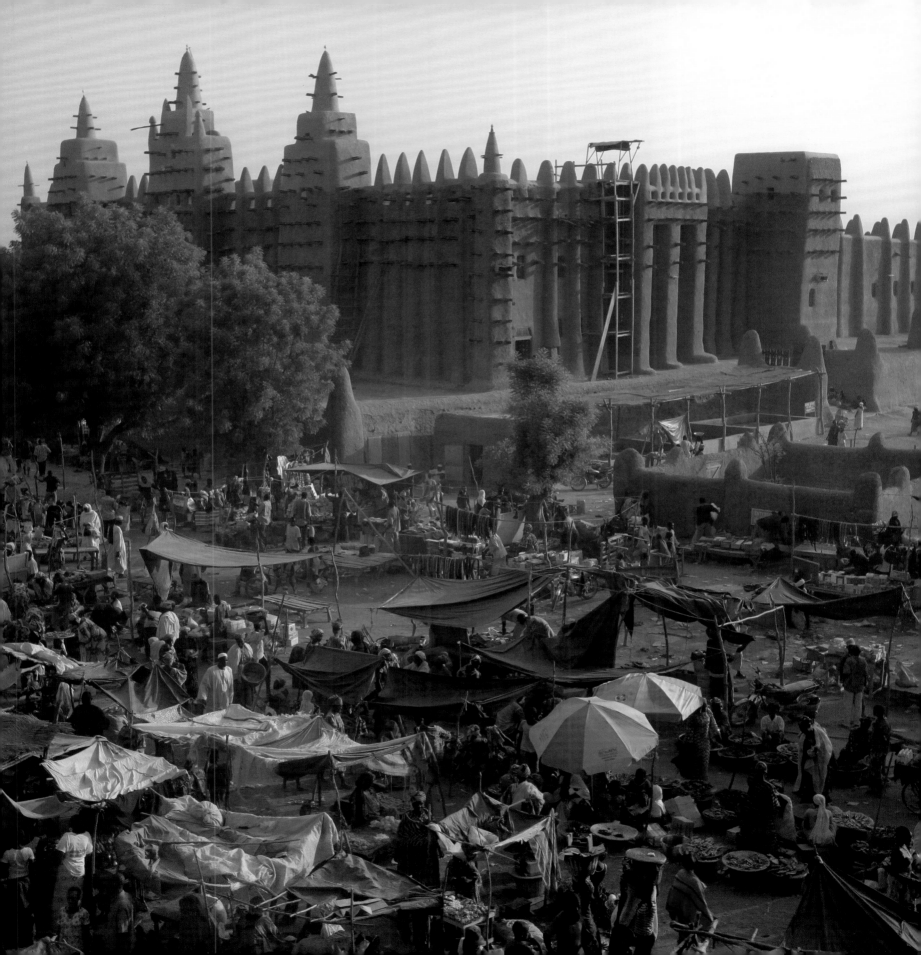

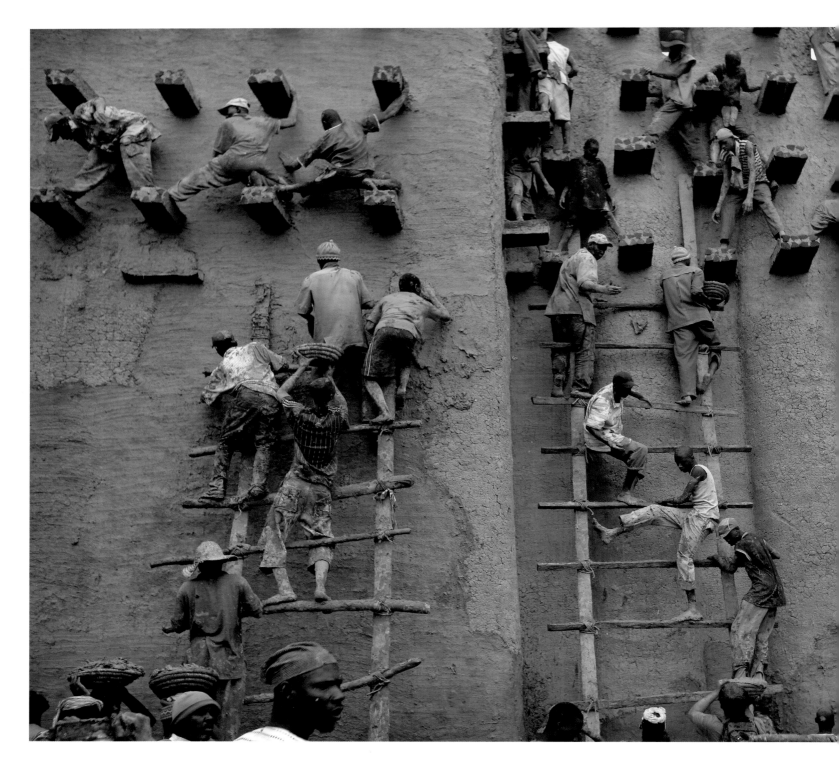

256

ABOVE *Men and boys swarming over Djenne's great mud mosque during the annual rebuilding festival.*
The specially prepared mud seals cracks and protects the building from the deluges of the rainy season.
OPPOSITE *A man in festival mode carrying the mud on his head in a specially woven mud basket.*

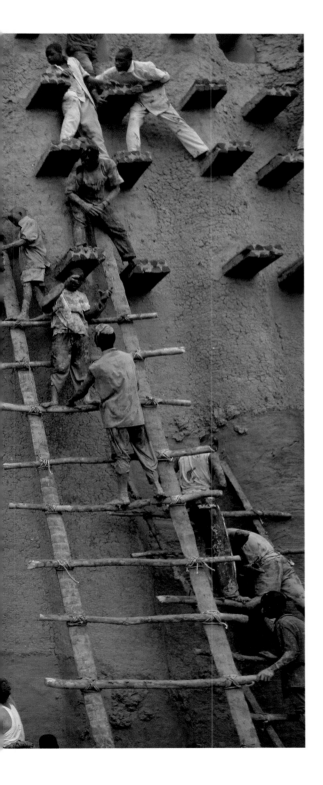

the horizon into an ochre haze. The former riverbeds are now channels of dirt, cracked and pockmarked with syrupy mud ponds. Fleets of fishing pirogues that lined the banks of the port are now marooned in the heat. But the retreating river leaves behind pockets of river mud, perfect for brick-making and mud-plastering.

In the centre of the city is Djenne's great mosque. The first mosque on this site was built in the thirteenth century, and when it fell into disrepair, a second was built before the present one took shape in 1907 – the largest mud-building in the world. It stands above the rest of Djenne, its superstructure echoing the blunt edges of the city's houses. Moulded at the top of its smooth, rounded minarets are ostrich eggs, symbolizing fertility and purity. But just like the riverbeds, the mud walls of the mosque dry out and crack. So every year, before the torrential rains come again, a replastering festival takes place to restore the natural mud varnish coating the bricks.

The citizens work to prepare banco – mud mixed with rice husks. They churn this by foot in the riverbed, like winemakers crushing grapes. The maintenance and repair of the mosque is supervised by 80 senior masons, who also decide when the banco is ready. Then the festival can begin.

Teams of men gather and march through the streets. At a signal, they race down to the riverbed and collect the fermented mud. It's organized chaos as everyone scrambles to get a load. Singing, dancing and chanting, they weave through the maze-like honeycombed passageways of the mud metropolis, heading to the mosque. Men balance the mud on their heads in baskets, while boys follow carrying plastic buckets or old cans. At the mosque, teams head up the stairs, while other men lay home-made ladders against the walls. Still others hoist themselves up the protruding palm-wood beams. Scrambling all over the mosque, they smack the banco against the walls and smear it by hand, palm-stroke by palm-stroke, spreading it evenly in long, wide streaks. At the end of the festival, the rich texture of the replastered mosque glitters silver in the sun, awaiting the onset of the torrential downpours of the rainy season – built and rebuilt directly from nature.

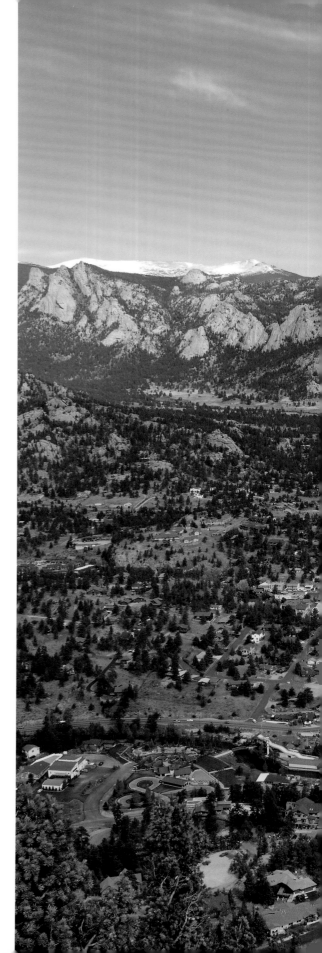

A WILD TOWN

We build cities to make our lives easier – safe places where we have access to what we need to survive. Food and shelter are our main requirements. It should come as no surprise that other animals want the same, and if wildlife can find what it needs in cities, it will move to the city, too.

The picturesque town of Estes Park, high in the hills of Colorado, framed by soaring peaks, is the gateway to the wilderness of Rocky Mountain National Park. Shops on Elkhorn Avenue cater to more than 3 million park visitors every year. Nature is neatly packaged up – from exotic-game products to wildlife posters and animal sculptures. A much more visceral encounter with nature can be found not just in the wilds of the national park but in the town itself. Herds of elk call this town home. And when the season changes to autumn, the hormonal elk begin to go a little wild.

In the late nineteenth century, elk were practically shot out of this part of the Rockies. Then, in 1915, the Rocky Mountain National Park was established, part of a great American conservation movement which recognized that the nation's natural treasures (Yellowstone, Yosemite, the Grand Canyon) needed to be protected for the enjoyment of future generations. But in the minds of the Park Service, not all creatures were equal. Elk were reintroduced, and predators such as wolves were exterminated. Hunting, though

ABOVE *Sergeant Schumaker of the Estes Park Police Department on his cross-country scooter, herding elk away from the road and conflict with cars.* RIGHT *Estes Park in the Rocky Mountains – the perfect town for people and the perfect haven for elk, offering abundant food, security and a safe place to raise young.*

URBAN

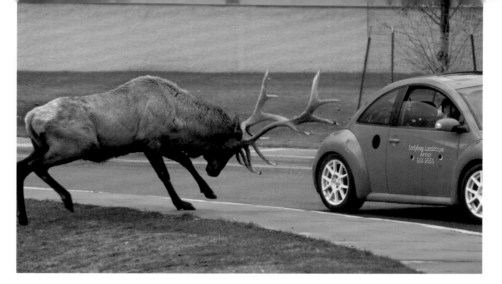

allowed in land adjacent to the park, was illegal in the park itself. Generations of elk bred in the park no longer feared natural enemies.

And with the rise of tourism and second-home ownership, Estes Park boomed. With more development came more tender greens – golf courses, lawns, parks, shrubs, ornamental trees – tempting fodder for herds of ungulates. Cow elk found Estes to be a great place to give birth and raise their young, free from hunters.

In the autumn, the time of the rut, the males start coming to town. The valley echoes with the sound of big bull elk bugling: a high-pitched sound designed to call in the females. In anticipation of battles to come, the bulls sharpen their antlers by rubbing them on tree limbs or the ground. Each male tries to gather and keep as many cows as he can, and the other males try to steal them away, either in head-on battle or by outright theft. It's an ancient, natural cycle. The difference here is that it takes place in the middle of a modern American town.

To compound the trouble, hordes of tourists come to witness the event. The elk pay no heed to the camera-toting masses, and the tourists draw closer, not realizing the danger of being near a large, powerful, sex-crazed animal with daggers on his head. Inevitably some get charged or, worse, gored.

It's the job of the Estes Park Police Department to control wayward elk battling it out in the streets. A call comes in: 'There's an elk jam on Highway 36.' A group of elk are tangled up in traffic, and the cars and trucks are backing up. Weaving through town on his two-wheeled, gravity-defying Segway scooter, an officer arrives on the scene, shoos the elk out of the road and gets the flow of traffic moving again. Meanwhile, elk are causing havoc on the golf course. Riding cross-country, the officer starts to herd a harem. This big bull has seen a lot of humans, but he's never seen one speed and weave like this. He bolts for the outskirts of town, his harem following. When night falls, though, his lusty needs will bring him back again.

ABOVE *Bull elk attacking a car in Estes. They may look like calm, domesticated animals, but male elks are in town to do business – to round up as big a harem of females as they can and, using their antler weapons, to battle to keep them. And when hormones rule, people who get in the way can be hurt.*

THE PINK-CITY MONKEYS

Hanuman is known as the monkey deity and is one of the most popular idols in the pantheon of Hindu gods. In the temples of Jaipur, the capital of Rajasthan in India, he is often depicted with a reddish-flesh-coloured visage, resembling a rhesus macaque. And it is due in part to his divine influence that a group of master thieves are able to operate brazenly in the heart of the city.

Jaipur was the first planned city in India, founded in 1727 by Maharaja Sawi Jai Singh II as his capital. The Pink City, as Jaipur is known, is considered to be one of the best planned cities ever built. More than 3 million people live there, and alongside them in the centre live about 4000 rhesus macaques. The rooftops and brick walls are their urban jungle; their climbing skills are well adapted to ledges, drainpipes and wires; and though they are wary of humans, they have little real fear of them.

Among the favourite targets of the rhesus troops are the fruit stalls. Perching on nearby signs and motor scooters, they surround a fruit cart. When the fruit seller is distracted, one will leap onto the cart and grab a handful of goodies. If the cart is left unattended, they will stage a full food raid, tipping over trays and rifling through peanuts, pomegranates, beans and bananas. It's such a common occurrence that passers-by pay no heed to the mayhem. And perhaps, given their Jaipurian affiliation with the god Hanuman, they have until relatively recently been revered by Hindus and therefore escaped retribution.

Rhesus macaques are native to the semi-arid plains of northwest India. No one knows exactly when the monkeys adapted to the human world, but one theory suggests

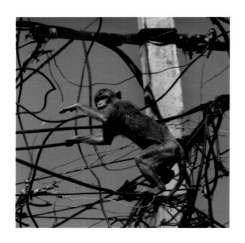

that they may have 'pre-adapted' to us. Traditionally, rhesus macaques fed on vegetation found on the edges of forests. Hence it was an easy habitat jump to areas farmed by humans. Coupled with their curiosity, agility and sociability, they quickly found the human world to be a good fit. They learned to steal food, raid fields and houses and accept handouts. As the suburbs pushed farther out into the hinterlands, the monkeys became more and more likely to live in the urban

ABOVE *A rhesus macaque using the telephone and electric wires of Jaipur as easily as he would lianas and tree branches.* RIGHT *High-rise gathering. The urban jungle of Jaipur is home to thousands of macaques, who live on the rooftops, descending to scavenge food from both willing and unwilling human providers.*

URBAN

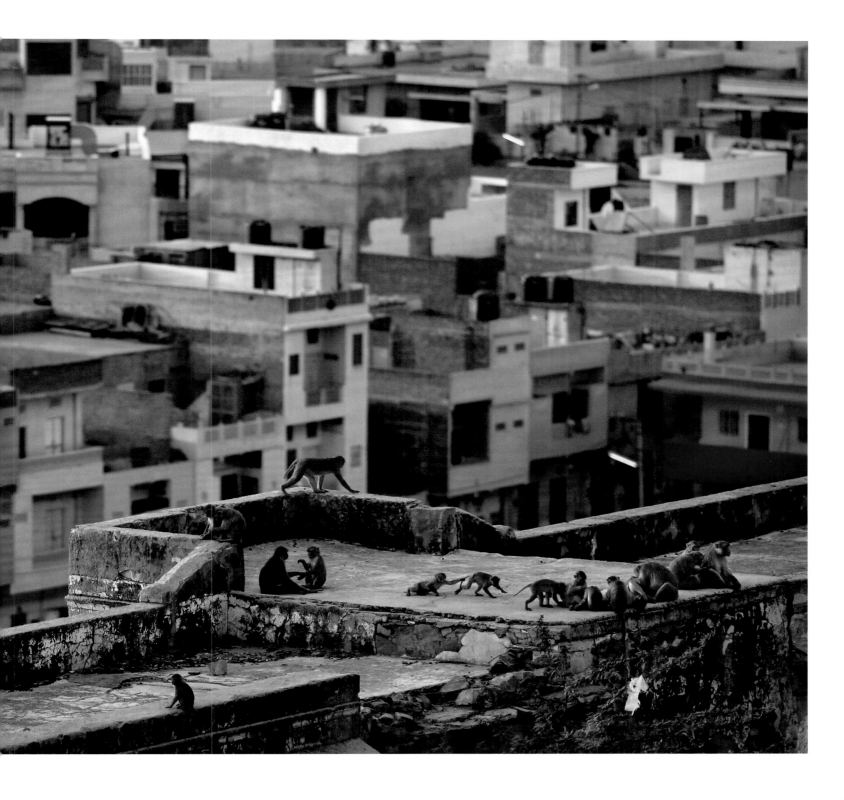

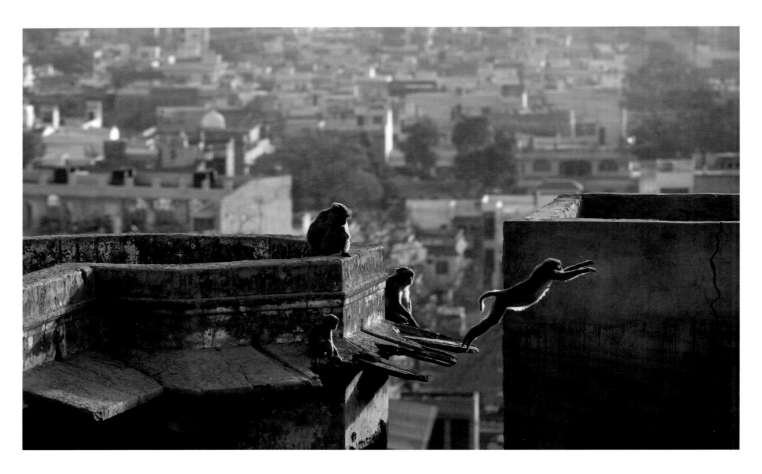

world. Some studies of macaques in north-central India have found that 86 per cent have contact with humans, with 48 per cent living in cities, towns, villages, temples and even railway stations. In Jaipur, the macaques are reliant on humans for their water, drinking from tanks, troughs and even taps.

In the 1950s and 1960s, the demand for rhesus macaques from the West led to their exploitation. Because of their physiological and anatomical similarity to people, they are ideal for biomedical research. In the space race between the USA and the former USSR, they were among NASA's first astronauts. By the 1960s, as many as 50,000 rhesus macaques were being captured a year, so many that, in 1978, India banned rhesus exports. The population quickly stabilized and then doubled, leading to the preponderance of monkey troops in cities such as Jaipur. In today's increasingly secular world, more and more removed from nature, there are calls to cull the monkeys. But, to date, Hanuman's influence continues to protect them.

ABOVE *Rooftop jumping. Like treetops, rooftops provide vantage points and safety for Jaipur's rhesus macaques.* RIGHT *Lookout post. The monkey's next investigation was the scooter seat, which it pulled apart.* OPPOSITE *Turning on the tap for a drink. Jaipur's macaques get their water from human sources.*

URBAN

BAT CITY, TEXAS

By day, Austin – the capital of Texas – bustles with the business of an average American city. Legislators and bureaucrats pour into the city to the imposing dome of the neoclassical, white-marble state-capitol building. Commuters clog the arteries of the city's freeway system, travelling from air-conditioned homes in air-conditioned cars to air-conditioned offices. Joggers roam up and down the banks of Lady Bird Lake. At night, the action continues, but with different crowds. Austin is the live-music capital of the world, and the city is packed with night prowlers frequenting the 200 or so music venues. Above their heads in the dark sky, millions of creatures of the night are on the wing.

Bats have always frequented the city regions, but in the 1980s their numbers started to increase, dramatically. In 1980, the Congress Avenue Bridge spanning Lady Bird Lake was reconstructed, with cracks designed to expand and contract with the annual temperature fluctuations. The engineers had unwittingly provided the perfect bat roost. Mexican free-tailed bats, returning from their winter quarters in Mexico, began to pack into the tiny spaces by the thousands.

Austin provides the perfect urban refuge. The underside of the bridge is undisturbed, the bright lights of the city keep natural predators (such as hawks) at bay, and there are ample feeding areas within flying distance. But when the citizens of Austin realized they had a bat colony, many reacted in fear, viewing them as disease- and vermin-ridden pests. Newspaper headlines screamed about a bat invasion, and people demanded that politicians eradicate the menace. Into the maelstrom stepped biologist Merlin Tuttle, who had moved to Austin and in 1982 set up Bat Conservation International. He began educating people about the benefits of bats, how they eat agricultural pests by the millions, saving farmers huge amounts of money on pesticides, and how they keep down the city's mosquitoes. In just a few years, the newspaper headlines had changed from calling for the bats' extermination to heralding their return in spring.

Now Austin proclaims itself to be Bat City USA, with upwards of 1.5 million Mexican free-tailed bats. Bat-inspired murals and public art dot the cityscape. Hipsters sport bat-themed tattoos and attend bat-city burlesque shows. And in summer, more than 100,000 people come to witness the columns of bats that, at sunset, begin to pour out from under the bridge. Hotels offer bat packages, bars offer bat-tini cocktails and tour-boats float under the bridge. Bat tourism generates an estimated $10 million a year for local businesses. There is even a bat hotline to check the forecast for bat activity. The city that once hated bats now embraces them.

RIGHT *Mexican free-tailed bats taking wing from under Congress Avenue Bridge in Austin, Texas. The bats migrate to the city in summer, roosting and giving birth under the bridge – forming North America's largest urban bat colony. Thousands of visitors come to Austin to watch their nightly emergence.*

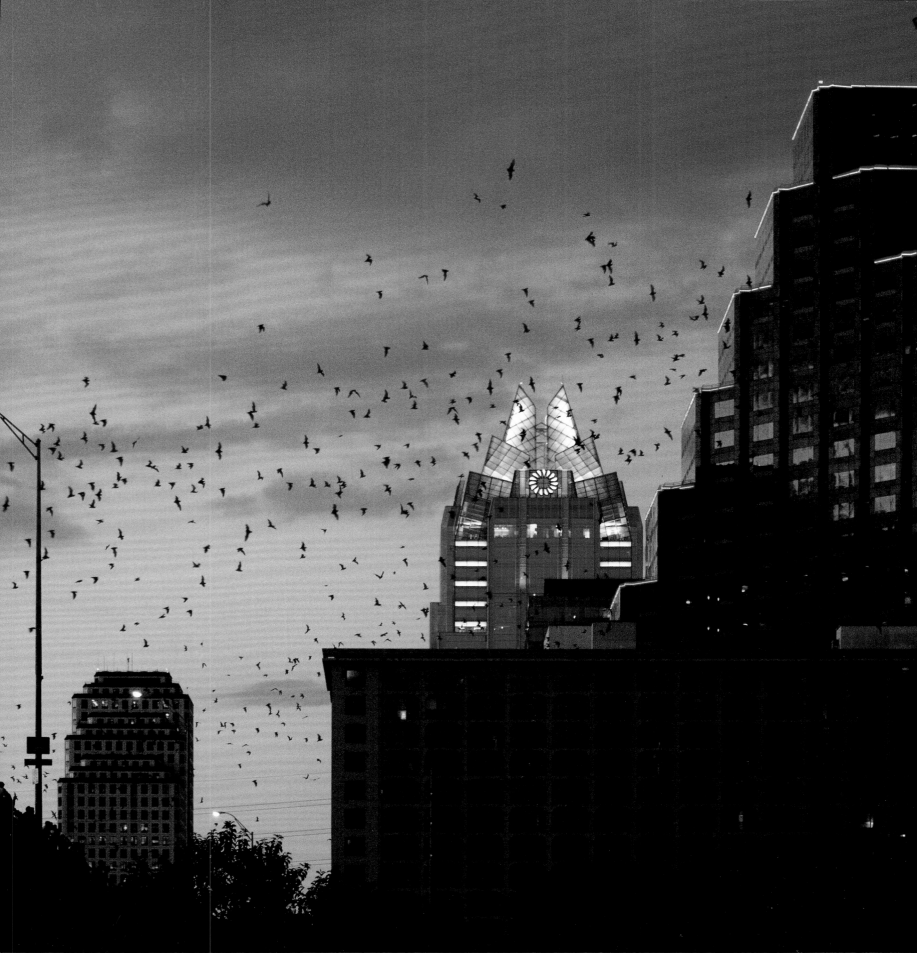

PIGEONS IN FANTASYLAND

No city on Earth is a better example than Dubai of a totally man-made environment – a desert pleasure-dome and proud of it. Though human settlement in the area has been traced back to 3000 BC, not until 1833 was the city officially founded. Until 1966, Dubai rode a boom-and-bust wave as a re-export port (where goods could be imported duty-free for further export). Then oil – the black gold of the Middle East – was discovered here.

This city's manipulation of nature is unsurpassed. In summer temperatures of more than 42°C (107°F), you can ski in a climate-controlled downhill resort, where a regularly scheduled blizzard blows through at a frosty -4°C (25°F). Visible from space are its man-made islands, including the Palm Jumeirah in the shape of a palm tree, and a collection of 300 islands that form a world map, all built from sand dredged from the Persian Gulf. The world's tallest building, the 828-metre (2,716-foot) Burj Khalifa, seems to defy gravity. Canals slice through the city, and captains of industry pilot their

yachts up to the golf course, where thousands of imported mature trees grow. Vast desalination plants provide the huge amounts of water needed by this artificial world.

But even this extraordinary city can never be free of nature. The ubiquitous urban bird, the rock dove, has invaded Dubai, as it has most cities around the world, breeding on the 'cliff ledges' of the tall buildings. Though not nearly as numerous as in London or New York, pigeons are just as unpopular among hoteliers. Their corrosive droppings damage the glittering edifices. The pigeons are also seen as dirty, carrying lice, mites and disease. Turning to nature to control nature, the UAE is using the services of its national bird and the rock dove's feared predator, the peregrine.

Falconry has always been big here but not until now as pest control. Once or twice a day, a falconer lets his peregrine soar around the glittering buildings. Unlike the sparrows and parrots that have also invaded the city, when one pigeon spots a peregrine, the whole flock takes off, which means the peregrine doesn't need to kill to chase off the pigeons.

But pigeons are merely an irritant, just a reminder of raw nature inside the city. Dubai proclaims its triumph over the local environment, describing itself as 'a fantasyland set right in the heart of the desert'. It's a crowded metropolis inhabited by 1.8 million people, with an economy increasingly geared towards tourism. One question remains: can this marvel of human construction and consumption ever be sustainable, as it is now wholly dependent on tourism, cheap energy and imported labour?

OPPOSITE *Ancient scourge of rock doves, a peregrine falcon, being used in Dubai to keep properties free of pigeons and their droppings.* ABOVE *Falconer David Stead preparing to fly his peregrine in the heart of ultra-modern Dubai.* LEFT *The city skyline of Dubai, seen from the world's tallest building, the Burj Khalifa.*

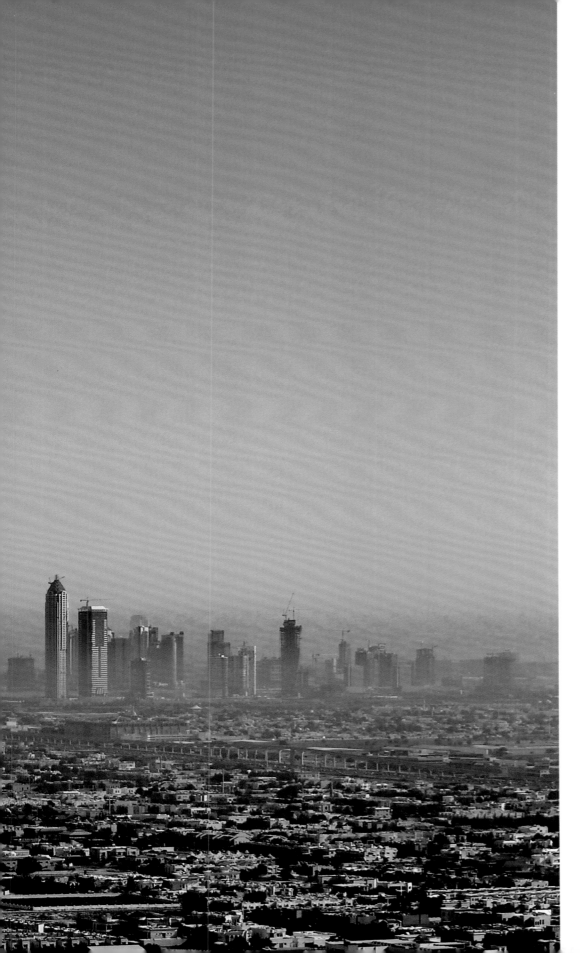

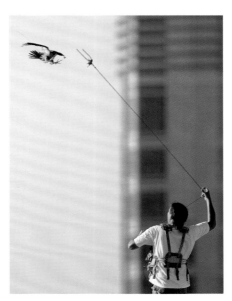

LEFT *The growing skyline of Dubai towering over the sprawl below like a desert mirage. It boasts the world's tallest building, largest artificial islands and largest amusement park.*
ABOVE *David Stead luring back his peregrine after successfully chasing a pigeon through the glass and steel canyons of downtown Dubai.*

THE URBAN ORGANISM

To sustain itself, a city needs water, land, energy and food, and it has to consume incredible amounts – which means a city is perpetually expelling tonnes upon tonnes of waste. Living in a city, it's sometimes hard to see a direct relationship with the natural world, but the fact is that even the most modern of cities depends completely on outlying nature.

Reliance on nature is measured in terms of an ecological footprint: how much productive land and water an individual, a city, a country or humanity requires to produce the resources it consumes and to absorb the waste it generates, using prevailing technology. According to a 2003 study, the average Londoner was found to have consumed three times more than the world average. "Materials and waste account for 44 per cent of the footprint, food for another 41 per cent, energy for 10 per cent, transport for 5 per cent, and water and degraded land for the remaining 1 per cent." London requires a staggering 125 times its own area to sustain itself – the land equivalent of virtually all of England and Wales. The city also consumes more energy than Ireland and about the same amount as Greece or Portugal. Each Londoner is estimated to require the equivalent of eight football pitches of land to provide for his or her current consumption and waste. To be completely sustainable within 40 years, London would have to reduce its ecological footprint 35 per cent by 2020 and 80 per cent by 2050.

Day-to-day life in Barcelona illustrates just how the modern city organism functions. Historically the fishing fleets of neighbouring Badalona trawled the Mediterranean for the delicacies that made Catalonian cuisine famous. Today, that fleet is down from 80 boats 15 years ago to a mere 8 today. The seas off the coast are polluted from sewage and industrial effluent, and fishing stocks have collapsed. But at the port of Barcelona, factory-fishing ships disgorge their bounty vacuumed from the seabed. Vast quantities of natural gas, petrol, diesel and fuel oil are also offloaded, powering both the nation's vehicles and the city itself. Food from the Spanish plains and products from the city's industrial plants are loaded onto container ships and exported around the world.

Just a few miles from the port, on Las Ramblas – Barcelona's historic main drag – is La Boqueria market. Since 1217, fruit and vegetable traders from local towns and farms have been coming to La Boqueria to sell their products. Today it offers a cornucopia of nature's delights under its roof. Up to 40,000 different products are displayed on stall after stall: mountains of fruit and vegetables, every cut imaginable of beef, pork and poultry – an ocean's worth of fish and a dairy farm's entire output of cheeses. At the end of a day, an army of trucks arrives to load up the spoilage, taking it out of the city and out of mind.

ABOVE *Barcelona's city centre. The bustling coastal conurbation imports huge amounts of petrol, oil and gas needed to power the city, as well as goods and food from far afield. Its famous La Boqueria food market offers hundreds of different products for sale, the majority imported.*

THE WASTELANDERS

All the detritus of the urban world has to go somewhere, and the resulting wastelands on a city's outskirts can offer some semblance of life and livelihood to the most destitute among us. One billion people worldwide live in slums, and the people with the very least live where we dump our rubbish.

On the outskirts of Mombasa, the second largest city in Kenya, is Kibarani dump. Located between a railway and a river, with the industrial cranes of the city looming in the background, the dump receives the waste of the city's 700,000 inhabitants. It's an unhealthy environment for all but the flies and their maggots. Packs of semi-feral dogs roam in search of the odd bit of rotten meat. Marabou storks, egrets and sacred ibis – creatures that once would have scavenged from lion kills on the savannah – root through plastic bags. Scavenging with them are humans, for whom the dump is home.

The day's routine for the inhabitants of Kibarani begins at about 10am, when trucks carrying waste arrive and tip their loads. A scramble ensues as the dump-dwellers fight over the bags of rubbish, snatching at anything that can be sold: plastic, sacks, tins. Metal rods bent into hooks are used as hoes. A kilo of metal might fetch 5 Kenyan shillings (about 6 cents) and a kilo of plastic, 3 shillings. A good day's work will earn someone about 40 shillings (52 cents).

URBAN

ABOVE *Salvaging anything that can be sold from Kibarani dump – the mountain of waste produced by the 700,000 inhabitants of Mombasa.* **RIGHT** *Drinking dregs of coconut milk. The dump provides food as well as income and shelter for its inhabitants. Scavengers also include feral dogs, rats and birds.*

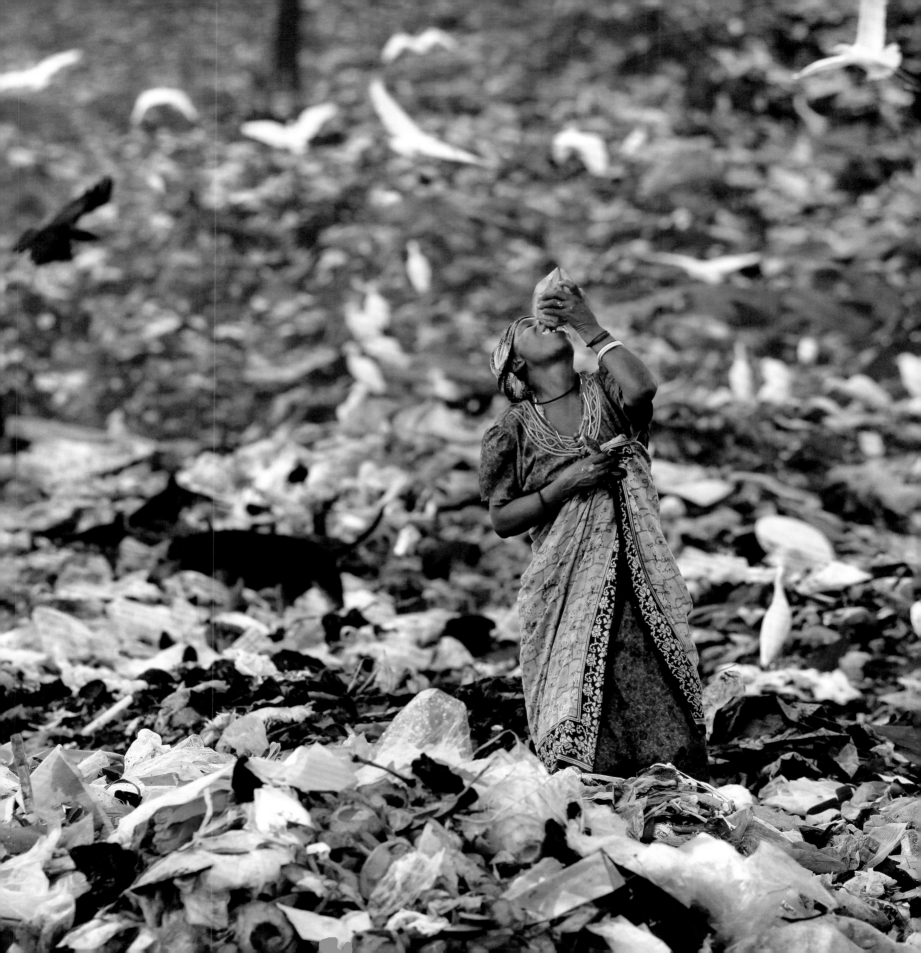

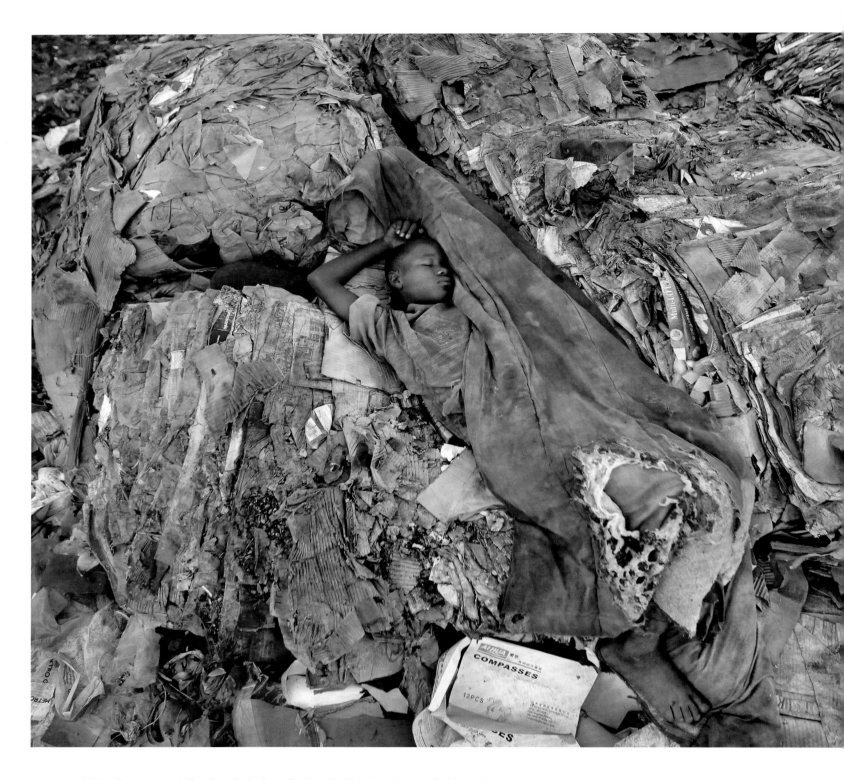

URBAN

ABOVE *A rubbish-collector on a bed of cardboard – his home for the night. The dump also provides his meals.*
OPPOSITE, RIGHT *A woman carrying her baby while hacking through garbage, looking for anything of value.*
Hazardous waste is dumped here, leaching into the water. OPPOSITE, TOP *Birds such as sacred ibis feed here, too.*

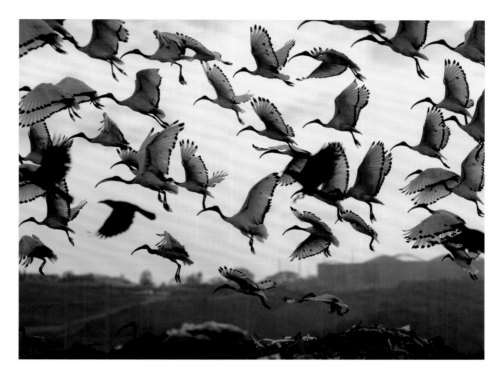

Scraps of meat, tossed-away fruit, lentils, beans, leftover maize or old potatoes are brought home for dinner. Water for cooking and washing is retrieved from broken pipes and stored in recycled plastic jugs. Drinking glasses are old jars and discarded bits of kitchenware. Generations of families have lived their entire lives in this toxic environment. Trash burned in cooking fires produce noxious fumes, and cuts from broken bottles and hypodermic needles lead to sickness.

Yet despite such hardship, human social life carries on. Women gather on piles of discarded cardboard to gossip and laugh. Men lounge, reading last week's thrown-out newspaper, perusing the sports scores. And children, oblivious of their poverty, turn plastic lids and bottletops into toys.

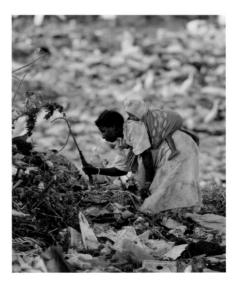

MOTOWN TO NO TOWN

More than half the people on the planet live in an urban environment, and by 2050, 70 per cent will. It's the habitat where our relationship with nature is newest, and it's the one we have to get right.

Like any organism, a city is born, grows, ages and dies. Detroit was once the wealthiest city in the world, with 2 million inhabitants; today, fewer than a million call it home. The Motor City – symbol of American manufacturing might, home to the sweet sounds of Motown and known as the Arsenal of Democracy in the Second World War – has become an urban wasteland. And vast parts of the city are reverting to nature as industry and people abandon them.

An area of vacant land the size of San Francisco lies within the city. Entire neighbourhoods have transformed into mini-ecosystems as they are reclaimed by prairie and scrub forest. Nineteenth-century mansions have trees growing through their roofs, and animals have taken over. Squirrels build their dens on the balconies and in the ceiling vaults. In some empty quarters, pheasants outnumber people by ten to one. Fox snakes hunt rodents in the urban prairie. With plenty of forage and no predators, whitetail deer are multiplying. Groups of people, too, are adapting to the greening of their city.

There are now more than 875 community urban gardens growing hundreds of tonnes of fresh produce in the heart of Detroit, rejuvinating neighbourhoods in the drive for self-sufficiency. The gardens are a refuge for both beleaguered humans and animals. Honeybees are attracted to the heart of the city, where abundant and pesticide-free urban prairies are filled with wildflowers.

Catherine Ferguson Academy, a school for unwed teenage mothers, is also a fully functioning urban farm, with goats, chickens, horses, orchards and beehives, all part of the science curriculum created by a biology teacher. The playground is now a pasture. Horses graze on the old running track. A solar-powered barn is topped with a wind turbine. Students grow vegetables, pick fruit, milk goats to make cheese and harvest honey to sell at Detroit's Eastern Market. The farm gives the girls a sense of purpose and ownership, and 90 per cent of the pupils graduate.

Detroit has recently recognized the need to shrink and has plans to consolidate existing neighbourhoods – demolishing abandoned homes and establishing semi-rural enclaves within the city limits. The former industrial powerhouse of the world may become a world leader in urban farming.

CITY OF TOMORROW

Steadfast sister to glamorous Dubai, Abu Dhabi, the capital of the UAE, stands as a conqueror of its harsh desert environment, but at a cost. With a tenth of the world's proven oil reserves, Abu Dhabi has used its natural resource to power energy-thirsty desalination plants that provide water where there is no natural source, to air-condition buildings, to build superhighways and to offer cheap petrol. The result is that the citizens of this emirate are among the highest per-capita greenhouse-gas emitters on Earth. But rising out of the desert is a new kind of city, borne from the riches of hydrocarbons and the government's vision and designed to be the world's first sustainable and waste-free urban centre.

Masdar is a 6-kilometre-square (2.3-square-mile) development, a $22-billion, back-to-the-future creation for 50,000 citizens, under construction outside the old Abu Dhabi city. It's a direct repudiation of the bigger behemoths of Abu Dhabi and Dubai. Instead, the city will combine the cultural knowledge gleaned from ancient cities such as Yemen's Shibam or Syria's Damascus, as well as the latest technological wave of sustainable infrastructure.

It will be walled, both to contain growth and block the searing desert winds. Cars will be banned, and planners aim to have public transport available within a short stroll of every citizen. The streets will be narrow, irregular and shaded to combat the effects of the 41°C (107°F) summers. Mesh shades will cut direct sunlight while allowing air to circulate. Traditional wind scoops (funnel-like ventilators) will direct breezes into courtyards and passageways.

Powered by renewable energies, with solar panels on almost every rooftop, the city will vie to be the world's centre for green energy. Researchers estimate that the area receives enough solar energy to equal 1.5 million barrels of oil. And Masdar, keen to tap into this sustainable energy resource, is looking at opportunities for solar-energy plants across the emirate. But all of this construction still begs the question: can we create a sustainable future while still continuing to build? After all, building is an inherently consumptive and heavily polluting process.

Cities the world over have the potential to revive and renew themselves through a reconnection with nature. Nature cannot be completely subjugated or controlled. Instead it is always there, in our midst – and the lessons we have learned from our collective experiences, gleaned from 250,000 years in the natural world, are vitally important in the urban man-made habitat. Our relationship with nature is constantly evolving. How we get it right is the most important question of all.

LEFT *An artist's rendering of Masdar, a zero-emission, carbon-neutral city under construction outside Abu Dhabi. Masdar will be a city combining the latest technological advances and ancient design techniques, adapted from thousands of years of human habitation in the Arabian Desert.*

POSTSCRIPT

Once upon a time, so the story goes, we lived in the Garden of Eden, and then we foolishly ate the forbidden fruit and all the sinning began. Whether that 'fruit' was knowledge, technology or just plain greed is never clearly stated, but the underlying trajectory is clear: from a state of living happily in the natural world, we started running amok in God's land, uncontrolled, wreaking havoc.

Another story goes this way. Some time ago a smallish upright ape in Africa started using its abilities – communicativeness, manual dexterity, social organization – to move away from mere survival towards an aspiration. What was that aspiration? Probably as simple as wanting to make existence a little more bearable. Killing those antelopes will probably be easier with these sharper blades.

Whatever the original motivation and whichever version you prefer, the end result is abundantly clear: there are humans living in every available niche on our planet and still spreading, still exploiting every available resource.

The ingenuity and sheer determination by which we've accomplished this expansion is a biological phenomenon. If we were all to be wiped out tomorrow by a sudden meteor impact or by some all-powerful disease or, indeed, by a drastic change in our climate – we would leave behind a permanent marker of our passing as dramatic as anything to be found in the fossil record. And the 'anthropocene' – a flash in the pan of geological time – would tell a story of rapid expansion and widespread destruction, as we've spread ourselves far and wide, colonizing new habitats and destroying just about everything that gets in our way. There's no avoiding it: for most of our time here on Earth, we humans have spread with little regard for the other species.

But is that the end of the 'human planet'?

I suspect not. In fact, I'm convinced that there is – despite appearances – some room for optimism.

At first glance, the human 'journey' on our planet suggests a species in steep ascent, still growing by the year and outstripping resources, ruining habitats, wiping out other species as we spread. This ship really does appear to be heading for the rocks.

But a closer investigation reveals some interesting new trends. First, a palpable sense that we humans have got problems to solve, issues to be addressed. This awareness started within the past 50 years – shall we date it back to *Silent Spring*, by Rachel Carson? – and has gained huge support. Second, the beginnings of international and collaborative planning – about everything from fishing quotas to climate-change treaties and a reduction in armaments.

We're getting together around the world to plan a common future with intelligence and foresight. And spiralling technological growth is enabling us to communicate with each other instantaneously, immediately, informing us of anything, everything that's going on from Tokyo to Timbuktu, revealing all that's happening right now in a flash of digital daylight.

Is it a coincidence that these are the three very areas – highly developed social organization, a compulsion to communicate and breathtaking technology skills – which have always set us apart and enabled us to colonize every habitat on the planet? I don't think so.

So, yes – the tanker is heading for the rocks, a result of our exploitation and short-sightedness. And, yes – we may be too late to avert collision altogether, a series of sticky ends through epidemic, climate change or war. But there can be little doubt that we are beginning to change course. Up on the bridge stand a few – but a growing few – influential captains, their hands now firmly on the wheel, starting to steer us away from that head-on collision.

So not harmony to chaos, but chaos to potential harmony.

What other species sits in meeting rooms and plans the protection of wilderness, tries to ensure continued food supplies, seeks to safeguard the air we breathe and the water we drink? If ever there was a species on this planet that had the power to avert disaster, we surely are that species. And once we begin to believe that we can solve these problems, then I suspect – on past form – we will act to ensure our continued survival.

We've done it before.

BRIAN LEITH

OPPOSITE *Sunrise in the Ethiopian highlands – where people still live close to the edge.* OVERLEAF *Wodaabe young men dancing at the jeerewol – a celebration, when the nomadic clans meet to socialize and to find partners.*

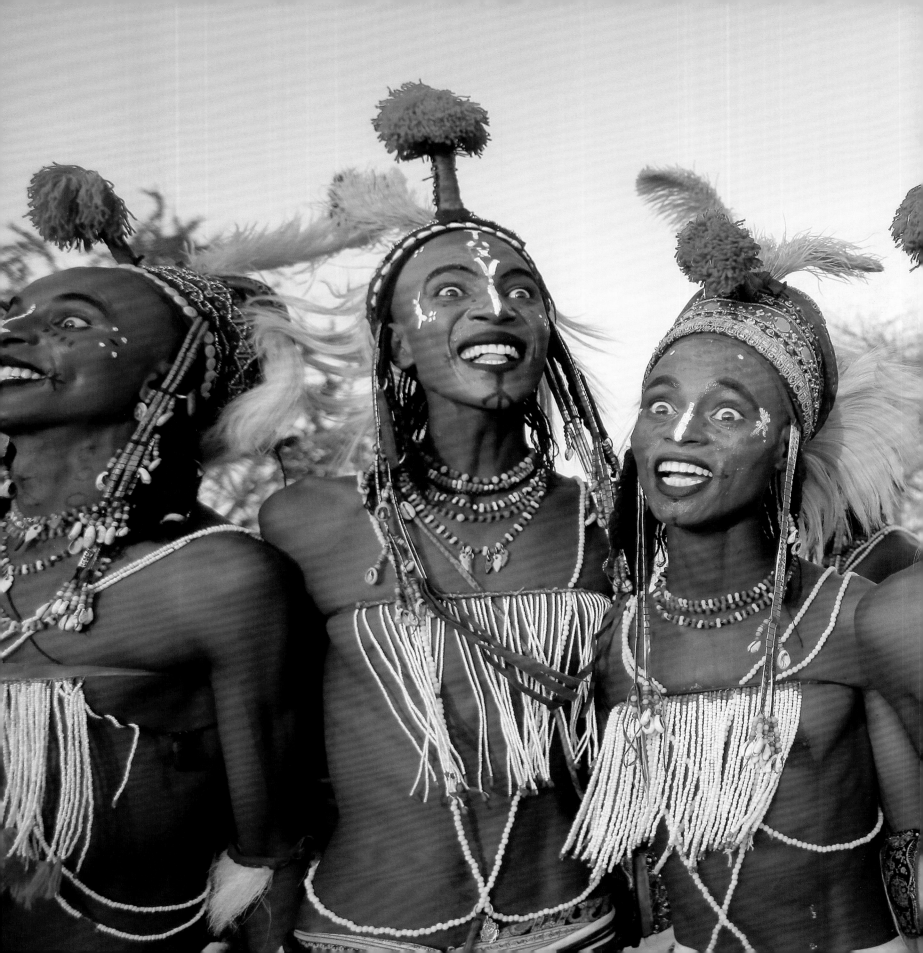

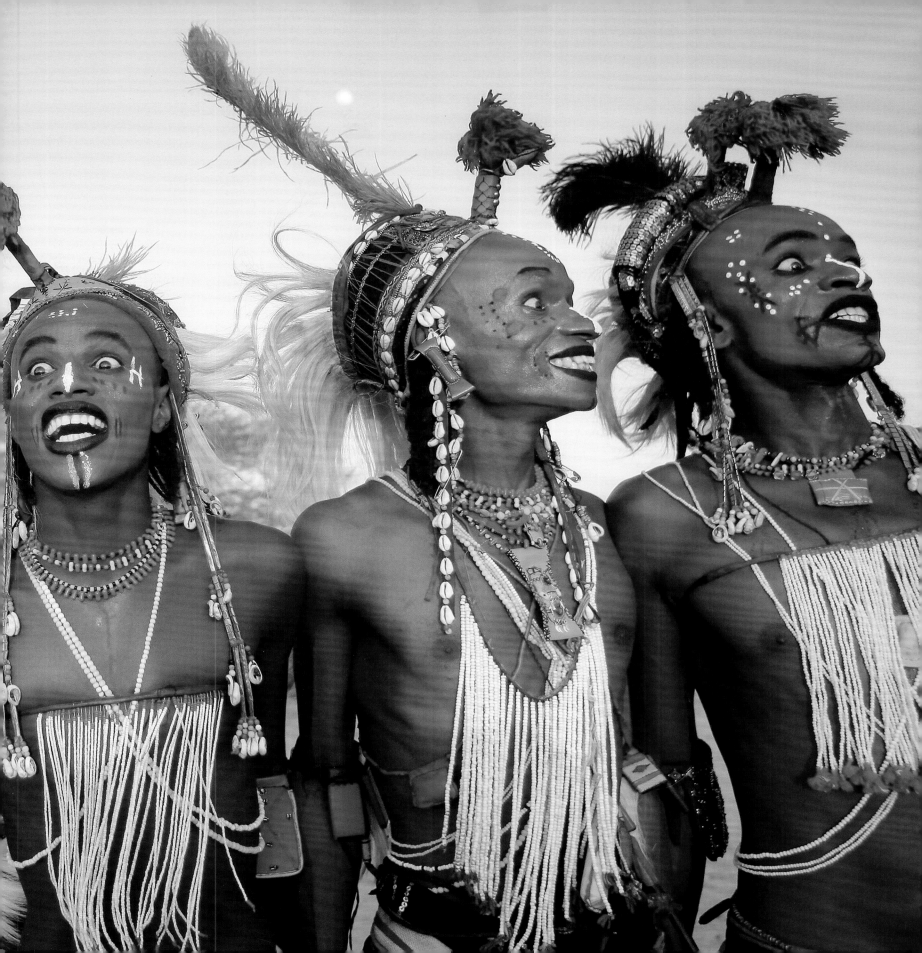

INDEX

This book is published to accompany the TV series *Human Planet*, first broadcast on BBC1 in 2010.
Executive Producer: Brian Leith
Series Producer: Dale Templar

10 9 8 7 6 5 4 3 2 1

Published in 2010 by BBC Books, an imprint of Ebury Publishing.
A Random House Group Company

The Random House Group Ltd Reg. No. 954009 Addresses for companies within the Random House Group can be found at www.randomhouse.co.uk
A CIP catalogue record for this book is available from the British Library.

ISBN 978 1 846 07956 6

The Random House Group Limited supports the Forest Stewardship Council (FSC), the leading international forest certification organisation. All our titles that are printed on Greenpeace-approved FSC-certified paper carry the FSC logo. Our paper procurement policy can be found at www.rbooks.co.uk/environment

Commissioning editor: Muna Reyal
Project editor: Rosamund Kidman Cox
Assistant editor: Laura Higginson
Designer: Bobby Birchall, Bobby&Co Design
Picture researcher: Laura Barwick
Production: David Brimble

Colour origination by XY Digital Ltd
Printed and bound in UK by Butler Tanner and Dennis Ltd

To buy books by your favourite authors and to register for offers, visit www.rbooks.co.uk

ACKNOWLEDGEMENTS

There is no 'I' in *Human Planet*, and that's for a very good reason. Making a series of this scale and ambition takes an enormous team of talented and dedicated people, as you will see from the credit list that follows. It seems such an obvious thing to do, make a landmark series about the human species. Yet it has taken 50 years for the BBC Natural History Unit, famed for its wildlife documentaries, to make the leap of faith and go 'human'.

The *Human Planet* concept took several years to lock down, and it pulled together the skills of many development teams across three BBC departments, all whom were involved in the production and all of whom should all be thanked. The first is the Natural History Unit, headed by Neil Nightingale when the series was finally commissioned in spring 2008. Next is the BBC Bristol Features Department, run at the time by Tom Archer, who has supported this series through thick and thin. Finally, the BBC Wales Factual Department and its head, Adrian Davies, who gave us the anthropology talent so essential to the series.

Landmark programmes are very expensive to make, and we have three major investors. First we must thank the BBC1 commissioning team, and then everyone involved at Discovery Channel (USA) and BBC Worldwide who have invested in this series at so many levels. Special thanks go to Jo Foy, our marketing manager, who has built *Human Planet*. And, of course, this book wouldn't have been possible without BBC Books, in particular, commissioning editor Muna Reyal.

Finally the biggest thanks must go to the very many people throughout the world who have taken part in the series, as inventive, resourceful and fascinating representatives of the species, 7 billion of whom now populate the 'human planet'.

PRODUCTION TEAM
Jane Atkins
Kate Borde
Nicola Brown
Nicolas Brown
Alison Brown-Humes
Isabelle Corr
Ellen Davies
Rhiannon Dew
Bethan Evans
Ciaran Flannery
Mark Flowers
Renee Godfrey
Stacey Hill
Cecilia Hue
Tom Hugh-Jones
Andrea Jones
Rachael Kinley
Brian Leith
Joanna Manley
Jasper Montana
Dina Mufti
Sylvia Mukasa
Patrick Murray
Willow Murton
Charlotte Scott
Tuppence Stone
Dale Templar
Julia Wellard

ADDITIONAL PRODUCTION TEAM
Mary Albion
Giles Badger
Laura Barwick
James Chapman
Sally Dyas
Matt Fletcher
Andrew Graham-Brown
Susan McMillan
David Marks
Claire Messenger
Sara Moralioglu
Esther O'Donnell
Wendhy Sierra
Ben Southwell
Heidi Williams
Erica Wilson
Simon Wylie

CAMERA TEAM
Doug Allan
Michael Brown
Steven Case
Rod Clarke
Jonathan Clay
Dany Cleyet-Marrel
Martyn Colbeck
Robin Cox
Gerry Dawson
Mark Deeble
Jonathan Dennis
Will Edwards
Simon Enderby
Mike Fox
Peter Fuszard
Pete Hayns
Mike Holding

Max Hug-Williams
Richard Kirby
Mukal Kishore
Ian McCarthy
Pete McCowan
Mark MacEwen
David McKay
Justin Maguire
John Marzano
Roger Munns
Gavin Newman
Matt Norman
Keith Partridge
Johnny Rogers
Steve Romano
Dan Rubock
Warren Samuels
Toby Strong
Gavin Thurston
Simon Werry
Toby Wilkinson
Mateo Willis
Richard Wollocombe
Mark Yates

ADDITIONAL CAMERA TEAM
James Aldred
Robin Barnwell
Keith Brust
Darren Conway
Jason Ellson
Matthew Franklin
Dean Johnson

Siby Joseph
Daniel Meyers
Steve Moss
Terry Parker
Simon Wagen

SOUND
Nick Allinson
Rob Davis
Jake Drake-Brockman
Simon Forrester
Alex Herrera
Subramanian Mani
Richard Maxwell
Sophie Meyer
Mr Mohandas
Jaxx Monteath
Mihali Moore
Mike Prickett
Nicholas Reeks
Zubin Sarosh
Dave Schaff
Dino Schiavone
Victoria Stone
Ikbal Wahyudin
Richard Whitley

POST-PRODUCTION
Craig Haywood
Steph Lynch
Carmen Roberts
Joel Skinner
Arthur Waters

FIELD ASSISTANTS AND FIXERS
Toufiq Aboubayd
Bryan Alexander
Esmedeh Altangerel
Christine Atallah
Rob Babekuhl
Zahra Oulad Bada
Hamdi Barka
Cal Barton
Zablon Beyene
Abhra Bhattacharya
Paul Brehem
Tanya Brzeski
Fabricio Bueno Telles
Mike Charlton
Said Chitour
Mia Collis
Gemma Delaney
Helen Douglas-
 Dufresne
Dramane
KT! Eaton
David Espejo
Fenelun
Fina
Parker Fitzpatrick
Lorenz Frutiger
Hans-Rudi Gertsch
Alex Ginting
Ali Gorjo
Tony Gray
Paul Greeves
Edgar Gudiel
Saul Gutierrez
Haratj Hakoubyan
Patrice Halley
Rankin Hank
Jean Hartley
MohdSaid Hinayat
James Hoesterey
Jose Huaman
Mohamed Ixa
Howard Jeffs
Hans Jensen
Moses Kaleku
T. Wangchuk Kalon
Peter Kay
Peter-Hain Uaakisa
 Kazapu
Prokrotey Khoy
Abdel Latif Cherif
John Leivers
Girlie Linao
Jim McNeill
Raymond Maloney
Pym Mamindi
Bushe Matis
Karina Moreton

Juan Pablo Morris
Sahidah Bin Muallam
Henry Nakpil
Lama Tenzing Norbu
Mads Nordlund
Phil O'Brien
Etienne Oliff
Seguere Boukary
 Ombotimbe
Srei Omnoth
Michael & Yuta
 O'Shea
Miguel Pacsi
Bob Palege
Simon Peers
Nick Pitt
Jean Cyril Pressoir
Alberto Prieto
Goyotsetseg
 Radnaabazar
Ange Rakatoarisoa
Ibrahim Ratu Loly
Nick Ray
David Reed
Oliver Reston
Jason Roberts
Inky Santiago-Nakpil
Louis Sarno
Scubazoo
Oliver Saurabh Sinclair
Shivraj Thapa
Luis Torres
Pemma Tharka Sherpa
Tenzing Sherpa
Toby Sinclair
Digpal Singh
Flavio Somogyi
Kit Spencer
Hugo Streeter
Lisa Strom
Ben Tapp
Jonathan Teko
Amadou Thiam
Efraim Valles
Freddy Vergara
Guido Vuildez
Waipa
Martin Webb-Bowen
Julia Wheeler
Daniel Wilde
Pablo Zuñiga

ROPE & CRANE, RIGGERS AND SAFETY
Jonathan Dennis
Mr Eddy
Tim Fogg
Tyler Frisby
Grant Harris

Dave Holley
Brad Irwin
Brian Morris
Colin Pereira
Alistair Rickman
Sam Rutherford
Eric Young

BOAT/DIVE SPECIALISTS
Arni
Theo Sugi Bataona
Helen Brunt
Andy Chia
Sen Hon
Daisuke Jomi
Anna Svizunova

STILLS AND TIMELAPSE
Timothy Allen
Kieran Doherty
Abbie Trayler-Smith

SCIENTIFIC CONSULTANTS
Arnaldo D'Amaral
 Pereira Granja Russo
Catherine Baroin
Mylea Bayless
Ron Beaton
Mette Bovin
Rod Camacho
Ian Douglas-Hamilton
Jim Edds
Roy Ellen
James Fairhead
Louis Forline
Guillermo Galdos
Dave Harmon
Penny Harvey
Stephen Hugh-Jones
Tim Ingold
Kristin Laidre
Kevin Lane
Melissa Leach
Jackson Looseyia
George McGavin
El Mehdi
Jose Carlos dos Reis
 Meirelles
Preston Miracle
Martin Nicholas
Julie Nikolai
Maria Isabel Remy
Robin Rodd
Paul Roscoe
Antonio Santana
Paul Sillitoe
Charles Southwick

Rick Spowart
Marilyn Strathern
Mark Turin
David Turton
Merlin Tuttle
Gonzalo Valderrama
Jake Wall
Holly Wissler

FILM EDITORS
Nigel Buck
Andy Chastney
Tim Coope
Stuart Davies
Mark Fox
Angela Maddick
Andy Netley
Dave Pearce
Jason Savage
Keith Ware

SOUND EDITORS
Darran Clement
Kate Hopkins
Tim Owens

MUSIC
National Orchestra of
 Wales
Nitin Sawhney

STORY CONSULTANTS
Frank Ash
Patrick Makin
Robert Thirkell
Michael Waldman

COLOURIST
Andrew Daniel
Richard Doel

DUBBING MIXER
Mark Ferda
Martyn Harries

TRACKLAY
Darran Clement
Wounded Buffalo

GRAPHICS
BBC Wales Graphics
Kiss My Pixel

CO-PRODUCERS & INVESTORS
BBC Worldwide
Discovery Channel
France 5
Wanda

WITH SPECIAL THANKS TO …
Grasslands
Ben Tapp, Rankin
Hank and National
Australian Helicopters,
Katherine, Australia;
Vaana and Vaani,
Cambodia; Eric
Vernet of OSMOSE,
Cambodia; Shahoori,
Bargulu, Artulla
and the Suri people,
Ethiopia; Rakita Ole
Shololo, Lemomo Ole
Liyio and the Dorobo
people, Kenya; Leitato
Ole Sairowa, Kuseyo
Ole Koisikir and the
Masai people, Kenya;
Chuluun Sonom-
Ochir and his family,
Mongolia; Ulaana and
family, Mongolia;
N//ao N!ani and /Kun
Nzamce of the Jo'hansi
people, Namibia.

Oceans
Alfredo Gariba Jr,
Edson Da Silva and the
Fishermen of Laguna,
Brazil; Ken Bradshaw
and Tom 'Pohaku'
Stone of Hawaii; Theo
Bataona, Benjamin and
the people of Lamalera,
Lembata, Indonesia;
Captain Alphonse and
the people of Belo
sur Mer, Madagascar;
Nohara, Sulbin, Jude
Awambeng and the
Bajau Laut of Sabah,
Malaysia; Blais Soka,
Papua New Guinea;
Joseph Calledo,
Dionisio Martinito,
Adriano Ostos and the
crews of Palawan Ferry
and the Virgin Mary
in the Philippines;
Angel Manuel Santiago
Fernandez, Francisco
Javier Castro Garcia,
Alberto Martinez
Pequeno and the
Percebes Collectors
of Cedeira and Ferrol,

Galicia, Spain;
Edmund Pusin, Paul
Lane and the Yap
Navigation Society.

Rivers
Josephat M. Chuma
and the community
of Victoria Falls,
Africa; Doralice Castro
Pinheiro, Jarnia Castro
Pinheiro, Francisco
de S. Colores and
the community of
Daracua, Brazil; Chuck
Wheatley, Marc Roy
and City of Ottawa ice-
blasting crew, Canada;
Lamdon Senior
Secondary School,
Leh, India; Harley and
the community of Siej
village, Meghalaya,
India; Stanzin Rabyang,
Stanzin Dolkar,
Stanzin Chosing and
the community of
Zangla, India;
Lenareu and the
Samburu people of the
Milgis region, Kenya;
Lamagas Samniang and
the community of
Si Phan Don, Mekong,
Laos.

Jungles
Imuj and Pikawaja
and the Awa-Guaja
of Brazil; the State
Government of Acre,
Brazil the Matis of
Aurelio, Brazil; the
British Army Training
Team in Brunei;
Kong Dy, Cambodia;
Tete and Mongonje
and the BaAka of
Central African
Republic; the Embera
Katio of Colombia;
Sumir Chakma, Gam
Seng and the elephant
loggers of Arunachal
Pradesh, India; Kiao,
Geling, Peke and the
Gol Goi Cultural
Group of Papua New
Guinea; the Korowai of

West Papua; Orlando, Rosanna and Gustavo of the Piaroa community of Pintado, Venezuela.

Deserts
Mahfoudi, Algeria; Orlando Rojas, Chile; Kiran and Shyamsunder and the Bishnoi people, India; Ogobara and the Dogon people of Mali; Amadou and the village of Bamba, Mali; Mamadou and the cattle herders of Mali; ; D. Ganbold and N. Otgonjargal of MongoliaMuuka and Purros Community Conservancy, Namibia; Shede, Ahmed and Foni and the Tubu people, Niger; Djah'o and Toombe and the Wodaabe people, Niger.

Arctic
Lukasi Nappaaluk, Attituq Kiatanaq, Mary Qumaaluk and the community of Kangiqsujuaq, Canada; Bob Windsor, April Lundie, the Dingwall family and the community of Churchill, Canada; Niels Gundel and the Ilulissat Choir, Greenland; Mikele, Gedion and Mamarut Kristiansen and the community of Qaanaaq, Greenland; the Oshima Family and the community of Siorapaluk, Greenland; Amos Jensen, Karl Frederik Jensen and the Communities of Saattut & Uummannaq, Greenland; Elle-Helen Siri, May-Torill Siri and the Arnøy-Kågn Siida community, Norway.

Mountains
Dereije Muthr and family and the Simien Cliff farmers and community, Ethiopia; Jadik Jarik Sailau, Jadik Sailau Berik and friends and family Jadik, Mongolia; Amchi Namgyal Lama, Mondo Uogn and Bharmay Furba, Nepal; Titini Tham1, Dr Sanduk Ruit, Nepal; Marcus Paringu, Andrew Pangian and George Fingu and the communities of Wamaian and Marik, East Sepik Province of Papua New Guinea; Constantino Puma, Elmer Abra Huaraya and the people of Checca and Quehue, Peru; Martin Mathys, Andreas Heim and Andreas Balmer of Switzerland.

Urban
David Stead, Nicola Ohlenforst and the city of Dubai; Vijay Sherma, Meeva Om Prakash, Shakauntla Hari Narayan and the city of Jaipur, India; Ali Kombo, Ashe Kombo, Hadija, Mariam and Halima Ali and the people of Kibarani Dump Site, Mombasa, Kenya; Lassaini Kayentoo, Mama Kayentoo and the community of Djenne, Mali; Manuel Villaroya and the city of Barcelona, Spain; Adam Juson, Carol, Indigo and Jared Anderson-Allen and the city of London, UK; Robert Schumaker, Eric Rose and the community of Estes Park, USA; Shannon Shaddock and the city of Austin, USA.

ORGANISATIONS AND CONSULTANTS
Ancine, Brazil; Jimbeau Andrews, APT Surfing Consultant; British High Commission, Port Moresby, Papua New Guinea; Robson Goncalves Batista and FUNAI; Indonesian Embassy, London; International Arctic Social Sciences Association (IASSA); the people of Liminangcong, Palawan; Mount Hagen Show Committee; Paul Barker, Institute of National Affairs, PNG; National Film Institute of Papua New Guinea; Cephas Kayo, Papua New Guinea Embassy, London; Panoramic Journeys, Mongolia; Parc Du Banc D'Arguin; Polar Bear International; Thomas Rabeil, Sahara Conservation Fund, Niger; Save the Elephants; Survival International (www.survivalinternational.org); Venezuelan Film Commission (CNAC); John K Westbrook.

PICTURE CREDITS

All photographs are by Timothy Allen unless listed below (with special thanks to Kieran Doherty and Abbie Trayler-Smith for their commissioned contributions).

GRASSLANDS
42–3 Tuppence Stone;
44 Nigel J. Dennis/NHPA/Photoshot;
44–5 Vadim Onishchenko/wildlife-photo.org;
45 Christopher Vernon-Parry/Alamy;
46–7 Toby Strong;
62–3 Bruce Davidson/naturepl.com;
64 Robert Garvey/Corbis;
64–5 Yann Arthus-Bertrand/Corbis

OCEANS
78–9 Ardiles Rante/Barcroft Media;
80–1 Ardiles Rante/Barcroft Media;
82–3 Roberto Rinaldi/Bluegreenpictures.com;
84–5 Anna Svizunova;
86–7 top Erik Von Weber/Getty;
86–7 bottom Daniel Aguilar/Reuters/Corbis;
88–9 Peter Sterling/Getty;
98–9 Shuuichi Endou/Tuvalu Overview http://10000.tv

RIVERS
108–9 Charlie Hamilton-James;
110 top Anup Shah/naturepl.com;
110 bottom Suzi Eszterhas/Minden Pictures/FLPA;
111 Renee Godfrey;
116–17 Kieran Doherty; 122–3 AP/Press Association Images

JUNGLES
138–9 Rachael Kinley;
139 Kathryn Jeffs;
150–1 top Steve McCurry/National Geographic Image Collection;
150–1 bottom W. Robert Moore/National Geographic Image Collection; 154–5 Gleison Miranda/FUNAI;
155 Rachael Kinley;
156–9 Tom Hugh-Jones

DESERTS
160–1 Abbie Trayler-Smith;
163 Abbie Trayler-Smith;
164–5 Tuppence Stone;
166 top Cecilia Hue;
166 bottom Tuppence Stone;
167 Nathalie Borgers;
168–171 Abbie Trayler-Smith;
172–3 Alain Buu/LightMediation;
180–1 www.franckvogel.com;
182–3 Gavin Newman

ARCTIC
192 Abbie Trayler-Smith;
193 Daisy Gilardini/Getty;
200 Nicolas Brown;
200–1 Paul Nicklen/National Geographic Image Collection; 202–3 www.patricehalley.com;
204–5 Bethan Evans;
206 top Nicolas Brown;
206–7 Staffan Widstrand/naturepl.com;
208–9 Doug Allan;
210–13 Abbie

Trayler-Smith;
214–15 T. J. Rich/naturepl.com

MOUNTAINS
230–1 Eric Valli;
241 Galen Rowell/Corbis;
242–3 Zubin Sarosh;
244–5 Richard Hallman/Getty;
245 Christian Arnal/Photolibrary Group;
246 top Ian McCarthy;
246 bottom Nicolas Brown;
247 Zubin Sarosh;
248 Ian McCarthy;
249 Zubin Sarosh

URBAN
253 Kieran Doherty;
258 Ciaran Flannery;
258–9 Mark MacEwen;
259 Edward Suthoff;
264–5 Fritz Pölking/FLPA;
266–271 Kieran Doherty;
277–8 Smith & Gill/Masdar

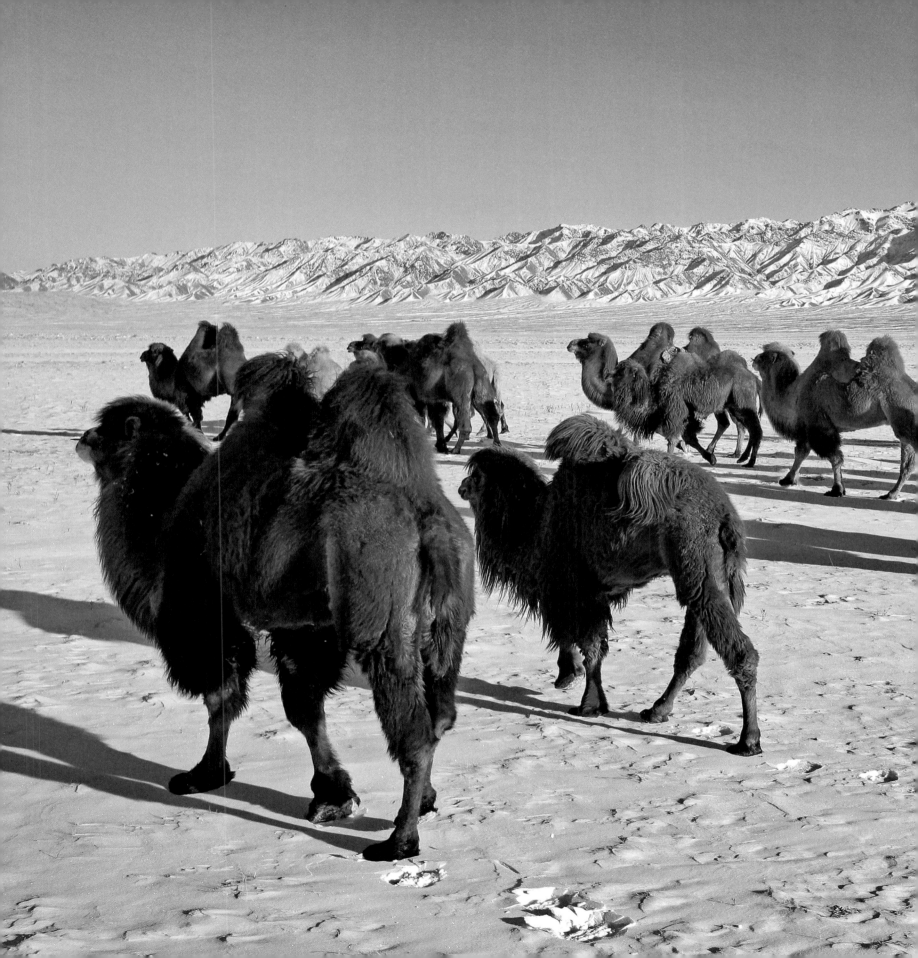